The World By Design

RosettaBooks®

To my mother, Hannah, and my father, William, who worked so hard to give me the opportunity to succeed.

The World By Design

The Story of a Global Architecture Firm

by A. Eugene Kohn
Founder of
Kohn Pedersen Fox Architects

with Clifford Pearson

First edition published 2019 by RosettaBooks

Cover and interior design by Claudia Brandenburg

ISBN-13 (print): 978-1-9481-2249-8
ISBN-13 (ebook): 978-0-7953-5265-2

Library of Congress Cataloging-in-Publication Data

Names: Kohn, A. Eugene, 1930- author. | Pearson, Clifford A.
Title: The world by design : the story of a global architecture firm / A.
 Eugene Kohn ; with Clifford Pearson.
Description: First edition. | New York : RosettaBooks, 2019.
Identifiers: LCCN 2019017030 (print) | LCCN 2019017778 (ebook) |
 ISBN 9780795352652 (ebook) | ISBN 9781948122498
Subjects: LCSH: Kohn Pedersen Fox (Firm)--History.
Classification: LCC NA737.K65 (ebook) | LCC NA737.K65 K58 2019 (print) |
 DDC 720.92--dc23

www.RosettaBooks.com
Printed in Canada

RosettaBooks®

Note on credits:
Architecture is a team effort and no building is designed by one person.
In certain places in the text of this book and its captions, though, I identify
someone as the "designer" of a particular project. When I do this, it is
merely to say who was the design principal in charge of that job. Keep
in mind that managing principals and various team members also play
critical roles in shaping projects and making them work.

Chapter 1 7

Perspective

Chapter 2 17

Beginnings

Chapter 3 51

Launching a Firm

Chapter 4 85

Dancing with History

Chapter 5 109

First Steps Abroad

Chapter 6 129

Pacific Overtures

Chapter 7 151

Millennium Approaches

Chapter 8 185

London Fire

Chapter 9 201

Vertical Urbanism

Chapter 10 227

Greater than Ever

Chapter 11 247

The Two Bills

Chapter 12 259

Re-Generation

Chapter 13 293

Future Perfect

Acknowledgments 308
KPF Principals and Employees 310
KPF Key Projects, 1977–2024 314
Index 318

Working the phone.

Perspective

For more than four decades, Kohn Pedersen Fox has shaped skylines and redefined cities around the globe. Launched by William Pedersen, Sheldon Fox, and me on July 4, 1976—at the nadir of a long recession—it has taken a few hits over the years but has prospered in both good times and bad. Along the way, it has had the good fortune to work with some remarkable clients, engineers, and consultants in creating buildings and places that have contributed to an urban resurgence transforming cities as varied as New York, Shanghai, London, Hong Kong, Frankfurt, and Jakarta. Just as important as any individual project has been the creation of a firm that embodies a set of values defined by its founders. My goal as an architect has always been to create a built environment that improves the lives of people and brings them joy, regardless of their ethnicity, nationality, religion, or economic status. KPF embodies that goal in action.

When Bill, Shelley, and I started KPF, we shared a vision of an architecture firm working as a team and pursuing excellence together. We weren't a single-name firm banking on the talent and allure of one big-time player.

Nor were we a collective of design studios, each with its own star at the top. The three of us liked sports a lot and thought of KPF as a team with members playing different positions but all working toward a common goal. When I was a kid, I wanted to be a baseball player and later toyed with the fantasy of becoming a sports broadcaster. I lacked the extraordinary talent needed to be a professional athlete, but I learned how to play on a team. Bill was a superb athlete and played hockey at the University of Minnesota with an eye on the National Hockey League. Corny as it might be, sports were a recurring metaphor for KPF. Fielding a strong team in the New York City corporate softball league was always important to us, and for many years Bill and I went to bat, literally, for the firm. I admit we sometimes hired people for their baseball skills—which helped us win five league championships—but they had to be good at architecture, too. Playing together was essential to us.

From the beginning of KPF, I understood that running an architecture firm was perhaps the most difficult kind of leadership task. Shelley and I had served in the military as officers during the Korean War—he in the Army, I in the Navy—so we knew about chains of command. The military is set up for leadership. Rank has its privileges and is identified very quickly, by stars and stripes. You have to listen and do what you're told. While officers usually have college degrees, most of the people they command do not. Corporations are different, but they too have management structures that are pretty well spelled out. From the CEO through the department heads and down to the rank and file, everyone knows his or her position within the company's lines of responsibility. On sports teams, you have owners, coaches, scouts, and players—all with specific roles. They don't win unless they work together. That's the key. You can have a fantastic quarterback, but he needs a great offensive line to protect him and receivers to catch the ball. One player's greatness is dependent on others.

But architecture firms—indeed, all creative service enterprises—are different. Architects are trained to be individuals, to shine as solo talents. Most are college educated, and today more and more of them have master's degrees, too. So you get a lot of big egos and lots of ambition. They're smart and have strong ideas. They're all critics and will take apart everyone else's ideas. They all want to be the next big star. That makes it hard for them to check their need for individual recognition. Leading a group of people like this, especially a large one, is really difficult. You can't run an architecture

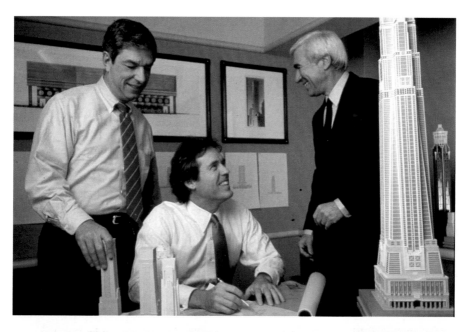

Top: Shelley Fox, Bill Pedersen, and I enjoy a light moment in our offices on West 57th Street with a model of a tower we designed for mid-town Manhattan that didn't get built.
Bottom: Jamie von Klemperer (right) is now president of KPF, leading a new generation of principals that includes Josh Chaiken (left).

At an event honoring Philip Johnson, I joined a group of illustrious architects all wearing copies of his famous eyewear. I'm the one on the right with my head even with the Chippendale-inspired top of Johnson's AT&T Building.

firm like a military unit or a corporation or even a sports team. It won't work. You'll lose your best people pretty quickly or won't be able to attract them in the first place.

Architecture schools, films, and books peddle images of the heroic architect—the master builder, the genius who does everything alone. It's sexy and it sells. But it's a myth. Architecture is actually an incredibly collaborative effort. Bill, Shelley, and I knew that from day one. All of us were trained as architects and read *The Fountainhead*, but none of us wanted to play the hero. It helped that we had different personalities and complementary skills. I'm a very good designer, but Bill is one of the best in the world, so I let him take the lead in that area. Shelley was the most organized person I've ever met. At the University of Pennsylvania, where he and I went to architecture school together, Shelley was the only student who would have his project done the day *before* a design charette ended. He would show up for the final review well rested and dressed in a beautiful sports jacket and tie while everyone one else would look like hell—unshaven and sleep deprived. He was never late. Never. So at KPF, Shelley took care of managing operations. I was the most outgoing of the three and the biggest risk taker. As a result, I took on the role of president and leader, which in the beginning meant getting the work—finding new opportunities and convincing clients to give us jobs. None of us tried to do everything. We each needed the other two. But we could back each other up, if needed. It was a formula that succeeded from the beginning and kept working for many years.

Most architecture firms don't last very long after the founders retire or die. Usually they sell to or merge with another firm, or their new leaders change the firm's name and identity. We wanted Kohn Pedersen Fox to be different. From the start, we talked about training the next generation of leaders, developing people who could take over from us. We weren't a single-name brand or a bunch of star individuals, so this seemed like the right way to go. We liked the idea of creating something bigger than the three of us that would live longer than any of us. To do that we needed to hire people who were as good as or better than the founders.

At the time of this writing, KPF has completed more than three hundred projects (many with multiple buildings) in forty-one countries and won nine National Honor Awards from the American Institute of Architects. We were the youngest practice to be recognized with the AIA Architecture Firm Award

(in 1990) and have touched the lives of millions of people. In the process, we have played a critical role in the biggest global construction boom in human history, which has reaffirmed the central role of cities in developed and developing countries alike. At the founding of KPF in 1976, though, the US was still reeling from the oil embargo of three years earlier, and New York City was struggling with its near default the year before. Big corporations were fleeing cities, and crime was on the rise. A lot of things seemed broken. But I just knew KPF would succeed. I'm not sure why I was so confident, but my gut told me to press forward, and I've learned to trust my instincts. Certainly, I was—and remain—an optimist.

From the beginning, Bill, Shelley, and I wanted to design commercial projects—such as office towers, apartment buildings, hotels, and retail complexes—because they have the most impact on the public life of cities. Many high-profile architects in the 1970s turned up their noses at such projects, seeing them as mostly dumb boxes with repetitive programs and lots of bottom-line pressure. Instead, they focused on houses, museums, and cultural facilities. But commercial projects are the dominant building type in cities and we felt it was wrong to ignore them. We wanted to tackle the challenge and make these buildings work as positive contributors to a city's fabric and a neighborhood's character. If we could do that, we could make a significant contribution to the architectural profession and urbanism.

In our first year, we landed a few significant projects and established relationships with clients who ended up becoming repeat customers and lifelong friends. Within our first few years, we had become a darling of the press and had a major profile in the *New York Times Magazine* to our credit. We worked really, really hard and had a lot of fun doing it. There were bumps along the way, of course, but we rode a remarkably steady path to the top. I think a lot of this success was due to the fact that Bill, Shelley, and I remained good friends. We liked each other's families and would vacation together. Through all the years, we always respected one another and enjoyed working together. On numerous occasions, clients would look at the three of us and shake their heads in surprise. "You guys seem to actually like each other!"

In 1989, KPF took its first steps abroad, landing jobs in London and then Frankfurt. By the end of the 1990s, we were a truly global firm with projects in Japan, China, Hong Kong, Korea, Singapore, Indonesia, the United

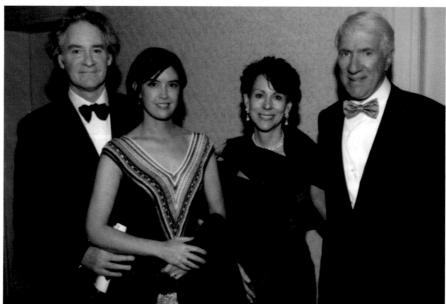

Top: Stephen Ross, the head of the Related Companies, came to one of my Harvard Business School classes and talked to my students about his approach to real estate development. **Bottom:** My wife Barbara (second from right) is active with many nonprofit organizations, including the Paul Taylor Dance Company. Here we are at a Paul Taylor gala with actors Kevin Kline and Phoebe Cates.

Kingdom, Holland, the Czech Republic, Germany, France, the UAE, and many other countries. It was exhilarating to engage with clients, government officials, design consultants, and the public in foreign places and learn about their cultures. When you design a large building in a city, you need to research everything about that place—its climate, its geology, its building traditions, its economy, and its society. As an outsider, you must prove you have done your homework and really studied the local conditions and the larger context. It's a huge challenge, but it makes you smarter.

Right after the attacks on September 11, 2001, many people wondered if anyone would want to work or live in tall buildings anymore and if people would start abandoning big cities for places that might be seen as safer. Remarkably, the opposite happened. The determination of the people of New York to rebuild at Ground Zero reaffirmed the preeminent role of the city in our nation's economy and identity and helped jump-start an urban resurgence around the world. Many other factors contributed to this city-centric wave, including rapid development in countries like China and India and the rise of technology companies in need of the kind of highly skilled employees who gravitated to metropolitan areas. With our expertise in the design of skyscrapers and complex, mixed-use projects, KPF was well positioned to take advantage of these transformational forces. In both the United States and abroad, clients have become increasingly sophisticated during the past decade and have demanded high-quality architecture to attract tenants and buyers, stylish interiors to encourage better performance, and innovative strategies to make buildings more environmentally responsible. These factors too played to KPF's strengths.

Now in our fifth decade, KPF has remained true to our faith in talented people working together. Shelley Fox retired in 1996 and passed away ten years later from brain cancer. Bill Pedersen has taken a less active role in recent years as he has helped his wife battle pancreatic cancer. In my capacity as chairman, I still come to the office every day and travel a great deal to lead our efforts on the West Coast of the United States and help get new work in other countries. But I have handed over the role of president to Jamie von Klemperer, who is in charge of a new generation of principals, directors, and associates. The ideals that inspired Bill, Shelley, and me, though, are as strong as ever in our firm. I have no doubt that KPF will continue to play a premier role in shaping the buildings and places of the future.

Leaning over a model of our Chifley Tower in Sydney.

Me at Camp Wayne in Preston Park, Pennsylvania.

Beginnings

Whenever someone asks me why I became an architect, I talk about my mother, Hannah Kohn. She was a remarkable person, a very creative lady. When she turned ninety in 1992, I put together an exhibition of her artwork at the KPF Gallery in our offices, which were then on Fifty-Seventh Street. Thomas Krens, the director of the Guggenheim Museum and a friend of mine, came to the show and was impressed. He went up to my mother and said, "Hannah, if you live to one hundred, I'll give you a show at the Guggenheim." Well, ten years later, she was still going strong, and Tom kept his word. He mounted an exhibition of one hundred of her paintings at his museum in New York, and it was fabulous. While it was up for just a short time, some of the people at the museum told me it was their favorite show of the year, because it represented one artist's personal vision of her life. Richard Meier, Bob Stern, Frank Gehry, and other big-name architects attended, as did my partners, my mother's friends, and many family members. It was a lovely evening. My mother stood on her feet for three hours and entertained everyone with her energy, charm, smile, and enthusiasm. At one hundred, she was still full of piss and vinegar!

At the Guggenheim opening, she called herself a "Sunday painter," and the *Philadelphia Inquirer* used that in its headline of its story on the show. But she was much more than that. After my father, William, lost his medical research laboratory business during the Great Depression, she went to work knitting and designing dresses. She had impeccable taste and strong opinions, so people came to her for all kinds of advice—on clothes, jewelry, hairstyling, their total appearance. She might say, "That hairdo has to go!" Or "Where did you get those ugly shoes?" She could be tough, but she made sure you looked great. If someone wanted to buy a dress that wasn't flattering on her, my mother wouldn't sell it to her. "Let's find something more appropriate for you," she would say.

While raising me, she set up shop in our two-story row house in Philadelphia and used my bedroom as one of the dressing rooms. Eventually,

she made quite a name for herself in Philadelphia. She met Karl Lagerfeld, Calvin Klein, Mollie Parnis, and many other important designers on her regular trips to New York.

I learned a lot from her. Her enthusiasm for aesthetics was contagious. She worked very hard and was a wonderful leader. She was the key figure for our entire family (including aunts, uncles, and cousins) and ran her business with great confidence. She helped other people manage their affairs, too—whether it was choosing a chair, a dress, or a painting or answering financial questions. And she knew how to enjoy life—good food, good music, good company. Her family came from Odessa in what was then the Ukrainian part of Russia, and she loved to dance, a skill she passed on to me.

On Saturdays, I would go to art school at the Philadelphia Museum of Art in the morning, then attend the afternoon rehearsal of the Philadelphia Orchestra, which was led by Eugene Ormandy and allowed children to watch for free. I'm not sure why, but the teacher always chose me to show the class the correct steps. I came up to just above her waist, and she held me close, which made me a bit uncomfortable. On Sundays, I painted with my mom. She wanted me to be well-rounded, so I took piano lessons, too. Much of the time, though, I just wanted to play baseball, football, or basketball. Sports were my first love!

My father, William, was of German descent, and both he and my grandfather were strict. My father went to Central High School in Philadelphia, the only public school in the city that requires an entrance exam and the only high school in the country authorized to confer Bachelor of Arts degrees. It has a glorious 183-year history and boasts a planetarium, an extensive library, and an impressive list of accomplished alumni. After getting his B.A. from Central, my father went to the University of Pennsylvania to study veterinary medicine and later medical research. In my family, education came first and play (fun) a distant second. Learning was important to my parents and it became important to me, too. To this day, I remain active with the University of Pennsylvania, where I went to architecture school. I've taught at Harvard's Business School and its Graduate School of Design and at Columbia. I've also lectured at many other schools. Education is an essential part of who I am.

While my mother could be tough, she treated everyone with respect—no matter what job they held or ethnic background they came from. She was sincere, fair, and positive, and people loved her for that. Give everyone a fair

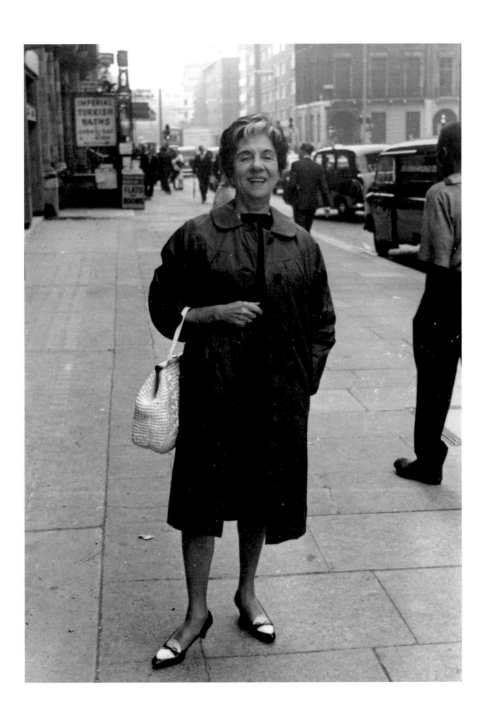

My mother, Hannah Kohn, in New York City. Her clothing business often took her to New York to find fabrics, meet with manufacturers, and attend fashion shows. Her sense of style and her love of art would have a major impact on me.

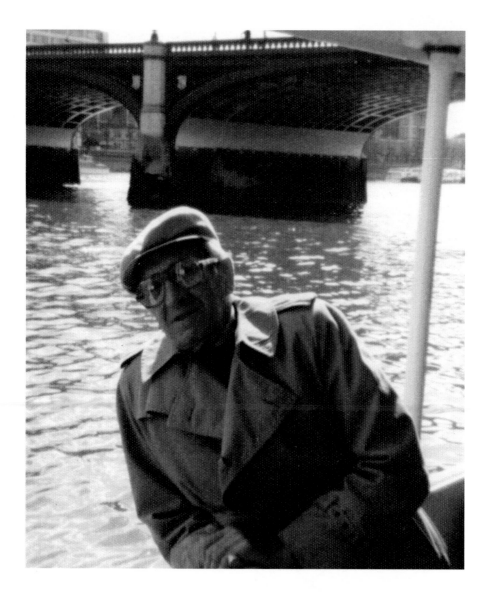

My father, William Bernard Kohn, on vacation in London. He taught me the importance of education and instilled in me a lifelong dedication to learning and earning top grades.

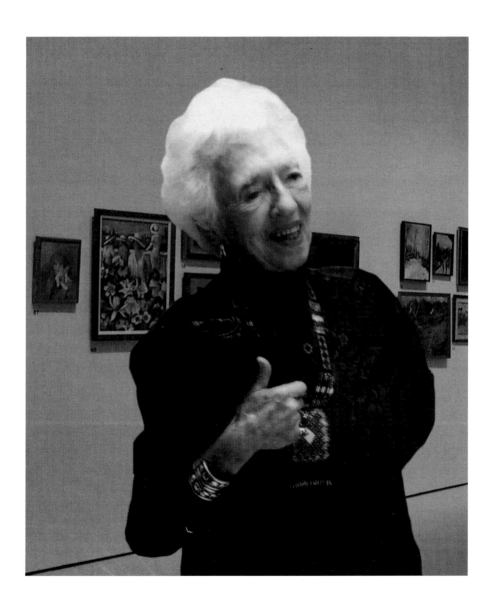

Hannah at the opening of her exhibition at the Guggenheim Museum in New York in 2002.
The exhibition presented 100 of her paintings in celebration of her 100th birthday. She was
still full of life and entertained everyone with her charm and wit.

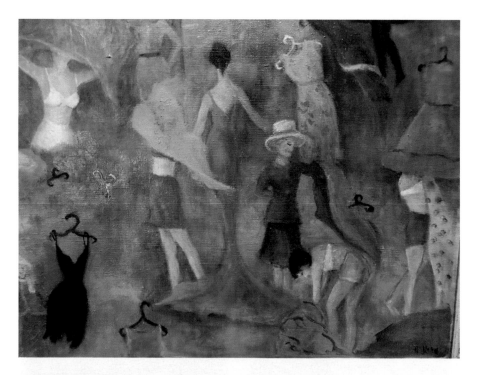

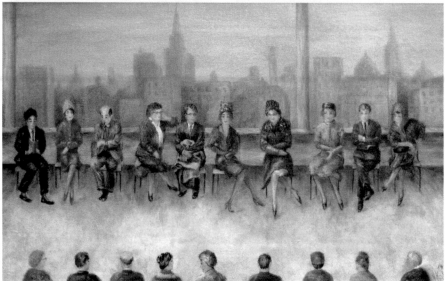

Top: Close-up of a painting by my mother focusing on fashion and clothing.
Bottom: Another painting by Hannah, showing her skill with composition and color.
She put herself in the painting in the red dress on the left.

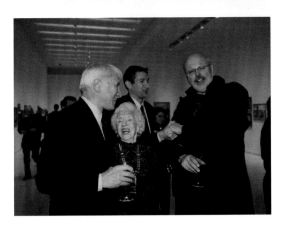
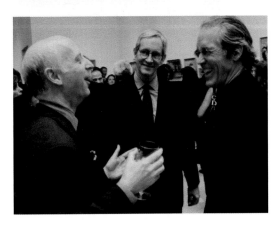

My mother's Guggenheim exhibition drew a crowd of important people, including (clockwise from top left) Hannah, me, Frank Gehry, Leslie Robertson, Trent Tesch, Paul Katz, Judy Fox, Shelley Fox, Paul Goldberger, William Bintzer, Bill Pedersen, me, Hannah, my son Steve, Thomas Krens, Jay Cross, and Bill.

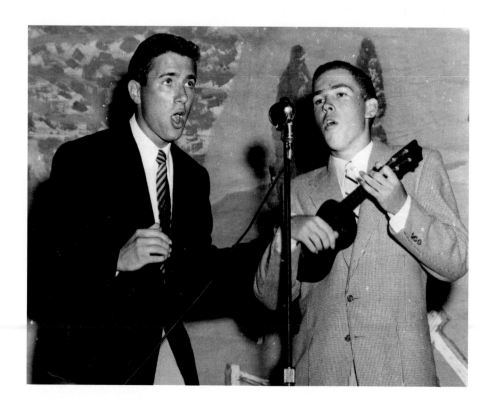

Here I am singing at camp, accompanied by an unidentified ukulele aficionado. Camp played a valuable role in shaping who I am, teaching me leadership and social skills as I became a lifeguard and a counselor.

shake and never talk down to them. When she closed her dress business in 1973, customers and manufacturers cried, and a lot of them sent letters. The most important lessons I learned from her involved how to treat others.

She never told me to be an architect, but she exposed me to the arts and bequeathed to me her passion for culture. I was an only child, so all of her parental attention was focused on me.

The second major influence on me was the University of Pennsylvania. In the late 1940s and throughout the '50s, Penn was one of the great places for architecture and design. Louis Kahn, a giant of twentieth-century architecture, taught there and inspired everyone around him. Paul Rudolph, another important figure in American architecture, did his initial teaching there. Ian McHarg, who ran the department of landscape architecture and regional planning, preached the gospel of environmentalism well before it became a mainstream movement. He had a fabulous mustache and a huge personality that was beyond belief. Lewis Mumford, who wrote the "Sky Line" column for the *New Yorker* and was an important thinker on urban issues, was on the faculty, too. G. Holmes Perkins, the dean at the time, had come from Harvard and was a major player in the field of planning and architectural education. As a result, all the great architects came to lecture—Frank Lloyd Wright, Le Corbusier, Walter Gropius, Richard Neutra, Marcel Breuer, I. M. Pei, and Philip Johnson, to name just a few. Talented young architects such as Robert Venturi, Denise Scott Brown, and Romaldo Giurgola, and the planner Edmund Bacon also taught there or gave lectures. It was a remarkable period for the school, and I was lucky to be part of it. At the time, American architectural education was shifting from the Beaux Arts model to Modernism and the Bauhaus. Penn was one of the leaders in this critical transition.

I remember hearing Neutra speak about his work and how he could focus all his energies on it because his wife took care of the household chores. I came home that evening and mentioned this to my wife Barbara. "He doesn't take out the trash or do dishes," I said. She gave me a hard look, said, "You're not Richard Neutra," and handed me a bag of garbage to take outside. I had married early—I was just twenty-one and Barbara was eighteen. (My wife today is also named Barbara, but I did marry a Diane in between the two.)

Le Corbusier's lecture caused a different kind of stir. He spoke in French but held our attention by drawing on an extremely large pad of paper at the

front of the auditorium. He sketched away, ripping the sheets off the pad as he went along and handing them to a student who pinned them to a wall right next to where I was seated. Boom, boom! It was a spectacular evening. At the end, after he had left the room, the drawings were still on the wall, so close to me. My parents had taught me not to take anything that wasn't mine, so I just stood there and watched as my fellow classmates and students from other classes jumped out of their seats and attacked the wall in a frenzy to grab valuable souvenirs of the lecture. I really wanted one of those drawings and later was angry with myself for not taking one. I was too nice.

When I started at Penn, I didn't really know what I wanted to be. I had creative abilities but thought maybe I would be a lawyer or a doctor or a sports-caster. The law and medicine were attractive because I wanted to do good in the world—cure a disease, save a life, or defend an innocent person. During my freshman year, George S. Koyl, who was in the last year of his deanship at the architecture school, told me that architecture was a good foundation for any kind of career, because it helped you think creatively and organize your thoughts. I enrolled in architecture but wasn't one of those people who knew from the very beginning what he wanted to do. The excitement at the school, however, caught me in its grasp. Listening to Mumford speak, for example, was amazing. His lectures were magical; you didn't want to miss a word. Later, McHarg grabbed my attention. He was always dressed beautifully with a decorative handkerchief in his breast pocket and a functional one stuffed in his sleeve. He had a deep voice and was always a scene to watch.

Rudolph was a rising star in the architectural world and was key to my sophomore year, his first year teaching at Penn. He was a fascinating person, the son of a Methodist minister who moved the family around the American South. Rudolph went to Auburn in Alabama before heading off to Harvard and studies with Walter Gropius. Rudolph spent three years in the Navy dur-ing World War II, got his master's degree, then practiced in Florida, where he designed some wonderful houses and became part of a loose group of de-signers known as the Sarasota School of Architecture. His houses were beau-tiful sculptures that played wonderfully with shadow and light. After his time at Penn, he became chairman of the School of Architecture at Yale and would pioneer what was called the Brutalist movement, a strain of Modernism that glorified rugged concrete structures and muscular expression. Some of his projects, such as the Art & Architecture Building at Yale and the Orange

County Government Center in Goshen, New York, attracted a great deal of controversy and elicited strong emotions both in favor of and in protest to their bold forms and roughly textured concrete. Some people called these buildings powerful, while others saw them as cold and off-putting. What surprised me in later years was how different his Brutalist buildings were from the delicate houses he did in Florida.

As a teacher, Rudolph was engaging and always enthusiastic. He made architecture seem like fun. I remember he arranged for my class to meet Philip Johnson at the Glass House in New Canaan, Connecticut. It was a fantastic experience for us. He took us to meet many architects and visit great buildings in the area. At school, he would sit with us at our drawing boards and sketch. Just watching him made you want to draw. All this shaped who I became. Another important influence on me was Robert Geddes, who was both an architect and an urbanist. His thoughts about cities and how they work and evolve helped shape my own ideas about buildings and their relationship to their larger physical and social contexts. In addition to teaching at Penn, he founded Geddes Brecher Qualls Cunningham, which would become a prominent Philadelphia firm. In 1965, Princeton lured him away from Penn to become the first dean of its School of Architecture.

Penn and all the people affiliated with it certainly influenced me. But oddly enough it was the Navy that convinced me to be an architect. After graduating from architecture school, I went to officer training in Newport, Rhode Island, and served in the Navy for three years during the latter part of the Korean War. I trained briefly with the Marines at Camp Pendleton in California and then at the Naval base in Port Hueneme, California. The Navy seemed to be preparing me for a tour of duty in Korea, supporting combat forces there. I requested duty at a Naval air base on Whidbey Island, Washington, though, because my wife Barbara wanted to finish college and could attend classes at a campus of the University of Washington on the island. But for some reason, the Navy assigned me to a facility in the north Atlantic and then to a ship heading to French Morocco.

My captain knew I had studied architecture, so—after I suggested the idea—he let me design a mobile canteen for sailors working on airfields in North Africa. Because those men were out in the boondocks and didn't have many support facilities, I devised a small structure that provided space for two people to make and serve coffee, doughnuts, sandwiches, and such. We

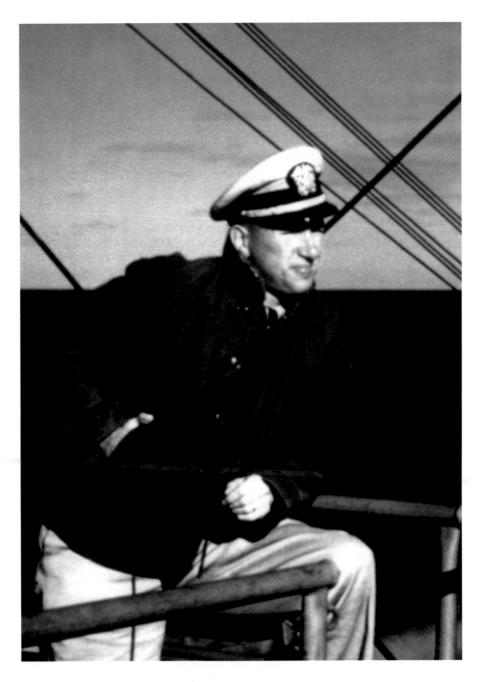

I spent three years on active duty in the US Navy during the Korean War and then several
years in the Navy Reserves. Here I am at the end of 1953 in the north Atlantic, on my way to
Morocco. The Navy gave me my first chance to run a design project, confirming my decision
to become an architect.

built it on a bomb carrier and then attached it to a Navy truck that pulled it around the airfield. It was a big hit. The guys out there really appreciated it.

Most of the time, though, I didn't think about architecture. I was a Naval officer and did what the other officers did on base and onboard ship.

While the real war was happening in Asia, North Africa—in particular French-controlled Morocco—was a critical concern for US military operations. Due to its strategic location on both the Mediterranean Sea and the Atlantic Ocean, Morocco could provide us with Naval and air bases that were key to our surveillance of Russian submarines in the region and served as vital communication hubs. Relations between the French and the Moroccans, though, were contentious throughout this period, and Morocco would become independent in 1956 after a revolution against French rule.

Before fighting with the French started, it was relatively quiet where I was. When I had some time off, I would take trips with other officers to Fez, Casablanca, Marrakesh, Meknes, and Rabat. We went into the Atlas Mountains to a place called Ifrane, where there were ski slopes and all the buildings looked like they came straight from Switzerland. Sometimes we went swimming in the ocean, though we had to be very careful of the dangerous undertow at many of the beaches.

One day we got word that the secretary of the Navy and the chief of Naval operations were coming to Morocco and would visit Port Lyautey, where the French had a base that we used to support Naval reconnaissance aircraft. The officers club there, however, was in bad shape. "How can we throw a great party in that place?" asked the US commanding officer at the base. So my captain turned to me and said, "You're an architect. Fix it up. You have two weeks to do the job. Don't worry about the budget—just make the place look great." He relieved me of all other duties and gave me twenty some men to work with. It was quite a challenge to transform all the interiors into a place fit for our distinguished guests in such a short time.

I got to work immediately, sketching ideas, drawing detailed plans, even doing a number of watercolors to hang on the wall. I went into town to find light fixtures and furniture. My team and I worked like dogs for two weeks— ripping out all of the shabby old stuff, building a new bar, and making everything fresh. We designed the party, too, making sure the experience fit the space. It was the first time I was given control of a project—along with the staff and money to do it right. The event turned out to be a big success, with

the secretary of the Navy and the chief of Naval operations complimenting us on it. There I was getting patted on the back and feeling important, at least for a moment. I thought, "God, this is unbelievable! Being an architect is pretty good!"

For the first time I realized the power of design. Changing a place and making it special actually affected the way people felt. It was exciting to have an impact on people. I had always wanted to do something that made a difference, that helped others. Now I saw that architecture could do something important, too. It wasn't about individual buildings. It was about affecting people's lives—the way they worked, lived, or even played. I said to myself, "Gee, this is a good thing!"

Near the end of my tour, fighting between the Moroccans and the French intensified and was accompanied by an earthquake, a plague of locusts, and sirocco winds that reached hurricane speeds and blasted us with incredibly hot waves of sand from the Sahara. Hearing about all this, my mother sent me a letter and asked, "What are you doing in such a dangerous place?" Well, the Navy had a long history of sending people to dangerous places and didn't give me much choice in the matter.

When I finished three years of active duty in the Navy, I decided to go back to school and get a master's in architecture. I thought about going to MIT to get a different take on education and learn from a new set of professors. But Barbara was studying English at Penn and I got a Theophilus Parsons Chandler Architecture Fellowship there. We didn't have much money, so going to Massachusetts would have been difficult and a bit selfish. To support ourselves, Barbara and I used my scholarship money from Penn and the salary I earned by working part-time at the Philadelphia Redevelopment Authority. In addition, the Navy provided funds for education and paid me for my service in the reserves, which I remained active in for five years.

Transitioning from the military back to school was a rude awakening. In the Navy, officers were treated royally. There were people who did our laundry, sometimes got us coffee, and at certain times brought us food onboard ship. Wherever we went, sailors saluted us. "Yes, sir!" You get used to that. Then you take off your uniform and go back to school and you're treated like a student again. Hell, I was married and an officer in the Navy reserves and by the time I left the service a lieutenant commander. If you want to know what a demotion feels like, go from Naval officer to student! You'll find that

Vincent Kling ran one of the biggest, and best, architecture firms in Philadelphia. A dashing figure who could do everything from charm clients to pilot a plane, he was an important mentor to me.

your ego gets corrected quickly. Looking back, though, it was a good lesson in humility and adapting to changing circumstances. Don't get too comfortable, because things don't stay the same.

As it turned out, my graduate year at Penn was fantastic. I studied with Kahn, Mumford, Venturi, and McHarg and learned so much. In addition to the regular faculty, some of the most famous architects in the world came as guest speakers. I always looked forward to hearing these important visitors talk, knowing they would add to my educational experience.

Kahn's informal lectures were legendary, famous for their poetry and passion. They would go on for hours and no one would leave, even to go to the bathroom, because you didn't want to miss a word. As a critic, he was great—as long as you designed the way he did. If you wanted to do something different, he had little patience. I remember one student came from Oklahoma State and had studied with Bruce Goff, who practiced a radical form of organic architecture influenced by Wright. Kahn glanced at this student's work and said, "Sorry, I can't help you."

Kahn had attended Central High and then the University of Pennsylvania—just as my father and I had—so I felt a particular bond with him. And like Kahn, I would be named a member of Central's Hall of Fame.

Kahn had a scar that circled his lips from being burned as a child growing up in a part of Russia that is now Estonia. Instead of repulsing you, it drew you closer to him. And he had a way of speaking that was a bit mystical and magical and always captivating. Once you were in his orbit, you couldn't help but see architecture through his eyes. His buildings had a remarkable rigor—everything was there for a reason; nothing was there just for show. Kahn never did architecture as sculpture. You understood his buildings from the spatial relationships they established between elements—such as elevators, circulation cores, mechanical ducts, and stairs—that clearly acted as servant spaces to the main parts, like the laboratories at the Salk Institute or the galleries at the Yale Center for British Art.

Look at any of Kahn's projects and you immediately see his love for materials, whether that's stone or brick or concrete. During the construction of the Richards Medical Research Laboratories at Penn, he spent time with the bricklayers, showing them exactly how he wanted things done. His attention to detail and his dedication to craft inspired the laborers to do their best work.

There's a solidity to Kahn's buildings. They give you confidence and make you feel secure. You know they won't fall down. He would never design a building that leans precariously or seems unstable. Although totally Modern, his buildings have roots in Egyptian and Classical architecture, which give them a sense of order, strength, and timelessness.

At school I saw the work of Mies van der Rohe in magazine articles but never felt drawn to it. Then I visited the Seagram Building in New York and marveled at the details, the materials, and the proportions, which were so beautiful. Mies would do the same thing over and over again, making it a little bit better with each project. Instead of reinventing something, he would perfect it. I still appreciate that dedication to getting things right, the same rigor that German car companies show in constantly improving their products. In photos, Mies's architecture was smart but reserved. Standing in front of the Seagram Building, though, it touched me deeply.

Penn was ahead of the times in many ways, including the makeup of its student body. I had classmates from all over the world—Britain, Europe, South America, and Asia. Today, this is typical of most schools of architecture, but back then it was rare. It broadened our outlook and introduced us to different perspectives and cultures. I remember an Afghan student who had a regal presence. He came from a wealthy family and could charm you with his elegant manners. But he always worked hard to earn your respect. I kept in touch with him over the years, and he eventually came to work at KPF. He could draw beautifully and knew how to detail a building better than most.

The student body at Penn, though, was almost entirely male. When I was an undergraduate, there were only two women in the entire five-year program. High school guidance counselors at the time discouraged women from studying architecture, because it required long hours while matriculating and later in practice. This never made any sense to me, since my mother worked long hours and ran her own business. Today, more than 50 percent of architecture students at most schools are women, though the profession needs to do a better job of moving women into leadership positions and finding ways to keep them there as they have children and raise families.

In the 1950s, Ed Bacon was a major force in Philadelphia, running the city's planning commission and directing redevelopment efforts such as Penn Center, which reconfigured a significant portion of the downtown core. He was a very creative planner, but controversial, too. He tore down what he

called the Chinese Wall, a set of elevated rail lines that separated North Philly from South Philly. He pushed forward important projects that shaped areas like Market East, Society Hill, Independence Mall, and Penn's Landing. He fought everyone—preservationists and developers alike. He didn't teach at Penn at the time, but he often came to lecture and serve on design juries at the end of the semester. He was smart and tough! You didn't want him criticizing your project, that's for sure. A few years after graduating, I worked for Vincent Kling, who ran one of the most successful and creative architectural firms in Philadelphia. Kling had a big ego and lots of accomplishments. But even he melted in front of Bacon!

Philadelphia had some very good mayors back then, such as Joseph Clark Jr., who worked with Bacon for most of the 1950s. It was a marvelous time. Bacon changed planning in the city and really got things going. The final projects never quite lived up to their initial promise, sometimes because the architecture wasn't as good as the planning and other times because the developer's goals and budgets got in the way. Bacon was an inspirational figure and made an international reputation for himself. He even landed on the cover of *Time* in 1964. So lots of people came to Philadelphia to meet him. He helped make the city a center for planning and design.

I got to know Bacon later in my career when Kohn Pedersen Fox designed One Logan Square in Philadelphia. I had to present our design to him and was a bit nervous. He was a tough critic, but we got approval and the building opened in 1983. We eventually became friends, and later he complimented me on the Mellon Bank Center (now called the BNY Mellon Center), a fifty-four-story office-building project that I led and Bill Louie designed. He loved the big space on the lower level. For many years I didn't realize that Kevin Bacon, the actor, is his son.

After graduating from Penn, I started looking for employment in Philadelphia. My mother bought me a really beautiful overcoat, a Chesterfield, and told me, "To get a job, you have to look like you don't need one." I set up a few appointments and soon realized I was better dressed than the guys interviewing me. The first firm offered me a job, and I was so excited I accepted it immediately. Then a second firm—a better one—offered me more money. I probably could have made some excuse to the first one, but I didn't want to renege on a promise. I stayed there a year, then went to work for Nolen & Swinburne, a well-connected firm that was doing fine work at Temple

University. It was a great place to start, because they had a three-year program to train new associates in every aspect of architecture. You worked as a draftsman for six months, then did planning and design work under a senior leader, then detailing and construction management.

I spent six months in the field working under a contractor. I learned how things really got built and what detail drawings should look like. The contractor was a tough operator and very smart. He told me, "Don't waste your time making the drawings look pretty with shading and nice little dots. They're just going to get stained with coffee and dirt out here on the site. Instead, make sure all the dimensions are accurate. Otherwise, there's going to be a change order, and we're going to charge the client more money and he's going to come after the architect for that added expense." I realized that detailing was serious business and made sure my team checked *everything*. It was a great learning experience. I was impressed that Nolen & Swinburne cared for its young employees and invested in them. By the time I took my licensing exams, three years after getting my master's degree, I was totally prepared for the four days of grueling tests and passed them all on the first try.

There was an older architect at Nolen & Swinburne who took me under his wing and spent a lot of time with me. I still remember his name—Charlie Ogg. He was terrific. He said the key to designing a building is knowing how to get started. You have to map out the whole project first. Don't start with just one small thing. Think about everything together—the plans, the sections, the elevations, the details. Understand the complexity of the project before you start drawing. He taught me how to approach a project, visualize it, and fit all its ingredients together.

My career really took off with my next job—working for Vincent Kling, who ran one of the biggest design practices in Philadelphia. Years later, after I had left, it became Kling-Lindquist Partnership and then KlingStubbins. Kling was quite a character, a tall, handsome guy with wavy gray hair and usually a pipe in hand. I think his wife had something to do with the Pew family, which probably helped him get started. If he had been in New York, he would have been more famous and had a bigger impact on the profession as a whole. But in Philadelphia, he was a major force and knew everyone.

I learned a lot from Kling. He wasn't some distant boss sitting in a corner office. He was directly involved in everything that happened at the firm. If there was an office outing, he would drive the bus with all of us on it. If

we were working late on a project or toiling on a Saturday, he would come in and bring a case of beer and then play his guitar for us. It felt good having the boss in the trenches with us, even though he would leave after a bit and we would keep working.

I started at Kling as a junior associate and eventually worked my way up to being one of the four senior designers. The firm was very well run, with a top person overseeing each aspect of the work. So there was a partner in charge of design (Fritz Roth), another one responsible for business operations, one making sure every building was detailed properly, and one managing construction. Vince called them partners, but I'm not sure they actually had equity stakes in the firm. Vince was the leader—and owner—without a question.

When I was still a junior designer there, I was asked to take over a religious project that one of the senior architects had started. Vince had moved him to a bigger project and asked me to pick up work on the smaller one, a beautiful precast-concrete building outside Philadelphia. The client loved what the previous designer had done, so Vince told me to stick with that scheme and develop it. A lot of architects wouldn't do that—wouldn't want to carry on someone else's design. But I did it exactly the way the other designer would have, and everybody was impressed. That's when Vince made me a senior designer. I showed I was a team player and wouldn't let my ego get in the way of doing a good job.

Vince was great with clients, always knowing how to tailor a project to their needs. I remember designing an art center for Marietta College in Ohio and going with him to present our ideas to the school's building committee. We always developed three schemes—one right on budget, one slightly over, and the third the best building you could do, which usually made it the most expensive. Each one had to work; you couldn't draw up a crummy design that you hoped would be eliminated.

Vince knew how to put on a show. The day of the Marietta presentation, I set up our large site model showing the context and the existing buildings on campus. When it was time for us to speak, Vince walked up to the model and gently set a cardboard representation of our first scheme into place. He talked about the research we had done on academic architecture, the ideas behind our design, and how our building related to its neighbors and the landscape. People on the committee were impressed. Then he slapped our

building off the model with the back of his hand and it tumbled onto the floor. Everyone gasped. He placed the second scheme where the first one had been and explained why it was better. The committee members nodded their heads. After waiting a beat, he flicked the second one to the floor. Dead silence. He placed the third scheme onto the site and gave an eloquent explanation for why this was the best one. When he took a step back, everyone started clapping. Done!

Vince would do his homework and make sure the client knew it. If we were on a short list of firms being considered for a project, he would go to the site and really study it. Then in the interview, he would talk about what he had learned. He might say, "You have a plane that flies overhead every thirty minutes, so we're going to develop a design that blocks out the noise." He would prove to the clients that he knew the challenges and opportunities better than they did. He knew how to read people and respond accordingly. One time we were having trouble with a project for the state of Pennsylvania. He walked into a room full of bureaucrats and regulators and immediately took control of the space. He put down his coat, slammed his fist on the table, and yelled, "Okay, let's get started!" The people in that room had planned to attack our design and pick him apart. He never let them. I watched him take that meeting in a completely different direction. It was a fascinating performance. He could have been a great politician.

Every Monday morning, all of the people with titles in the firm—about thirty of us—would meet with Vince. We would talk about active projects, what needed to get done that week, and what problems had to be addressed. Everybody had a chance to speak up. It was a great way to learn what was going on in the firm and understand the big picture. On Friday evenings, he would bring in beer and we would review some of the designs we were working on. He used any excuse to have a party. So people enjoyed working there. At the annual Christmas party, he would dress up a bit like Santa, walk around, and give each of us our bonus check. I would leave the party early so I could go to a favorite store and buy a beautiful piece of jewelry for my wife Barbara as a special holiday gift.

During my tenure at Kling, I contracted hepatitis and got seriously ill. For six months I couldn't work and needed to restrict my contact with other

people so I didn't infect them. For another six months I remained weak and could handle only a limited workload. Vince paid me my salary the entire time, even though he had no obligation to do so. Barbara and I didn't have much money then, so losing my paycheck for an entire year would have been devastating. I don't know what we would have done. Vince's loyalty to me—and his staff in general—left a lasting impression on me. I'll never forget it.

The Kling offices were in a series of row houses in North Philadelphia. Courtyards connected the four-story buildings and gave us lovely places to eat lunch, talk to our colleagues, and have parties. I loved that arrangement. Each project team occupied a different row house, which allowed me to wander at lunchtime from one to another and see what each team was doing. I would talk to the other designers and study their drawings. Or I would go to one of our construction sites nearby and see how that project was getting built. I would listen to the workers and project managers and absorb everything I could. That's when I developed my appreciation for craft and detail. Kling's way of operating allowed me to learn a lot and gave me a head start on running a firm.

While I was a top designer at Kling, two of my projects—one for Westinghouse and one for Lafayette College—won national AIA awards. I wasn't credited officially for this work, but word got around in the profession, and other firms started contacting me about joining them.

Philadelphia was a great place to work but had limitations back then. If you didn't come from the right background, go to the right schools, or belong to the right clubs, it was hard to make your own mark. From what I had heard, New York was different—more open to new talent, no matter what your history, race, or religion. If you were good, you would succeed quicker there than anywhere else. Both Barbara and I loved the arts. Philadelphia had great museums and performance venues, but New York was much bigger and offered a whole lot more. New York was king. It was the center of the world. So by the end of the early 1960s, I started looking for work there.

I called up Shelley Fox, who was by then a partner at Kahn & Jacobs in Manhattan, the firm that designed the Bergdorf Goodman store on Fifth Avenue and the wonderful Art Deco office building at Two Park Avenue. (The head of the firm, Ely Jacques Kahn, was no relation to Louis Kahn.) Shelley and I hadn't stayed in touch with each other for nearly a decade, but I knew he had spent two years in the Army during the Korean War, then

While working at John Carl Warnecke & Associates, Bill Pedersen and I designed the headquarters for the Aid Association for Lutherans in Appleton, Wisconsin. Later, KPF did an addition to the building.

moved back to New York, where he had grown up. He got me an interview with Bob Jacobs, the senior partner, who offered me a job as a designer. I stayed there two years, designed an office project in Syracuse, and then started getting offers from other firms.

When I first moved to New York, someone suggested that I talk with the Fisher brothers, Larry and Zachary, who operated one of the city's important real estate companies. Born in Brooklyn to Russian immigrants, Larry and Zachary worked as bricklayers as teenagers, then started Fisher Brothers with their older sibling Martin in 1915. What began as a small contracting company had become a major developer by the time I landed in New York. I had no interest in working as an employee for a developer, but I was smart enough to know that people like Larry and Zachary could give me advice on who to meet and how New York works. They were self-made businessmen who became generous philanthropists—supporting hospitals, Alzheimer research, and the US Armed Forces. They helped save the *USS Intrepid* and turn it into the Intrepid Sea, Air & Space Museum. I learned that in New York, families like the Fishers, the Roses, the Rudins, the Urises, the Minskoffs, the Dursts, and the Tishmans shaped the skyline. Little did I know, however, that fifty years later, my architecture firm would be designing a luxury apartment tower for Larry's son Arnold, who now runs the family business and has become a major donor to the Intrepid and to brain-injury treatment facilities for military personnel.

One of the firms that expressed interest in hiring me was run by Charles Luckman, an architect turned businessman turned architect. He studied architecture in Illinois but graduated during the Depression, when no buildings were being designed. So he worked as a draftsman in the advertising department of the Colgate-Palmolive Company. In just a few years, he became head of sales at Pepsodent and was making a huge success of himself. At the age of twenty-seven, he was featured in a cover story in *Time* and dubbed "the Boy Wonder of American Industry." Eventually, he became president of Lever Brothers and hired Gordon Bunshaft of Skidmore, Owings & Merrill to design the company's headquarters on Park Avenue, a building that's now a landmark of Modern architecture. In midlife, he decided to go back to architecture and opened an office in Los Angeles. He designed some decent office buildings, as well as the Flamingo Hotel in Las Vegas and, most unfortunately, the mediocre office building that replaced McKim Mead & White's

Pennsylvania Station in New York. Luckman was an interesting person and wanted me to lead his New York office. But I sensed that his work was more about showmanship than performance, and decided I wouldn't be a good fit with him, though I appreciated all he had accomplished.

At about the same time, I was talking with Welton Becket about a top designer job at his firm. Although he was based in Los Angeles, Becket wanted me to head design in his New York office. He had designed the Beverly Hilton Hotel, the circular Capitol Records building in Hollywood, the Habana Hilton in Cuba, the Dorothy Chandler Pavilion, and the Santa Monica Civic Auditorium and ran one of the largest practices in the country at the time. It was a great opportunity, because the firm was strong but didn't have much going on in New York.

So I took the job and had fun. I built up the design team in New York, and we won a big competition to design a visitors' center for NASA at Cape Kennedy in Florida. I got along well with Becket, but the person he had running the New York office was not the type of leader I respect. He had an explosive temper, was a poor architect, and didn't know how to inspire others. When we won an award for the NASA project, this guy—who had nothing to do with its design—took all the credit. He accepted the award and wouldn't let me or anyone else on the design team go to the event. I got the chance to design some interesting projects, though, including One PNC Plaza, a thirty-story tower in Pittsburgh that has its vertical circulation core pulled off to the back, so it can offer seventy-foot-wide, clear-span office spaces on each floor.

I had been at Becket for a couple of years when Carl Russell, who had worked for Becket in a senior position and left to run John Carl Warnecke's firm asked me to meet his new boss. Jack Warnecke was an imposing figure—six foot four or five—with chiseled features and charisma to spare. He had played football at Stanford on the "Wow Boys" team that won the 1941 Rose Bowl. He had grown up in San Francisco, the son of a prominent architect, and had started his own practice there. Jack established a national reputation in the early 1960s with some significant projects in Washington, DC. At Stanford, he had struck up a friendship with Paul B. Fay Jr., who later became secretary of the Navy under John F. Kennedy. Fay introduced him to JFK, a connection that would prove to be extremely valuable. Shortly after Kennedy became president, he asked Warnecke to help save some historic row houses on the east side of Lafayette Square—opposite the White

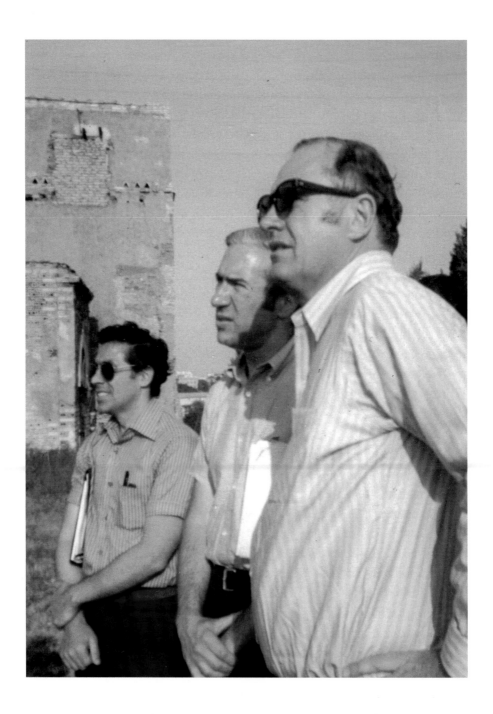

Jack Warnecke (right) and I worked on a number of projects for Iranian clients. Here we are in Isfahan, the third-largest city in the country and an important cultural site. A tall and imposing person who had played football in college, Jack lived big.

House—that were slated to be razed to make way for a large government building. Warnecke developed a plan that set two new structures—the National Courts Building and the New Executive Office Building—in court-yards behind the existing row houses. The president and first lady pushed for Warnecke's design, and it got built, to great fanfare. In 1963 Kennedy appointed him to the US Commission of Fine Arts, which oversees federal buildings in Washington, and brought him to Boston to help select a site for the Kennedy Presidential Library a little more than a month before the assassination. After the tragedy in Dallas, Jackie Kennedy asked Warnecke to design the slain president's grave site at Arlington National Cemetery. The two developed a close relationship, and for a while he and Jackie were romantically linked.

Jack Warnecke lived big—with a gorgeous ranch on the Russian River in Northern California, offices in San Francisco, Washington, and eventually New York and then Los Angeles. He had lady friends everywhere, between his divorce in 1961 and his marriage in 1969 to Grace Kennan, the daughter of George F. Kennan, the famous diplomat who shaped the United States' policy of containing the Soviet Union during the Cold War. Warnecke's firm designed the US Embassy in Bangkok, the Hawaii State Capitol in Honolulu, and a building for the family of the Shah of Iran in New York. He was an incredibly social creature and had the gift of gab, a big handshake, a huge smile. He threw great parties that brought together businessmen, politicians, cultural figures, and all kinds of glamorous people. They were a lot of fun but also served a critical business function—strengthening his relationships with existing clients and attracting new ones. He believed in marketing done socially, over a few drinks and at weekend parties at his house. I learned the importance of entertaining from him. "Bigger than life" is a phrase used too often, but it fit Jack to a T.

He and I talked for nearly a year before he finally asked me in 1967 to lead the New York office. Sadly, Carl became ill soon thereafter and retired; I would have liked to work with him longer. With Carl gone, I took on more responsibilities and became Jack's only partner and then president of the firm. I didn't always agree with Jack, but we got along well. He would invite my family to his California ranch each summer to spend a week or more hiking, swimming in the Russian River, sleeping outdoors, soaking in the scenery. My kids loved it there and always looked forward to going. In Washington, he had a lovely

apartment, where some of the most powerful people in town would come for drinks and conversation. He threw more parties than anyone I ever knew.

It was fascinating to see him operate—a West Coast boy charming the East Coast establishment. He had a standard business pitch that he used over and over. I could recite every word of it. He would talk about playing on the Stanford football team and how it lost every game his freshman year. By the time he was a senior, they won every game and beat Nebraska in the Rose Bowl. No matter who the clients were, he found a way of relating the speech to their business—because everyone wants to be a winner.

I learned a lot from Jack, both what to do and what not to do. He was great with clients but didn't always treat his employees well. He could lose his temper and sometimes was unfair. He would fire people for no good reason. At the beginning, we were incredibly busy, and I traveled forty-eight weeks out of the year. Each Monday, I would fly to LA, spend a day there, then go to San Francisco, spend one or two days there, then go to Washington and back to New York. Periodically, I would go to Italy or Iran, where we had projects. It was exciting but grueling. Meanwhile, Jack would occasionally hit the beaches in Hawaii and come back with a tan.

I had three children by then and was coaching their baseball and basketball teams every weekend. Despite all my traveling, I missed only one game in all those years. But it was the one in which my younger son's basketball team was playing for the championship, and they lost by one point. My son Steve was so upset, convinced they would have won if only I had been there to coach. I had coached my older son Brian's team, and they were the undefeated champs of their league. Seeing how much I traveled and worked, none of my children wanted to be an architect.

Traveling to Iran was particularly tough. It was a long flight, and you would get to Tehran at two or two thirty in the morning. By the time you got to the hotel, it was four o'clock and the person behind the counter would say, "Sorry, Mr. Kohn, we don't have your room." So you would give him fifty bucks and he would magically find your reservation. The Iranians could be incredibly warm and charming, and you would think everything was going well. Then right before you were scheduled to leave, they would take you to a lovely French club with the most amazing caviar I've ever tasted and after many glasses of champagne they would renegotiate everything. They had the whole system down. And they never paid for anything up front, so you would

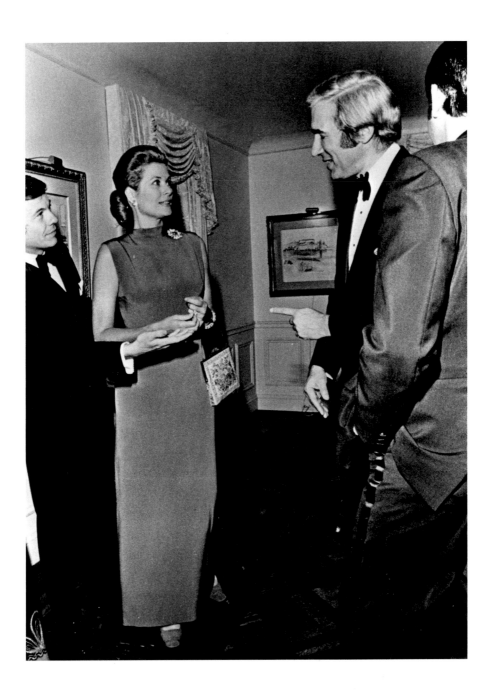

As president of the Warnecke firm, I worked on a number of projects for Stanley Marcus, the head of Neiman Marcus. Each year the retailer celebrated a different country in its stores and threw a big party in Dallas. At a Monaco-themed event, I got to meet Princess Grace.

incur lots of expenses before you got reimbursed. It was a fascinating but very difficult place to work. In addition to an unfinished bank project in Iran, we did a big office building at 650 Fifth Avenue for the Pahlavi Foundation, which was run by the Shah's family.

Although we did work for the Shah, we had very little direct contact with him. Instead, we had to deal with a bunch of people who, for the most part, didn't have the authority to make major decisions. So when an Iranian architect employed by the Shah mentioned that I might be able to meet with him, I jumped at the chance. It was winter and the leader of Iran was skiing in St. Moritz, Switzerland. He had a private house there, but would eat breakfast each morning at the Suvretta House hotel and then go bowling at the hotel's single alley a floor below the main dining area. Afterward, he would hit the slopes. I would have three opportunities to talk with him.

I booked a flight to Switzerland and a room at the Suvretta, a grand, 250-room hotel built in 1912 that's one of the best in the world. Fritz Rehkopf, a vice president at Warnecke & Associates and a good friend of mine, joined me on the trip. It was high season and we got the last room left in the hotel, an awkward space on the top floor that felt like the attic. On the appointed morning, we woke up early to make sure we got to the dining room in plenty of time. When the Shah appeared, a small army of bodyguards surrounded him. As he walked by, I got up, introduced myself and managed to get a few words in before he proceeded to a private dining area where I dared not go. Fritz and I had carefully selected a table near the door leading to the staircase down to the lower level, so the Shah would have to walk past us to get to the bowling alley. I had been told he loved to bowl and never missed an opportunity to enjoy a game or two. It's amazing what we learn as architects!

After waiting a polite amount of time for the occupant of the Peacock Throne to walk downstairs, I followed in his footsteps. But when I tried to enter the bowling room, the Shah's bodyguards—all of whom were remarkably large physical specimens—blocked my way and made it perfectly clear I wasn't welcome. Okay, I'll join him on the slopes, I figured.

It was a beautiful winter day and I went outside to enjoy the view and the crisp mountain air. The setting was spectacular with the impressive stone hotel tucked into the Upper Engadine region of the Alps. Fritz didn't want to ski, so he stayed at the hotel, while I went to the slopes by myself. At the base of the lift, I could see the Shah coming down the mountain, surrounded by

his entourage and accompanied, I was told, by Gianni Agnelli, the head of the Italian car company Fiat. I decided to watch the Iranian leader ski down the slope and see how good he was. I would join him on his second run.

In public, the Shah was never alone. As he headed down the pristine white mountain, his security detail went with him—more than half a dozen men, each armed with a large automatic rifle. While the Shah was an expert skier, his bodyguards were not. As they tried to keep up with their boss, the burly guards bounced precariously on their narrow wooden skis, holding their deadly weapons in their arms, rather than using poles to steady themselves. One of those guns could go off at any moment and someone nearby could easily get hit. That's when I told myself, "No way am I going to join that group on the slopes!"

Rather than risk my life for what would inevitably be a very short conversation with the Shah, I decided to ski on my own. I ended up on the top of the mountain where there weren't any trees to mark the trails, just colored poles in the snow—a directional system I didn't understand. I set out and did okay, until suddenly I found myself flying over a jump. I was a pretty good skier, but not a jumper. As I hit the ground, one of my skis broke its restraining strap and careened down the mountain. I followed it about a hundred feet into a ravine, sliding ignobly on my rear with my ski-less foot in the air. Reuniting with the wayward ski, I put it back on and proceeded down the mountain, careful not to fall and lose it again. When I got to the bottom of the hill, I hailed a ride back to the hotel, took a long soak in a hot bath, and gave up any hope of talking with the Shah.

Jack gave me the chance to run a big firm, and it was a great opportunity. I lured Shelley away from Kahn & Jacobs and brought him in to run our New York office. Then I heard about a young architect at I. M. Pei & Partners named William Pedersen, who was a talented designer working on the East Building of the National Gallery in Washington with I. M. himself. I met with him and knew immediately he was special. I offered him a job, but he said he wanted to stay with Pei until the National Gallery design was completed. I respected that. It said a lot about his character. When he finished work on the project, he accepted my offer and joined the Warnecke firm. I was building an incredible team, and it felt great.

Jack had a great eye for architecture but wasn't really a designer. After Stanford, he spent a year at Harvard's Graduate School of Design. World

War II was underway then, and schools were pushing men through programs as fast as they could. Jack got his degree after just a year, which isn't really enough time to develop the skills necessary to become a solid architect. He never really learned to draw, but he could look at a range of schemes and pick the best one. He was an excellent critic whose comments would push projects in the right direction. We had a bunch of talented designers on staff, so this worked fine. He also was a fanatic for writing and made sure every letter we sent out was perfect. I remember spending two days on one letter until we got it just right. It was quicker to get a critique of your design from Jack. He did not review every project, just the ones he was most interested in.

He always thought big. On a blackboard in his office in San Francisco, he always had a list of ten companies he wanted to buy. Some of them were architecture firms, but some weren't. I would tell him, "Jack, it's tough enough running this firm as it is. It would be crazy to buy anybody else." He would reply, "No, Gene, we're going to expand. We're going to build an *empire*!" He never did, but he kept revising that list, adding new companies and dropping others.

What Jack needed to do was devise a better system for running his existing business. I was his only partner, but we had offices in four cities and projects all over the place. I told him, "We need ten partners, two or three in each office. Right now we have no one in charge in LA and no one in Washington. We need partners there to develop relations with the community, pursue new work and watch over the studio. I can't keep running back and forth to all these places." Instead, he offered to increase my share of the firm from 10 percent to 25. But that wouldn't deal with the problem. I would rather have had less stock and more partners so we could grow the business and better serve our clients. He kept saying no. Then on a few occasions, as we were wrapping up interviews with prospective clients, he asked me to tell them I would move there if we got the job. "I can't lie, Jack! I have a family in New York, three kids, a house and a mortgage. I'm not moving to Timbuktu!"

In 1973, a major recession hit the US and world economies, in the wake of the Arab-Israeli war and the OPEC oil embargo. Plans for new buildings stopped all over the country, and architects got hit really hard. Right about this time, Jack went out and bought a vineyard in California, borrowing funds from the firm! I couldn't believe it. We struggled for the next few years, cutting expenses wherever we could. I remember coming back from

one trip and getting a call from the person leading our work in Iran: "Gene, I've run out of money in my bank account, and it's only the middle of the month. What's happening?" Jack had cut his salary in half and never told him. I called California immediately. "Jack, you can't do that!"

We restored those salaries, but then Jack fired many of those people. He even let Bill Pedersen go. I was stunned. "He's not bringing in new business," Jack told me.

"But he's going to be one of the very best designers in the country," I replied. "That helps us attract new clients." It was to no avail.

Trying to hold everything together was painful. I told Jack, "Look, if we don't change, we're not going to survive." I put together a plan for reorganizing the practice—creating eight new partners and empowering them to run the various offices. It gave Jack 51 percent of stock, so he would retain control of the firm, and the rest of us would split the remaining 49 percent. Over time, we would buy more stock from Jack at what we expected would be an increased value. It was a good deal for Jack and made sense for everyone else, too. I presented it to him, but wasn't optimistic he would agree to it. "Let me talk to my business advisor about it," he said. A few days later, he rejected it.

The firm was crippled financially, and Jack was unable to chart a new course for it. At the end of 1975, we parted ways and I set up my own practice, Kohn & Associates.

I never intended to run my own little shop. I wanted partners and associates so we could do great architecture. I believed in collaboration and didn't think that any architect, no matter how talented, could do it all alone. My first project in 1976 would be putting together the team that would make my vision real.

Amoco Tower (1670 Broadway) in Denver.

Launching a Firm

At the start of 1976, I set up Kohn & Associates and began planning my next move. The economy was stuck in a horrible recession, so no one was building much of anything. It seemed like an awful time to start an architecture firm, especially since nearly 60 percent of architects in the New York area were out of work. Some of my friends and family thought I was crazy to leave my position as president of a major architecture firm like Warnecke & Associates, no matter how bad things had gotten there.

I saw things differently. I saw opportunity and the chance to put together a dream team. With so many unemployed architects, I could attract the best talent in the field—people with years of experience and strong relationships. Top-flight design architects, project managers, and construction specialists were pounding the streets, looking for jobs. These are the people you need to make architecture. I knew, of course, whom I wanted as my partners: Bill Pedersen and Shelley Fox. Bill had been laid off by Warnecke toward the end of 1975 in one of Jack's ongoing efforts to reduce payroll and stanch the flow of red ink. Shelley was still leading the New York office at Warnecke, but he was ready to leave as soon as possible. I kept in touch with both of them and let them know my plans. Bill was thinking of moving back to St. Paul, Minnesota, where he had family and could practice in a less intense environment. I needed to keep him in New York, so I explained the kind of firm I planned to build and the type of people I aimed to work with. He wanted the same things.

Recessions are also good for setting up meetings with potential clients. Important people have time to talk with you. For the first six months of the year, I made a concerted effort to meet with successful people with whom I had established relationships at various stages of my career. I didn't ask them for projects to work on, because there weren't really any out there then. Instead, I asked them for advice. Successful people like sharing their wisdom, if approached in the right way. Every one of these smart, accomplished

people whom I contacted was happy to talk with me about starting a business, building it over time, attracting talent, and developing a mission that would anchor the firm and inspire its staff. What I also realized was that leaders who give advice like to see their advice come true. So the conversations I had with these business leaders in 1976 turned into ongoing help from them over the course of many years.

One of the first people I met with was Matthew Forbes, who owned a big share of Lorillard, the tobacco company that made Newport, Kent, and other brands of cigarettes. I got to know him when I was a camp counselor during my sophomore year at the University of Pennsylvania. His kids went to Camp Wayne near Preston Park, Pennsylvania, and I taught their son, Paul, to swim. Mr. Forbes really appreciated this, and before the start of the next summer, he invited me to come to California, where he was renting a house in Beverly Hills from the actress Judy Holliday, and give the children more swimming instruction and act as lifeguard at the pool. It turned out to be a very special summer in a beautiful place with beautiful people.

We kept in touch over the years, so he knew about my time in the Navy and my early career in architecture. He was a very fine man and was always supportive. He had a lovely house in New Rochelle, New York, and was happy to meet with me. When I told him I was starting my own firm, he said, "I'll give you some advice. Your success will be determined by the work you turn down as much as the work you do." It seemed like odd counsel at the time, since I didn't have any work and no chance to turn anything down. I must admit I was a bit disappointed in our conversation. I had hoped he might give me a few leads on potential jobs or maybe offer some financial support for my new firm. Little did I know that his admonition would turn out to be remarkably valuable soon thereafter.

On July 4, 1976, Bill, Shelley, and I met at the Hilton hotel in Rye, New York, and signed the papers establishing Kohn Pedersen Fox. Over coffee, we defined the kind of firm we wanted it to be. First, we wanted to do outstanding architecture. Each building we did had to be special. We weren't interested in iconic buildings per se but wanted to do ones that were excellent and solved real problems with beautiful design that improved people's lives for a long time.

Shelley and I met at Penn in 1948, and after graduation in 1953 went our separate ways for more than a decade. He went into the Army during

Top: Pat Conway, me, Shelley Fox, and Bill Pedersen at KPF's first anniversary party at Shelley's house in Stamford, Connecticut, on July 4, 1977.
Bottom: The same cast of characters at work in our offices on 57th Street and Madison Avenue.

the Korean War, and I served three years in the Navy. After the service, he moved back to New York, where he had grown up, and eventually became a partner at Kahn & Jacobs Architects, a leading firm in the city. After I became president of Warnecke's firm, I lured him there. Bill, who was seven years younger than Shelley and me, had gone to architecture school at the University of Minnesota, then got his master's degree from MIT. In 1965, he was awarded the prestigious Rome Prize in Architecture and spent much of that year in Italy as a fellow of the American Academy in Rome. After that, he worked for Pietro Belluschi on a building at Lincoln Center and then joined I. M. Pei & Partners and assisted I. M. himself on the East Building of the National Gallery of Art in Washington, DC.

The three of us talked about how to define our responsibilities. Each of us had different talents and we acknowledged that. So we developed dual spheres of duty for each of us. Shelley and I learned this in the military. In the Army and the Navy, everyone had both line and staff duties. Line duty was your primary mission—say, as a gunnery officer—which you did while being able to substitute for another officer who might be injured or on leave, or worse. In addition to your line duty, you would have a staff assignment dealing with, say, overseeing a particular aspect of crew performance.

For an architecture firm, line duty was designing and building buildings. All three of us were architects who had experience with this, so we shared this type of responsibility. Each of us would have projects to run. But each would have different staff responsibilities. Shelley had excellent organizational skills, so in addition to overseeing particular projects, he would manage the firm's business. Bill was so superb at design that he would focus primarily on that.

Since I was the most outgoing, I would venture out to get the work and lead the firm. My experience up to this point, though, had primarily been as a designer—senior designer at Vincent Kling, vice president of design for Welton Becket in New York, and head of design at the New York office of John Carl Warnecke—before becoming president of that last firm. So I would also assist in KPF's design process and critique individual projects. I took the title president, because I would be meeting the most people and asking them to put their trust in us. But in terms of ownership, we were equals.

In the early days, the three of us did most things together—meeting with clients, developing building designs, hiring staff. As we got more work,

though, the division of staff duty became more pronounced. If one of us went on vacation, however, the other two could fill in and handle his responsibilities. Having that redundancy was critical at the start of the firm. To clients, we always appeared to be one entity, because we spoke with one voice.

We set up a board with the three of us having one vote each. In theory every major firm decision needed two votes to pass. But we never needed to vote, because we talked with each other all the time and always developed a consensus. We were a tight band of warriors and spent lots of time together, both at the office and on weekends when our families would get together for barbecues and other occasions. We even vacationed together at times. All of our wives and kids got along. We respected each other and really enjoyed each other's company. It was a special bond we shared. Bill and I furthered our relationship by leading and playing for our championship softball team; I pitched and Bill hit the long ball.

A key part of our vision for KPF was that it would continue after we retired or died. From the very beginning, we designed the firm so it would be more than the three of us. Very few firms do this. The star-architect practices aren't very effective without the star architect around. For example, it's not easy to run Frank Lloyd Wright Architects without Frank Lloyd Wright. Most architects, though, don't start thinking about succession until they're getting ready to retire, when it's actually too late to develop a structure that can continue without them.

Planning for a second and a third generation of KPF was important to us, not because we were thinking about retirement back in 1976. No, we did it because we knew it would affect the people we hired and the expectations they would have in working for us. We wanted to hire only people who were as good as or better than we were. And we wanted them to know that if they worked hard and performed well, they could become partners and maybe even lead the firm someday. If they don't see that possibility, talented people will leave and create their own opportunities. We aimed to attract the best and keep them.

Ever since then, we have made a practice of identifying employees who have the potential to be future leaders. We give them every opportunity to grow and prove themselves, then we promote and reward them. Seeing the chance for this kind of advancement spurs on the best people. One of the first people we hired was a young man named Bill Louie, who worked his way up from the rank of draftsman before joining KPF to become a design

Bill and I loved playing on the firm's softball team and helped guide it to five championships in New York's architecture and design league. I pitched and Bill hit the long ball.

partner with us in 1982. He's still with us after forty years. Not everyone with talent, though, turns out to be a leader. But we give them all a chance. Our strategy is to develop the firm's future leaders on a continual basis. You have to keep doing it, because the future top people will need talented individuals right behind them and ones behind those.

To keep these people engaged and motivated, you also need to share the glory. At many architecture firms, only the big names get the recognition. We wanted to create a different kind of environment—one in which we share credit and give talented people the chance to shine. Bill Pedersen is one of the best designers in the world, but he never got in the way of other people at the firm getting plum design assignments and developing their own reputations. For us, it has always been about the team—developing a group of great people who can work and succeed together. We share credit among us, so clients see the breadth of our talent and realize that a group of people contributed to its success.

When I was at Warnecke, I had worked on a couple of projects for Iranian clients. One was for a big bank in Tehran that never got built, and the other was an office building in New York for the Pahlavi Foundation, which was run by the Shah's family. The Pahlavi project was a thirty-six-story office tower at Fifth Avenue and Fifty-Second Street that was under construction when we launched KPF.

As I was spreading the word about our new firm in 1976, I got a phone call from a man I knew from Iran, an executive at a major bank there. He was looking for an architect to design a new technical building in Tehran. It was a big and complex project, so he wanted a foreign architect who had experience in the country. The design fee was $1.1 million, which was a lot of money back then and seemed to be an invaluable lifeline to a firm with no work. Was I interested?

Winning a job is always a thrilling moment, but for some reason I felt something else in addition to the adrenaline rush of victory. I've never been one to second-guess or doubt myself. But as I hung up the phone, I started to think—uncharacteristically—about the things that could go wrong.

I immediately called Shelley and gave him the big news. Shelley's great talent was to see everything holistically and place it within a larger context of what it would require to make it happen. We would need to hire a lot of people immediately. We would have to travel to Iran to visit the site, talk with

the client, understand all aspects of the program, develop schematic ideas for a design, put together work schedules, and handle all kinds of challenges. Shelley and I discussed the pros and cons of working in Iran. Both he and I knew that Iranian clients were notoriously late with payments and tough with contract negotiations. We would need to secure a line of credit from a bank or find financing to cover the up-front expenses of staff, rent, overhead, and travel, since the client would most probably pay us only after much of the work had been done.

I spoke with Bill and told him about the project. He was intrigued by the design challenge but wasn't thrilled about the prospect of many long trips to a faraway place. I remembered going to Iran for Warnecke, arriving in the middle of the night, tipping the hotel clerk to find my room reservation, haggling with the client, and dealing with all the other aggravations. Iran is an incredibly beautiful country with a rich history, fascinating culture, and wonderful people. But it was a very difficult place in which to work, especially as a foreign architect.

I was no expert in Iranian society or politics, but I could see some signs of danger as the country embraced rapid change and modernization. Was the Shah trying to do too much too fast? Would more traditional elements in the country resist his efforts? It was hard for a foreigner like me to really know what was happening, but I often had a sense of unease there.

For the next several days, Shelley, Bill, and I talked and talked about the project. We analyzed it and dissected it and tried to put it back together. How many people would we need to hire? How quickly could we get them up to speed? How many trips to Iran should we schedule for the first three months? What kinds of drawings would we need to produce and when? We turned the project upside down and inside out to get our heads around it. The more we did this, the more we realized that the risks were at least as big as the potential rewards. Our biggest fear: If we took the project and didn't get paid quickly enough to cover what we knew would be huge up-front expenses, we could go bankrupt before we ever really got going.

The last of these meetings was at Shelley's house in Stamford, Connecticut, on a Sunday, which is a workday in Iran. That's when I remembered Matthew Forbes's advice: "Your success will be determined by the work you turn down, as much as the work you do." I told this to Shelley and Bill, and we all agreed to turn down the job.

I picked up the wall phone in Shelley's kitchen and called the person at the Iranian bank. I literally felt sick to my stomach, so I held on to the refrigerator as I spoke. KPF had no clients and no work, and here I was turning down a project with a $1.1 million fee. The first job is always the hardest one to get, and walking away from it is even harder. As an eternal optimist, I wanted to believe we could make this project work—that we could defy the odds, break even on the expenses, and make a big splash with a giant project abroad. It could put KPF on the map. But my head, my gut, and my partners told me the risk here was too great. Our first job would not be in Iran.

I drove home in a daze. Later in the day, I picked up the real estate section of the *New York Times*, hoping desperately for some kind of lead, something that might point me in a direction that might somehow end with a project for KPF. Still queasy about walking away from the Iranian job, I went through the paper with a determination fired by ambition and a touch of fear. I wasn't a kid anymore. I was forty-five years old and had a family to support, as did Shelley and Bill. I went through every page of that section, read every article and every one of the listings. Finally, I saw a brief item about the American Broadcasting Company (ABC) buying an old armory on West Sixty-Sixth Street with the intent of converting it into a television production studio. The building had been used by an Army medical battalion on weekends only and served as an indoor tennis venue during the rest of the week.

Although ABC had been around since 1943, it expanded in the 1970s to become the third national broadcaster, after CBS and NBC. In 1976 it had all the energy of a young company aiming to do big things. Under the leadership of Leonard Goldenson, it was becoming a major force in its industry. It had some property on the Upper West Side and hoped to consolidate its operations there. Shelley and I knew a couple of vice presidents there from our days at Warnecke—one named Bob Goldman and the other Al Schneider. As soon as I saw that tiny story in the *Times*, I saw a chance.

I hadn't been in contact with ABC in a while but gave Schneider a call first thing Monday morning. Shelley did the same with Goldman, who was VP of administration and would help us set it up. When we all got together, Goldman and Schneider told Shelley, Bill, and me that ABC was starting to produce hour-long soap operas, a significant departure in format from the half-hour shows of the past. They needed a big facility where they could stage productions on both sides of a very long aisle, along which cameras could

move back and forth. It was basically just an interior renovation, but an interesting one. It wasn't a glamour commission and was nowhere near the scale of the Iranian project. But it was a start, and that's what we needed at that moment. We pitched hard and made it clear that KPF was a perfect fit for the job.

ABC wanted the project done in less than a year and needed architects to start as soon as possible. "KPF is ready to start today," I explained. Goldman and Schneider chuckled but liked the idea of a firm with nothing else on its to-do list. They were a young and creative company, too, and understood that we, like them, had something to prove. ABC was hoping to eventually build a new headquarters near the armory and develop a campus of buildings. "We can help you with a master plan," Shelley told them.

It turned out that we were the only architecture firm to approach ABC about the armory project. We got the job. Looking back, it would have been embarrassing to lose this one, since we were the only ones competing for it! ABC turned out to be a dream client. We did the armory on schedule and completed the master plan, and, over the next two decades, we designed seventeen projects—some quite small, some quite big—for the company. Most were clustered along Sixty-Sixth and Sixty-Seventh Streets, but a few were in places like Cleveland and Washington, DC. ABC paid us good and fair fees and never nickel-and-dimed us. And they paid within ten days of every bill. That was key, since we didn't have to borrow money to survive that first year.

Goldman, Schneider, and the other executives there were true professionals—smart, organized, honest, and dedicated to doing things well. We got to know some of the actors and newscasters, too, including Peter Jennings, the national anchor who died in 2005 from lung cancer. Over the years, we became good friends with many of the people at ABC, including Roone Arledge, who turned the sports division into a powerhouse and then became president of ABC News after we got hired to transform the old armory.

If we had taken the job in Tehran, we wouldn't have bothered with a renovation on West Sixty-Sixth Street. We would have been running back and forth to the Middle East all the time, borrowing money to cover our costs, constantly negotiating fees, and totally exposed when the Shah fell a year and a half later. I don't see how we could have survived after that. KPF would have been dead in the water by January 1979, when the Shah left Iran. Looking back on it all now, I can't believe how lucky we were. There was no way for

Our very first job was renovating an old armory on West 66th Street (left) for use as studios for ABC. Over the next two decades, we designed 17 projects for ABC, including its world headquarters (right) on the same block.

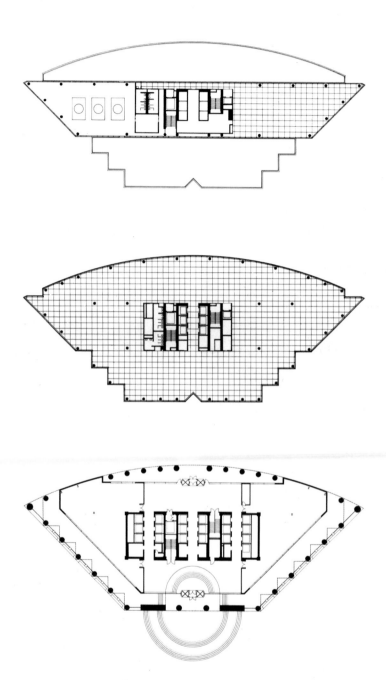

Floor plans of 333 Wacker Drive, from the bottom: ground floor, typical floor, and upper floor. Before our design was approved, we collaborated with Gensler to prepare a study that showed the client that a curving floor plate would work for prospective office tenants.

us to know that the Shah's regime would collapse or that we would get to do seventeen projects for ABC over the next twenty years. But we listened to our instincts, which told us to be wary of overextending ourselves too soon.

The other big surprise about the ABC project was the remarkable chain reaction it set off in helping us attract other clients. It turned out to be the mother of all projects.

As we were working on the armory in early or mid-1977, I got a call from Tom Klutznick, who ran Urban Investment and Development Company in Chicago. His father, Philip M. Klutznick, was a secretary of commerce during the Carter administration, so he was very well connected. He knew me from my days at Warnecke and wanted to ask a favor. "I understand you are working with ABC and I'd like your help with them," he said. "Their Chicago affiliate is a key tenant in one of our buildings, but they need more space and are looking to move. We're planning to develop a new office building on Wacker Drive and want them to anchor the project. You're advising the company and know how they think, right? Can you help us with them?" I was happy to help, though I wasn't sure how much clout I really had with ABC executives back then.

"Come to Chicago and take a look at the site we have for the new building," said Tom. "We'll pay you to do a study." Doing such studies is time-consuming and rarely lucrative. But they can lead to the much better job of designing a building. It wasn't stated on that first call, but I could tell that if the project moved forward, Tom would want us to do the architecture, not just the initial planning. Chicago is a town filled with great architecture and talented architects. It's the birthplace of the modern high-rise. Walk around the Loop and you'll get an education in the history of modern architecture—from Louis Sullivan and Frank Lloyd Wright to Mies van der Rohe and SOM. For a New York architecture firm, especially an unknown one like ours, to have the chance to work in Chicago was incredible.

The site for Tom's building was at the bend of the Chicago River, in an industrial area beyond the downtown Loop. The Merchandise Mart was across the river, but there wasn't much on the Wacker Drive side—no restaurants, no amenities, no stores, just a few run-down industrial buildings. Today, it's a fantastic neighborhood filled with business activity, but back in the 1970s, it was an edge location without a lot going for it other than views of the river. Back then, the Loop was the place to be.

Architecture draws inspiration from its surroundings and upgrades them.

Bill and I flew to Chicago to walk the site and meet with Tom's team. Bill devised a wonderfully elegant scheme for the building with a facade that curves along Wacker Drive and captures the sweeping vitality of the river. Since Wacker is actually two levels, we could bring cars and trucks in at the lower one and pedestrians above. Everybody loved Bill's design immediately. But some of Tom's people weren't sure they could sell prospective tenants on leasing space in a building with curving floor plates. In a later study, we showed how the office floors would work, and Tom got it.

But then ABC's Chicago station decided to stay in its existing space, and the project went on hold. It was a big disappointment after pouring so much time and energy into the job. Tom was crestfallen, too; he really loved Bill's design. Without an anchor tenant, though, he had to put it on hold. He placed a model of the scheme on a shelf above his desk and looked at it every day. He wasn't going to forget it.

About a year later, Tom called me and said, "Gene, I love the design, so we are going to build the building on spec." We were thrilled.

The project, 333 Wacker Drive, would serve as a high-profile display of Bill Pedersen and the firm's talent in creating a marvelous and appropriate building for the site. It broke dramatically from all the boxy office buildings that had gone up in major cities in the 1950s, '60s, and '70s, but it was tailored to its specific location and alluded in spirit to Chicago's long tradition of downtown buildings. People talk mostly about the gracefully curving elevation on Wacker Drive with its blue-green glass that captures the changing color and light of the nearby river. But the opposite side of the building—on Franklin and Lake Streets—adheres to the city's rectangular street grid. Bill studied the neighborhood carefully and made sure his building fit into its context while at the same time pointing to a new direction. He organized the thirty-six-story building according to the tripartite division that Louis Sullivan advocated for tall buildings in the late nineteenth century—a base, a shaft, and a capital. The base would be clad in stone, which made the glass-and-stainless-steel shaft above it "float" above the ground. At the top of the building, Bill recessed a square frame to secure the bulging shaft and serve as a modern entablature. It was brilliant.

When Urban Investment decided to move forward with the project, George Darrell, the company's executive vice president and a trained architect, paired us with Perkins + Will to work on the design and produce the

construction drawings. Perkins + Will was—and still is—one of the most acclaimed architecture firms in Chicago, a major force in the city since 1935. For us, working with a firm like P+W was a great honor. But I wasn't sure how the people there would respond to the idea of collaborating with an untested firm from New York like ours, especially since we would take the lead in terms of design. Nobody knew who we were, and here we were invading P+W's backyard. The people at P+W, however, were incredibly gracious and professional. They never tried to undermine or upstage us. A lot of firms of their stature would have resented working with us and might have tried to sabotage our relationship with the client. Not P+W. They were wonderful partners, and I will always be indebted to them for supporting us.

Another important collaborator on 333 Wacker was Gensler, which like P+W was a bigger, more established firm than ours. Gensler did the studies on the interiors that convinced the client that the curving floors could work for a variety of tenants. When Nuveen became the lead tenant in the building, Gensler designed beautiful interiors for the company, putting circulation—not private offices—along the curving perimeter, so all of the office workers could enjoy views of the river. Such open plans are pretty common today but were pioneering back then.

People often describe 333 Wacker as "elegant" and "glamorous," which it certainly is. But we also made it inexpensive, much to the client's delight. We used Ford Motor glass for its curving facade, not some pricey custom curtain wall system. I joked with Tom that we took the Ford product and just eliminated the windshield wipers. Of course, making something look simple actually required a lot of work and ingenuity.

When 333 Wacker opened in 1983, Paul Gapp, the architecture critic for the *Chicago Tribune*, gave it a rave review. Later, his successor Blair Kamin would call it "a renowned example of architecture that simultaneously draws inspiration from its surroundings and upgrades them." Kamin likened it to a grand mirror, reflecting the river, the clouds, and all the beauty of Chicago's built environment. In 1986, Paul Goldberger, the architecture critic for the *New York Times*, wrote a big article about us and said this about 333 Wacker Drive: "The curve plays beautifully off the river and the huge boxy mass of the venerable Merchandise Mart just across the river from it. The building's two other sides, which are more geometric, relate appropriately to the grid of the city streets."

Our master plan for Motorola in Austin, Texas, gave us the chance to develop some of our ideas about corporate campuses, even though it never got built. We envisioned a multiphase complex on a 235-acre site divided by a ravine.

Although we had a few projects finish before 333 Wacker, none had the same kind of impact in terms of public opinion. 333 Wacker put us on the map and announced KPF as a rising player in architectural circles. And it has passed the test of time. In 1995 it was voted "favorite building" by readers of the *Chicago Tribune*, and it remains one of the most loved in town today. In 2015, it was listed as one of "26 Iconic Downtown Buildings That Every Chicagoan Must Know" by *Curbed Chicago*, and Mayor Rahm Emanuel told Kamin that same year that it was one of his favorite buildings in Chicago.

While we were working on 333 Wacker, we did some interesting projects in the suburbs and smaller cities. They didn't get the same kind of attention and didn't have the same architectural glamour or impact, but they were good designs and pointed us in a direction that proved to be important for the firm for many years. One was for Motorola in Austin, Texas. I heard about it from a friend named Walt Benoit, whom I knew from his years at Westinghouse and mine at Vincent Kling's office in Philadelphia. He called me up, told me about a big corporate office campus that Motorola was planning, and asked if I knew any architects in Austin. I gave him a few names, then said, "Give us a shot."

He paused, then replied, "But Gene, you're in New York."

I persisted. "Give us a chance and I'll show you what we can do." He relented and agreed to put us on the list of architects to be considered.

For some reason, I couldn't make it to the first interview, so I called up a friend in Texas and asked him to represent us. He was an architect but not an employee of KPF and wasn't seeped in our culture. He wasn't my first choice, but I couldn't find anyone else to go. I fed him everything about KPF—our approach to design and our emphasis on teamwork—and hoped for the best. That didn't happen. The day of the interview, bad weather struck, his flight was canceled, and he couldn't get to Austin. The next day, Walt called me and said, "Gene, I told you. You can't do this project from New York. We need someone here."

I wouldn't give up, though. "Give us one more chance, Walt. C'mon." Somehow I convinced him to let us try again, much against his better judgment.

At that point in time, we didn't have any completed corporate buildings to show. Bill and I, however, had done a very nice project for the Aid Association for Lutherans (AAL), an insurance company in Appleton, Wisconsin, when we were at Warnecke. We were proud of that building and

felt it embodied a lot of our ideas about using architecture to encourage a collaborative work environment.

I flew to Austin with a young associate named Brad Springer and Pat Conway, a talented planner whom we had made a director in the firm. We arrived the day before the interview to play it safe and give us some time to rehearse our pitch. We had a photograph of the AAL headquarters, but not much else to present to the client. Today, we go to interviews with PowerPoint presentations and books that have all kinds of photos and drawings of projects we have done around the world. In Austin in 1977, we were practically naked in terms of supporting material. So we had to be creative. We went to the University of Texas, found the campus bookstore, and bought some paper and a watercolor pad. Pat was a brilliant writer and spent the evening creating a wonderful narrative about KPF, our design philosophy, our goals, and how we worked.

The next day, the three of us went to the interview, excited but very concerned that we didn't have enough to show. We met with a vice president named Al Stein, who would be Motorola's key leader for the project. Pat handed him the narrative she had written the night before and talked about who we were and what we could do. Then I took out the watercolor pad and started drawing. I drew the site of the building and sketched a few ideas. Al picked up one of the colored pencils on the table and drew on top of my drawing. That gave me a new idea, which I sketched out and he marked up. For the next few hours, we analyzed the site, dissected the program, explored a broad range of design challenges, and kept drawing and drawing. It was a fantastic session that allowed Al to get deep into our design process and how we operated. He saw we were a firm that engages with clients and collaborates with them on solving problems. He loved it. And we learned that we need to connect with our clients—get them involved, not just work for them. We got the job.

About the same time, we competed for another corporate headquarters, this one for Hercules Corporation in Wilmington, Delaware. Hercules was a manufacturer of chemicals, munitions, and solid-fuel rocket motors and had lots of military contracts. Somehow, as a very young and unknown firm, we got on a list of possible architects that included some of the biggest firms in the country. I worked with Arthur May, one of our designers who later became a partner, and we developed a really interesting approach to the project that included engaging with the local community, connecting the building to its

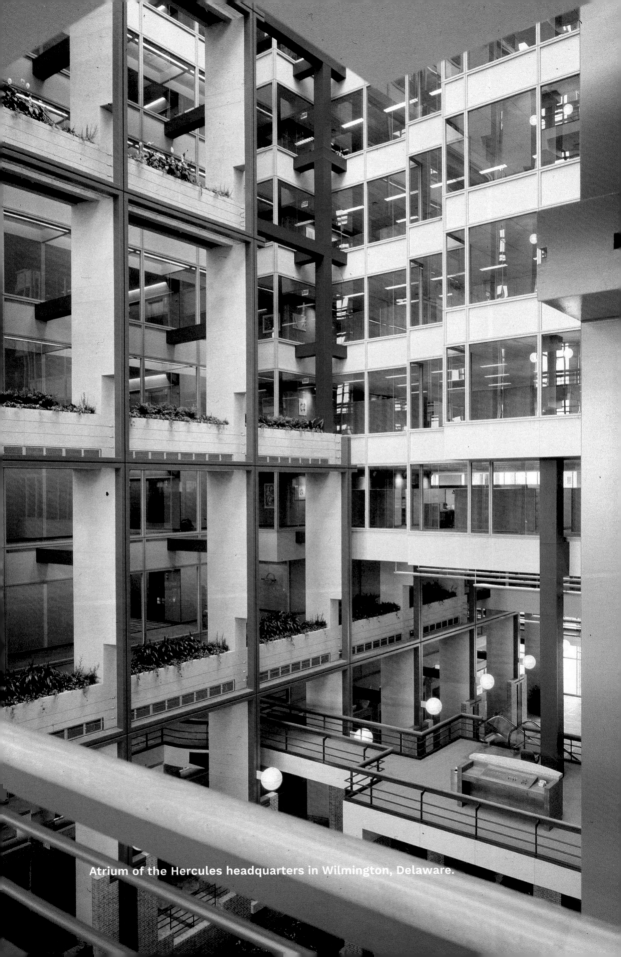

Atrium of the Hercules headquarters in Wilmington, Delaware.

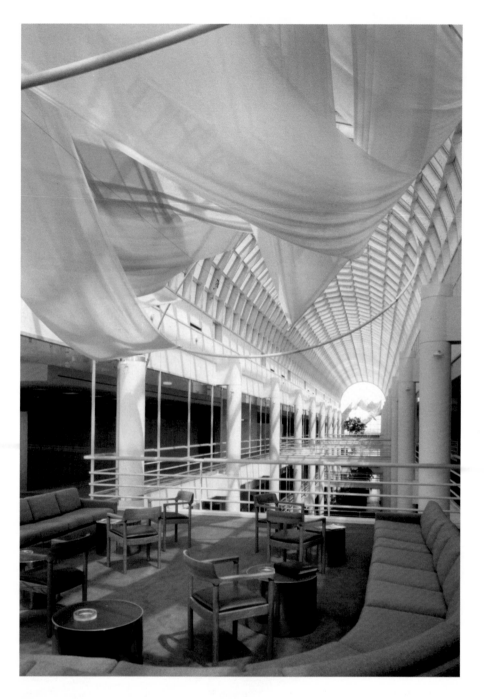

A barrel-vaulted glass spine runs through the AT&T Long Lines Eastern Regional Headquarters in Oakton, Virginia. Inspired by the glazed galleria of Milan, it serves as both the main circulation spine and a social space for people working in the building.

context, and creating a light-filled atrium that rose to the top of the structure. The design got us to the final round, in which we were up against Skidmore, Owings & Merrill, one of the biggest and most prestigious architecture firms in the country. We were thrilled to be playing against the big guys so soon.

On the day of the final presentation, we were scheduled for the afternoon. Skidmore got the more coveted morning time slot and an invitation to have lunch with the chairman of Hercules. This told me that the client expected to pick Skidmore. By the end of lunch, the deal would probably be struck, and we would be heard afterward as mostly a courtesy.

To my surprise, we got the job. Much later I learned why. According to the story I heard, Hercules was, indeed, planning to pick the other firm, but changed its mind over lunch. The architect from Skidmore, who was a star in his own right with a reputation for brilliance, but also arrogance, blew it during the meal. When the waitress forgot part of his order, he yelled at her and embarrassed her in front of everyone. The chairman of Hercules decided this wasn't someone he wanted to work with.

KPF was developing a very different kind of reputation. Clients often told me they were surprised at how well Bill, Shelley, and I got along with each other and our staff. They had seen plenty of architects come into meetings with swagger and a tough-guy attitude. They had heard partners on the same design team argue with each other and try to outshine one another. In their attitude, body language, and tone of voice, they often sent the message, "We're the most important guys around." I guess that works some of the time. But lots of clients would rather work with people who actually like each other and treat everyone with respect.

The Hercules building was a significant project for us. It was big—680,000 square feet—and showed we could do a corporate headquarters that got rave reviews from the people who worked in it. The spacious atrium, all the daylight coming into the offices, and the gardens that flowed around the building created a really attractive work environment. We interviewed people after the building was completed, and many of them said they liked it so much that they spent more time there than they had at the old building. "It's nicer than my home," said one person.

Another person I spoke with when I went around in early 1976 asking people for advice was Richard Hough, the president of AT&T Long Lines. When I was at Warnecke, I worked with him on the Long Lines headquarters

in Bedminster, New Jersey, which is still there and still looks great. He was one of the businessmen who didn't have any projects for us at that time but felt invested in what we were doing. So when a project came up in the suburbs of Washington, DC, just a year after KPF got started, he put us in contact with his team down there.

The company was going to build its eastern regional headquarters in Oakton, Virginia, and wanted it to be a showplace for its latest technology. Customers from around the country would go there to see AT&T's newest products in action and meet with executives. Bill and I worked on the design, and the client liked it immediately. A week or two later, though, Bill came up with a different scheme that he thought was even better. He'll do that—keep working on a design, keep pushing himself, never quitting. But when we showed the new concept to AT&T, the president of the regional division was furious. "Two weeks ago, you told me you had devised the best way of doing the building. Now you say you have a better way. How do I know you won't come back in another two weeks and say you have yet another better way?" He had a point, and I told Bill we could never do this again.

Eventually, we convinced the company to go with the second scheme, which featured a central spine topped by a curving glass vault with workplace pods on either side of it. Bridges cut across the spine to connect the two office wings and offer views of the landscaped space under the glass vault. We had looked at the galleries in Milan and tried to generate the same kind of pedestrian activity inside. It worked. I went to the building a number of times after it was completed and talked with some of the people who worked there. Everyone loved the way you could see friends from the bridges or just bump into colleagues on your way to the cafeteria. In fact, one woman told me she met the man she married that way!

One of the AT&T executives told me, "We have the most sophisticated communications equipment in the world in this building, but nothing beats meeting face-to-face to get things done. Calling someone on the phone and waiting to hear back can be really frustrating." He said that people in the building got more done because they would run into colleagues they had been trying to reach or meaning to call by phone. It's a fairly simple building, but it works really well.

The budget for the project, though, was extremely tight. At one of our first meetings, they showed us numbers that were quite low. I told them,

"There's no way you can build this for that amount. And if you do find a way to build it, you'll spend a fortune maintaining it after it opens." I wasn't sure how they would respond and knew I was taking a risk. They could have said, "Well, then we'll find someone else to design it." But the president supported us and found a bit more money—not much, mind you—for the construction budget. The problem was that AT&T was developing its main headquarters in Manhattan at the same time. This was the famous Philip Johnson/John Burgee design with the Chippendale top and hugely expensive granite exterior. Johnson's project went far over budget and sucked money out of our building. We gave AT&T quite a good building, but the exteriors were just brick and metal panels and had little in the way of sophisticated detailing. Spatially, though, it was terrific.

Another early project that had a minuscule budget was an office building we did in Kentucky. There was nothing fancy about it, but we had very little work at the time and were hungry. An engineer I knew called me up and said, "Gene, I've recommended you for a project in Lexington, for the Kincaid Group, which provides legal, insurance, and banking services." Bill, Shelley, and I flew down there for the interview and stayed at a terrible motel. We didn't know the area and just booked rooms at a place we could afford near the Kincaid offices. The motel was so bad, I think they rented rooms by the hour. I'm not sure they changed the sheets.

The next day, we met with the clients, who were tough cookies, local boys who knew their business and were aggressive negotiators. Somehow, though, we impressed them. It was a good-size building, over 420,000 square feet of offices in a tower. After we designed it, Kincaid asked us to do the interiors, too, which doesn't often happen with office buildings. I remember going back to Lexington to show them our scheme. We brought drawings and a model and dragged along samples of the materials we had selected. When we showed them the fabrics and color samples, the head of the client's design review committee screamed, "What the hell! This is orange and white!" It was actually a very nice orange, the kind that some sophisticated Modern designers were using at that time to provide a splash of color to neutral backdrops. "Orange is the University of Tennessee. We're Kentucky—blue is our color! Change it!" He went bananas.

I was surprised that grown men were making business decisions based on their school affiliation. But I learned that we need to know *everything*

about our clients. Understanding their business, how it works, and how it can improve is just part of the calculus. We need to understand clients as people, whose likes and dislikes may be influenced by a broad range of experiences, including where they went to school and what teams they root for. We changed the Kincaid color scheme to blue and white.

Searching for jobs to sustain KPF in the late 1970s, I stayed in touch with people I had met while working at other firms. So I called on Rob Maguire, a young California developer making a name for himself. Rob and I had always gotten along and we would socialize periodically either in Los Angeles or New York. He was starting work on an office-and-retail complex for Crocker Bank with more than two million square feet of space in downtown LA and gave KPF the job of designing the master plan. Wanting to make his mark, Rob was open to fresh ideas and willing to hire a firm like ours, even though we were brand new.

Bill worked on the master plan and impressed Rob in the process. Turning his attention to the architecture of the buildings—a pair of office towers with a retail atrium in between—Rob asked Bill to design them. At first, he suggested that Bill move to LA to oversee the project. When Bill made it clear he wasn't going to leave his family and transplant himself to Southern California, Rob said, "Well, then you can come out here for a couple of weeks at a time. Start packing your bags!"

When we got back to New York and were talking with Shelley about the fantastic project we had just landed, Bill sheepishly revealed, "Actually, I don't have a suitcase big enough for a two-week trip."

"Well, go out and get one!" I exclaimed. Having excellent taste, Bill went out and bought an expensive suitcase with enough space to hold a fortnight's worth of clothing. Money was tight for us back then, so such a purchase stuck in my head. As soon as Bill bought the item, we got a call from Rob, saying his real estate advisor had told him he'd be crazy to hire unknown architects from the other side of the continent. Ultimately, Skidmore, Owings & Merrell got the project, which opened in 1983 and is now called the Wells Fargo Center. Losing such a major job stung, I admit, because it would have been a fantastic project and given us a significant foothold in Southern California. More than forty years later, KPF is finally doing a big project for Rob in the mid-Wilshire part of LA.

On the whole, though, the late 1970s and early '80s were very good to KPF. We went on an incredible winning streak—getting projects all over the

country. Our first project in the Denver area was the Amoco Tower and our client was Reliance Insurance. Henry Lambert, a good friend of mine, led the real estate division of Reliance and was an important force in the development of the region. We also did a beautiful headquarters for Rocky Mountain Energy in Broomfield, Colorado, just outside Denver. In downtown Denver we designed the Tabor Center, a fantastic mixed-use complex with a thirty-story office tower, a fancy hotel, and three floors of retail. It was a big project with almost seven hundred thousand square feet of space and exposed, poured-in-place concrete. It got a lot of attention in both the press and the business community.

Because of 333 Wacker, we became popular in Chicago and did two buildings next door to that project, as well as 900 North Michigan Avenue, which combined six floors of retail anchored by a Bloomingdale's, a Four Seasons hotel, offices, and condominiums. A unique structural system allowed all of these components to work together without interfering with one another. And at 871 feet high, 900 North Michigan literally stood out in the crowd.

In Cleveland, the Jacobs brothers—Richard and David—invited us to compete for another big, mixed-use complex. We made it to the final two and were up against Pei Cobb Freed, which was a great honor. I knew the Jacobs family owned the Cleveland Indians, so I included some photos of our championship softball team in our presentation. We showed Bill and me playing in the field and hitting, as well as shots of the rest of the team and one of our championship trophies. The committee members got a big kick out of this. It made us *human*, more approachable than other architects. I wrapped up my presentation by saying, "In case you don't pick us to be your architects, perhaps you might want to buy our baseball team." Everybody laughed.

We got the job. I like to think that our design was the main factor in the client's decision. But I also believe that the baseball slides helped.

A few months later, Bill had a party at his apartment in New York and invited Harry Cobb, who was the design partner for Pei Cobb Freed's participation in the Cleveland competition. When Bill told him about the baseball slides, Harry got angry. "That's unethical! You can't talk about baseball in a meeting like that!"

In the end, though, the market crashed and the project was killed before construction began. It would have been a great building, alas.

I'm not a fan of gimmicks, but showing a client you're having fun can be a great way of connecting on a personal level. I remember directing a sales presentation as if I were announcing the starting lineup at a baseball game. As my team waited in an adjoining room, I introduced them one by one. "Playing lead designer and hailing from the University of Minnesota and MIT, please welcome Bill Pedersen!" I handed out programs with bios and head shots of each of our "players," a simple graphic device that proved to be remarkably powerful. I noticed the CEO pointing to a photo and then to Bill, as if to say, "Wow, that's *the* Bill Pedersen!"

Perhaps the most important project we got in this period was the headquarters for Procter & Gamble in Cincinnati. In 1980 the company invited a group of outstanding architecture firms to interview for the job. It was an enormous opportunity: more than 835,000 square feet of offices, amenities, and visitor facilities adjacent to the corporation's existing limestone-clad 1950s building on the eastern edge of the city's downtown. Whether it is rolling out a new consumer product or developing its latest marketing plan, P&G is one of the most methodical and research-intensive organizations in the world. Every one of its products is tested and tested and tested again before it gets approved. The company never takes a step without carefully doing its homework and considering all of its options. It applied exactly this kind of thoroughness to the job of hiring an architect. The list of firms the company interviewed was impressive, in part because it included a few practices like ours, which were not on most people's radar screen at that time, as well as all of the big guys, like SOM, Pei Cobb Freed, and César Pelli. I'm sure the big-name architects scratched their heads when they saw us on the list and asked, "Who the hell are *those* guys?" I used to joke back then that even our wives didn't know who we were. I'm not exactly sure how we got on that initial list, but I had called up a person I knew at the Rockefeller Group, which was advising P&G on the project, and told him we would love a chance to show what we could do.

The selection process was pure P&G: thorough and time-consuming. It took almost a year and a half! They interviewed all the architects on the list to get a feel for the people behind the firms, then narrowed the list and set up another round of interviews. They kept whittling down the list and we kept surviving, much to my surprise. Finally, they put together a short list of three: us, Pei Cobb Freed, and SOM's New York office. Both of the

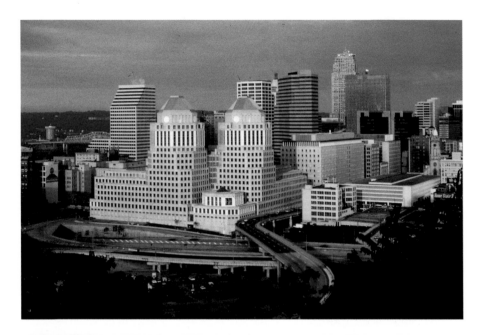

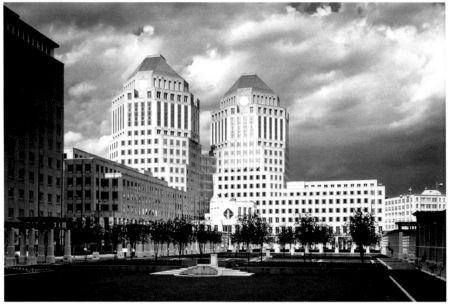

The 830,000-square-foot headquarters for Procter & Gamble in Cincinnati helped
solidify KPF's reputation as a major player in corporate architecture when it was completed
in 1985 and has served ever since as a landmark on the eastern edge of the city's central
business district.

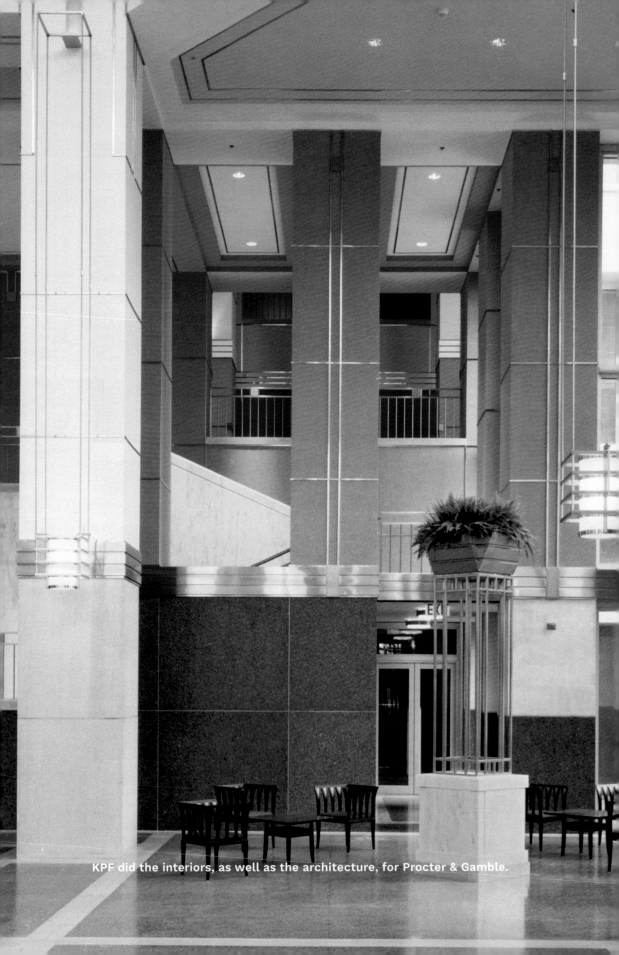

KPF did the interiors, as well as the architecture, for Procter & Gamble.

other firms had done work with P&G in the past, which gave them another leg up on us.

After our sixth or seventh meeting with the client, the selection committee called us and said, "We want you to come back and talk with Brad Butler, the company's chairman, and John Smale, the president." So Bill and I flew back to Cincinnati, wearing our best blue suits, white shirts, and conservative ties. I'm at ease talking to almost anyone, but I must admit, this was one of the few times I was really nervous, as was Bill. We presented our scheme, then looked at the P&G people. Butler was an impressive guy who had worked his way up the business ladder and would become a forceful advocate for early childhood development and corporate support for it. Smale was equally accomplished—a powerful voice for innovation at P&G, who would later become chairman of General Motors and help transform that company. The interview was nerve-racking. The two top executives of this major American corporation asked us all kinds of questions about our approach to the project, our qualifications, our working methods, everything. P&G is a major force in Cincinnati, and it was going to do a significant building. There we were sitting at a table in a very big room, answering one question after another.

After two hours, they thanked us for our time and showed us to the door. "We'll let you know," said Butler as we left. He didn't let on anything about his reaction to us. We couldn't tell from his face, body language, or tone of voice whether he liked or disliked us. I felt we had done a good job with all the questions and had been sincere in our answers. But I had no idea if that was going to be good enough.

Bill and I made a couple of phone calls back to New York, visited the restrooms, then went down the escalator to the lobby. Neither of us said a word. As we were heading out the door to grab a taxi to the airport, we saw Butler rushing up to us with a big smile on his face. "I know you're heading back to New York, so I thought I'd make your trip a little more pleasant," he said. "You got the job."

I felt like screaming, "Yes!" but somehow managed to stay composed. On the flight to New York, Bill and I were like two kids who had just won tickets to the World Series. We really did not need a plane to fly us home that day.

It was a great victory, all the sweeter for having beaten out some of the best architects in the world. And it was a real turning point for KPF,

providing us the chance to design the headquarters of one of America's top corporations, including all of the interiors and the extensive grounds flowing outside the building.

We had a great run through most of the 1980s. We were the new girl in town, and everybody wanted to date us. So a lot of projects flowed our way.

The Paul Goldberger article in the *New York Times* that I mentioned earlier was a major profile of the firm—almost five thousand words—and ran in the magazine section in March 1986. We had been told it was going to be the cover story, but it got bumped by an article on the space shuttle *Challenger*'s tragic flight six weeks earlier. In any event, Goldberger's article was an important milestone for KPF, putting us in the big leagues of architecture. The headline read, "Architecture That Pays Off Handsomely." It went on to say that KPF, which was just nine years old at the time, was "a decidedly unstuffy group whose rise to the front rank of American architectural firms has been meteoric." A few lines later, Goldberger stated, "Kohn Pedersen has managed to do what few architectural firms have—to make a lot of money and to produce first-rate architecture." He overestimated how much money we were making, but I like to think he got everything else right.

I've learned over the years to take good and bad reviews alike with a grain of salt. I try not to let them either go to my head or get me down. But I must admit that the 1986 article brought a big smile to my face and stroked my ego a bit. Goldberger called me "perhaps the most persuasive salesman in the architecture business. His silver tongue could sell almost anything—but in this case, thanks to his partnership with William E. Pedersen, 47, Sheldon Fox, 55, and a group of designers who work with them, Kohn's aggressive salesmanship is put to the service of some of the most provocative commercial architecture in America." I didn't think of myself as a salesman but rather an enthusiastic architect who loved design and working with clients and, of course, the KPF team.

We were on top of the world.

Bill, Bob Cioppa, and me.

Procter & Gamble atrium.

Dancing with History

In addition to being a major business win for us, the Procter & Gamble headquarters represented an important shift in architectural style for both KPF and the profession. Bill Pedersen and some of our other designers had long been interested in learning from history and breaking free of the Modernist orthodoxy that had given us so many glass boxes with flat tops and little true connection to the street or the larger urban context. P&G set us on a long and sometimes controversial journey to a new kind of architectural and planning vocabulary, one that included references to older buildings and design principles.

While most people think of 333 Wacker Drive in Chicago as a Modern building, it draws much of its strength from the ideas of Postmodernism—using stone on the ground floor and carefully adapting its form to the city's street grid on two sides. Bill gave it a tripartite organization, just as Louis Sullivan had done with his skyscrapers, so it had a clear base, middle, and top. Such an arrangement had important advantages in terms of scale and proportion that allowed the building to fit better with its surroundings. One of my all-time favorite buildings is the Seagram Building in New York—the epitome of Modern architecture—but it sits by itself on a lovely plaza and has no other structures butting up against it. That's a luxury most urban buildings don't have. Usually, a tower needs to relate to an existing street wall and a context established by its neighbors. Both Bill and I believe that Postmodern planning principles can help it do this better than Modernist ones.

For P&G, Bill employed a richer palette of materials and a fuller expression of historical forms, such as pyramidal roofs over two octagonal towers and pergolas out in the gardens. The towers with their iconic roofs gave the building a presence on the Cincinnati skyline that midsize structures—they're just seventeen stories high—usually don't have. And the gorgeous Indiana limestone on the exterior connected the project to the city's long

history of early-twentieth-century architecture. But Bill didn't go overboard with allusions to older buildings. You can see the influence of stripped-down neoclassical designs from the 1920s in the handsome elevations with their crisply framed windows, but there's nothing fussy or pretentious here.

We got to do all of the interiors, which is unusual for this kind of project, so we continued the Postmodern expression inside as well. We used beautiful materials—such as various kinds of wood and stone—for interior surfaces, which imbued the offices and communal spaces with a wonderful sense of texture and warmth. At the same time, though, we created a thoroughly modern office environment with open floor plans, light-filled atria, and the latest technology. We designed almost everything, including the workstations and interior partitions. In their old building, P&G executives had private offices, so we needed to convince them to give these up and embrace a big change in their work culture. Our design helped ease this transition, creating a sophisticated environment with elegant finishes, lots of daylight, and great views of the gardens enclosed by the two wings of the building. Being one of the most respected corporations in the country and maybe the biggest consumer-products company, P&G had visitors all the time. Advertising people and executives from lots of different fields came there for meetings. So the project gave us a lot of exposure.

P&G turned out to be a great client. John Smale and Brad Butler, the president and chairman, were involved all the way through—particularly Smale—contributing to every major decision. They took off their jackets and dug into key elements from the exterior cladding to the office layouts. As a result, we had buy-in from the top of the organizational chart. It was a fun project, one of the most rewarding we've ever done.

A year after the building was completed in 1985, Paul Goldberger said this about it: "The profile of the Procter & Gamble building is lively, yet the consistency of materials and the fine detailing give it coherence and unity, as well as texture and richness."

In the same article, Goldberger talked about KPF and Postmodernism, writing that "The firm's ability to make post-modernism commercially palatable is similar to what Skidmore, Owings & Merrill did in the 1950s with the altogether different architectural style of steel-and-glass modernism. Indeed, in many ways Kohn Pedersen is the Skidmore, Owings & Merrill of the 1980s. Like that now-venerable firm, KPF has taken a style

In the mid-1980s, the principals of KPF sat for a group portrait: (left to right) Arthur May, Bob Cioppa, Shelley Fox, Bill Louie, Bill Pedersen, Pat Conway, and me.

One Logan Square in Philadelphia, which I designed with Arthur May.

that had been considered too sophisticated for the commercial marketplace and managed to broaden its appeal without compromising its basic integrity." Near the end of the article, he stated, "At its best, Kohn Pedersen's architecture manages gracefully to leap the often unbridgeable gap between the classic and the contemporary, and to do it in a manner that enriches the cities of the present."

Even before P&G, we were starting to experiment with Postmodernism on certain projects. In Philadelphia, we did a building on Logan Square, one of the five historic squares that William Penn envisioned in his 1684 plan for the city. It's an incredibly important site with a number of historic buildings such as the Free Library of Philadelphia, the Academy of Natural Sciences, and the Franklin Institute nearby. As a result, the Philadelphia Art Commission, in addition to the city's planning department, has to approve of anything built on the square.

I was good friends with Henry Lambert, who was the president of the Reliance Development Group and a food enthusiast who launched the Pasta & Cheese stores in the 1970s and owned a number of fine-dining establishments as well. Henry was a great practical jokester. The first time I met him, he showed up at my office and told the receptionist that he was from the IRS. Coincidentally, I had just paid my tax bill a few days late and got a lump in my throat when I heard who was waiting to see me! Another time, he called on the phone, affected a British accent, and told my assistant he was Prince Charles.

Henry's brother Ben was the head of Eastdil Realty—and is still there today. Back in the 1980s, Eastdil was part of INA Insurance, which owned a site at One Logan Square and wanted to build a mixed-use complex with offices and a hotel. Henry put in a good word for us with his brother, even though we had not completed many projects at the time. I interviewed with Ben and INA and had a good meeting. I talked about KPF's experience with the ABC building in New York and my thoughts for the project in Philadelphia but didn't have anything completed to show him. I was born and raised in Philadelphia and knew the city and the history of the site, so I was able to engage Ben and his colleagues in a lively conversation. I was so confident we could do a great job that I offered to do a study of the site in one month without any pay. I knew the people at the Art Commission, so I had a good idea of what they would want for the site. Near the end of the meeting, Ben

leaned back in his chair and said, "I'll tell you what, Gene, if you can design this building in one month and convince Morgan, Lewis & Bockius [a powerful law firm] to move in, the job is yours." It was a crazy challenge, since all the classy law firms and banks had their offices on South Broad Street, but I was a bit of a gambler, and we were hungry.

Philip Johnson had done an earlier proposal for the Logan Square site, using a U-shaped plan and lots of black glass. The open space inside his U faced an existing open space on Logan Square, bleeding the life out of both. The Art Commission realized this and turned down the proposal. In addition, the commissioners really wanted a lower structure along the square that would relate to the historic buildings there in terms of height and scale. I worked on our design with Arthur May, one of our top designers, who would later become a partner, and we developed a scheme with two buildings—an office tower and a lower block for the hotel. By breaking the bulk of the complex into two components, we reduced the visual impact on the historic square. In addition, we placed the hotel with its granite facade and classically proportioned windows directly on the square and angled the thirty-one-story modern tower away from the park. Between the two buildings, we created a lovely courtyard where hotel guests could have drinks or a meal.

We made a big presentation to the lawyers at Morgan, Lewis & Bockius and convinced them that a new office building would work much better for them than their existing one and that the hotel with its graceful courtyard would be a perfect place to entertain clients. They went for it.

Later, at a public meeting in front of the Art Commission, I saw a mother with her young daughter and walked up to them. Putting my hands on the girl's shoulders, I said, "And when this young lady grows up, she can get married in the courtyard, which will be a place where beautiful memories are made." The mother beamed. The commissioners loved our design and approved it.

While working on the project, I heard about a new hotel chain called Four Seasons, which had only two properties at that time—one in Toronto and a redo of an old Holiday Inn under way in Washington, DC. I had stayed at the hotel in Toronto and found the service and the people there wonderful. This was exactly the kind of operation we needed for the hotel at Logan Square. So I contacted the founder of the company, Issy Sharp, and we hit it

off immediately. Issy was enthusiastic about One Logan Square and would become a dear friend. Next, we got Ben and Issy together and then brought in Tom Klutznick's company, Urban Investment, as the developer. So in addition to designing Logan Square, I helped assemble the essential pieces that made the project work as a business venture. Not many architects get involved in such things, but I enjoy bringing people together and am happy to do anything that will increase the chances of a plan becoming a reality. Doing this also allows me to work with people whom I like.

Issy Sharp is an impressive man who started with nothing and has built an empire. His father escaped pogroms in Poland, went to Palestine, then settled in Toronto and became a building contractor. Issy worked for his father on construction sites during summers, studied architecture, and then built his first motor hotel in Toronto in 1961. In the 1970s, he opened a hotel in London and started focusing on the luxury end of the market. When I talked to him about Logan Square, he was just getting started in the US. Our project would be the first new building for a Four Seasons Hotel, but its Postmodern architecture gave it a sense of history and a connection to its particular location. In a 1990 article in the *New York Times* about the changing skyline of Philadelphia, Goldberger talked about "the splendid Four Seasons Hotel, a civilizing, low-rise gift to the cityscape."

One Logan Square helped shift development in Philadelphia. Before it, all of the major towers were in Center City, and growth tended to move south along Broad Street. After it, a lot of businesses looked to the north and west, moving closer to the Schuylkill River. Having an impact like that on a city, especially the one I grew up in, was incredibly exciting. It made all our hard work feel worth it. We ended up doing about eight major projects in Philadelphia, including Eight Penn Center, Two Logan Square, the Mellon Bank Center (now BNY Mellon Center), International Terminal 1 at Philadelphia Airport, Children's Hospital of Philadelphia, and Huntsman Hall at the University of Pennsylvania's Wharton School of Business. Today, we're still active in the city, working on a forty-seven-story residential tower called Arthaus, being developed by my old friend Carl Dranoff.

Working on those early projects in Philadelphia was fantastic for me. My mother was alive and well and lived in the center of the city. She would always prepare a great dinner for me and would even entertain some of

my clients. In addition, my son Steve had just graduated from college and was working for Reliance in Philadelphia. So it was wonderful to spend time there.

One of the reasons we were able to win projects in those early years was the enormous amount of research we did. For each job, we studied the program, the client, and the particular location. We always did our homework and came prepared for every meeting. I remember interviewing for an office tower in Nashville and talking about the city's history, demographics, urban-development patterns, and real estate market. I discussed what was on the site at that time, what had been there before, and how this influenced our design. With a portrait of Andrew Jackson on the wall behind him, the president of the bank that was developing the property turned to me and said, in a thick Tennessee drawl, "Sir, are you from here?" I shook my head. "But you know more about Nashville than I do!" For a different project, we researched the homes and cars, of all of the people on the client's building committee, so we could get an idea of their tastes in design. We wanted to know who these people were and what they liked.

In the early and mid-1980s, we had a great run of corporate headquarters—mostly in the suburbs. A lot of companies were afraid of big cities back then and wanted to get away from the crime, the crumbling infrastructure, and the congestion they associated with urban places. We liked doing headquarters, because the clients didn't just put up the building but used it, too. It was their home, so they took a longer view of the project and were willing to invest a little more in the architecture. We also liked the challenge of creating workplaces where people could collaborate and interact in a more spontaneous, less hierarchical way. The building type was changing rapidly back then. Private offices with doors were giving way to open floor plans where everyone could share daylight and views from perimeter windows. We helped pioneer this new kind of corporate environment, and it was exciting. We did buildings for AT&T Long Lines in Oakton, Virginia; Hercules in Wilmington, Delaware; Western Digital in Irvine, California; and Rocky Mountain Energy in Broomfield, Colorado.

One of these projects was the headquarters for General Reinsurance in Stamford, Connecticut, the city where Shelley Fox lived. I heard about this project while talking with Keith Roberts, an executive I had recently met at Olympia & York, the giant real estate company controlled by the Reichman

family. He told me to call Bill Hartz at General Re and said he would put in a good word for me.

When I got Hartz on the phone, he told me, "Sorry, Mr. Kohn, but I've already interviewed twenty-eight architects, and I don't need to talk to any more. We've made our selection and are going to announce it soon."

I honestly believed we could do a great job for General Re, but I only had a few seconds to react to Hartz's comment and the fact that he was ready to hang up the phone. I never have done this before or since, but before he could get off the phone, I told him, "Mr. Hartz, you don't know me, but KPF is going to be one of the greatest architectural firms ever. And I think you'll be very disappointed if you don't at least interview us." I fully expected him to hang up.

But to my happy surprise he said, "You really mean that?"

I didn't hesitate. "Yes, sir, I do. We're going to be the best."

He paused for a moment, then replied, "Okay, well, I'll tell you what. I'll give you an interview."

A few days later, Shelley and I met with him, and the three of us hit it off. He was impressed with us, and after an hour of conversation, he handed us a book of background material on the project. "Do a scheme and I'll take a look."

Bill Pedersen worked on the project and came up with the *most* Postmodern design ever. He got carried away, creating a heavy-handed interpretation of an English castle. It was practically a fortress. Hartz and his team disliked it. Bill's batting average with design ideas is very high, one of the best in the profession. But he struck out with this project.

I asked Hartz to give us another chance. For some reason, he said, "Okay."

Bill Louie took over the job and used a lighter touch to devise a lovely Postmodern building that addressed an adjacent highway with a crisply detailed glass facade, then turned a more historicizing face to the city with an abstracted clock tower. Bill Pedersen was a mentor to Bill Louie, so he was happy for him. Having his protégé do the project took some of the sting out of it for him.

In New York in the mid-1980s, we were busy designing a number of important high-rises that would make significant contributions to both the city's skyline and its street fabric. Each responded to its particular site in a unique, even idiosyncratic, manner.

At the corner of Lexington Avenue and Fifty-Seventh Street, for example, we designed a thirty-four-story office tower for Madison Equities that has a public plaza and a freestanding *tempietto* out front and two stories of space for antique dealers on the first floor and belowground. In a surprising gesture in a city known for its street grid, Bill Pedersen pushed most of the building behind the plaza in a bold, concave arc. In a review with the headline "Breaking the Rules to Make a Corner an Urban Event," Goldberger in 1988 called the building "a startling success as a work of architecture and even more as a piece of urban design."

After explaining how most towers set behind plazas weaken the urban fabric around them, Goldberger said, "So this whole building appears to violate a set of design rules that have become the common wisdom of our time, but in fact turns out not to violate the principles on which those rules are based. What Mr. Pedersen has done is to reject the standard formula of urban design in our age, and find another way of respecting the street and relating his building to its surroundings—a way that, in the end, is so convincing visually that it appears to be the natural solution, rather than the unorthodox one."

He liked the architecture, too, writing, "this is the most ambitious example New York has yet seen of Kohn Pedersen Fox's style, which is a kind of abstracted classicism, an attempt to pick up the spirit of the great romantic office towers of the 1920s and '30s without copying them literally." He summed up his feeling about the building, stating, "There is something of the air of the W.P.A. classical buildings of the 1930s to his work, but jazzed up, given a shot of adrenaline to rid them of their musty, dry air."

He was less impressed by some of the interiors, though, criticizing the main lobby as having too many materials and being "bombastic."

A few years later, we completed a very tricky building on Fifth Avenue between Fifty-Fifth and Fifty-Sixth Streets that also earned rave reviews. The project was started by the developers Ware Travelstead and David and Jean Solomon but was eventually taken over by Alfred Taubman, who had made a fortune developing suburban shopping centers and then become a major art collector.

Al Taubman was a bear of a guy, six foot three, with a barrel chest and a big personality. He was a tough businessman, but if he liked you, he could be remarkably supportive. Luckily, he liked me, and took me under his wing.

Bill Pedersen's design for 135 East 57th Street in New York picks up the spirit of the great romantic skyscrapers of the 1920s and '30s and wraps around a new plaza with a freestanding tempietto at the corner.

Trained as an architect, Al would bring out a roll of yellow tracing paper at every meeting and use it to draw ideas over our plans. When he spoke, you listened. If he didn't like something, you knew it. I love direct people like that and we became good friends.

Al was a generous supporter of the University of Michigan's school of architecture and urban planning, which he attended in the 1940s and donated enough money for it to be named for him now. He had a deep commitment to education and collaborated with me in establishing a real estate center at my alma mater, the University of Pennsylvania. Peter Linneman, who was a professor at the Wharton School, helped us set up the program, now called the Samuel Zell and Robert Lurie Real Estate Center, and served as its first director.

In 1983, Al bought Sotheby's and turned the venerable-but-stodgy auction house into a major force in the art world. In the 1990s, he invited me to join a group of distinguished people, including architect Norman Foster and the developer and architecture patron Lord Peter Palumbo, to advise the Hermitage Museum on managing and updating its buildings in St. Petersburg, Russia. It was an amazing experience getting to know Foster and Palumbo and watching Russia transform after the fall of the Soviet Union. At the end of the decade, Al hired KPF to design a new headquarters for Sotheby's on the Upper East Side of Manhattan, a project that allowed the company to mount generously sized presale exhibitions, rather than shuttling artwork back and forth from a warehouse in Harlem. It also provided spaces for auctions, a café, a wine store, and offices for the company.

Our office tower for Al at 712 Fifth incorporates a pair of old townhouses that we converted into a lovely home for the Henri Bendel store. It shows off a set of spectacular Lalique glass windows that had been hidden behind layers of grime for many years and were discovered after we started designing the project. Working with the architecture firm Beyer, Blinder, Belle, we renovated the old three-story buildings and added a third one to create a low-rise retail component on Fifth Avenue.

Set fifty feet behind this historic base, a fifty-two-story office tower rises as an elegant composition of limestone, marble, granite, bronze, and glass. In a 1991 review in the *New York Times*, Goldberger said, "The building will probably be ranked by architectural historians as an assertive synthesis between these architects' classical skyscrapers and the late-modern towers they

have been designing more recently." Discussing the interiors of the retail portion of the project, he wrote, "The mood is Art Deco, not the garish Art Deco re-creations that are common in New York but a soft, sensual Art Deco."

By the end of the 1980s and start of the '90s, however, the tide began to turn against Postmodernism, and a number of architecture critics attacked some of our designs. Paul Gapp, the critic at the *Chicago Tribune*, wrote approvingly of the engineering "muscle" behind the hybrid steel-and-concrete-frame structure of our 900 North Michigan Avenue project, but hated the sixty-six-story building's top with its four neoclassical lanterns, saying we "got the scale wrong." Frankly, we didn't like those lanterns, either, but the client insisted on them. Gapp also described the exterior as "a composition-ally erratic work reflecting uncertainty of intent and an unsuccessful groping for stylistic focus." Ouch. He appreciated, however, the way we combined the various programmatic elements—a large shopping complex with a Bloomingdale's store at the base, a Four Seasons hotel, apartments, and office floors—saying this was "intelligently handled." And he called the Four Seasons "the best looking of all the luxury hotels built here since the Ritz Carlton opened in Water Tower Place" in 1975.

Gapp's successor at the *Tribune*, Blair Kamin, gave our Chicago Title & Trust building a mixed review as well in 1991. He liked the base of the project, saying, "Chicago Title works best at the ground level, projecting a sense of permanence that is perfectly in keeping with the quiet dignity" of two of its neighbors. He also admired the "elegantly roofed" retail arcade that runs north-south through the building. But examining the top of the building, he said, "While the western facade of the tower has a strong, symmetrical presence that manages to bridge the gap between dignified and dynamic architecture, the rest of the building's topside surfaces are visually hyperactive, nervous to a fault."

Herbert Muschamp, Goldberger's successor at the *New York Times*, rarely paid attention to our work, instead writing frequently about out-of-town architects such as Frank Gehry, Rem Koolhaas, and Arquitectonica. On the rare occasions when he discussed KPF, he was tepid in his praise. In a review of an exhibition on public architecture in New York in April 1996, he lumped our Supreme Court Building together with Hellmuth, Obata + Kassabaum's Federal Office Building—both on Foley Square in lower Manhattan—saying, "These are sturdy, classical buildings of gray stone, stylistic throwbacks to

The Chicago Title & Trust tower (now called 181 North Clark Street) displays a stripped-down historicism that helps it anchor a site in Chicago's North Loop. It was supposed to have a twin next to it, but only one got built.

government architecture of the 1930s. Designed in deliberate contrast to the Jacob Javits Federal Office Building, a bleak modern slab, the new buildings are a pair of nicely cut gray suits. They do their best to fit in. But why didn't someone in charge object that the '90s aren't the '30s? People have done some thinking about government in the last sixty years."

I believe we did a lot of very good Postmodern buildings, projects that work well with their contexts and that contributed to urban vitality. But by the early 1990s, the movement entered a kind of baroque or mannerist phase in which the layering of historical forms and details became too extreme. What had started as an effort to imbue new buildings with a sense of texture and even ornamentation often associated with older architecture eventually became a sort of game in which designers competed to show off all the new tricks they had learned. I must admit, a few of our buildings went too far, and one of our design partners got too caught up in the style. He ended up "overcooking" his architecture—adding too many different materials, too much detailing, too much *stuff*. It came across as heavy-handed. He did two projects in particular—one in Philadelphia and one in Washington—that I find embarrassing. I literally steer clear of these buildings, driving out of my way to avoid them. In the end, we asked this partner to leave the firm.

It has been more than twenty years since KPF has done a Postmodern building, and projects from that period represent a small percent of those we have done in our four decades of practice, but some people still associate us with the style. This has hurt us. Just recently, we were about to get a big job in Philadelphia at Drexel University. Everything seemed to be in place. Then someone on the selection committee at Drexel nixed it. He didn't like some of our Postmodern buildings in town and wouldn't look at all the Modern designs we have done in the past twenty-five years. It was infuriating.

In Sydney, Australia, we did a very good Postmodern project, Chifley Tower, for businessman Alan Bond. Completed in 1992, it rises forty-two stories above the city's famous harbor and has been a business success, attracting law firms, corporations, and financial services companies as tenants. The client and the city loved the building when it opened. But we have no other completed buildings in Australia, which is strange, since we have done so many projects throughout the Asia-Pacific region—in China, Korea, Japan, Indonesia, Thailand, Singapore, Vietnam, everywhere. But only one

in Australia! We've been invited to compete for work and have flown there for interviews, but current city officials and the critics can't see past that one building we did more than a quarter century ago. I've been told that people still think of us as Postmodern architects. There's no doubt that we've lost jobs or not been considered for ones due to this outdated reputation.

By the early 1990s, our architecture was evolving beyond Postmodernism. Bill Pedersen was working on new ideas, and he led the other designers to an updated Modernism that was more sophisticated and complex than the simple glass boxes of the 1960s and '70s. Clients were looking for something fresh that exploited the latest technologies and materials, and we were going in that direction, too.

Our Federal Reserve Bank of Dallas, a one-million-square-foot complex in the Uptown neighborhood, opened in 1992 with a bold concrete-and-glass office tower and a lower structure for civic facilities. There was nothing Postmodern about this design. It won an Urban Design Award from the city of Dallas and a Distinguished Architecture Award from the American Institute of Architects. Not only did the project earn accolades for its architecture, but we got it built about a year ahead of schedule and under budget by nearly $25 million. That was pretty impressive for a federal project! At the official opening of the building, I mentioned these facts in my speech and looked at Alan Greenspan, who was chairman of the Federal Reserve at the time. He nodded approvingly. Then I decided to have a bit of fun. Addressing Greenspan, I suggested, "Since the Fed is saving so much money on this building, perhaps it won't raise interest rates any time soon." He didn't laugh, just gave me an ugly stare.

The project that probably best represented our pivot back to Modernism was the World Bank Headquarters in Washington, DC. In 1989, the bank announced an international competition to design a major expansion and transformation of its aging complex of buildings on Pennsylvania Avenue, two blocks west of the White House. We almost never enter open competitions, because they cost so much to do and the odds of winning are so low, no matter how good you are. But I loved the sound of "World Bank" and thought it would position us as a global architecture firm. When I mentioned the idea of entering the competition to Bill and Shelley, they both looked at me like I was crazy. "C'mon, let's give it a try," I urged. I coaxed the hell out of them and eventually convinced them it was a rare opportunity to make a

The Federal Reserve Bank of Dallas represented a pivoting away from Postmodernism and a return to a Modern vocabulary for KPF. The limestone-clad building was completed in 1992, ahead of schedule and under budget.

The bank wanted a design that welcomed the world.

The World Bank Headquarters in Washington, DC

significant mark on our nation's capital and explore new design ideas that had been percolating in our minds for a while.

More than three hundred architects requested the competition brief, and seventy-six firms from twenty-six countries ended up submitting schemes. The design challenge was wickedly complex, because the bank had six buildings on the site with more than four thousand employees working there and couldn't just move everyone out as the new project got built. The existing structures were erected at different times and didn't all connect or even have the same floor heights. The competition rules said that at least two of these buildings had to be retained temporarily during the construction process. But it was clear that the bank wanted a new landmark that looked to the future.

The selection committee narrowed the list of architects down to eight teams: Arthur Erickson from Canada; Cannon from the US with Moriyama & Teshima (Canada) and Dissing + Weitling (Denmark); Edward Larrabee Barnes/John M. Y. Lee & Partners (US); Hellmuth, Obata + Kassabaum (US); John Andrews (Australia); Norconsult with Platou Architects and Lund+Slaatto Architects (Norway); Skidmore, Owings & Merrill (US) with Charles Correa (India), and us. It was an impressive group of powerful firms, and we were proud to be part of it.

Bill Pedersen led our design team and loved the complexity of the project. He developed a brilliant scheme that was the only one to keep two of the existing 1960s buildings permanently, and inserted a glass-vaulted atrium in the center of the compound to pull all of the pieces together. We felt it would be a shame to tear down the old structures—one by my former employer Vincent Kling and the other by Bruce Graham of SOM—since they were very good buildings and after renovation could help provide a sense of richness that comes from an assemblage of pieces from different eras. Also, we didn't like the idea of adding a giant pile of building materials to a landfill somewhere.

The other ingenious aspect of our scheme was the way we got thirteen floors within the maximum 130-foot height of the buildings, while everyone else could manage just twelve. We did this by using eight-inch floor slabs instead of the standard twelve-inch ones and finding creative ways of weaving air ducts and mechanical systems into the building. The enormous atrium at the heart of the project would serve as a wonderful social hub for all bank

employees and provide the architectural wow that a project like this needed. The vaulted-glass roof over the atrium rose to a height of 178 feet, which was allowed because there wasn't any habitable space up there.

We won the competition and garnered media attention from around the world. It was a really big deal, a powerful announcement of our design ideas and where we were headed.

When the project opened in early 1997, it got rave reviews. Benjamin Forgey, the architecture critic of the *Washington Post*, called it "an exciting, sophisticated work of modern architecture. Its architects, Kohn Pedersen Fox, got almost all of the big things right, and most of the small ones, too." Later in the article, he said, "In the architectural competition that Kohn Pedersen Fox won seven years ago, the bank stressed it wanted a design that, in symbolic and real terms, welcomed the world...it definitely got what it asked for—the design is uplifting."

Speaking of the atrium, Forgey stated, "This isn't an empty container that impresses you only with its size. Rather, the space is splendidly modulated with architectural elements from the giant—120-foot concrete columns—to the human-size—a sitting ledge alongside a channel of water. It is a complex towering space almost like those of Piranesi's prison scenes, but without the frightening overtones. To the contrary."

In 1991, *Progressive Architecture* magazine gave our design for the World Bank a P/A Award for unbuilt work. After the project opened, the American Institute of Architects gave it a prestigious national Honor Award for Architecture. It was a phenomenal building, one of the best we've ever done, and it positioned us as a major force in international architecture.

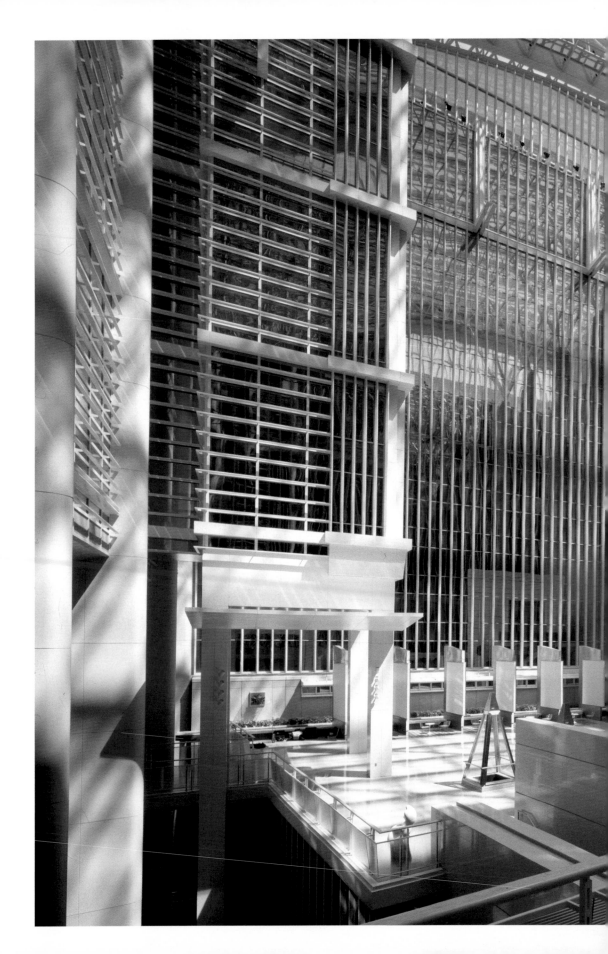

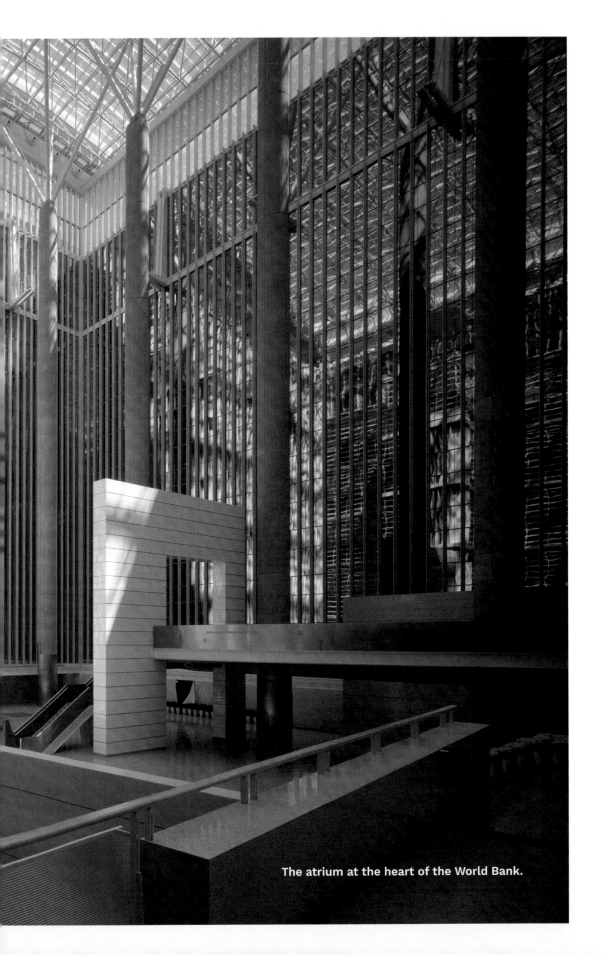

The atrium at the heart of the World Bank.

KPF offices in London.

First Steps Abroad

In 1985, I attended an Urban Land Institute conference in San Francisco and heard one of the keynote speakers—an economist—warn the audience of developers, investors, architects, engineers, planners, and other consultants, "If you're not global by 1990, half of you will be out of business." He was a persuasive speaker and got my attention. For several months, I had been talking with real estate investors I knew, and most of them agreed that the US economy was slowing down. A large percent of our projects were office buildings, which would be the first type of construction to be affected by a recession. KPF was in a vulnerable position.

When I returned to the office after that ULI conference, I told Bill and Shelley we needed to look beyond the United States for our future growth. From what I could tell, there was strong activity in the UK, France, Germany, and Holland and even greater potential in countries like Japan, Korea, Singapore, Indonesia, the United Arab Emirates, and China, which were starting to build on a scale unheard of in the past. These places needed the services of architects who could design and oversee complex building projects. KPF had the skills and qualifications to do this. Not only were our skills needed overseas, but working in other parts of the world would serve as a critical hedge on the uncertainty of business cycles. If the economy was suffering in the US, a boom in another country could save us. Diversifying our base of operations would increase our chances of navigating hidden shoals in turbulent economic waters.

It took some effort, however, to convince Bill and Shelley of the wisdom of going global. They were both smart but cautious people and often played the important role of checking my more ambitious tendencies. "It's tough enough doing work here in the US," said Shelley. "Getting and doing work abroad is only going to be tougher." In the end, after many discussions, both of them supported the strategy.

There were big risks and expenses involved with this expansion, but the potential rewards in terms of revenue and, equally important, design opportunities were just too great to pass up. Another advantage was the chance to keep our key people active during any slowdown and expand their knowledge and experience so they would be better prepared to lead large-scale projects in the US when the market rebounded.

As it turned out, the 1990s were a particularly fallow period for commercial construction in the United States. Only eighteen million square feet of office space was built in New York City during the decade, an average of 1.8 million per year—roughly the size of two large office buildings. The economist at the ULI conference was right, and going global was a critical decision that helped secure the future of KPF.

London seemed like a good place to start, since it was a global city, a gateway to Europe, and wouldn't pose any language problems other than adding a *u* to "color" and tacking on *me* at the end of "program." I started to make business trips there in 1985 but had visited there a number of times as a tourist and had developed a deep love for the city—its history, culture, and people. If KPF was going to be a global firm, it needed to be in London.

On one visit there, I met with Peter Murray, who had been editor of *Building Design* and then the *RIBA Journal*. In 1983, he and Deyan Sudjic founded *Blueprint* magazine, which made a big splash in the worlds of publishing and design. He was a big fan of KPF and thought British architects would be interested in learning about us. By the end of our conversation, he suggested that we do an exhibition on KPF's work at the headquarters of the Royal Institute of British Architects, a beautiful Art Deco building on Portland Place near Regents Park. I jumped at the chance. Within a few months, we put together a fabulous exhibition with about a dozen of KPF's key projects, some completed, others still on the boards. We shipped models of the projects—all built to the same scale and painted white—to London, setting each one in a glass box on a wood base and lighting it from above. On the walls we displayed photographs and drawings of the projects. The show looked fantastic and brought us a lot of attention. It turned out to be a great way of announcing ourselves to an international—and influential—audience.

One of the first people I met on my business trips to London was Michael Baker, who was a founder of Baker Harris Saunders, a firm of chartered surveyors that was a key player in the city's development community. He and his

partner Simon Harris understood the value of good design and would work with some of the most talented British architects, including James Stirling and Norman Foster. Michael introduced me to a number of very important people, told me what was happening in the real estate market, and taught me what to look for. He and I have remained friends ever since, and I see him and his family at least once a year. In fact, one of the most remarkable dinners I attended in London was at his induction as the Master of the Chartered Surveyors Livery Company. It was a black-tie affair with hundreds of people in a beautiful historic hall and featured a host of ancient rites, including sipping beer from a large goblet that was passed from one person to the next.

One of the people Michael introduced me to was a chartered surveyor named David Fletcher, who was a partner at the firm Fletcher King. He and his family remain close friends of mine today, too. One of the very special things he did for me was arrange a meeting with Prince Charles, whom he knew quite well. I was thrilled and intrigued. Prince Charles had been speaking out about architecture for a few years, criticizing modern buildings and advocating a more traditional approach to design and planning. In 1984, he took the architectural profession to task at the RIBA's 150th anniversary dinner and famously described a proposed addition to the National Gallery in London as a "monstrous carbuncle on the face of a much-loved and elegant friend." The project, designed by the firm ABK, was quickly killed and eventually replaced with a Postmodern design by Robert Venturi and Denise Scott Brown. I didn't always agree with Prince Charles, but I admired his fearlessness and thought the national debate he initiated on architecture was good for both the public and the profession.

On the day of my meeting with the prince, David drove me to Kensington Palace, where I was greeted by a royal protocol officer who told me the prince was delayed playing polo but would be along shortly. I was escorted into a waiting room that had the feel of a private library. There was a grand wood table close to twenty feet long that held piles of books and small paintings that seemed to be gifts to the prince. Knowing he was an amateur painter, as I am, I had sent him a watercolor I had done recently. As I looked at the assembled art, I wondered if my painting was somewhere there.

After a few minutes, the protocol officer turned to me and said the prince had a train to catch for a visit to Birmingham that evening, so I would need to keep the meeting short. I nodded my assent, then heard a noise come from

Top: Shelley, his wife Judy, my daughter Laurie, and I watched a parade in London in honor of the Queen in 1985, the same day a KPF exhibition opened at the RIBA headquarters. **Bottom:** Prince Charles, Nigel Webb, me, and my current wife Barbara at Buckingham Palace in 2018.

under the table. Suddenly the royal aide ducked under the ornate furniture and removed two young boys—William, the future Duke of Cambridge, and his brother, Harry—who were a bit sweaty and red. They must have been wrestling, but they straightened up as true princes, shook my hand, and left. Over the years I got to see them grow up and become important figures in their own right.

Prince Charles arrived some twenty minutes after I did and immediately put me at ease. On television, he often comes across as stiff and formal. But in person, he was relaxed and engaging. He gave me a wonderful tour of the palace, showing me everything, even his bathroom, which he had just redone. I couldn't believe how gracious he was—explaining the history of the palace and telling stories about particular items, such as portraits and photographs of his family. These relatives had names that started with "King," "Queen," and "Lord." I thought of the pictures in my home—of aunts, uncles, cousins, none of whom had a title. He pointed out cherished pieces of furniture, ceramics, and art, offering an episodic history of the British monarchy. He was truly charming and wanted me to enjoy my visit. He also expressed interest in me and what I was doing.

We talked about architecture, art, and the future of London. The conversation flowed easily, but I kept thinking of the protocol officer's admonition to keep this meeting short and periodically checked my watch. Charles saw me do this a few times and finally asked, "Gene, do you have to go somewhere?"

A bit flustered, I said, "No, of course not. But I know you have a train to catch, and I don't want you to miss it."

With a gentle smile on his face, he leaned over and replied, "Don't worry, Gene. The train will wait."

Since that first meeting, we have stayed in touch, usually getting together once or twice a year at some charity event or social occasion. I count him as a friend, one whom I respect enormously. At one of his charity events in the 1990s, I met Princess Diana, who turned out to be more beautiful in person than in any photograph I had seen. Sitting next to her during cocktails, I was speechless, something that almost never happens to me. She was charming and was able to engage with people in a simple, direct way.

Years later, I visited Middleport Pottery Studios and its Burleigh Factory, historic facilities that had fallen into disrepair until the Prince's Regeneration

Trust helped rescue them in 2011. I see all the great things he is doing for his country and am impressed. He is a skilled painter, and I have bought some prints of his work at benefit events, in the process getting to know Anna Hunter, who owns the Belgravia Gallery and represents his artwork. Our shared love of art and architecture has helped bolster our relationship.

In the late 1980s, I kept an eye on the UK and learned that G. Ware Travelstead, an American working with Credit Suisse First Boston Real Estate, was devising plans to redevelop the decommissioned docks at Canary Wharf. Located on the eastern edge of London, along the Thames, Canary Wharf back then was an aging industrial area that had lost its economic reason for existing—the shipping business. Some developers saw the potential of using the old warehouses there as inexpensive back-office space. But Ware saw a bigger opportunity—constructing a premier business district with the kind of modern office buildings that were almost impossible to find in London's historic core. He envisioned a brand-new financial district that would offer office towers with the large floor plates needed by investment banks and global services companies and would provide all of the retail, residential, and hotel space to support such development.

Both Bill Pedersen and I knew Ware from our days at John Carl Warnecke & Associates when we worked with him on the headquarters for the Aid Association for Lutherans in Appleton, Wisconsin, a project that Kohn Pedersen Fox would design an addition to many years later.

I started speaking with Ware as he developed his concept for Canary Wharf, and he hired us to do a master plan and design a trio of office buildings there, including a major skyscraper. He also hired SOM to plan a different part of the complex and design some other office towers. The scope of his vision was gigantic and the need for it persuasive. If London was to remain a global financial center and an essential part of an expanding European Union, it would need millions of square feet of new Grade-A office space—something that just was not available in the city's existing financial district.

Ware was an interesting character—dynamic, but also a bit of a wheeler-dealer. His family came from Kentucky, where one of his great-grandfathers was a powerful state politician. His father established a construction company in Baltimore that did projects in Maryland but also worked on the World Trade Center in New York and Cape Kennedy in Florida. Building and deal making were in his blood.

Canary Wharf FC-4 and FC-6, which opened in 1991, were the first buildings we completed at London's new financial district on the old West India Docks. A César Pelli tower rises behind our ten-story buildings.

We had a series of meetings with Ware at a hotel near Heathrow Airport, usually spending the weekend there with his team and people from SOM. Ware wanted buildings that would be dramatically modern and grab everyone's attention. Since there wasn't much context at Canary Wharf, we were free to explore new directions in architecture. It was a lot of fun, and Bill Pedersen came up with an incredibly elegant design and top for our central tower.

The problem with Canary Wharf, though, was getting there. London's Underground didn't extend that far, and a light-rail line that would open in 1987 had only limited capacity. Ware was a persuasive guy and intrigued a lot of people with his bold plans, but business executives kept wondering how in the world they would get thousands of office workers to a new development all the way out on the West India Docks. By the summer of 1987, several of his major backers had pulled out, and he had to give up. He was heartbroken. We were, too. My son Brian, who was working for Ware at the time, developed a particular attachment to Bill's design. He still has a model of the central tower, I believe, and thinks it's one of the best we've ever done.

Later that summer, the Canadian developer Olympia & York took over Canary Wharf and started building the kind of new CBD that Ware had envisioned. O&Y, which had worked with César Pelli on the World Financial Center in New York, hired him to do the first towers at Canary Wharf. But KPF did a number of buildings there over the years and dealt quite a bit with Michael Dennis, who ran the giant project for O&Y. Michael, a Canadian who didn't suffer fools gladly, was a tough negotiator. We had to work hard to earn his respect and meet his high standards. Today, he is one of my best friends. He and his wife, Kathy, have a house in Washington, Connecticut, near the one Barbara and I own. Whenever both couples are there, we get together.

It would take decades for the full potential of Canary Wharf to be realized. In the meantime, a major recession forced O&Y into bankruptcy in the early 1990s, and it wasn't until the Underground opened its Canary Wharf station in 1999 that the project became a true success. Today about 105,000 people work there, and the complex provides sixteen million square feet of space. KPF has done nine buildings there, and we are proud to have played a part in making this an exciting place to work, shop, and dine.

After working with Ware on Canary Wharf, I got a call from Claude Ballard, who was the head of real estate for Goldman Sachs. We had been friends since his days as senior vice president at Prudential Insurance in the

1970s. Claude was an imposing figure: six foot three and smart as a whip. He was one of the most respected people in real estate, a straight shooter whose word was trusted by everyone. At Prudential, he helped pioneer the field of pension funds investing in real estate, a break with an earlier era when these institutions focused almost exclusively on stocks, bonds, and Treasury securities. Both he and I were active in the Urban Land Institute, so we kept in touch on a regular basis.

At Goldman Sachs in the late '80s, Claude was overseeing the company's construction of a new London headquarters. Located on Fleet Street in the historic center known as the City of London, the building would include an enormous trading floor and had to fit on a tight site in a heritage area. Goldman had hired a local architect for the job, but Claude wasn't happy with the design from this firm. So he gave me a call and explained the problem. "The London authorities are never going to approve the design that we have right now. So I need an architect who can do better." I assured him we could design a fantastic building that even the notoriously tough City of London Corporation would embrace. I said this without having ever worked in England—a bold but confident statement.

I flew to London to meet Claude, check out the site, and discuss the project in detail. Fleet Street was famous at the time for the major newspapers based there, and our site, now known as Peterborough Court, was just behind the headquarters of the *Daily Telegraph*. This was a historic area, and the governing authorities were very sensitive to large new buildings. Issues of height, bulk, and aesthetics would be carefully scrutinized. The home of Dr. Samuel Johnson, the eighteenth-century writer and lexicographer, was a stone's throw away, and St. Paul's Cathedral was nearby, too. Next to our site, the oldest pub in London stood as an enduring (and lively) reminder of British traditions. Raising a pint of ale there was a good way for Bill and me to appreciate the special nature of this commission.

Bill developed a remarkably sensitive building—Postmodern in its expression, but outfitted with the latest technology for running a global financial services company. It had a large barrel vault over the trading floor and a beautifully proportioned and detailed facade on Fleet Street. The design bridged eras with grace and power. We produced a set of gorgeous hand renderings that showed the building emerging handsomely from its context. When Claude first saw them, he smiled broadly and said, "That's it!"

Goldman was a terrific client and really helped me understand how to run a business. Everyone there was incredibly organized, took notes, and could tell you months later exactly what had been said and decided at every previous meeting. They followed up on everything and made sure things got done. They were smart and did things the right way. It was a refreshing change from Ware and his brilliant but unorthodox management style.

Getting approval for the project was time-consuming and involved meeting with a long list of local stakeholders and review boards, including the Royal Fine Art Commission (RFAC). At the time, the RFAC chairman was Norman St. John-Stevas, a powerful and cantankerous politician who had been leader of the House of Commons and then minister of state for the arts in Margaret Thatcher's government. Brilliant but notoriously difficult, St. John-Stevas was an intimidating figure who would later be made Baron St. John of Fawsley.

I wasn't able to attend our presentation to RFAC, but Bill will never forget it. It took place in a historic structure furnished with antiques and all the trappings of British culture. Fred Krimendahl, who was a senior partner at Goldman Sachs and a key player in the headquarters project, accompanied Bill and provided moral support. Before we got to this moment, we had spent many hours with the head of planning for the City of London Corporation, Peter Wynne Rees, who scrutinized every aspect of our proposal and ultimately became a strong (and necessary) supporter of it. Now RFAC would have to approve not only our building's bulk, which would be significantly larger than what the existing zoning allowed, but also its character as it relates to the historic context. To best express our design ideas, we built enormous models at one-sixteenth-inch scale, and prepared drawings and renderings—all done by hand by our design team headed by Craig Nealy. Both quantitatively and qualitatively, these materials were truly impressive—covering all the walls in the meeting room and occupying all of the tables. Walking space in the room was minimal, forcing people to maneuver around the furniture in just one direction.

As Bill tells the story, his introduction to Sir Stevas was one of the coldest he has ever experienced. Sir Stevas offered him a limp hand and immediately requested that he make his presentation in three minutes or less. Bill launched into the impossible task of explaining our key concepts in less time than it takes to soft boil an egg but was quickly interrupted by a sharp question from

Sir Stevas. He answered it, then went back to his prepared remarks, only to be stopped again by a question from the RFAC chairman. Finally, Bill decided to focus on the most critical element of our design—its sensitive response to its historic setting. To do this, he moved over to the large site model that rested on a lovely table of great age and picked it up for everyone to see. Alas, it slipped from his hands, crashing into and scratching the venerable table. There was dead silence in the room, until Sir Stevas said, "Have you any idea of what you just did?" Well, in fact, Bill did. At the time, he was collecting Regency furniture, of which this table was a very fine example, making it just under two hundred years old. The symbolism of the crass American defiling hundreds of years of English history was lost on no one at that meeting. Had Bill no respect? If he could so clumsily damage a precious table, how could he be trusted with the urban fabric of the City of London?

Bill soldiered on with his talk, but there was no escaping the chilly expression on everyone's face. He went on for about twenty minutes, then ceded the floor. "Well, that certainly was moving along at a snail's pace," remarked Sir Stevas. A few other RFAC members asked questions, and Bill generated a bit of conversation on the merits of our design. As the meeting came to a close, Sir Stevas got up to leave, only to find himself walking along a narrow space in the opposite direction as Bill. The two of them did one of those awkward dances of advancing and retreating, until Sir Stevas, annoyed, told Bill, "Will you please get out of my way!"

In the car back to the hotel, Bill remembers sitting with Fred in dead silence, slowly absorbing a shared sense of futility.

For three weeks, we waited for the inevitable rejection from RFAC. When we finally got the decision from the commission, we were pleasantly dumbstruck. The Royal Fine Art Commission gave the project its approval and even commended us on our presentation!

It took three years to build the project, and all of us were excited seeing it go up. At the topping-out ceremony during construction, we brought the beautiful renderings to show what the headquarters would look like after completion. Comparing the drawings with the view of the actual building, some of us noticed a big difference. "My God, this is taller than I thought," exclaimed Eugene Fife, who was chairman of Goldman Sachs International and was overseeing the headquarters project. Remember, this was before computer modeling made such illustrations more accurate tools for

envisioning the future. All of us were surprised at the height of the steel framing rising above the City of London. I must admit I felt uncomfortable and even feared for a moment that someone might call for construction to be halted. Luckily, that didn't happen, and when the building was completed in 1991, everyone from the city government and Goldman Sachs loved it. I realized then that the unfinished edifice at the topping-out ceremony was like a gangly adolescent who would eventually mature into a handsome adult. The official opening of the building was a major event with former Prime Minister Thatcher giving the keynote speech. As we left the ceremonies, Bill spotted Stevas, who had recently been elevated to Baron St. John. Bill walked over and offered him his hand, only to have it refused.

Gensler designed the interiors of the Goldman project and did an excellent job. When I visited the headquarters after it had been open for awhile, I spoke with people there and learned they really enjoyed working in the building. The dimensions of the windows, the finely crafted details, and the rich materials made it an extremely comfortable place. Lots of corporate headquarters are imposing, but this one was graceful, even friendly. Goldman today has outgrown the building and has hired us to design an additional 1.2-million-square-foot building a few blocks away. The new building is nearing completion—another handsome, modern, and sensitive insertion in a historically rich neighborhood.

The original Goldman project put us on the map in the UK and Europe. It was a high-profile building for a very powerful client and showed that we could build outside the United States. Perhaps most important of all, it led me to my third (and final!) wife, Barbara Shattuck, who had been at Goldman and was introduced to me by Ken Brody, a Goldman partner, and his wife Carolyn Schwenker Brody, who had been chair of the National Building Museum's Board of Trustees.

As we were designing the Goldman building, I got a call from a Dutch pension fund, PGGM, that was developing an office tower in Frankfurt for DZ Bank. Most of the time, we have to invest a lot of effort in identifying and wooing prospective clients. And like a hitter in baseball, you're doing well if you succeed three out of ten times. But this Dutch fund called us out of the blue because they had heard about us and liked the buildings we had already done. Were we interested in designing one of the tallest buildings in Germany? "Yes!" I answered.

Cross section of the DZ Bank tower in Frankfurt.

Z Bank tower.

So Bill and I flew to Frankfurt and had a great interview with representatives of the fund and a German consulting firm. That put us on a short list of architects invited to compete for the project. The other architects were all German, including Josef Paul Kleihues, who was one of the most admired in the country. In the end, it came down to us and Kleihues, who had never heard of us and clearly thought he had this one in the bag. When we were selected, he was furious.

Bill and I worked hard on the Frankfurt project, which would be named after the lead tenant, DZ Bank, and devised a striking building that's a pair of attached towers: a boxy twelve-story structure and a fifty-three-story one that's rectilinear on two sides and curving on the third. At the top of the taller tower, Bill designed a steel ring beam that projects out above the curving glass-and-granite facade and gives the building a distinctive look on the skyline. Some people call the top a crown, which they say is particularly appropriate because it faces a bend in the Main River and the old city of Frankfurt where German emperors had their coronations. I'm not sure Bill had a crown in mind, but the best designs and art can be interpreted in different ways.

Like Goldman, the Dutch pension fund and its German partner were meticulous in their business dealings. Everything was organized and done by the book. If they called a meeting for eight forty-five in the morning, it started exactly at eight forty-five, not a minute later. The German lawyer who worked on the contract was a tough negotiator, but I liked him a lot. Once you agreed on something, it was done and you moved on. No need to ever go back and renegotiate. I really appreciated German precision. German law, German management, German protocol: you knew exactly what you were getting.

It was fascinating to see Bill work on Goldman and DZ Bank at the same time. They were both major projects in important cities, but their contexts couldn't have been more different. In London, we had to squeeze a large building into a dense and historic setting. In Frankfurt, we had essentially a clean slate, since most of the downtown had been destroyed during World War II and there were almost no historic buildings nearby. So for London, he developed a sensitive Classical design that complemented its neighbors without aping them. And for Frankfurt, he came up with a bold statement of Modern architecture at its best. Claes Oldenburg and Coosje van Bruggen did a wonderful sculpture in front of the building, a forty-foot-high inverted collar and tie that seems to be fluttering in the breeze and pokes fun at all of

the businessmen who work in the area. Bill wasn't a chameleon or an architect lacking design principles. Rather, he was a designer always attuned to context and interested in doing the right thing for a particular place.

With Goldman Sachs, DZ Bank, and then work at Canary Wharf for Olympia & York on our boards, we decided to open a London office in May 1989. It was a big decision, changing us from an American firm with a single office to an upstart global operation. We had a pretty good idea of the financial costs and logistics of such a move, but we could only guess at the intangibles—such as its impact on our office culture, the relationships between partners and associates in different cities, and the quality of our designs.

Bill would continue to lead the design of Goldman and DZ Bank from New York, but we needed to move some key people to London. To head the London office, we picked Lee Polisano, a talented project manager who had worked for Kevin Roche and had a take-charge personality. He was a gifted presenter who could turn on the charm when he wanted. To support him, we sent five other senior people: David Leventhal, Karen Cook, Michael Greene, Anthony Mosellie, and Lloyd Sigal. Later, we hired talented British architects, including Fred Pilbrow and John Bushell, to round out the London leadership team. It cost quite a bit to make these moves, but we wanted to instill the same kind of creative culture and strong leadership there as we had in New York. Eventually, we made them all partners, because it's important for the firm to be represented abroad at the highest level. To get top clients, we needed to have outstanding people working in London.

At first, the office wasn't very big, just eight or nine people. We didn't have a proper address for the first year—instead, we borrowed some desks at the offices of the local architect we were working with on the Goldman Sachs project—so the partners all lived and worked in the Ritz Hotel. The food and rooms there were lovely, and telling clients to meet us at the Ritz always had cachet. It was wonderful but horribly expensive. The concierge, Michael de Cozar, was our key guy. He handled our phone calls, packages, and car service reservations while juggling requests from all of the other guests at the hotel. He wasn't an employee of KPF, but we probably paid him a year's salary in tips! Without him, I don't know if we would have made it.

For much of its early history, the London office lost money. Setting up a foreign operation is a long-term investment, and the very high costs of living

and doing business in London made this even more so. But Lee quickly developed strong relationships there and embedded himself in the British architectural scene.

I visited London all the time to help out. I'd go on new-business runs with Lee and David Leventhal, spending time with clients and prospects. David's father, Robert, was a developer in Boston and had helped me when I was a young architect at Welton Becket—introducing me to successful people and giving me advice. He was a mentor to me. So when David graduated from architecture school, I was happy to offer him a job. Later, I helped him advance in the firm and supported him for partner, even though some of my colleagues weren't sure he was ready. David wasn't a great designer, but he was a sensitive one who loved the arts and was a sophisticated collector. He had thought about being a museum curator earlier in his life and took to London immediately. At one point, though, he developed some health problems that required regular treatment in the US. For nearly a year, KPF flew him back home twice a month so he could get the medical care he needed. I remembered Vincent Kling's generous support for me when I got sick, so I made sure—with Bill and Shelley's agreement—that David got the care he needed.

We had some great times traveling around Britain and the continent, getting to know our clients and helping them create remarkable buildings. Lee had an astute mind and an ability to speak at length about a lot of different topics. I remember many lovely conversations with him over good food and a few glasses of wine.

Lee and David made an odd pair, though. Lee was tough and demanding, while David was softer and less aggressive. Both were smart and stubborn in their own way, which led to a long series of spats. Over the years, I found myself running to London on numerous occasions to calm their tempers and talk them through whatever was aggravating them. Usually, it was just personal stuff, not major issues. But it set a bad tone in the office and was a sign of more serious problems to come.

The quality of the work being done in London was high, and I was really proud of the office—like a father seeing his kids succeed. We had a good mix of young people and experienced hands. Over time, we moved fifteen to twenty people there, and some of them have become leaders in the firm today. Working there gave them a chance to shine. London turned out to be a great proving ground for young talent.

By the early 1990s, the London office was competing with the best of the British firms—Foster, Rogers, Grimshaw—and often winning. Lee had a knack for promotion and generating buzz in the British press. The architecture magazines there showed our projects in their pages, and a publisher came out with a book on the London work. Lee loved the attention. Reading the articles, though, I noticed he always talked in the first person—"my" projects, "my" work, "my" firm. He never mentioned KPF projects other than the ones he worked on. He never talked about the firm as a whole.

Our globalization strategy proved hugely successful. In the early 1990s when the US economy was stuck in low gear and many big architecture firms were laying off staff and scrambling to survive, we thrived. In London we were busy with Goldman Sachs, Canary Wharf, a redo of a building on Old Bond Street, and DZ Bank in Frankfurt. At the same time, our New York office was expanding its reach as well, designing a headquarters in Jakarta for Bank Niaga, which opened in 1993, and a forty-seven-story office tower at 1250 René-Lévesque in Montreal, which served as IBM's Canadian headquarters when it debuted in 1992. These were more than just business opportunities; they were impressive pieces of architectural design that helped us develop expertise in doing innovative and complicated buildings in far-flung places. They also served as calling cards that helped us attract top-tier clients around the world. This in turn helped us recruit the best young architects and nurture their talent.

Now we had people in our two offices who could speak Dutch, German, French, Bahasa Indonesia, and a few other languages, which helped us attract and work with a broader range of clients. It became a virtuous cycle of getting work abroad, doing it well, and then using those projects and relationships to build more business opportunities. While working in London was expensive, the fees there are much higher than those in the US, and we got paid in British pounds, which were strong at the time.

Maintaining the London office took a lot of work and patience, though. I think Shelley and Bill periodically questioned the wisdom of keeping it going, since it posed so many challenges in terms of costs, moving personnel from one place to another, balancing workloads, and supervising the quality of the work. But all of us loved the projects and design opportunities we were getting. By the mid-1990s, we were doing work in Holland, France, Italy, and Spain, in addition to landing new projects in England and Germany.

We developed methods for working abroad but also learned that every place is different—different laws, different cultures, different tax codes, different ways of approaching design.

We did an interesting office building in Warsaw, Poland, for Golub & Company, an important Chicago developer. Its size (more than eight hundred thousand square feet) and striking modern design made it an instant landmark in the Polish capital. We also made trips to Russia and thought for a while that we had landed some projects there. It turned out, though, that most of the people we were talking with in Russia weren't serious and wanted us to work for free, while the others got tripped up by economic hurdles. We learned our lesson: Russia is a very tough place to work and wasn't for us.

By the mid-1990s, KPF had changed in a profound way. We were no longer a New York firm that occasionally did projects in Chicago, Denver, or California. We were an international firm with partners on two different continents. We were a lot bigger and our operations more complex. While our American colleagues were struggling and often laying off people, we continued to hire people in London and had exciting projects that helped us attract the best architects. Our international work allowed us to train our people, so they became terrific designers, managers, and technical experts. As a result, we developed a core of extremely talented people, many of whom are still with us and are the backbone of our success.

By the end of the 1990s, we were working in dozens of countries around the world. The London office was getting new work on its own, so I didn't need to fly there every month. I would go there for important meetings, but not all the time. London turned out to be an excellent test-drive for our push toward globalization. It gave us experience operating multiple offices, navigating different tax and labor systems, and pursuing work in far-flung places. But it also raised some red flags in terms of personnel—flags that I noticed but didn't pay enough attention to.

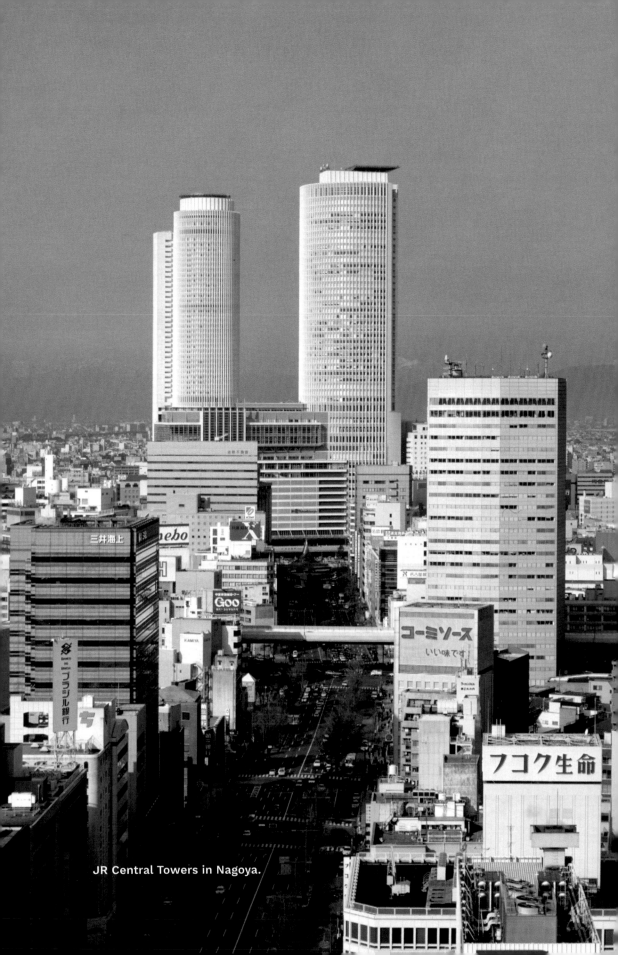

JR Central Towers in Nagoya.

Pacific Overtures

Relationships are the foundation of every business, whether it is a furniture manufacturer or a creative services firm. A lot goes into building them, starting with an initial gut reaction to another person's personality, then moving to the establishment of trust and the successful delivery of a project. They take a lot of work to create and maintain, and often go in unexpected directions. They're the glue that connects us to clients, partners, collaborators, employees, government officials, colleagues, friends, and family. Some people have a natural ability to spark them, while others need to acquire such skills along the way. All of them require constant attention, because even the best will wither if ignored for a while. I've always enjoyed this aspect of architecture and understand it has been important to my success.

In particular, I love the way relationships can offer surprises. Who knew that our job renovating an old armory on the Upper West Side of Manhattan would lead to a long series of projects for ABC and the chance to design 333 Wacker Drive in Chicago? I certainly didn't back in 1976 when my partners and I had just turned down a much bigger project in Iran and were desperate for work. Relationships have a tendency of overlapping, creating either confusion or more opportunity—depending on how you react. So ABC led us to 333 Wacker, which began our long-term connection with Tom Klutznick, the head of Urban Investment and Development, and Jack Burnell, the UID executive who managed our One Logan Square project in Philadelphia. When Jack became president of the Palmer Group, a Chicago-based developer, he asked us to design 225 Wacker Drive, right across Franklin Street from 333 Wacker.

While working on 225 Wacker, we got to know people at Taisei Corporation, which co-developed the project with Palmer Group. Taisei was established in 1873 and is the oldest of the five so-called super general contractors, or *suupaa zenekon*, in Japan. These companies are gigantic enterprises that encompass construction, engineering, and real estate development and dominate the building industry in Japan in a way unparalleled in the US. Taisei

worked on the Imperial Hotel in Tokyo, which was designed by Frank Lloyd Wright in the 1920s, the Ginza subway line in Tokyo, the National Stadium in Tokyo, which was used for the 1964 Olympic Games, and all kinds of other major projects around Japan. These guys are heavy hitters at home, the New York Yankees of the Japanese construction world. In 1982, Taisei established its first office in the US and began doing work in New York, Los Angeles, Honolulu, and Chicago.

By the time we finished work on 225 West Wacker in 1989, we had cemented a strong relationship with Taisei, and some of the company's executives asked us to collaborate with them on an invited competition in Tokyo. Back in the 1980s, it looked like Japan was going to take over the world. Japanese companies were buying premier real estate in the US, such as Rockefeller Center in New York and the Pebble Beach resort in Northern California. The yen was strong, and Japanese businesses were showing a boldness in vision that seemed to give them an edge over everyone else. When I was growing up, "Made in Japan" meant a cheap knockoff. Now it conferred an image of precision and excellence.

When I started thinking about expanding KPF to other countries, I imagined Britain and Europe. These were places I had visited and had developed an appreciation for. I loved walking around the streets of London and dining in Paris and Rome. They were foreign but seemed knowable and comfortable. I picked up bits of the languages. I understood the food. I could imagine doing business there and feeling comfortable learning the ways things are done. Japan, on the other hand, required a much bigger leap of faith. But it was also terribly exciting, especially in 1989 when the country was at the peak of its power. Not only were Japanese businesses the envy of the world, but Japanese architects such as Kenzō Tange, Kisho Kurokawa, Arata Isozaki, Fumihiko Maki, Tadao Ando, and Toyo Ito were some of the most talented. To work over there would be a remarkable experience!

We wouldn't be going blind into Japan, but at the invitation of one of the country's biggest construction companies. I looked around the firm for someone who could accompany me on the trip, knowing that Bill Pedersen and many of our other top people wouldn't want to fly 6,750 miles and skip thirteen time zones to get there.

Then I thought of Paul Katz, a talented associate in his early thirties who had a big personality and with whom I was close. A true citizen of the world,

Paul Katz, Bill Pedersen, me, and Bill Louie were all involved in KPF's push into Asia—
designing projects around the region and developing relationships that would stay strong
for decades.

he was raised in South Africa, studied architecture in Israel, then came to the US for graduate school at Princeton and stayed for work. He loved flying everywhere and felt most at home in a hotel. Later, he even designed his apartment in New York to feel like one. A tall, lanky guy with a shock of dark hair, he had played rugby in school and never ducked from confrontation. Loud, smart, and demonstrative, he was a force that either wowed or scared you. Some of my partners had wanted to get rid of him when he first joined KPF, but I saw he had many strengths—including a fearless love of adventure, an indefatigable competitiveness, a talent for design, and a knack for developing new business. When I asked him to come to Japan, he jumped at the chance.

So Paul and I flew to Tokyo and blocked out a few days to work with the Taisei team on a strategy for the design competition. I was excited but wary. Our relationship with Taisei was excellent, but it was a short-term one based on a single project in the safe confines of Chicago. It was like going on a few dates with a foreign girl while she's visiting the US. Now we were going to visit her in Japan and meet her family! Lots of things could go wrong.

I was a teenager during World War II, so I grew up knowing Japan as an enemy power. I remember listening to reports on the radio and going to the movie theater on Saturday evenings to watch the Movietone newsreels that showed the latest reports on the war in Europe and in the Pacific. By the 1980s, Japan was one of our most important allies in Asia and a rising economic power. New layers of knowledge rested on top of older ones, obscuring some parts but never hiding all of them. Americans of my age approached Japan with complex feelings—attracted to the remarkable progress made over there, but unable to forget what happened in the 1940s.

Paul and I stayed at the Hotel Okura, not far from the US Embassy in Tokyo. It was a gorgeous work of postwar Japanese Modernism, designed by Yoshiro Taniguchi, Hideo Kosaka, Shiko Munakata, and Kenkichi Tomimoto and exuded a wonderful early-1960s glamour. In fact, James Bond stayed there in the 1964 novel *You Only Live Twice*, and the 1973 movie version of the book showed Sean Connery walking through the famous lobby. We too immediately fell in love with the place and the gracious service we received there. We arrived in the evening and went to one of the hotel restaurants for a light meal. I had a delicious onion soup that was rich and satisfying. The next morning, I ordered French toast, which turned out to be the best I've ever eaten and would become a beloved must-have dish for me on every trip to Tokyo.

Sadly, the Okura was razed in 2015 to make way for a bigger hotel, designed by one of the original architects' sons, Yoshio Taniguchi, who did the 2004 addition to the Museum of Modern Art in New York, for which KPF served as executive architect and designed the renovations of the existing buildings.

We soon learned that excellent service is a hallmark of Japan. Every taxi driver in Tokyo wears white gloves, and every salesclerk gives you the kind of knowledgeable attention that only the best stores provide in the US. The city is remarkably clean and the parks are beautiful. And there's no tipping!

Arriving at the Taisei headquarters on our first full day, Paul and I were whisked into a meeting room and offered tea. Everyone was welcoming, and there was a lot of polite bowing. The Japanese bow with a precision and grace that seems respectful without being obsequious. Earlier that morning, I remember our car from the hotel had stopped for a moment as a white-gloved parking attendant directed a different car onto the road in front of us. After that car had moved forward, the attendant turned to us and bowed crisply, silently thanking us for being patient. It took less than a second, but the bow said a lot about Japanese culture. It explained how a country of 125 million people squeezed onto a handful of islands could operate so smoothly. A tiny bit of etiquette went a long way toward easing tensions and making sure people got along. On a later trip, I noticed an amusing update to this ancient tradition. I was in the subway with a Japanese colleague who was helping me buy a ticket at a vending machine. I watched the screen as he pushed a few buttons and inserted some coins. As the transaction was being completed and my ticket printed, a cartoon character on the screen bowed politely and exclaimed what I imagine was "Arigato!" It was impossible not to smile and feel a slight jolt of joy as I walked away.

In the Taisei conference room, we met a number of executives and exchanged pleasantries. Our hosts gave Paul and me beautifully wrapped boxes of Japanese sweets, and I made a mental note to bring small gifts from America on my next trip to Japan. Over the years, I brought home a lot of boxes of sweets and teas and other such things and often had to give them away to friends in the States so Barbara and I wouldn't be inundated by them.

When I asked about the project on which we were going to collaborate with Taisei, there was an awkward silence. A couple of executives looked at each other, but said nothing. Finally, the senior person turned to me and explained, "Mr. Kohn, we are deeply grateful that you and Mr. Katz have come

all the way from New York to meet with us, and we are honored that you would want to associate with us on a project in our home country."

Even though the executive was speaking Japanese and I was hearing his message translated by an attractive woman in high heels and a beautifully tailored business outfit, I could tell what was about to come. Some things need no translation. I could read the Taisei executives' faces and their body language and see that something had derailed the prospective collaboration between them and us.

"Our chairman has decided that we will not enter the design competition and pursue the project."

Needless to say, I wish they had told us this before we flew 6,750 miles to get here! I didn't say anything, but the Japanese could read my expression. Paul turned to me and looked just as frustrated as I was.

Our hosts apologized profusely, but I wasn't really listening. They took us on a tour of their headquarters and showed us images of some of the giant projects they have built all over Japan. I can't say I paid much attention.

After the tour, they took us to lunch in a private room at a nearby restaurant. There we met an executive more senior than the ones we spoke with earlier. He apologized for the company's change in plans and said Taisei valued its relationship with KPF. It turns out that his company had recently heard about an enormous project that Japan Rail was planning on building at its bullet-train station in Nagoya. Taisei would like to recommend us to Japan Rail to design the multibuilding complex. Would we be interested? I didn't know the business or cultural landscape here, so I wasn't sure how to respond.

"If you want, we can arrange for you to take the train to Nagoya and meet with Japan Rail tomorrow," said the executive. "We apologize for any inconvenience to you and are deeply disappointed that we will not be able to collaborate with you on the Tokyo project."

Paul and I had come too far to simply give up and head home. So I said yes to the offer. Later that evening, I told Paul, "We might as well see what they're talking about." He was uncharacteristically quiet and simply nodded.

In Nagoya, we had a series of meetings that, I must admit, I found a bit confusing. I wasn't accustomed to Japanese protocol and sometimes the translations were amusingly off. At one point, I thought I heard an executive tell me, "What we'd like to do is find your drumstick." I must have had a quizzical look on my face, which probably confused the Japanese in the room.

Eventually, it became clear that the client was looking for an architect to design a five-million-square-foot complex to be built on top of active train tracks. It would include a fifty-five-story office tower with the headquarters of Japan Railway Company, a fifty-nine-story hotel tower, lots of retail and restaurants, a convention center, and a multi-modal transit station linking two national rail lines, two private rail lines, four subway lines, and two bus lines. It was an incredibly ambitious project. Its scale and programmatic complexity were almost unimaginable in the US. But in Asia, such developments were becoming increasingly common as cities grew rapidly and required massive amounts of investment. Paul and I loved the challenge.

After a couple of days of intense discussions and brainstorming, the Japan Rail executives told us, "We would like to work with you on this important project. We can pay you a design fee of $1 million." Paul and I were dumbfounded. There was no way we could do a project this big and this complex for $1 million. It was a ridiculous fee. That evening, Paul and I talked about the situation. This was a spectacular opportunity, but required some intense negotiating. We devised a strategy in which I would return home, acting as the tough boss offended by the client's offer—not a role I normally play. Paul would stay in Nagoya and keep negotiating.

During those negotiations, we realized that Japan Rail already had a plan in mind for the project and wanted an outside architect merely to design the wrappings around it. That's not the way we approach architecture, though. We explained that we could work with the client team to develop a more sophisticated program, identify critical issues, and then solve the problems raised by these issues. It was essential for Japan Rail to invest the time and energy to properly address the complex challenges, we argued. We explained how KPF worked and the advantages this would provide them. The extra costs of such an effort were minuscule compared with the total price of the project.

Paul stayed in Japan for another ten days, and every evening we would talk by phone. He used me as the tough guy and played the role of the nice guy. People who knew us would have laughed at this reversal, since Paul was a lot tougher than I was. I had never even pretended to walk away from a deal before. But the Japanese didn't know this.

Each evening, I would ask Paul, "Where are they?" and he would reply, "They increased it by a million dollars." By the end, we got them to $10 million and we agreed to the deal. At five million square feet, that meant two

dollars per square foot, which was still a fairly low fee—even for design only.

Taisei served as executive architect and general contractor for the project, so we ended up collaborating with them after all. Their recommendation of us to the client was certainly a major reason we got the project, as they probably knew it would be. Relationships are important everywhere, but in Japan they're essential.

Although Paul spent more time in Japan than I, the client expected me—the white-haired leader—to come for all of the major presentations and meetings. It was a lot of traveling, but I loved Japan—the people, the culture, the refinement of the arts, the beauty of the food. I'm not an adventurous eater, but I learned to enjoy sushi and some other local delicacies that had scared me at first. Paul always took good care of me, making sure I had a good room at the hotel and buying tickets for us to see a baseball game or a sumo wrestling match. And he always reserved a couple of hours on our last day in Tokyo for us to visit a few shops specializing in pottery. Both of us began collecting Japanese ceramics, starting with a small vase or bowl, then acquiring larger and more expensive pieces. The Japanese brought the same dedication to quality to the construction of buildings. Contractors there made a mediocre architect look good, a good architect look great, and a great architect look like a god.

Because Paul and I couldn't speak Japanese, meetings took longer, as everything needed to be translated. After the initial formalities, they would fall into a particular rhythm with someone from the client's team speaking Japanese and the translator saying it in English. At one meeting, though, the president of the company, who was bilingual, said something in English. Like an idiot, I waited for the translation. Everyone looked at me. Paul gave me a nudge. "Answer him." I felt foolish, but apologized and asked him to repeat his question. He smiled at my mistake and repeated the question in Japanese, so the translator could put it to me in English.

On our first trip to Japan, we relied on translators supplied by our Japanese hosts. These people would translate whatever was said to us or by us, but they never told us what the Japanese were saying to each other. So we were missing those important asides that might help us understand what the other people in the room thought of us and our work. On subsequent trips, we always brought our own translator. Today, we have a principal, Ko Makabe, and a number of associates who are Japanese and bilingual, which helps us in many ways.

The Nagoya complex was a monster of a project—in terms of its scale, scope, and impact on the city. Located in the center of town, it needed to act as a landmark and a catalyst for further development in the area. Built above an active rail yard, it involved sophisticated phasing and logistics, because you could close only two tracks at a time and needed to bring structural columns down at carefully specified points. It would have fifteen floors of retail and restaurants, which was unheard of then in the US. On the fifteenth floor, we designed a "sky street" that connects the two towers, the retail complex, and the Marriott Associa Hotel, which is now rated one of the best in Japan.

When the project, called JR Central Towers, finally opened in 2000, it was the largest train station complex in the world and included the second-tallest tower in Nagoya. It was a big success immediately, impressing both the public and the architectural community. It served as a catalyst for construction in the area, attracting other commercial and mixed-use buildings. Japan Rail hired us to design a second phase, which added three million square feet of space to the project. All this development has helped make Nagoya into an attractive place—halfway between Tokyo and Osaka—for meetings and events.

The JR complex gave us the chance to plant the KPF flag in Asia, which has fluttered proudly ever since and attracted clients for us in almost every country in the region.

Taisei and some of the other big construction companies in Japan have programs that place a few of their employees in the offices of foreign architects for twelve months at a time. We've participated in these programs and found them to be fantastic. The Japanese employees get hands-on experience working in an American firm and develop strong relationships. Sometimes we send some of our employees to Taisei, so the learning goes both ways. It's a win-win for both sides.

Although we stayed busy in Japan, we never set up an office there. It was just too expensive. We developed such strong ties with local partners such as Taisei—and later Mori—that we could rely on them to provide excellent people to work on our projects. Also, there are so many superb architects in Japan that I knew we would get only one or two projects at a time there. In other parts of Asia, especially places like China, there was a lot more potential for us. We had the kind of expertise in large-scale, modern projects that few architects there had in the 1990s and early 2000s. Rent, salaries, and

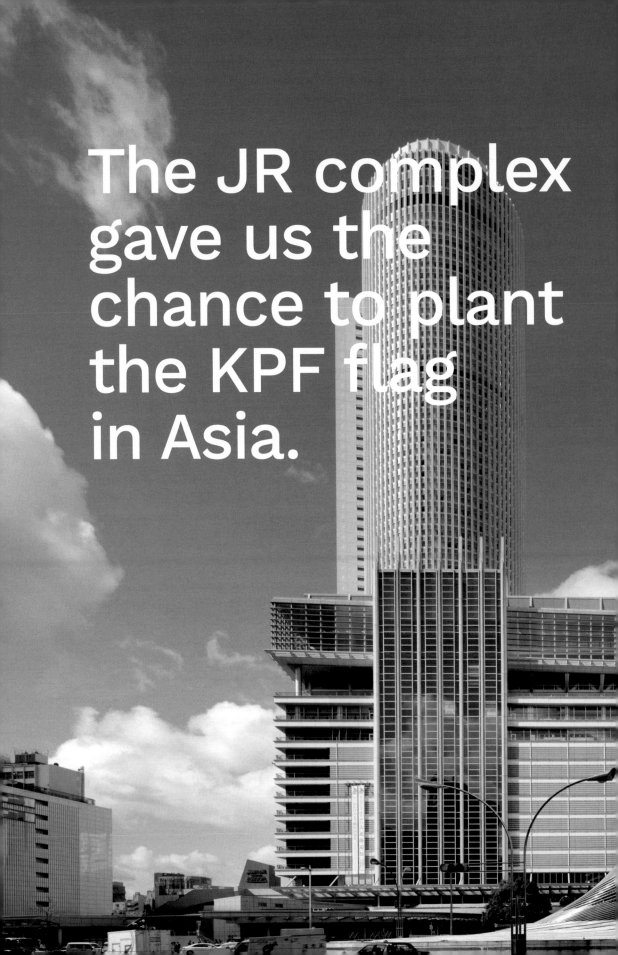

The JR complex gave us the chance to plant the KPF flag in Asia.

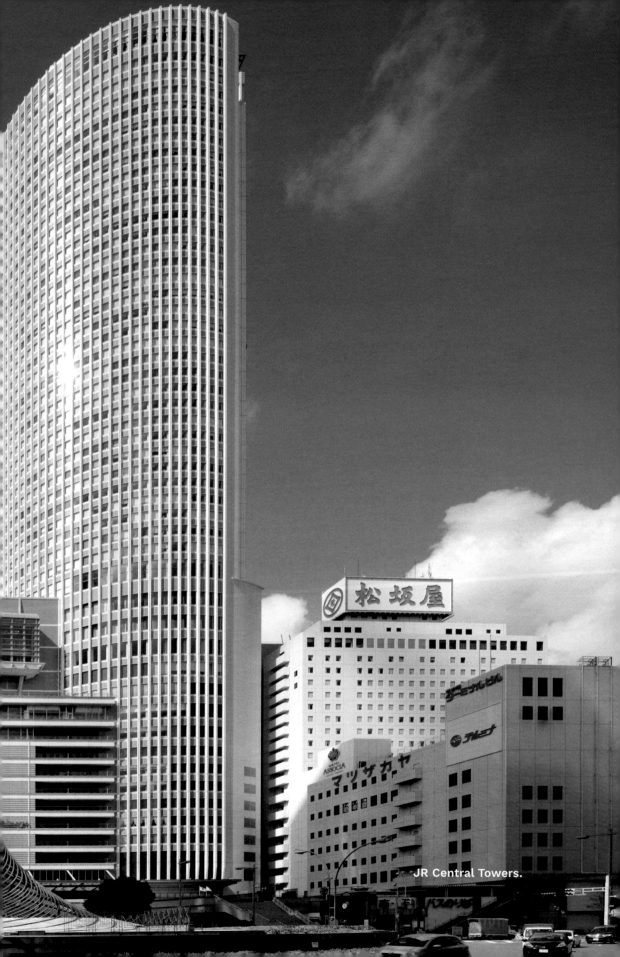

松坂屋

JR Central Towers.

living expenses were also much cheaper there, though issues of payment, contracts, and other legalities were more difficult. Eventually, we opened offices in Hong Kong, Shanghai, and Seoul, which have all flourished. We don't have design partners there, but we have excellent people—both local nationals and foreigners—who can run projects and maintain relations with clients.

In 1989, I had a gut feeling we needed to expand our practice to other countries. Little did I know that my timing would be so good. According to an article in the *New York Times* in March 2018, "The 1990s and the first years of the 2000s were one of those extraordinary periods in which economies became more interconnected...and many once-poor nations became more integrated into the global economy, especially China." The article goes on to say, "The flow of goods and services across national borders as a share of all economic activity hovered near 16 percent through the 1980s and early 1990s, then from 1993 to 2008 shot up to 31 percent." It has plateaued at about that level since then, says the article, citing data from the McKinsey Global Institute.

After Paul got back from that first trip to Japan, I told him, "Whenever we go there, we need to extend the trip to other places as well. Once we're in Japan, we might as well go to Hong Kong or Seoul or Shanghai and meet with potential clients." So that became our standard strategy—to piggyback new business development while servicing an existing client. It forced us to broaden our horizons, which proved to be hugely successful, especially in the 1990s, when things were painfully slow in the US. The ten years from 1990 to 2000 turned out to be the worst for office-building construction in New York in a century. Many big firms in America had to lay off architects, but we were getting amazing work in Asia. This allowed us to develop some really talented people on our staff and give them the chance to shine and move up the ladder.

Paul dived into Asia headfirst and cultivated a remarkable network there. He met people in Hong Kong, Shanghai, Beijing, and Seoul and went there all the time. I would go with him periodically, but he was flying across the Pacific almost every month. He could do cigars with the best of them! He was great with that. Whenever I traveled with him, he knew all the best places to eat and visit. The staffs at hotels and restaurants all knew him and made sure he got great service. He was always welcomed wherever he went. It was like coming home for him. Like me, Paul was one of the first people in our profession to recognize the importance of China. He loved going there and

blazing new territory. He even made sure that his son Jonathan learned to speak Mandarin!

Our first step outside Japan was in Hong Kong, where most executives spoke English and the legal system was based on Britain's. Hong Kong is one of the most amazing places in the world. Squeezed between mountains and water, it has erected a jagged skyline that rivals its dramatic landscape and reflects gloriously in the waters of Victoria Harbor. Everything goes faster in Hong Kong: deal making, design, construction, even escalators. Everyone is in a hurry and has little patience for others getting in the way. Walk too slowly in front of a little old lady, and she'll brush past you while giving you a dirty look. The city buzzes with an energy found almost nowhere else in the world. It's the first place I saw with construction crews working in shifts twenty-four hours a day.

We were lucky to connect early on with Hongkong Land, one of the very best developers in the city. A few years before, I had gotten to know some of the top people at Trafalgar House, a London-based developer that had hired KPF to do a residential project in New York. While on a trip to London, I had lunch with Nigel Rich, Trafalgar's group chief executive, who had been the managing director of Hongkong Land before returning to the UK. I told him about our project in Nagoya and my goal of doing more work in Asia. "Well, you should contact Michael Arnold at Hongkong Land," Nigel said. "He's in charge of design and construction at the company."

So I did just that and set up an appointment for Paul and me on our next trip to Hong Kong. Michael told me that they usually work with local architects who don't have to travel halfway around the world to come to project meetings. He was nice enough, though, to arrange a lunch at a private club where we could present our work to Alasdair Morrison, who had succeeded Nigel as managing director of Hongkong Land. The lunch and our presentation went well and we could see that the Hongkong Land people liked our work. But they didn't have any projects for us and reiterated their preference for architects with offices in Hong Kong.

Paul and I, however, don't give up easily. Later that day, we walked over to Landmark, a shopping center owned by Hongkong Land that Michael said needed to have its storefronts refreshed. We could tell immediately that the property was getting long in the tooth and hadn't stayed up-to-date with the latest trends in retailing. The ceiling was ugly, and the circulation

was confusing. Paul had a great eye for noticing anything that was wrong or needed work. So that evening, the two of us sketched out some proposals for totally renovating the shopping center. No one had asked us to do this. And showing such a thing to Mike could backfire; not every prospective client wants you to point out problems with an existing project. But we showed our ideas to him the next day and he loved them. "Okay, fix it," he told us. That was our first job in Hong Kong.

Back then (the early 1990s), it was cheaper to book a flight to Hong Kong with a layover in Tokyo than to buy two separate tickets. So we got into the habit of visiting Hong Kong and Japan on the same trip.

During the course of these visits, we developed a strong relationship with Ronnie Chan, the chairman of Hang Lung Properties, which was founded by his father in 1960 and has grown immensely under his guidance. Ronnie has become one of the most influential business leaders in Hong Kong, serving as the vice president of the Real Estate Developers Association of Hong Kong and co-chairman of the Asia Society. He got his MBA from the University of Southern California in 1976 and now sits on the university's board of directors.

I think we first met Ronnie through an architect who helped us with some projects that Paul oversaw. She had worked for Ronnie and recommended us to him for a small job in Hong Kong. We got it, did it well, and never complained about its diminutive size (and fee). That endeared us to Ronnie. So when he began looking for an architect in the early 1990s to design Plaza 66, a major mixed-use project in Shanghai, he invited us to compete. We ended up beating out César Pelli and some other big-time players.

Located on Nanjing Road West, probably the most important commercial street in Shanghai, Plaza 66 was a huge win for us. It's a landmark project with two office towers (the taller one being sixty-six stories and 946 feet high) and a five-story shopping center. Bill Louie worked on our competition entry, then Jamie von Klemperer led the design team and Paul managed the project, a combination of talent that proved very successful. Jamie gave each of the towers its own elegantly curving profile in response to a bend in the road and topped the taller one with a jaunty metal peak that makes it easily identifiable on the skyline. Tower One opened in 2002 and Tower Two four years later. Ever since then, KPF has had a major presence in Shanghai and played a critical role in its development as one of the world's great international cities.

Plaza 66, which rises 945 feet above Nanjing Road in Shanghai, was our first major project in China. While I provided input, Bill Louie, Jamie von Klemperer, and Paul Katz shaped the competition entry that won us the project. These players also worked on the architecture that got built, with Jamie taking the lead role in the design.

Figuring out China back in the early 1990s, though, was challenging. Under Mao, everything was owned by the government, and there was essentially no private sector. Now huge enterprises were starting to do business, and their status as quasi-state, quasi-private players made it difficult for foreigners like us to understand them. The local design institutes—the gigantic architecture organizations that foreign firms have to work with on projects in China—were equally opaque and mysterious. Many of them were professional dinosaurs kept alive by subsidies and work provided by the government, but a few of them were transforming themselves into savvy enterprises with talented young Chinese architects who had studied in the West and returned home to make their mark. Identifying the good clients and the reliable local design institutes from the bad ones was extremely difficult, in part because all of the players were new to us and none had much of a track record working with foreigners.

In Japan, we could look up Taisei and quickly see they had an impressive history. In Korea, we could do the same with the powerful *chaebol* like Samsung and Hyundai. But there was no such road map for China. So a number of young, Western-educated Chinese agents started marketing themselves to foreign architects as go-betweens to establish relationships with potential clients, LDIs, and even Chinese architecture publications. Many of them were people with degrees from American, British, or Australian universities; all of them promised to help foreign architects navigate their way through the confusing landscape of China's emerging businesses. It was hard to tell, however, how useful these agents actually were. On one of our first trips to China, Paul and I met with one such person at a hotel restaurant and heard her talk about her connections, her *guanxi*. There was no way for us to tell how much of this was a true reflection of reality and how much was smoke and mirrors. After she left, I turned to Paul and asked, "How in the world are we going to figure this place out?"

I remember visiting Shanghai with Paul in the early 1990s and going to Pudong, where the Chinese were planning to build a new central business district across the river from the Bund and the old part of the city. It seemed like a pipe dream at the time. They had erected the Pearl of the Orient, a weird transmission tower with pink glass observation bulbs attached at various heights. But there was practically nothing else around. The area had been farmland just a few years before and now was laced with enormous

roads but very few buildings. No one knew if the Chinese could pull it off and deliver a modern financial district, essentially a new city within an older one. Paul believed they could do it. I had my doubts. Chairman Mao had died less than twenty years before, and the Communist Party was still in control. Did Mao's heirs have the business savvy, planning skills, and technological ability to build what they were promising? Today, Pudong is world famous for its skyline of glittering towers rising above the Huangpu River, a scene photographed by millions of people every year. One of KPF's tallest and most recognizable skyscrapers stands at the center of this futuristic ensemble. Back in 1991, 1992, or 1993, though, betting on Pudong, Shanghai, or even China took courage.

We weren't the first American or foreign architecture firm to do work in China, but we were among the first. That has proved to be extremely important. Chinese clients remember that we were there early and they figure—rightly—that we have the most experience. They also appreciate that we now have deep roots in their country and an extensive network of connections.

In addition to Paul, other talented people in the firm stepped up. Jamie, who is now our president, proved himself in China, Indonesia, and Korea. That's why Asia was so important to us. It changed KPF forever—giving us the chance to design enormous and complex projects that weren't being done in the US at the time. As a result, we were able to attract the best young architects and give them opportunities that few other American firms could. Going global was absolutely critical to our success in the 1990s and early 2000s and remains so today.

As we were starting to do work in Europe and Japan, I gave a talk at the University of Wisconsin and showed some of our projects. Afterward, a pair of students—a brother and sister—came up to me and said how much they liked KPF's architecture. I thanked them for their comments and began to walk away. But they followed me and asked if they could have some books on our work. I liked their eagerness and their admiration for KPF's designs. They said their father was a developer in Indonesia. They would share the books with him. The next day I called my office and arranged for my assistant to send the books to the boy and girl. I didn't give it another thought.

Until we got a call from someone in Jakarta, asking us to come to Indonesia and discuss a new building project there. It would be a headquarters for CIMB Niaga, the fourth-largest bank in the country and an

The Bank Niaga tower in Jakarta was one of our first projects in Southeast Asia, where we have stayed busy ever since. Bill Louie designed the building, which includes an office tower, a banking hall, and a small mosque.

innovative company that was the first in Indonesia to introduce ATMs. Located on Sudirman Avenue, the city's main traffic artery, the project would be a twenty-seven-story tower with 688,000 square feet of office space, a low-rise banking hall, meeting rooms, and even a small mosque. (Indonesia is the world's largest Muslim country in terms of population.)

Bill Louie designed the building for us and was assisted by Jamie and a group of other young architects. They did a fantastic job, creating a handsome tower with stone cladding and a system of projecting metal elements that shade the building from the intense tropical sun. They varied the shading elements and the fenestration depending on the solar orientation, which added visual interest and made the building perform better. It was a sensitive piece of modern architecture that respected both the local culture and the climate.

By the time the Bank Niaga tower opened in early 1993, we were running around Asia, chasing and getting work. We got important commissions in Malaysia, the Philippines, Hong Kong, and Vietnam. Even before the US re-established diplomatic relations with Vietnam in 1995, we were doing work there—mostly for Hongkong Land, which was active in the region. Hongkong Land would make the arrangements and get us our visas, since we couldn't do it from the US. One of our first projects there was a spec office building near the old opera house in Hanoi that would become the local headquarters for the World Bank. It was impossible to do really sophisticated buildings in Vietnam back then, but we gave them a very nice structure and a comfortable place to work.

I remember eating dinner with a group of people at a small hotel in Hanoi one time and watching as the maître d' motioned for an American man sitting next to me to pick up the old-fashioned house phone in an adjacent area. I could see the man's body language change as soon as he heard the voice on the line. He stood up straight, as if at attention. I couldn't help but turn and listen carefully. It was clear he was speaking with someone very important. When he came back to the table, I asked, "Who was that?" After a short pause, he said, "President Clinton. I'm here to help return the remains of American servicemen who died in the war." It was a pivotal moment in our history with this country, a time for healing wounds from the past and looking to a new era.

When any of us went to Asia back then, we would spend a week or ten days there—meeting with existing clients and local architects, but also connecting

with prospective clients in the region. I told Paul and the other people going there, "Your plane ticket alone is $10,000 to $15,000, so you might as well stay a few extra days and make the most of your trip." Today, a lot of our people will go to Asia for just a day or two. I think they miss some opportunities as a result. I also think it puts a lot of stress on their bodies and isn't healthy, even though the new planes have seats that recline all the way. I want people at KPF to work hard, but I want them to take care of themselves, too.

It wasn't easy getting or doing work in Asia back then. It took a lot of time and effort to develop the relationships necessary to land important projects. Every country was different—with its own laws, regulations, building traditions, and skills—so we needed to do a great deal of research. We had to check out the reputations of prospective clients to make sure we wanted to work with them. We had to figure out how we would get paid and deal with local taxes. We had to find the right local architects to associate with so our projects would get built properly. We had to learn about the local context—physical, urban, cultural, economic, and environmental—so we could design buildings that were right for their particular place. The internet was a fraction of what it is today, so getting good information was much more difficult then.

It was exciting traveling in Asia, but it could also be a bit scary, depending on the location. On my first trip to the Philippines with Paul, we were met at the airport by a very nice gentleman and a couple of bodyguards. They whisked us into a van with dark windows, and the guys with machine guns sat right behind us! That van and those men took us everywhere. Wherever we went we pulled into a secured area. I remember thinking, "What are we doing here?"

One of our clients in the Philippines ran a family business. He was a very nice person, but his operations were less than first-rate. We gave one presentation in a room where we had to project our images on a wall with ugly, crumbling fabric on it. They didn't even have a screen for us. Our images looked horrible on the wall, which bothered me, even though it didn't seem to matter to the client. In places like that you realized you're working in a third-world country still facing big problems. Businesses in the Philippines have gotten a whole lot more sophisticated now, but they've had to come a long way. We've done a number of buildings there and we're proud of them.

I sometimes wonder how we became so successful in Asia. Considering the differences in culture and the distance in miles, failure should have been an equally likely result. Relationships were part of the reason, as was the

high level of design talent at KPF, and the amount of preparation we did. So skills, hard work, and commitment certainly mattered. But there was something else that was important, something that didn't show up in our portfolio or list of clients. That was enthusiasm. Especially in our early years in Asia, we were thrilled to be there, and our excitement was contagious. Over the years, I've learned that enthusiasm breaks through all barriers—linguistic, cultural, economic. People—no matter where they come from—want to hire people who are excited about their work.

Also, we were never arrogant. I think this surprised a lot of clients in Asia, especially back in the 1990s, when some of these countries were just starting to hire foreign architects. They expected us to tell them what to do and be the know-it-alls. We don't do that. Instead, we respect our clients and engage in a process that requires both them and us to learn from each other. We think this makes the work more interesting and more connected to the particulars of each site, each project, each moment. We never start a project thinking we know what to do or what it should be. That has to emerge from the complex back-and-forth between us, our clients, our consultants, and other collaborators.

We also paid close attention to putting together the right team for each project. We needed to have the right people for the job. As we grew to several hundred employees and a couple dozen partners, picking the best lineup for each commission became harder and harder. To do this, we needed to understand the personalities on the client's team and those on our own, as well as the particular character of the project. Our people needed to have the right skills and the right attitude.

One project, one client at a time, we grew our business in Asia. By 2000, we had designed more than two hundred buildings in twenty-three countries in the region. Work in Asia represented 13 percent of our total business and provided us the chance to help shape the skylines of cities like Shanghai, Tokyo, Hong Kong, Singapore, Jakarta, Bangkok, Seoul, and Kuala Lumpur. While we are hired and paid by clients with particular business goals in mind, our buildings in these places serve the public as well. We never forget that. With each commission, we try to create a building that contributes to its block, its neighborhood, its city. Watching Asian metropolises develop into hyperdense, culturally complex places in the 1990s and early 2000s—and knowing that we played an important role in this process—was extraordinarily rewarding to me and everyone else at KPF.

Buffalo Niagara Airport.

Millennium Approaches

When architects talk about their work, a lot of them forget that every great project starts with a great client. One of my favorite buildings in the world is Louis Kahn's Salk Institute in La Jolla, California. The massing of the building, the way it clearly expresses the relationship of the laboratory spaces to the circulation elements servicing those spaces, the way it frames a spectacular view of the Pacific Ocean are all perfect. It's a masterpiece of twentieth-century Modernism. Kahn, of course, was a genius. But Jonas Salk was a smart and demanding client who challenged Kahn and brought out his best. At KPF, we have been blessed with a lot of great clients. I feel fortunate to have worked with them and become friends with many of them.

The most expensive client I ever had was Stanley Marcus, who was the president of the luxury retailer Neiman Marcus from 1950 to 1972 and then its chairman from 1972 to 1976. He was an incredible salesman who made his company one of the most innovative in the fashion business and never missed an opportunity to raise its profile. When he died in 2002 at the age of ninety-six, his *New York Times* obituary told how he made sure Mamie Eisenhower and Lady Bird Johnson got their gowns for their husbands' inaugurations from Neiman Marcus.

I met Stanley when I was running Jack Warnecke's firm and we were doing some projects for him. Every time I went to Dallas to meet with him, he sold me a suit, a few shirts, and some shoes. They were always made of the best material, and their prices reflected that! I remember one time he pulled out a suit with epaulettes and insisted it was perfect for me. I needed another suit like a hole in the head, and this one made me look like an officer in the British cavalry, which wasn't quite right for any business meeting. Somehow, though, he convinced me to buy it, along with matching accessories, a yellowish shirt, and shoes. "Gene, you look like a million bucks!" By the time I got back to New York, I felt like I had spent a million bucks.

Stanley's philosophy was to surround people with the best. He told me, "The key to a really great building is the same as really great retailing—make people feel good about themselves." I've never forgotten that advice. He made everything look special. One time when we were walking through one of his stores, he stopped and pointed out a shirt on display. "See that? I have fifteen other shirts I could put here; there's plenty of room. But it's better to show just one and make sure it looks fantastic."

He also emphasized service—always the best. All of his salespeople wrote thank-you notes to their customers. Every year, I got Christmas cards from the people who sold me Neiman Marcus clothes. He made sure you felt important, special. I learned a lot from him.

On my first project with Stanley, a store in Atlanta, we planned to clad the exterior in travertine. It was an unusual travertine—a rich brown with hints of beige. It was gorgeous and bold, but Stanley wasn't convinced it was the right choice. "Are you sure you want to use this, Gene?" I pretended to be sure. "Yes, it's perfect, Stanley." He looked at me in the eyes and said, "Okay. But I want you to know that if this doesn't work out, it will be the last project you ever do for me." I stuck to my guns. "This is going to be great," I told him, believing what I said.

Months later, as the stone was being quarried, I learned there wasn't enough of this particular color for the entire building. Gulp. We could get another shade that was a little darker. But when we placed the two samples next to each other, they looked awful together. I had already sold Stanley on this particular color and how perfect it was for the project, so I couldn't go back now. I told the contractor to use the original color on three facades and the alternate one on the north side, which always looks darker because daylight hits it differently. At the grand opening of the store, I walked around the building with Stanley, and he never noticed anything amiss. I don't recommend deceiving clients, but sometimes you need to be resourceful in handling them.

Finding good clients is a never-ending process that requires energy and optimism. My best advice is to get engaged in organizations where you can develop relationships with important people. For example, I have long been active with the University of Pennsylvania—speaking there and serving as a trustee and as a member of the Penn Design Board. Each year I fund a scholarship for a student at the school of architecture. I needed a scholarship to go to graduate school, so I know how important such funding is. In 2010 I received

the Alumni Award of Merit, the highest honor granted by the university to an alumnus. I've always enjoyed giving back to my alma mater and my profession and felt this is an essential responsibility I have as an architect. It has allowed me to keep learning and growing as a person. It also has expanded my contacts with a broad range of people, some of whom would become clients or recommend me to clients. Doing the right thing turns out to be good business.

I have served as a trustee and governor of the Urban Land Institute and gone on trips with the organization to cities around the world. These often turn out to be great opportunities to meet business leaders, government officials, and interesting people. They also generate opportunities to speak at various events, which help me raise the profile of KPF and spread the word about our work.

Getting out of the office is critical to developing your business. I have always used breakfasts, lunches, and dinners to meet new people and strengthen existing relationships. You can work really hard in your office, but you're not going to meet any new clients there. You need to use the night as well as the day. It's a lot of time and can put strains on your family life. So it's best if you have a spouse who enjoys accompanying you on such occasions. I'm lucky that my wife Barbara is great at this, though she is often busy with her own activities—being an investment banker and serving on the boards of two public corporations. She also helps many nonprofits, chairing the board of the FDR Four Freedoms Park on Roosevelt Island in New York, and having served for many years as the chair of the board at her alma mater, Connecticut College. If she can't come, I'll usually invite one of my partners or someone from marketing to join me. It's important to give other people in the firm this kind of exposure.

At architecture school, everything is focused on design. Learning the design process is essential to what we do and who we are. But we need to do a better job of training architects in the business of architecture. Going out and finding new clients and winning jobs can be incredibly exciting. There's nothing like the moment when you find out you've just been selected for a new project. "My God, they picked us!" It's a fantastic feeling. Once you get a taste of that, it's hard to get it out of your system. I love design, but there aren't many moments when you get that kind of blast. In design, it's mostly, "Yes. No. Modify this," though occasionally a client will exclaim, "That's it! You've nailed it!"

I like to be creative in my search for clients and jobs. For many years, I went to Bergdorf Goodman to have Gio cut my hair. Gio was a celebrity barber. His clients were actors, media stars, bankers, and a lot of New York developers. It was the most expensive haircut in town, but it gave me the chance to talk with people like Steve Roth, the head of Vornado Realty, and members of the Rudin and Rose families, who are also important developers. If you went in the morning, the salon would offer coffee and pastries or get you breakfast from the hotel. If you went in the late afternoon, they would serve you a glass of wine. It was an informal setting, so I could casually ask Steve or one of the Roses what they were working on and what might be coming down the pike. Everybody was relaxed, so it was a great place to pick up information on what was happening in the business community. I was like an intelligence officer—having a good time but doing my homework. After Gio passed away, Nick took over the business and I still go to him. I can't say whether sharing a barber with Steve Roth helped or not, but he has hired KPF for a number of projects over the years, including the renovation and expansion of 640 Fifth Avenue, an office building near Rockefeller Center.

I also made use of my time on airplanes. I traveled so much that the people at the airline counters and the flight attendants on the planes knew me well. I was always nice to these people and got to know their names and their stories. So I would ask about someone's spouse or their kids and establish a connection with them on a personal level. In part, this is my nature. I like talking to almost anyone—rich or poor, famous or not. But this also allowed me to meet some important players on my flights. Before the September 11 attacks changed everything, I would ask the agent at the check-in counter, "Who else is sitting in first class?" He or she would tell me, "This guy works for one of the big oil companies. Would you like to sit next to him?" Some of the agents knew me so well, I didn't even need to ask. They would just review the seating chart and make a suggestion. "You might want to sit in 5B, Mr. Kohn. I think you'll have a good conversation there."

The agents also knew I was a big sports fan, and one of them put me next to Willie Mays on a flight going back to New York from San Francisco. It was fantastic! Willie turned out to be a lovely person, and we had a wonderful conversation. I told him I had seen him play his first game outside New York; it was in Philadelphia in 1951. He remembered the game and we talked for a couple of hours. As we were landing, I told him, "Willie, I've got

a crazy request." He smiled. "My firm has a softball team and we're pretty good. We've won five league championships. Well, we have a game tomorrow in Central Park. Will you still be in New York?" He nodded. "Well, if you have the time, would you come and play for us?" I felt like a kid asking for a pony for Christmas. He laughed that amazing laugh he has. "We're allowed to have two players who don't work at the firm," I said, "so the rules allow it." He laughed again and said, "Gene, I'll try, but I can't make any promises."

The next day I kept looking for Willie, thinking how incredible it would be if he walked onto the field and I announced him as our centerfielder. Imagine what kind of reaction we'd get from our players and those on the other team! Every inning I looked around at the other ball fields to make sure he wasn't wandering in search of us. He didn't show up.

Finding talented architects to work for us was as important as finding clients. Most years I would speak at a number of architecture schools around the country. I would show slides of our latest projects and talk about the ideas and values that drive us. I would almost always show at least one image of our softball team and talk about its importance in developing our firm culture. After each talk, students would come up to me, many of them looking for jobs. Often someone would hand me his résumé and say, "I was all-state in high school, playing third base." I would note that on the résumé and keep it in mind when we made hiring decisions. That was one reason we won so many championships.

By and large, we have always tried to bring in talented people straight out of school and develop them in-house. That takes a lot of work up front but ends up giving us a deep pool of architects who understand the way we work and are committed to the firm. Occasionally, we'll get a big project and need to recruit a senior person from somewhere else. But that's the exception, not the rule.

KPF's rise to prominence was strikingly rapid for an architecture firm. In 1990, the American Institute of Architects named us the Firm of the Year, passing over many bigger, more established practices. Paul Gapp, the architecture critic for the *Chicago Tribune*, wrote at that time, "If KPF were an old-line design shop, its prestigious award might be regarded with less awe. But the tribute is paid only to firms that have 'consistently produced distinguished architecture for at least ten years,' and KPF was founded only thirteen years ago. In architecture, that pace of ascendancy qualifies as warp speed." He went on to say, "Plainly speaking, KPF is the hottest large design firm in

the nation.... Many regard KPF as a serious national challenger to Skidmore, Owings & Merrill, the large Chicago-founded design firm that, in the 1960s and 1970s, became America's preeminent shaper of corporate skyscrapers."

The AIA award citation stated, "The skillful handling of a variety of complex programs has allowed the firm to rise to prominence in a very short period of time. Their buildings, now dotting the skylines of many American cities, combine an imposing originality with a sensitive respect of contextual tradition within the constraints of the urban environment."

We didn't win every job, of course. Sometimes we blew it. I remember competing in the early 1980s for a project for AT&T, a company with which we had a strong relationship. Tom Boland, an executive with the company, brought his team to our offices on Madison Avenue, and we gave them a show. The problem was that the show was too long. About halfway through the presentation, I realized we had way too many slides and not enough focus in our pitch. I could see Tom's eyes glaze over. Heck, even I was getting bored. Overkill doesn't work. I was really mad at myself for doing such a poor job with the presentation and felt I had just dropped an easy pass in the end zone.

By 1993, we were expanding our presence abroad and designing buildings in nineteen countries. While our international work buffered us a great deal, the US recession of 1990–91 did take a toll on us. For the entire decade, 1990–99, only 18.5 million square feet of office space was built in Manhattan. Compare that with 385.2 million built in 1900–09, 431.5 million in 1910–19, and 344.6 million in 1920–29! We had to reduce our staff to 240 in 1993, down from a peak of 360 a few years before. We cut some positions through attrition, but had to lay off some people. This is always an extremely hard thing to do. We tried to distribute the pain as fairly as possible and required all partners to take pay cuts. Most other architecture firms, though, suffered more than we did, especially those that didn't have foreign work to provide ballast.

We also made a concerted effort at this time to expand our practice to a broader range of building types. We had done very well with office buildings but could no longer rely on them as a steady source of income. So we competed for and started to win commissions to design airports, educational buildings, government projects, medical facilities, and multifamily housing. We also started doing more planning work, which didn't pay particularly well but could lead to building projects later on.

The Wharton School Huntsman Hall, completed in 2002, at the University of Pennsylvania was part of our effort to expand KPF's expertise beyond commercial buildings to include educational and institutional work.

As part of this strategy, Shelley and I hired Jill Lerner in 1994 to expand our work with academic and institutional clients. She was the first senior-level person we hired from outside the firm, but we felt it was important to branch out and make sure we didn't have all our eggs in one basket. Jill had been at Ellerbe Becket and had developed a strong record of doing great educational projects. Since joining KPF, she has led the design and management of some great projects, including the Chapman Graduate School of Business at Florida International University, Huntsman Hall at the University of Pennsylvania's Wharton School of Business, and the Stephen M. Ross School of Business at the University of Michigan–Ann Arbor. She has also taken charge of institutional projects—such as the Advanced Science Research Center at the Graduate Center, CUNY; the Methodist Hospital in Houston; and the expansion of the Children's Hospital of Philadelphia—and planning efforts for academic and research facilities like the UCLA Semel Institute for Neuroscience and Human Behavior at the University of California, Los Angeles. All of this has strengthened the business foundation on which KPF rests and earned us numerous design awards in the process.

Jill is a smart and engaging leader with whom everyone likes to work. Many years after we hired her, she would spend a year as president of the New York Chapter of the American Institute of Architects, focusing on the theme Global City/Global Practice.

We had always done interiors, but in 1984 we created a separate entity, Kohn Pedersen Fox Conway Associates, to focus on this type of work. We put Patricia Conway, a talented planner and long-time employee, at the helm of that ship. Pat is an excellent writer and was able to make KPFC a significant force. When Equitable moved into its Edward Larrabee Barnes–designed building in midtown Manhattan in 1985, KPFC got the job to design the interiors of its offices, thanks in part to my relationship with developer Jerry Speyer. It was an important project for us, establishing our new firm as a player in the interiors field. In 1986, *Interiors* magazine named Pat Designer of the Year, and a year later KPFC was billing $8.5 million. Over time, though, we realized that the interiors business has some significant differences from architecture—in terms of billings, operations, and expectations. We found it difficult to compete with some of the big interiors firms in terms of fees and got hit hard when the commercial market plummeted in the late 1980s. About the same time, KPF was trying to get the job to do the architectural

design for a major office tower and discovered that a competing firm had hired KPFC to do the interiors for its proposal. That's when we realized something was wrong. In 1993, we decided to end KPFC, and Pat left the firm. We still do interiors at KPF, but only on projects where we are the architect.

Other changes occurred in the early 1990s, as one of our partners, Arthur May, who was closely identified with Postmodernism and became stuck in that style, left the firm. With our work on the World Bank and other projects, our design direction was clearly moving away from the historicizing strategies and details of Postmodernism. Arthur no longer fit in with KPF.

In 1996, Shelley decided to retire, shocking Bill and me. But he had accomplished what he had set out to do and didn't think he had anything else to prove. As he had done in architecture school, he knew when he was done with a project, even as the rest of us kept madly working on. He wanted to spend more time with his wife, Judy, and three children, Peter, Jeffrey, and Mindy. Ever the master organizer, he had groomed a successor, Bob Cioppa, who took over seamlessly. The firm kept humming with Bob as managing principal.

A few years later, Shelley developed prostate and then bladder cancer. He received treatment, and the tumors went into remission. But then came brain cancer. So his decision to spend more time in Stamford with his family turned out to be sadly prescient. He passed away near the end of 2006, leaving a huge hole in our hearts and a legacy of cautious wisdom and professionalism that continues to inspire us to this day. The day before he died, I visited him at his house and we hugged goodbye. We had met on our first day at architecture school in 1948, so letting go of him was difficult. He was a very special guy. I still see Judy and Mindy a few times a year, and they always come to the summer party Barbara and I host at our house in Washington, Connecticut, for all of the firm's partners and principals. They are an important part of the KPF family.

Even before Shelley died, a new group of leaders was starting to take the reins at KPF. In addition to Bob Cioppa, we had elevated Lee Polisano, and would later promote Greg Clement, Paul Katz, and Jamie von Klemperer to key roles in the firm.

By 1997, we were growing again. Our New York office alone was busy with about fifty projects with a construction value of approximately $7.8 billion.

One of our key New York projects was a "vertical campus" for Baruch College. Occupying almost an entire city block on Lexington Avenue between

Baruch College stretches fourteen stories above grade (and three below) to create a vertical campus in the middle of Manhattan. Bill Pedersen and Jill Lerner led the team that designed the innovative project and earned rave reviews from both design critics and students.

Multi-story atria serve as indoor "quads" for the three educational programs housed in the Baruch building. The atria bring in daylight and help orient students as they move through the large project.

Twenty-Fourth and Twenty-Fifth Streets, it rises seventeen stories and encompasses nearly eight hundred thousand square feet of space for classrooms, research facilities, a five-hundred-seat auditorium, a three-level sports and recreation center, a theater, a recital space, a bookstore, a food court, and even a television station. To help organize all this and make it legible, Bill Pedersen and Jill Lerner carved out three atria that essentially serve as vertical quadrangles for the campus. Each atrium serves as a hub for a different educational program: the Zicklin School of Business, the Weissman School of Arts and Sciences, and the Executive Education Program. On the outside, the building tapers at the top in a gentle curve that cuts an elegant profile.

Although Baruch has other buildings in the area, our $319 million project brings together about half of all its facilities. Colleges in other locations might have the luxury of spreading out horizontally, but Baruch had to go vertical to solve its needs. Making this work spatially and programmatically was a huge challenge for our design team. But the sun-filled atria and the beautiful mix of materials give this massive structure the feeling of a wonderful community—or actually, a series of communities.

When it opened in August 2001, the *New York Times* marveled at the way the sophisticated elevator system moves as many as three thousand students between classes at a time. "The new building has six roomy elevators side by side—nicknamed the six-pack—each holding up to forty-five people," said the article in the *Times*. "To speed their operation, the elevators open on both ends and stop only at every third floor. (Riders are expected to take escalators or use the stairs to get to the floors in between or take the slower, smaller elevators farther away from the classrooms that stop at each floor.) ... riders rarely [have] to wait more than a few minutes." In the past, students often had to wait fifteen or twenty minutes and stand on lines that went out the building and around the block.

Unfortunately, Baruch has not done a good job of maintaining the building, so it usually looks unkempt these days and often needs a thorough cleaning.

As the private sector slowed down in the 1990s, we made a concerted effort to get commissions from the government. This resulted in major courthouse projects in lower Manhattan, Minneapolis, and Portland, Oregon, and a strong relationship with the General Services Administration (GSA). Most people aren't familiar with the GSA, but it's an independent federal agency

The US Federal Courthouse in Minneapolis, which opened in 1996, joins an illustrious group of KPF courthouses, including ones in New York, Buffalo, and Portland, Oregon. Landscape architect Martha Schwartz designed the striking plaza in front.

that oversees the design, construction, and operation of almost all federal buildings. It's huge—employing about twelve thousand people—and has an enormous impact on the built environment. In 1996, Ed Feiner became the agency's chief architect and initiated a Design Excellence program to support high-quality architecture. Ed is a force of nature, a crew-cut dynamo who made the GSA a place for innovative thinking and great expectations. He put together a list of talented architecture firms from around the country and steered jobs their way. He established a peer-review process for these projects that helped good designers do their best work and protect the importance of design as projects moved forward during design development and into construction.

Although our three federal courthouses started before the Design Excellence program, they came under Ed's protective attention and benefitted as a result. In Chapter 4, I spoke about Bill Louie's Postmodern design for the Daniel Patrick Moynihan United States Courthouse, which opened in 1996 on Foley Square in lower Manhattan, and how it reinforces the civic character of the area.

Our designs for the US Courthouse in Minneapolis and the Mark O. Hatfield US Courthouse in Portland—buildings that were designed by Bill Pedersen and completed in 1997—are more Modern in their architectural expression, but like the one in New York respond sensitively to their historic contexts and contribute to their cities' public realm. All three demonstrate innovative ways of squeezing large programs on tight urban sites and pioneered vertical solutions for judicial complexes.

In Portland, we collaborated with BOORA Architects, an excellent local firm, and broke down the mass of the 565,000-square-foot building into two parts: an eight-story, limestone-clad block with administrative offices and law library that respects the height of the nearby county courthouse, and a seventeen-story tower with a pair of courtrooms on each floor. A concrete elevator tower at the northwest corner holds the composition together and serves as a kind of modern turret capturing the eye. The complex overlooks the Plaza Blocks, a part of downtown with three public parks and a series of civic buildings such as City Hall, which opened in 1895, and Michael Graves's Portland Building, which debuted in 1984. Portland has become one of the country's most popular and progressive cities, and I like to think that our building there makes an important contribution to its urban fabric.

The 740,000-square-foot courthouse in Minneapolis rises thirty stories and wraps around a curving plaza designed by landscape architect Martha Schwartz. The vertical fins on the base provide the same kind of visual rhythm and dignity that columns would on a Classical building, while the modern curtain wall on the taller portion brings in plenty of daylight to the interiors. The project won GSA Design Excellence Awards for both architecture and landscaping.

I spend a lot of my time flying, so I know a lot about the problems posed by airports. The need to move large numbers of people from check-in counters to security points and then to departure gates often results in terminals that seem geared for processing crowds rather than creating welcoming places. This is a shame. Airports are essentially small cities and should offer travelers a range of civic experiences—impressive spaces to gather, stimulating places to shop and eat, and calming areas to wait and relax. Passengers interact with airports in very different ways, depending on if they're on a business trip or a vacation, if they're arriving or departing, so architects need to create places that are both efficient and exciting. Great airports and terminals accommodate the mundane while at the same time offering the extraordinary.

For many years, I was intrigued by the challenge of designing an airport, but I knew that breaking into this business was very difficult. Clients want to hire only architects who have proven track records with the building type. Whenever we interview for a type of project that we haven't done before, I tell the client that we'll do more research and explore more possibilities than a firm that has already done this kind of work many times. Experience is important, but so is creativity. Coming to a problem with a fresh mind can be a big advantage, I say. Alas, such an argument doesn't always work. Of course, now that KPF has done pretty much every kind of building, I guess this kind of thinking helps more than it hurts us.

In 1991 I heard that Buffalo was planning a new building to replace a pair of old air terminals that were too small and outdated for the region's needs. So I contacted Mark Mendell, who was the president of Cannon Design, a big firm based in Buffalo, and Bill Bodouva, a New York City architect with a lot of experience in the aviation field. Let's work together, I proposed. Each of us has talents that complement the other's. Mark and Bill agreed, and we formed a team to pursue the job. I remember our final presentation to the client. I was really on that day, and both Mark and Bill did fantastic jobs as

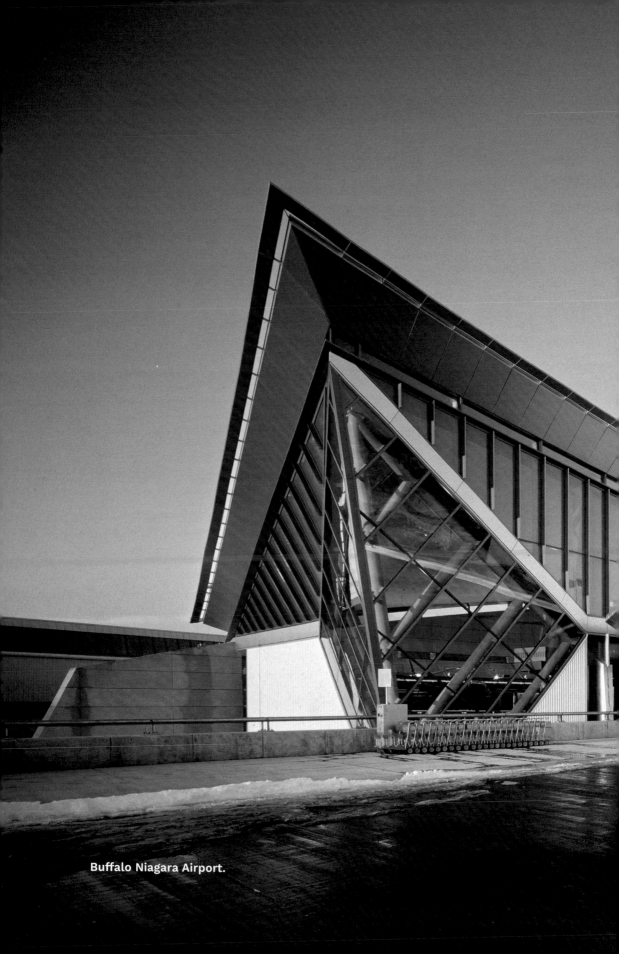

Buffalo Niagara Airport.

The design generates an uplifting sense of spatial excitement and captures the drama of flight.

well. I knew as soon as we left the room that we had wowed the audience. There was an electricity in the air that happens only when everything clicks. We got the job.

The three firms worked together to create a fantastic new structure built between the two old ones. As soon as our building was completed at the end of 1997, the old ones were torn down to provide space for future expansion. With fifteen gates and a sweeping entry facade, our terminal heralded a new era for the Buffalo-Niagara region, the second-largest in New York State. Inspired by the aesthetics of midcentury icons, such as Eero Saarinen's Dulles Airport in Washington, DC, and his TWA terminal at John F. Kennedy International Airport in New York, our design contrasts big, expansive spaces with tighter, more compressed ones; heavy elements with lighter ones; dynamic moments with more static ones; opaque surfaces with transparent ones. This dialogue between opposites generates an uplifting sense of spatial excitement and captures the drama of flight.

The project has been a huge success for Buffalo, giving the city a progressive identity and becoming the busiest airport in the state other than JFK and LaGuardia. For KPF, it opened lots of doors, leading to work at Philadelphia International Airport, Abu Dhabi International Airport, and Changi Airport in Singapore.. These are the kind of large, exciting commissions that a big firm like KPF needs to keep its staff busy and raise its profile within the profession. I was particularly proud to get the Philadelphia job, since that's my hometown and my former employer Vincent Kling had done work there on an earlier terminal. In one of our interviews for the project, I told the client that my mother would be mad if I didn't get the job. Everyone laughed, proving to me once again that humor is a valuable tool to be employed at critical moments.

We also were selected to design a project at Dulles, which was exciting, since Saarinen's building there is spectacular. A remote terminal connected to the rest of the airport by an underground people mover, the project would keep a respectable distance from Saarinen's work. Unfortunately, it didn't move forward.

During the depths of the recession in the early 1990s, a new developer named Millennium Partners approached our old client ABC about buying a few of its properties on the Upper West Side of Manhattan. The buildings we had done for ABC were all east of Broadway on Sixty-Sixth and Sixty-Seventh

Lincoln Square in New York.

Streets; Millennium was interested in three sites west of Broadway that ABC owned but hadn't redeveloped. One of the founding partners at Millennium was Philip Aarons, who had served as assistant to the mayor under Ed Koch and then became president of the NYC Public Development Corporation, a government agency that developed projects such as the South Street Seaport, the Joyce Theater, and the restoration of Carnegie Hall. A lawyer by training, Phil knew New York very well, having worked in both the public and the private sectors. For their first big project, he and his partners, Christopher Jeffries and Philip Lovett, decided to bet on a neglected piece of Manhattan between the ABC blocks and Lincoln Center. Using an innovative financing scheme that brought in companies such as Sony, the Gap, Reebok, and Barnes & Noble as retail tenants and partners, Millennium was able to get funding at a time when very few big projects were moving forward.

ABC recommended us to Millennium, and we ended up getting the job to design its first building, the fifty-six-story Lincoln Square tower. Although neighbors were surprised at its height (and some protested), Lincoln Square was a marvelously urban building that mixed retail and entertainment uses at its base with apartments above. When it opened in 1995, the project brought new vitality to a site that had previously seemed betwixt and between, giving the Upper West Side its first Barnes & Noble superstore, a multiplex cinema, and custom-designed retail spaces for Sony and Reebok. It launched Millennium into a trajectory as a major developer in New York and other cities around the country, including Boston and San Francisco. And it helped KPF burnish our credentials as architects for mixed-use and high-rise residential projects.

Partway through the project, money became tight for the client, and Millennium offered us two apartments in the building in lieu of the rest of our fee. It was an unorthodox proposal, requiring us to forgo cash now in exchange for the chance to make more money if the value of the units increased in the future. Bill and Shelley were adamantly against the idea, but I was intrigued. Bill and Shelley won this argument, and we got paid the old-fashioned way. The project, though, was a big success financially, and I'm sure the price of residences there has increased dramatically.

A different kind of issue arose during construction of the project and affected our relationship with Millennium. As the tower went up, members of the KPF team providing construction supervision began to complain about

the general contractor, saying he was verbally abusive to them. No one should be surprised that language on a construction site isn't always the most polite. But there is no excuse when it becomes personal and is used to demean or attack people. After hearing from members of our team, Bill, Shelley, and I met with Millennium and asked them to talk to the contractor. To our surprise, they said that's the way contractors act and we should just get used to it. We protested and never worked with Millennium again.

As the economy began to pick up in the mid- and late 1990s, we once again got busy designing corporate headquarters and office towers. One of our first projects in Canada, 1250 Boulevard René-Lévesque in Montreal, became IBM's Canadian headquarters. I had kept in touch with IBM over the years, so when the company decided to build a new global headquarters on its property in Armonk, New York, about fifty miles outside Manhattan, they asked us to compete for the job of designing it.

The night before our presentation to IBM, I was invited to a dinner that I didn't really want to attend. The hostess, though, prodded me to come, and I finally relented. I'm really glad I went, because I ended up talking with a guy named Jason Wright, who had worked with IBM's new CEO, Louis V. Gerstner Jr., when they were at RJR Nabisco. Gerstner had earned a reputation for turning around companies in trouble and was famous for being both brilliant and tough. When he joined IBM in 1993, its stock price was sinking, and many of its top executives were talking about splitting the company into autonomous business units, such as processors, storage, software services, and printers. Gerstner killed that idea and emphasized providing integrated business solutions to customers. The strategy worked, and IBM regained its status as one of America's corporate jewels.

After telling Jason about my upcoming meeting with Gerstner and the IBM selection committee, he smiled and said, "Gene, let me give you some advice about Lou. He's going to try to upset you. That's the way he tests people. Don't disagree with him, but don't back down, either. He wants to work only with people who know what they're doing and are confident."

Sure enough, we were tested shortly after we started our presentation. After just a few slides, Gerstner barked, "Stop! I don't care what you've done for other companies. I just want to know what you can do for IBM." Instead of requesting to show a few more images, we calmly turned off the projector and switched to a conversation about our ideas for this particular project.

The IBM Headquarters in Armonk, New York, pioneered a new model of corporate architecture with more open workspaces indoors and a more direct relationship to its site and the outdoors. Bill Pedersen and Doug Hocking led the design team for this project.

Gerstner seemed to be impressed, and we had a great discussion about new models for the modern workplace. We got the job.

With its business and culture changing, IBM needed a building that would represent its future, not its past. Working with Gerstner and his team, we rethought the suburban office building—providing fewer private offices but more open space. Instead of emphasizing work behind closed doors, the architecture would create places for collaboration, impromptu meetings, and informal gatherings.

Gerstner challenged many accepted notions of corporate architecture. For example, "I want a building that can't be expanded," he told us. "I want every part of IBM to grow, except headquarters." So we designed a dramatic Z-shaped structure that fits tightly onto its wooded, rocky site and creates a charged relationship between indoors and out. There's no way to add onto it without blasting away a lot of rock and radically reshaping the landscape. By keeping the three wings fairly narrow, we were able to bring daylight to all of the open work areas and thereby reduce the amount of electric light needed for people to work. Although the 283,000-square-foot building, which opened in 1997, is anchored to the ground with a stone base, most of it is clad in stainless steel and glass, giving it a forward-looking identity. IBM loves the building, and the Chicago Athenaeum gave it an American Architecture Award in 1998.

On another suburban site—this one in McLean, Virginia, outside Washington, DC—we got the opportunity to design a headquarters for Gannett/*USA Today*. The 820,000-square-foot complex features a pair of office towers, one for Gannett and one for *USA Today*, that steps down to meet at a glass-enclosed structure housing communal facilities. From a distance, the project looks like a modern hill town overlooking a "town square" where employees can enjoy outdoor dining and views of a small lake and the rolling landscape. To encourage a healthy balance between work and recreation, the complex weaves together architecture, jogging and walking trails, grassy areas, planted terraces, and even tennis courts on top of a garage. Inside, common spaces spread out on the entry level, while large newsrooms and production studios occupy high-ceilinged spaces on levels two and three of the podium. Glass curtain walls reflect the lush landscape and bring plenty of daylight inside, but also complement materials that range from rusticated fieldstone to polished granite, aluminum leaf, and wood. In the main lobby,

a scissor stair seems to float in front of a three-story glass facade.

As many corporate clients do, Gannett hired a real estate company to serve as its representative and oversee development of the project. In this instance, Gannett hired Hines, a global investment, development, and management firm founded by Gerald D. Hines in 1957. We established a great relationship with Hines and continue to collaborate with the firm to this day, especially with Tommy Craig, who is the senior managing director at the company's New York office. Jeff Hines now runs the company and his daughter Laura Hines-Pierce, who was a student of mine at Harvard Business School, is a managing director.

The Gannett project, which opened in 2001, was a big hit with the people working in it and also the design and business communities. It won a slew of honors, including a *BusinessWeek/Architectural Record* Design Award, a National Honor Award from the AIA, and recognition as Best New Office Development from the *Washington Business Journal*.

At the turn of the millennium, optimism seemed to be getting the upper hand over fear and doubt. Yes, we had all read and heard about the dreaded "Y2K" problem—the computer bug that made many software programs unable to recognize the difference between the year 2000 and the year 1900. Some experts warned that all of our computers would crash on January 1, 2000, wreaking havoc with airplane reservations, billing systems, government accounting software—you name it. No such things happened, either because the severity of the problem had been overstated or because a lot of coders worked hard to fix it. The economy chugged forward with US gross domestic product growing from $9.66 trillion in 1999 to $10.28 trillion in 2000 and then $10.62 trillion in 2001.

KPF was in good shape, too. In New York, we were finishing up work on a world headquarters for Sotheby's, a new office tower at 745 Seventh Avenue, and an addition to New York University's School of Law, and were collaborating with Yoshio Taniguchi on the expansion and renovation of the Museum of Modern Art.

Taniguchi is a brilliant architect, but he had never done a project outside of Japan. So Jerry Speyer, who was vice chairman of MoMA's Board of Trustees and was overseeing the expansion, asked me if KPF would act as executive architect and prepare the construction documentation for the project. I was with Jerry in Paris at the time, doing legwork for a building we were doing for his development company, Tishman Speyer, when he pulled

For Gannett/*USA Today*, we created a modern hill town with extensive outdoor areas
for recreation and relaxing. The 820,000-square-foot complex in McLean, Virginia,
outside of Washington, DC, provides separate buildings for the Gannett Company and
its biggest newspaper.

me aside and asked us to help with MoMA. "Jerry, we don't usually do working drawings for other architects' buildings," I told him. "But Gene, this is a really important project, not just for MoMA, but for the city of New York," he explained. "I'd like to have KPF involved to make sure everything gets done properly." It's hard to say no to Jerry, so I agreed to take the job. As it turned out, our role went beyond that of a typical executive architect. We sent about a dozen of our people to Taniguchi's Tokyo office to assist with schematic design and then had a team in New York work on design development. Also in New York, we took charge of renovating the existing MoMA buildings, designing new office spaces, developing working drawings, and providing construction administration.

Jerry is both a client and a good friend, as is his wife Katherine Farley, who is a director at Tishman Speyer. KPF has designed a number of buildings for the company, including towers in New York, San Francisco, Rio de Janeiro, Paris, and Shenzhen. Right now, we're working on a big project in Shanghai for his son Rob, who is now president of the company. It encompasses six office buildings, six residential towers, and lots of landscaped outdoor spaces.

As we worked with Jerry on the MoMA expansion, we were also doing a remarkable number of projects in Japan, China, and other parts of Asia. And our London office was busy designing headquarters for AIG, Clifford Chance, Unilever in London, and Endesa in Madrid. For Unilever, John Bushell, one of our London-based principals, transformed a grand neoclassical structure on the Thames Embankment into an exciting workplace for the twenty-first century. For the Spanish energy provider Endesa, Cristina Garcia designed a cutting-edge building that wraps around a 33,000-square-foot atrium and is naturally ventilated so it requires no conventional air-conditioning.

At this time, new leaders in the firm—such as Lee Polisano, Greg Clement, Paul Katz, Bob Cioppa, and Jamie von Klemperer—were making important contributions. I was feeling pretty good about things.

Then the unimaginable happened. The attacks on September 11, 2001, horrified the world. Nearly three thousand people were killed as airplanes struck the World Trade Center, the Pentagon, and a field in Pennsylvania. Some of us at KPF knew people who died at the World Trade Center. All of us were shocked and realized that nothing could be taken for granted. With cities and high-rises now seen as targets for radical terrorists, would people

still want to live in places like New York, Chicago, London, and Tokyo? Would anyone want to work in a skyscraper? As Americans, we needed to evaluate our position in the world and how we would respond to the events of September 11. As architects, we needed to rethink our role in shaping cities and the buildings that enliven them.

On the morning of September 11, 2001, I was at a breakfast meeting for the New York chapter of the American Institute of Architects. One of the things I love about my work with the AIA is the chance to spend time with architectural colleagues who also happen to be competitors. I'm not sure exactly what the meeting addressed that beautiful September morning, but I remember talking with George Miller, who was a managing partner at Pei Cobb Freed. Born in Berlin a few years after the end of World War II, George came to the US as a child and then studied architecture at Penn State. Like me, he was actively involved with his alma mater and issues of architectural education, while helping to run one of the best firms in the world. We chatted briefly about the women's final at the US Open two days before, when Venus Williams beat her sister Serena. It was a wonderful match and Venus was at the top of her game, winning in straight sets. We wondered why the architectural profession had so much trouble attracting talented African Americans. Only 2.3 percent of US architects are black, said George. "We need to do better." I agreed and said it has to start with schools of architecture and then continue with firms like his and mine.

The meeting ran longer than expected, and I needed to go to the pharmacy to pick up a prescription. So I called my office to tell them I was running late. No one picked up the phone. That was the first indication that something was wrong. Then my cell phone stopped working.

At the drugstore, the pharmacist said, "Did you hear about that plane hitting the World Trade Center?" I got my medicine and hurried to the office. KPF occupied several floors of the Steinway Building at 111 West Fifty-Seventh Street, a beautiful neoclassical structure designed by Warren & Wetmore, the firm that had done Grand Central Terminal. At the base of the building was Steinway Hall, a domed space that displayed Steinway pianos and sometimes served as an impromptu recital hall for famous musicians wandering by. When I arrived at the office, everyone was either huddled

around their computers or watching the news in the conference rooms that had televisions. Now I learned that a second plane had flown into the other tower at the World Trade Center and a third one had crashed into the Pentagon. What had seemed at first to be a tragic accident was now clearly a well-organized attack on our country. There were reports of a plane missing in Pennsylvania. No one knew how many other aircraft might be involved or whether the planes were just the first wave of a broader assault. Everyone remained calm, but no one felt safe.

Bill Pedersen, Bill Louie, Bob Cioppa, and I gathered in my office to discuss the situation. Everyone was calling spouses, relatives, and friends to make sure they were okay. No one knew if midtown Manhattan might be the next target for the terrorists. We needed to get our people out of the building and let them be with their loved ones. By late morning, we announced that everyone should go home. Managers and team leaders would call everyone that evening to tell them if they should come to work the next day. All we knew was that nothing was certain.

I called my wife Barbara, whose office was at Rockefeller Center, and told her I'd meet her on Fifth Avenue and we would walk home together. It was a remarkably lovely day weather-wise, which somehow made the horrific events that much more disturbing. The contrast between the perfect late-summer sky and the black clouds of smoke and debris rising from lower Manhattan was so stark that I had a hard time comprehending it. When I saw Barbara walking up Fifth, I waved and rushed over. Then I thought of all the people who were waiting to hear from loved ones at the World Trade Center, and I felt a bit guilty for having my wife safely next to me. On our way home, we stopped at an ATM to get cash, then at a store to get food. Millions of New Yorkers were doing the same thing at that moment. Money and food. Be prepared for whatever might come next. Anything was possible.

My wife and family were all safe. None of my employees or partners were hurt. But I lost a friend, David Alger, an investment banker whose office was in the Twin Towers and who perished there. Just two days before the attacks, I had played tennis with him in the Hamptons. We weren't Venus and Serena, but we had fun, and the world seemed to be a good place. Now he was gone.

As an active member of the New York chapter of the AIA and an architect with high-rise building experience, I was asked to serve as the spokesperson

for the AIA on the September 11 attacks. People had lots of questions for architects. Why did the Twin Towers collapse like huge stacks of pancakes? Would a different design have reduced the tragic loss of life? What could we do to make skyscrapers safer in the future? How might cities change in the wake of the attacks? I must have given seventeen or eighteen interviews to all kinds of journalists—print, radio, and television. I even did an article in a fancy cigar magazine.

My partners and I were good friends of Leslie Robertson, the engineer who designed the structural system for the Twin Towers with his former partner John Skilling. KPF had worked with Les on a number of skyscrapers, including our two biggest ones—the Shanghai World Financial Center and the Hong Kong International Commerce Center—which were being designed in 2001. In fact, Les was in Hong Kong on September 11, meeting with the developers of our ICC tower when the attacks took place.

Les was taking a lot of flak for the way the WTC towers performed after the attacks. The images of the towers collapsing were seared in everyone's brain, having played on TV over and over. Minoru Yamasaki, the architect of the towers, had died in 1986 and Skilling in 1998, so Les became the prime target of a lot of criticism, most of it unfair.

The Twin Towers were steel-tube structures with perimeter columns just forty inches apart, much closer together than most other tall buildings. This gave the towers their iconic pinstripe look, provided a lot of strength at the perimeter, and allowed the spaces inside to be column-free all the way to the structural core. But it also meant that the large open floors—sixty feet from exterior wall to core in one direction and thirty-five feet in the other direction—were the weakest link in a structural system that otherwise was quite robust. Designing anything—whether a building or a car—requires you to evaluate a series of trade-offs and then decide which way to go. No solution is perfect.

When the two 767s filled with jet fuel crashed into the Twin Towers, the buildings' dense outer structure withstood the impact much better than a more conventional skyscraper would have and prevented them from falling over and endangering other buildings nearby. The North Tower, which was hit first, stayed up for nearly an hour and forty-five minutes. The South Tower remained standing for less than an hour, because it was hit at a lower height. Luckily, neither tower was struck at a corner, which would have

compromised the structure quicker than a straight-on shot. More than 2,750 people died at the WTC that day, including 343 firefighters, seventy-one law enforcement officers, and 157 people on the two planes. According to the best estimates, there were more than seventeen thousand people in the two towers at the time of the attacks, almost fifteen thousand of whom survived. I still marvel that the towers stood long enough for so many people to escape.

I spent a lot of time after September 11 explaining these facts. I wrote a couple of stories, gave talks, and granted interviews. I participated in panel discussions on ways to improve tall buildings to make them safer. There were lots of lessons to be learned from what happened at Ground Zero. Nearly everyone agreed that building codes should require more (and larger) stairwells and high-speed lifts for firefighters. Some experts advocated protected refuge floors placed every twelve or so stories, which is done in most parts of Asia and Europe. But other observers noted that many more people might have been killed in the Twin Towers if they had gone to refuge floors instead of leaving the buildings immediately. A concrete core would also have provided greater protection against the impact of the jets and the fire generated by their burning fuel. But Yamasaki and Robertson had been asked to create the most efficient and lightweight structure possible, which they did with their innovative tubular steel design.

On the morning of September 11, a friend of mine, Geoffrey Wharton, was at Windows on the World, the restaurant on top of the North Tower. Geoff worked for Larry Silverstein, the developer who had just acquired the lease to the two buildings, and was having breakfast with Neil Levin, the executive director of the Port Authority. He left the meal a bit early to meet with a prospective tenant and ended up taking the last elevator to reach the ground before the attack. As he walked onto the enormous plaza with its twenty-five-foot-tall Fritz Koenig sculpture known as Sphere for Plaza Fountain, he noticed a jet striking the building he had just left, the building where Levin would soon die. The experience shook Geoff to his core. He quit his job shortly thereafter and wouldn't get on an airplane for a long time. It took him quite a while to fully recover.

At a ULI event in Boston shortly after the attacks, I remember hearing a newspaper columnist say we shouldn't build skyscrapers anymore. "Why go taller than ten stories?" she asked. I replied that there's a danger in every kind of building, but we need to remember why we erected tall buildings in

the first place. "They inspire the human spirit," I said. They embody innovation and rise as beautiful landmarks in the places where we live and work. And they're the most efficient use of resources in terms of materials, land, and infrastructure. If we replaced the Twin Towers with ten-story buildings, we would need twenty of them, and they would occupy twenty acres instead of two. Vertical cities have much smaller carbon footprints than sprawling ones and emit less pollution and greenhouse gasses. "Instead of making buildings shorter, let's make them safer," I said.

The US economy had been in a precarious state since March 2000, when the NASDAQ exchange crashed. GDP, though, continued to grow, albeit slowly, for several quarters afterward. But by March 2001, a recession officially began. A month after September 11, the Enron scandal hit the news, further weakening faith in the economy. It was a terrible time.

In the last quarter of 2001, we reviewed every one of our high-rise projects that were still in design to make sure they were as safe as possible. Our two tallest projects, the 1,614-foot WFC in Shanghai and the 1,588-foot ICC in Hong Kong, had already been designed to meet building codes in Asia, which were stricter than those in the US. We ended up making only minor adjustments to these projects.

KPF had a few projects planned for the area around the World Trade Center, and these were put on hold after the attacks. Ground Zero was now a sixteen-acre hole in the city's urban fabric with fires smoldering for months and crews of workers sorting through a mountain of debris, looking for the remains of victims and then slowly clearing the site. Many buildings nearby had been damaged during the attacks, and some had to be abandoned, at least temporarily. Some people who lived at Battery Park City a few blocks away were traumatized and decided to move elsewhere. Many people wondered if lower Manhattan would ever fully recover. It was a legitimate question.

Looking back at what happened in New York after September 11, I am amazed at how quickly the city bounced back. New Yorkers came together in a way I had never seen before. People approached cops and hugged them, something unheard of previously (and pretty rare once again today). Pedestrians would walk past a firehouse and see photos of firefighters who had lost their lives on that awful day, and they would thank the men and women still on duty. I saw teenagers help strangers take baby strollers down subway steps and tough-looking guys let the elderly go ahead of them. There

was a remarkable sense that we were all in this together and we all needed a bit of help. On streetlamps and mailboxes, everyone saw the xeroxed posters made by the families of people lost on September 11, pleading "Have you seen this person?" Our hearts were being tugged in thousands of directions, which somehow encouraged us all to pull in one. The worst had brought out the best in us.

This remarkable spirit of cooperation and support lasted several years. In August 2003, a major power outage struck much of the northeast US, and most of New York was blacked out. The previous big blackout hit New York in 1977 and left an ugly trail of looting and crime. In 2003, crime actually went *down* during the days of no power. People would walk up to strangers and say, "Do you need any batteries? I have some extra ones." Tourists in midtown who couldn't get into their hotel rooms because their magnetic room cards didn't work found themselves overwhelmed with offers of help by complete strangers, and some said that Times Square turned into a giant outdoor party welcoming one and all.

Planning and rebuilding Ground Zero seemed to take forever at the time. There were huge fights over the master plan, the memorial, and the buildings that would go up on the site of the nation's worst terrorist attack. But I realize now that the city moved forward and healed itself in a surprisingly short period. I credit much of this to Mayor Bloomberg, who provided a vision and a steady hand at the helm of a ship that could easily have listed or sunk. He made sure that the business community and the public maintained their faith in the city.

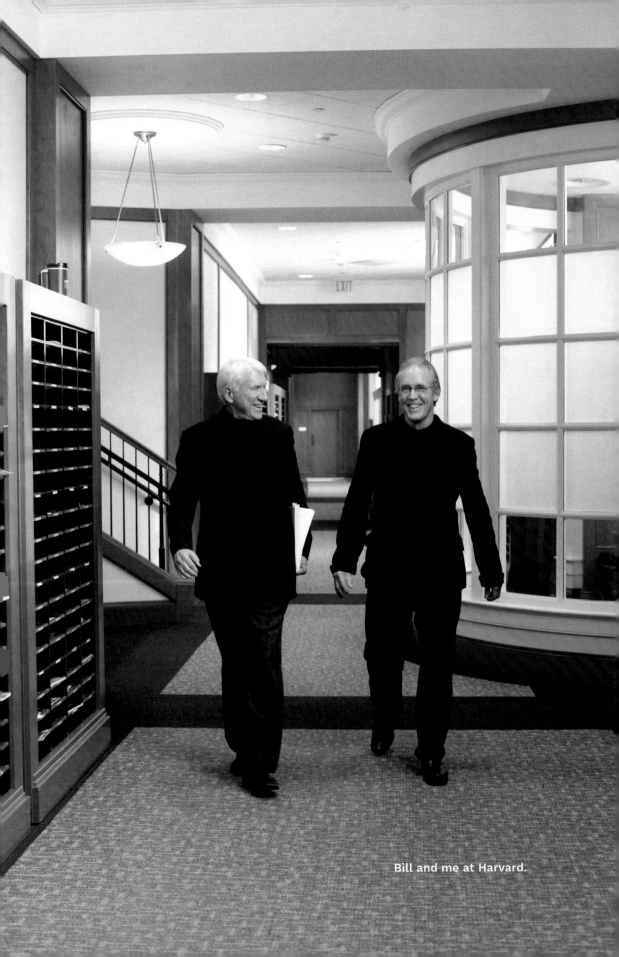

Bill and me at Harvard.

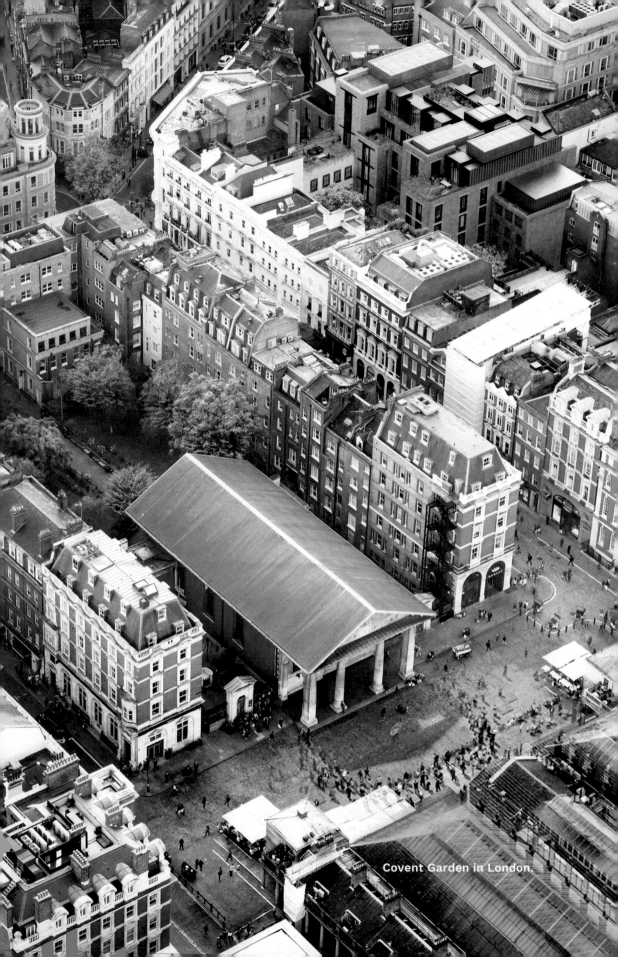

Covent Garden in London.

London Fire

Relaxing wasn't easy in early 2009. The financial meltdown the previous fall had clobbered most architects, as clients—big and small—canceled projects, put others on hold, and hunkered down. KPF was doing a good job of weathering the economic storm, thanks to our work in China and other parts of Asia, but I could see the damage done to my colleagues and friends. Surveying the economic landscape, I knew the next few years would be difficult. KPF operated offices in New York, London, Hong Kong, Shanghai, Seoul, and Abu Dhabi, so we needed a lot of work to keep our staff employed and our vessel moving forward.

What I didn't know was I would soon engage in a battle for the soul of my firm, a struggle that would test me personally and the principles on which KPF had been based for thirty-three years. The threat didn't come from shifting economic forces or aggressive competitors, but from an internal source. It was like nothing I had confronted in my long career. It forced me to reexamine the structure of my architectural practice and, most painfully, some of the people I had trusted. Looking back on the events of 2009, I see now that we are defined, in part, by what we fight for.

When we set up our London office, our first foreign post, in May 1989, we moved Lee Polisano and four other key people from New York to London. During the course of the next few years, Lee and his team did a great job building up our practice in the UK. By the end of 2002, I felt it was time to transition the firm to a new generation of leadership and saw Lee as the person to take charge. He and I had been working closely for a number of years on business development and projects on the other side of the Atlantic. Over dinner and at meetings in our London office, we would discuss a range of topics, from clients and staff to his goals and vision. He was smart and ambitious—attributes that would serve the firm well.

In February 2003, I told Lee we wanted to make him president and asked when he would move back to New York. He surprised me by saying

he planned to stay in London. "But our headquarters is in New York," I said. "All of our other leaders are in New York. I think that's where you need to be." He was adamant, though, saying he had established great relationships in London and they were bearing fruit. "Let's compromise," I said. "Stay in London for another year to make the transition, then come back to New York." Much to my surprise, he wouldn't budge. Against my better judgment, I (and other senior leaders) let him stay abroad.

Lee had built strong relationships with our British and European clients and enjoyed his life in London, where at a distance from New York, he could present himself as the leader of an American firm. I didn't realize then how much that autonomy meant to him.

By the mid-2000s, our London office was busy doing work in the UK, on the continent, and in the Middle East. Lee was flying all over but was coming to New York less and less frequently. He would visit our headquarters maybe four times a year and never really engage with the people. He didn't know most of the staff and wasn't close to any of the partners, except Bob Cioppa. Increasingly, he seemed uncomfortable in New York. I would go to London periodically, but he didn't really want me there—except when he needed me. "Don't worry, Gene, London is my city. I'll take care of it," he would say. He was protective of what he perceived as his turf and didn't want me or Bill Pedersen interfering. That's not the way we had run KPF in the past.

Lee also became increasingly confrontational with the other partners of his generation—people such as Paul Katz, Greg Clement, and Jamie von Klemperer, who were rising stars in New York and were being groomed to be the next leaders of the firm. I kept telling Lee, "These guys can help you. They're really smart, so keep them close to you and use them wisely." But he saw them as competitors, not colleagues.

I remember going with Lee to MIPIM, a big international property conference held each year in Cannes, and he ran around town meeting with clients and prospects on his own. I was there with a couple of other partners, and we would discover Lee had had dinner or drinks with this person or that and never told us. I was furious and told Lee he couldn't behave that way. He had an excuse for each transgression, but it was clear he enjoyed running his own show and couldn't be bothered to include his partners.

About the same time, I met with a prospective client in the UK, who asked if Bill Pedersen could design his project. "Let me check with him and

At Floral Court, we carefully inserted a series of new residential buildings into the tight
urban fabric near Covent Garden, using handmade bricks and steel framed windows to evoke
nearby warehouses.

In the heart of London, Heron Tower breaks the usual mold of office buildings by placing its core to one side, rather than in the center, and using a series of triple-height atria to organize office areas into vertical "villages."

see if he has time to handle another job," I replied. When I mentioned this to Lee, he blew up and started yelling at me, "London is my town! Keep Bill out of it!" His response infuriated me.

By 2008, the situation with Lee had gone from bad to worse. Without informing his partners in New York, he had hired a law firm in San Francisco to prepare a plan to restructure KPF so the Shanghai, Hong Kong, Seoul, and Abu Dhabi offices would report to London, leaving New York by itself. We found out about this only a year later when the lawyers had done their work.

"Now that London is doing so well, it makes sense to consolidate things there," he argued one time when we had brought the London partners to New York for a meeting.

I told him, "You're crazy. Bill, Shelley, and I started KPF in New York, and we're going to keep it there. I don't think we should treat New York as a satellite of London!"

Later in 2008, Lee called me up and said he was flying to New York. "Great, I'll set up a meeting with the other partners," I said.

"No, I want to meet with you privately, outside the office," he replied. "I'll be staying at the Plaza Athénée. I'll meet you there." Lee always traveled in style and stayed at the best hotels. The Plaza Athénée on East Sixty-Fourth Street gushed with old-world opulence: crystal chandeliers, marble floors, Louis XVI furnishings, expensive displays of flowers, and lots of staff attending to every detail.

I knew the meeting would be fraught, but nothing in my career prepared me for it. In the hotel lobby, I asked for Lee and a bellhop escorted me to a suite on an upper floor—a really beautiful set of rooms. After brief pleasantries, we began an awkward conversation that only got worse as it progressed.

"Gene, you and I know things have changed at the firm," he said, trying to sound reasonable. "I think it's time we accept the new situation and make it official."

"What do you mean?" I asked.

"We need to split the firm in two. I'll take London and you can have New York."

"It's not yours to take, Lee."

"Look, I've built London into a very successful business. It's time the ownership structure reflected that."

"Lee, I admit you've done a good job in London. But without the KPF name, track record, and global resources, you wouldn't be here."

"I'm willing to pay you for the London operations," he said.

I looked at him incredulously. "Bill, Shelley, and I didn't build KPF so you could tear it apart!"

He ignored my comment and made an offer on the London office that was outrageously low.

"That's ridiculous," I said. "The London office design fees are worth eight to ten times that amount. The Abu Dhabi airport alone is worth many times more than what you're offering. Plus we've invested a huge amount of money in the office—in people, software, equipment, and overhead. We poured money into London for years. Its value is huge."

He repeated his initial offer.

"I'm not going to haggle with you over price, because the firm isn't for sale."

I looked him in the eye, and he looked back at me coolly. He was a tough cookie and showed no emotion. I had seen him command his London staff with the same kind of toughness. It could be impressive, but it lacked the compassion and concern for others that Bill, Shelley, and I had always valued.

"Talk to your partners, Gene, and see what they say."

"The board will never agree to this," I stated flatly.

"I wouldn't be so sure, Gene. Bob Cioppa is on my side, and I think Paul Katz will support me, too."

I grabbed my coat and walked out.

The next day, I made some inquiries and discovered that the law firm Lee had hired to come up with the restructuring plan was billing KPF for their services! So we were paying outside consultants tasked with dismantling us. We fired them immediately.

I quickly met with Bill, and Paul, who sat on the board with me and Lee. For several months I had been trying to get Jamie von Klemperer on the board, but Lee and Bob kept resisting. Now I knew why.

Bill was as shocked as I, but his initial response was to let Lee take the London office and its projects, including the multibillion-dollar Abu Dhabi airport. He was always happiest when focusing on design and making the best buildings possible, so he rarely made a fuss when management issues came before the board. After several conversations, though, I was able to convince him that Lee's plan would undermine the core

principles of KPF and endanger its future. Eventually, he agreed to back me up and fight Lee.

When I spoke with Paul, I realized Lee had been working on him, making promises I knew he couldn't keep. Lee made it sound like an exciting opportunity, a win-win situation for both New York and London. He also pitted Paul against Jamie, hoping to create a division that would weaken New York and help justify a split. I reminded Paul of the firm's strength as a global business, an advantage that few other architecture firms could match. Giving up London with its projects in the UK, Europe, and the Middle East would turn KPF into a rump of its former self and reduce its prospects for the future.

Although different in so many ways, Paul and I had a special bond. I loved traveling with him and seeing him in action. He was a natural salesman who knew his clients well. He dazzled them with his intellect and connected with them on a personal level, remembering the names of their children and showing pictures of his. His son Jonathan was learning Mandarin (and eventually would become fluent in it), which Paul never failed to mention to our Chinese clients.

After a few conversations, I convinced Paul that Lee's plan was wrong for the firm and for him. He agreed to oppose it. When the board voted it down, I thought we had resolved the issue.

Now I needed to heal the internal wound inflicted on the firm I had helped create more than three decades before. I had always been able to get people to work together. So I did what I had always done: sit everyone down at a table, present a set of common goals, develop plans to get things done, then support the efforts of talented people. But in this instance, the damage was severe, and resolution was more difficult than I had imagined.

To respond to Lee's damaging scheme, I came up with a different plan—make Paul president of the New York office and reduce Lee's role to president of the London office. As a buffer between the two of them, Bill Louie—always a calming force—would serve as CEO.

During the next few months and into 2009, we had a series of board meetings, each one marred by anger and conflict. They were the most unpleasant in our history. I tried to play referee, but the issues separating us were both professional and personal. Lee wanted to take the firm in a very different direction than the one Bill, Shelley, and I had envisioned.

My favorite retreat was our country house in Washington, Connecticut. Designed by Ehrick Rossiter in the first quarter of the twentieth century, it was a Shingle-style home that my wife Barbara and I had renovated into a lovely fusion of vernacular and modern. Rossiter was a talented architect with an intriguing pedigree. Born in Paris in 1854 to American parents, he learned to draw from his father, Thomas Prichard Rossiter, who was a painter associated with the Hudson River school of artists. He studied architecture at Cornell and was part of that school's first class of graduates. Then he set up his practice in New York and designed a number of country estates in Washington, as well as the Gunn Memorial Library and Saint John's Episcopal Church, also in town. Over the years, Barbara had overseen the landscaping of our house so that building and gardens enriched one another. In mid-July 2009, it was the perfect place to be.

When Lee called me there on July 18, he sounded more tightly wound than usual. He spoke quickly but deliberately—as if he had been rehearsing this conversation for a while. I wondered if our American staff in London had done anything special for Independence Day this year—maybe a barbecue or a pickup game of baseball in a local park. I was going to ask, but Lee didn't give me a chance.

"Gene, we've made a decision. The London office is splitting from the rest of the firm."

"What do you mean, 'the London office'?"

"The partners and staff."

"Everyone?"

"Yeah, pretty much."

"You can't do that, Lee. You can leave, if you want. But you can't speak for the staff. As soon as you resign, they're not yours anymore."

Barbara walked by and heard the anger in my voice. A minute later, she brought me a glass of iced tea and left me alone.

"Look, Gene. I know this is difficult, but I think it's best for the entire firm. We've put together a plan to swap our KPF shares for ownership of the UK operations."

"Who's 'we'?"

"Me, David, Karen, Ron, and Fred," he said, referring to David Leventhal, Karen Cook, Ron Bakker, and Fred Pilbrow.

That was five out of the six partners we had in London. John Bushell, the

sixth one, refused to join the breakaway group. The departing partners were all accomplished architects, thanks in no small measure to the work we had provided them at KPF. But I was most concerned about losing Fred Pilbrow, who was the best designer of the group.

"We told the London staff today, and most of them want to stay with us."

"How can you announce this to the staff before you talk to all of your partners?" I was furious. "I will fight you on this, Lee. I won't let this happen. You'd better not speak with any of our clients. They're not yours; they're KPF's."

"The clients are coming with us, too. Almost all of them say they want to keep working with us."

"Their contracts are with KPF, not Lee Polisano. We'll go to court, if need be, to enforce that."

"Good luck, Gene."

I stopped myself from cursing him and took a deep breath instead.

"We've written a press release, and the *Financial Times* is running a story tomorrow on the split. It's all done, Gene."

"Just because you announce it, Lee, doesn't mean it's done."

I couldn't believe he had talked to the press, as if everything had been settled. For twenty years, my partners and I had invested money and resources in the London office and built a business there. We had given a group of young architects the chance to work on fantastic projects and develop valuable skills. They had accomplished a great deal. We had trusted them. Now they were betraying us. I was heartbroken.

I was seventy-eight years old and could have just let the London partners walk away with our business. There was enough work in New York to keep me and the rest of my partners comfortably compensated. But money wasn't the issue. I had spent the last three decades crafting and nurturing a very special enterprise. Bill, Shelley, and I had poured our savings and our souls into this firm, and a lot of other people had contributed their time and talent, too. I never saw it as a collection of offices; it was a single practice that just happened to have people and projects in different places. I wouldn't condone KPF being broken into pieces. I would fight it with everything I had.

"We've hired an investment banking firm to put together our proposal. I'm sending the papers to you."

"Have them delivered to the office and I will look at them on Monday when I'm back in the city."

"You'll have them today."

"I'm in the country, Lee."

At that moment, the doorbell rang. Barbara opened it, and a man in a pressed white shirt and tie stepped in with a large envelope in his hand. The logo on it said Ondra, a company, I found out later, that had been recently started by the guy who had headed the UK investment banking business for Lehman Brothers, the financial services firm that had collapsed so dramatically just ten months before.

The young banker in the white shirt was sweating from the July sun. How long had he been standing out there?

I had a hard time fully processing the impact of Lee's actions. All of the hard work that Bill, Shelley, and I had done over the decades, along with the dedication of our many partners, associates, and staff, was now threatened. Personally, I was crushed. I felt betrayed. People I had trusted had turned against the founding ideals of KPF, undermining its mission as a collective enterprise that would always be stronger with everyone working together rather than separately.

A lot was at stake. Divided, KPF would no longer be the global firm we had assembled over the past few decades, no longer the kind of place where young associates and partners could work on projects around the world. But more importantly, it would no longer embody the collective mission that Bill, Shelley, and I had dedicated ourselves to since 1976.

Struggling with the situation, I started to note lessons to be learned from the experience. I should have recognized warning signals of bigger problems—such as the infighting between Lee and David, the growing estrangement of Lee from his colleagues in New York, and the way Lee treated his partners at events like MIPIM. I should have addressed these issues before they grew too big to manage. I also should have considered Lee's character and not just his talents when I recommended him to be our president.

I knew immediately that I wouldn't let KPF be torn apart. I would fight Lee and his collaborators. I was well past the age when most people retire, but I wasn't about to give up. I spoke with Barbara, and we decided to move to London. I had to be there on the ground with my sleeves rolled up. Luckily, Barbara adores London—its theater and arts—and agreed wholeheartedly

John Bushell (at center with microphone) helped rally the troops in our London office after a group of principals left and set up their own firm in 2009. Today we have about 150 employees in London and are stronger than ever. To the left of John are Nick Dunn and Bill Pedersen. To his right are me and Jamie von Klemperer. In the front row on the right are Philip Jacobs and Charles Ippolito.

to the move. She also knows a lot of people in Britain, which proved to be very helpful.

The work ahead of me was daunting. But I must admit, I was excited by the challenge of doing battle to preserve the firm I loved.

My first task was retaining as many of our employees in London as possible. They were working on important projects and had firsthand knowledge that was critical to keeping these jobs moving forward without interruption. They also were representatives of KPF, so losing them would send a bad message to clients and the architectural community in London.

I held a series of evening meetings with our staff, both as a group and individually. Labor laws in the UK are different from the US, so we hired a good lawyer whose job was to advise our employees on their rights. At the first big meeting with the entire staff, most of the people were solidly behind Lee. He had fired them up with talk of a revolution and a firm that would be theirs—all before anyone in New York knew of his plan. I remember one guy at this meeting yelling, "America declared its independence in 1776. Why won't you let us declare independence? We want to be free." I was taken aback but replied, "You are free to leave KPF or stay. That's your choice. But you don't own the firm and can't take it with you."

Then I explained why I thought it was in their own interest to remain with KPF. "This is a great firm, a global firm that offers you amazing opportunities to work on important projects around the world. We have a history and a reputation—based on the impressive work that you and many others have done for thirty-three years. So clients trust us with big, complex buildings. We support our people and make sure they have everything they need to develop their talents and grow. And when they prove themselves, we make them principals and partners. We give them leadership roles. If you're really good, you could eventually run KPF. If you join a new firm, do you think you'll have the same opportunities? Do you think big clients will immediately give that firm major commissions? Probably not. You'll end up working on smaller projects and getting paid less, because a new firm may not have the resources to pay you what KPF can. Most important, though, are your long-term prospects. Will this new firm help you develop new skills? Will it give you the chance to become a partner and perhaps, one day, to run the whole show? I don't think so."

For several years I had been thinking about the leadership structure of KPF, preparing for the day when a new generation would take over. We seemed to have a deep bench with four very talented people—Lee, Greg Clement, Paul Katz, and Jamie von Klemperer—all capable someday of running the firm. All of them had the ability to lead, manage, get new work, and represent KPF. They were smart, excellent architects. Sadly, Greg developed melanoma and died at age fifty-six in April 2007, less than four months after Shelley passed away. Shelley's death was tough on me personally, because he and I had such a deep history together. There would be no KPF without Shelley. But he had retired from the firm ten years before, so his demise didn't leave a hole in the fabric of our practice. Greg's death, however, was more jarring professionally and more disturbing because he was still young.

Now with Lee's departure, our new wave of leaders had been depleted by half. My main responsibility in the second half of 2009 was to shore up the firm's foundation, rebuild the London office, and position KPF for future growth.

In the past, I would gather everyone in the firm together once a month and give a "state of the union" talk. In good times, it was a chance to show off our best new projects and give rising stars a chance to shine. In bad times, it was an effective way of updating everyone on what was happening and calming their fears. Being transparent is the best way of dealing with rumors.

After moving to London, I met with the staff all the time and talked to them honestly about our challenges and our goals. I had an open-door policy and made it clear that anyone could come talk to me. People in the office were surprised by this. Most of them didn't have this kind of access to Lee. He was the boss. He wasn't the sort of person a typical employee could just sit down with and have a casual chat. But I loved talking with them and learning about their interests outside of architecture and what they did on their last vacation. I wanted them to feel they were part of a team that was designed to do great things together. This approach was new to our people in London. Over the course of a few months, the great majority of our employees there shifted from preparing themselves to jump ship to rededicating themselves to KPF. It was hard work convincing people one by one to stick with us, but it was also incredibly rewarding to me. It gave me the chance to tell them about KPF's values and what we

stand for. In the process, it reaffirmed to me the importance of holding the firm together and energizing our London colleagues.

John Bushell was a big help in keeping things together. A talented designer, John had earned the respect of the entire staff and was an invaluable asset in my meetings with employees. He didn't get along with Lee, and had a different view of running an architectural firm. He also felt a deep loyalty to KPF, having joined us in 1994, and believed it was important to behave in a principled way. He proved to be a rock in our battle to save London, convincing key people in the office to stick with us, people who then convinced others to do the same.

On one of my trips back to New York, I met with David Silfen, a close friend who had been a leading partner at Goldman Sachs and a trustee of the University of Pennsylvania, and talked to him about the situation in London. He shook his head and said, "This kind of split often happens with law firms. But it is much rarer with architects." I gave him a quick overview of the projects that the London office was working on. "You would be a fool to walk away from it," he said. "If you are a global firm, you need to be in London. Giving up the office and all of its projects is giving up your legacy." He also said the Abu Dhabi airport would be a key to getting future airports and other large projects, which proved to be true. His support encouraged me to follow my beliefs and continue the fight for our London office.

My second big task was to hold on to as many of these projects as possible. So I immediately called every one of our London clients and set up meetings.

Paul Katz joined me for most of these appointments, contributing his energy and insights to the conversations. Although he had once thought of siding with Lee in splitting up the firm, he now was a tireless warrior for saving our London business. A true competitor, Paul was determined to win back every project, convince every client to stay with us. To many clients, though, Lee appeared to represent continuity. He had long relationships with them and knew their projects. But the clients had signed contracts with KPF, not Lee Polisano.

The biggest project was the Midfield Terminal Complex at the Abu Dhabi airport, a job we won in August 2006 and would need more than a decade to work on from schematic design to the completion of construction. At nearly eight million square feet, the terminal would have sixty-five gates

and handle eighty million passengers a year. It was the kind of long-term project that every big firm hopes to land, because it offered a fantastic design opportunity and the chance to keep several dozen architects busy for many years. Without this job, our London office would be in trouble.

For the first few months, Lee and his cohorts continued to work from the same offices in Covent Garden as we did. Not only was this awkward, to say the least, but it maintained the illusion that he still represented KPF.

I spent a lot of time in the second half of 2009 talking to lawyers, and the bills added up quickly. But we got Lee to move his new firm to another location and eventually resolved all outstanding issues with the departing partners.

It was a long, hard battle, but in the end, we kept about three-quarters of our employees and about the same percent of our projects. After several trips to Abu Dhabi, Paul and I made sure the airport there didn't slip away from us. We retained other key projects, such as the Heron Tower in the City of London and various buildings at Canary Wharf, and built relationships that have led to a growing roster of work. Today, the airport in Abu Dhabi is about to open and our London office is busier than ever. Some fights make you stronger.

Shanghai World Financial Center

Vertical Urbanism

With their high population densities, cities in Asia have served as laboratories for innovative urbanism during the past few decades. New York has a density of 27,016 people per square mile. Compare that to 107,561 in Manila, or 54,790 in Macau. When land is so precious, planners, developers, and architects need to be creative in how they think about the way people live, work, and get around. Our Japan Rail complex in Nagoya, for example, includes a shopping center with fifteen floors of retail, which is unheard-of in the US. In Asia, people think nothing about going to a restaurant on the top of a skyscraper, and developers don't flinch at stacking a hotel, condominium apartments, office space, entertainment, and retail all in one building. The result is a vibrant mix of uses and people. Such development might not work everywhere, but it does well in places with strong urban infrastructure.

Cars are extremely expensive to own in Asia, so most people use mass transit. Shanghai's subway system started operation only in 1993 but now has 398 miles of track. During that same period, New York City added exactly three miles to its system. In New York, about 5.7 million passengers use the subway each day, compared to about ten million in Shanghai.

In the past, people saw density as a problem. Today, we understand it can be a solution to some of our critical environmental issues. Denser places have smaller carbon footprints—using less energy and generating less pollution per person. Of course, they face other kinds of challenges, such as dealing with congestion, affordability, income disparity, and quality-of-life issues. In the US, 82 percent of the population now lives in cities, up from 70 percent in 1960. In China, 58 percent of the people reside in urban areas now, a dramatic increase from 1960 when only 16 percent were there.

During the past three decades, hundreds of millions of people have migrated from China's countryside to its cities, generating a radical transformation that is both awe-inspiring and frightening. Anyone who has visited Shanghai or Beijing or Shenzhen multiple times in recent decades has seen

massive change in action—modern business districts rising out of nowhere, remarkable museums popping up everywhere, and extensive shopping and entertainment options opening for an emerging middle class. At the same time, though, vibrant neighborhoods have been torn down, and large numbers of people have been moved into soulless housing blocks. It's the urban equivalent of the good, the bad, and the ugly.

When properly harnessed, the extreme economic and social pressures found in Asian cities can produce amazing places. Our Nagoya project, which was our introduction to this part of the world, brought together a corporate headquarters, office space for other companies, a five-star hotel, a convention center, restaurants, and shops—all sitting on top of a multimodal transit hub with two national rail lines, two private railways, four subway lines, and a station for both local and intercity buses. That's a lot going on in one complex! But each use helps the others. Clients of Japan Rail and any of the other companies with offices there can take a train from Tokyo, have a business meeting, go to lunch, do some shopping, and then spend a night at the hotel without leaving the complex. People arriving by bus and local residents who work in the area can frequent the restaurants and shops, too, making them more economically viable and socially diverse. It's a win-win-win situation.

Since that project, KPF has been continually developing strategies for what we call vertical urbanism. We've learned that more is better than less, that people like to be around other people, that diversity is a strength. Although big, mixed-use projects are difficult to assemble, plan, design, and build, their size allows them to provide amenities that aren't economical in smaller ones. They can amortize the costs of gardens, plazas, public art, cultural programs, and the services of the best architects, landscape designers, engineers, and consultants.

While working on the Japan Rail Towers and Station in Nagoya, Paul Katz and I met with Minoru Mori, the second in command at Mori Building, one of the biggest developers in Tokyo. A remarkable man who studied Camus and Sartre at Tokyo University and was writing a novel in 1959 when he joined his father's real estate company, he had a powerful vision for remaking cities. Instead of merely developing office towers or apartment buildings on the small sites usually available in big cities like Tokyo, he wanted to generate a new kind of urbanism that would bring public open space and

Top: Michael Greene and Ko Makabe are two of our principals who have been involved in our high-rise work in Asia.
Bottom: Minoru Mori talked to my students at Harvard about his vision for vertical cities and how Roppongi Hills created a new development model for Tokyo and other parts of the world.

the arts to the densest parts of town. By combining living and working in one development, he could radically reduce commuting times, which can be a couple of hours each way for some people in Tokyo.

Although cherry blossoms and exquisite gardens often come to mind when we think of Japan, Tokyo actually has one of the lowest amounts of green space of any major global city. Vienna devotes 45.5 percent of its land-mass to public parks and gardens, and New York has set aside 27 percent. In Tokyo, the figure is just 7.5 percent. The city has some big parks, such as Yoyogi and Ueno, but very few neighborhood green spaces.

Mr. Mori recognized this problem and decided to address it. After seven-teen years of work, he opened the ARK Hills complex in 1986 in the Minato district. In addition to a thirty-seven-story office tower, it includes several apartment buildings, the Suntory Concert Hall, a television studio, restau-rants, shops, and a series of gardens open to the public. It pioneered a new type of development for Tokyo that went well beyond the typical office build-ing with some retail at the base.

In 1991, *Forbes* magazine named Mr. Mori's father, Taikichiro Mori, the world's wealthiest man with a net worth of $15 billion. The elder Mori, who started his real estate business in 1959 after teaching economics and serving as the dean of the faculty of commerce at Yokohama City University, re-mained active in the company, even though his two sons, Minoru and Akira, ran much of the day-to-day operations.

Paul Katz and I had some wonderful conversations with Minoru Mori. He was a big admirer of Le Corbusier, who had designed the National Museum of Western Art in Ueno Park, which opened the same year his father started Mori Building. I told him about attending a Le Corbusier lecture at Penn when I was a student and how I wished I had grabbed some of the drawings created during the talk. He laughed and told me I could come over to his private club at the top of the ARK Hills complex and take a look at his collec-tion of three hundred Le Corbusier drawings and paintings. We talked about his ideas of the city and how Tokyo needed to build taller. He was frustrated that government officials and building codes discouraged anything over fifty stories, a legacy of the city's long and tragic history with earthquakes and fires. Modern engineering, though, made such restrictions unnecessary, he said. There's no reason why a seventy-five- or one-hundred-story tower to-day can't be the safest place to be in an earthquake, he told us. We agreed.

(Another quirky requirement particular to Tokyo was that no building could block television transmission to the Imperial Palace at the center of the city.)

Mr. Mori was starting to work on a new project, similar to ARK Hills, but much bigger and more ambitious. For nearly fourteen years, he had been quietly purchasing small parcels of land—about four hundred of them—and had finally assembled a twenty-eight-acre site in the Roppongi area, where he could develop what would essentially be a city within the city. Roppongi was not the best part of town—far from it. Perhaps best known for its concentration of foreign embassies and hostess bars, the neighborhood attracted a lot of expats and tourists looking for a good time. It wasn't where you would first think of building an upscale, mixed-use complex. Not that many people were thinking of building anything big in Japan at that time. Ever since the so-called Bubble Economy burst in early 1992, Japan had been mired in a terrible recession, with prices spiraling downward and demand for almost everything dropping, too. No end seemed to be in sight in the 1990s, so planning a gigantic development and doing it in Roppongi took a lot of guts. Minoru Mori had plenty of guts.

During this period, I met with Mr. Mori about six times, usually for lunch or dinner and usually with Paul. He talked to us about his ideas for the Roppongi project and how he wanted it to be a place where people could live and work and find art, green space, and all kinds of activities. He wanted to update Le Corbusier's vision of "vertical garden cities," improving the concept by reducing its dependence on automobiles and emphasizing the pedestrian experience. Although reserved in demeanor, he was passionate in his pursuit of a new form of urbanism.

And unrelenting in his determination. According to an article in *Fortune* in 2008, Mr. Mori or his representatives attended eight hundred meetings with five hundred individual landowners to put together the site for what became Roppongi Hills. He also needed countless meetings with city officials to get all the approvals for a complex that broke dramatically with the standard model of development in Tokyo at the time. So many people were skeptical of the scale, timing, and economics of his plan. Even his brother, Akira, was critical of the high-risk strategy of borrowing large sums of money to fund the project. Before it was built, Akira split with his brother, left the company, and started his own development business, Mori Trust, which undertook more traditional, less risky projects.

When Roppongi Hills in Tokyo opened in 2003, it was the largest private development in Japanese history with thirteen buildings and 8.2 million square feet of space. KPF did the master plan with Yoshito Kato, as well as the architecture for many of the key buildings, including the fifty-four-story tower at its heart.

Between our meetings with Minoru Mori, Paul and I sketched up ideas for him, working in consultation with his architect Yoshito Kato, a chain-smoker who endeared himself to us with his positive attitude and remarkable knowledge of local conditions. We hadn't been hired to do anything, but we knew that drawings would help Mr. Mori see what we could contribute and that we shared his vision. They helped us develop our approach to the project—how the huge complex would engage with the dense neighborhoods around it, how it would connect with the city's mass-transit systems and existing streets, how it would create a unique kind of place within its confines, and how it might relate to Tokyo's skyline. These conversations helped us establish a strong bond with Mr. Mori as both a businessman and a person.

Finally, he told us, "You need to meet my father." Minoru Mori was nearly sixty years old but always deferred to his father. All big decisions needed to be approved by the family patriarch. He set up a time for me to meet him on my next trip to Japan.

On the day of the big meeting, Paul and I were nervous. We were new to Japan and still learning the culture and business etiquette. Taikichiro Mori was a revered figure in Japan—a former educator and a spectacularly successful businessman. Hell, he was the richest man in the world!

Wanting to make the most of our time in Tokyo, Paul and I set up a second and a third appointment for later in the day. The younger Mr. Mori had told us that the meeting with his father would probably be short, maybe just a half hour. So Paul set up our second meeting for an hour and a half later. That should give us plenty of time, we figured.

We arrived at the Mori headquarters a bit early and chatted with Minoru Mori in his office. He was always formal in business situations, but was even more straight-backed than usual that day. Paul and I could feel a certain tension in the air. At exactly the time of the appointment, I walked over to the father's office, while Paul remained with the younger Mori. It would be just the two gray-haired guys in conversation.

I was greeted by an aide who explained that he would serve as translator. The father stood up from his desk, beautifully attired in a traditional Japanese kimono. I bowed my head in my awkward American way, wondering if I was doing it properly. The aide handed me a silver tray with Mr. Mori's name card. I took it and held it in both hands, as I had learned to do in earlier meetings. In Japan, a person's business card, or *meishi*, isn't just

a piece of cardboard with some helpful information on it. No, it's a physical manifestation of the person himself and must be treated with the same kind of respect. I had heard stories of Americans who had absentmindedly fiddled with business cards in meetings and shocked older Japanese people with such casual care. As I held Mori-san's *meishi*, I looked at it for several seconds, showing that I recognized the importance of the person it represented. I bowed again and gave him my own business card. He took it, held it in both hands, inspected it slowly, and bowed his head.

Formality is an art form in Japan. It's a connection to the past and adds rigor to behavior in the present. It's often difficult for Americans to understand or appreciate, but it has a certain beauty to it. It also takes time.

Although in his mid-eighties, Taikichiro Mori was sharp as a tack. He asked me a series of questions about KPF's approach to architecture, our process, and our ideas about the Roppongi project. He listened politely as his aide translated my answers into Japanese and his questions into English. After an hour, I realized there was no way Paul and I were going to make our next appointments. Luckily, I knew Paul would figure this out and reschedule the later meetings.

The back-and-forth with the elder Mr. Mori went smoothly, albeit slowly. After nearly two hours, he asked me one final question. "Mr. Kohn, what can you do for my company?" I thought to myself, "This is the richest man in the world. He has done fine all these years without KPF." So I answered him honestly. "Mr. Mori, there's little we can do for you. Your success over the years proves that. But I think that if we work together, we can do great things." He thought about my reply for a moment and bowed his head. I seemed to have given him the right answer. While KPF might not be able to do a lot for Mori, he, of course, could do a great deal for us!

We got the job and worked on it for more than a decade. The Moris were fantastic clients—smart, engaged, dedicated to quality, and totally reliable in everything they said or promised. We never had to worry about getting paid on time or finding the client cutting corners. There were some bumps along the way, and we didn't agree on everything. But we always knew where we stood and that our input would be properly considered.

Minoru Mori had strong opinions and knew what he was doing. From the beginning, he and I had a number of disagreements. I originally recommended that the office component be a pair of buildings with a common

base, so the project could provide large floors at the bottom and smaller ones in the two towers above. He said no, it would be one structure that would have very large plates on all floors, the better to attract financial services companies that need trading floors with huge amounts of flexible space. In the early 1990s, with Japan's economy stuck in neutral, that seemed like a crazy approach. But he was right. When Roppongi Hills opened in 2003, it became home to Goldman Sachs, Lehman Brothers, top Japanese law firms, and online-retail companies. In its first year, the fifty-four-story, four-million-square-foot tower was 90 percent occupied.

With Mr. Mori, I sometimes took a contrarian position to generate a full discussion of different strategies. He didn't always like this, since top executives in Japan are rarely challenged in business meetings. At a few points, I thought he was going to fire us. But to his credit, he stuck with us and grew to appreciate the value of our debates. Both of us soon realized that the energetic project meetings would make Roppongi Hills better and more successful. We had a great team at KPF working on the huge complex, including Bill Pedersen, Paul Katz, Doug Hocking, and Craig Nealy, as well as myself.

As the project moved forward—getting funding and approvals, starting construction in 2000, and finally opening in March 2003—Mr. Mori and I became close friends. In meetings, he was all business and always prepared. But over dinner, often with his wife, Yoshiko, a sophisticated woman who spoke English very well, he would loosen up, and we would have great, rambling conversations about cities, architecture, art, education, business, and whatever might be in the news.

One time at a gallery in New York, I saw a beautiful Le Corbusier drawing for sale. I sent a note to Mr. Mori's office, thinking he might want to buy it. His art adviser came to New York, took a look, and decided not to purchase it. Mori's collection was so extensive it had very few holes that needed to be filled.

Roppongi Hills turned out to be the largest private-sector development in Japanese history, encompassing thirteen buildings with a total floor area of 8.2 million square feet and costing $2.47 billion, excluding land costs. KPF did the master plan (with Mr. Kato) for the entire complex, as well as the architecture for the central office tower, commercial and educational spaces in the tower, the shell of a multiplex movie theater, and the 380-room Grand Hyatt Hotel. New York architect Richard Gluckman designed a two-story contemporary art museum at the top of the tower, which had been suggested

Minoru Mori and I worked on the Shanghai World Financial Center for more than a decade, waiting out a recession in Asia in the late 1990s and revising the design a number of times. Today it rises 1,614 feet in the Pudong district, near SOM's shorter Jin Mao Tower.

by the Guggenheim's Thomas Krens, and a five-story glass cone at the base that gets people's attention and directs them to elevators to the museum and an observation deck on the fifty-fourth floor. Fumihiko Maki, a Pritzker Prize winner and one of the most esteemed architects in the world, created a 795,000-square-foot broadcasting center for TV Asahi, while Terence Conran designed four apartment towers and Jon Jerde did the retail components. The complex also includes a Virgin Group multiplex cinema and amazing gardens and art-filled plazas. It has structured parking for 2,760 vehicles and connects directly to Tokyo's metro system.

From the day it opened in March 2003, Roppongi Hills has been a huge hit with the public. In its first six months of operation, it attracted twenty-six million visitors, more than double what Tokyo's top two theme parks, Tokyo Disneyland and Tokyo DisneySea, typically draw. During its first year, forty-two million people came to shop, dine, relax in the gardens, see movies, go to work, and appreciate all of the artwork animating the grounds and the Mori Museum. A *New York Times* article in October 2003 quoted Mr. Mori as saying, "You could call it a theme park, but a theme park with a theme of art." The same article states, "Slightly larger than Rockefeller Center, Roppongi Hills offers a host of multiple uses, blended so well that consumers here defy the stereotype of Japanese savers sitting on their wallets."

Three years later, a *New York Times* article about a book of photographs taken at Roppongi Hills said, "Mori Building now sets the standard for most things in the city, from architectural aesthetics to art to food to fashion." It goes on to say that, "Understandably, high-end brands compete ruthlessly for floor space in Roppongi Hills; it's a mark of success and ultra-high visibility to be able to afford retail floor space, however small, in the Hills complex."

Roppongi Hills not only validated Mr. Mori's business strategy, but would confirm his faith in modern engineering's ability to create safer buildings. During the horrific 9.0 Tohoku earthquake and tsunami on March 11, 2011, the Mori Tower at Roppongi Hills performed exactly as experts at Kozo Keikaku Engineering had designed it to—swaying, but not breaking. The tower was perhaps the safest place to be in Tokyo on that fateful day. In the months afterward, many big companies moved their offices to the tower, wanting to protect their employees and their operations in any future emergency.

Not one to rest on his laurels, Mr. Mori began work on another record-setting project—this one in Shanghai—even before construction started on

Roppongi Hills. In Tokyo he needed many years to assemble the Roppongi site and had to fight to get a fifty-four-story building approved. But in Shanghai, the city government offered him a large piece of land in the still-emerging Pudong district across the Huangpu River from the city's historic core and requested that he build tall, very tall.

Mr. Mori asked me if we had any experience in China, and I mentioned our Plaza 66 project in Shanghai, which we designed for Ronnie Chan's Hang Lung Properties. It was under construction at the time—the mid-1990s—on Nanjing Road, the city's premier commercial street. That China experience convinced Mori to give us the job of designing his Shanghai building.

Inspired by the opportunity, Bill Pedersen developed a remarkably elegant tower that uses abstract geometry—rather than clichés such as pagodas—to refer to Chinese culture. The floor plan starts as a square (ideal for office tenants), then turns into a lozenge on the upper levels where a hotel would reside. Beginning with a rectangular prism, the symbol used by the ancient Chinese to represent the earth, Bill carved away at the form with two vertical arcs that make the building look broad from some directions and slender from others. He punctured the top with a perfect circle that in Chinese geometry symbolizes the sky and alludes to traditional moon gates. Mr. Mori even envisioned a gondola ride spinning visitors around the circle. The opening also served a more practical function—dramatically reducing wind loads on the structure. The tower was one of Bill's most brilliant designs.

The Shanghai government was eager to develop this part of Pudong into a new central business district known as Lujiazui and told Mr. Mori that his building would be the tallest in the city: ninety-four stories. Next door was Skidmore, Owings & Merrill's Jin Mao Tower, which began construction in 1994 and would be eighty-eight stories when it was completed in 1999. The pace and scale of work in Pudong was breathtaking. Everyone was excited when construction began in 1997 on our super-tall, which would be called the Shanghai World Financial Center (SWFC).

Then the Asian financial crisis hit, starting with the collapse of the Thai baht in July 1997 and roiling the economies of the Philippines, Indonesia, South Korea, Hong Kong, Malaysia, Japan, and China. After the enormous concrete foundation of the SWFC had been poured, construction was halted. For five years, nothing happened.

REFUGEE FLOOR

REFUGEE FLOOR

REFUGEE FLOOR

REFUGEE FLOOR

REFUGEE FLOOR

REFUGEE FLOOR

REFUGEE FLOOR

Seen in cross-section, the SWFC reveals the way it stacks a series of different uses on top of each other. From the bottom to the top, it provides space for parking, shopping, offices, hotel, a multi-story sky lobby, and observation. While the building is most famous for its cut-out top, its form shifts as you move around it and the cut-out disappears from certain angles.

Working with Morgan Stanley, Mr. Mori finally put together new financing for the tower, and we returned our attention to it. The Chinese economy was surging again and so were ambitions for its major cities. The mayor of Shanghai, Chen Liangyu, met with Mr. Mori and told him how important the project was to the city's efforts to establish Pudong as a glittering symbol of progress. Looking at a model of the building, he said, "Make it taller."

While keeping the essential ideas behind Bill's design and the foundation that had already been poured, we collaborated with structural engineer Leslie Robertson to update the project. We stretched it to 101 stories and abandoned the original concrete-frame system in favor of a diagonal-braced steel frame with outrigger trusses attached to mega-columns made of concrete and steel. These changes reduced the weight of the building by 10 percent, saving money on materials and producing a more elegant form.

In terms of program, we stacked a series of uses on top of each other to create a vertical city: a shopping center at the base, followed by sixty-two floors of offices, a fourteen-story Park Hyatt hotel with 174 rooms, and finally, a multilevel observation and visitors' center at the top.

After unveiling the revised design, which elicited glowing remarks from the mayor, we heard nothing for many months. No one could figure out what was happening. Finally, the mayor announced he needed to talk to us. Bill flew to Shanghai for an emergency meeting, and we all held our breaths. "I love your design," he told Bill. "I know you see the circle at the top as a moon gate, but to us, it is the symbol of Japan. We can't have the rising sun of Japan overlooking our city ever again," he said, pointing at the circular aperture at the top of the building. Japan's brutal occupation of China in the 1930s and '40s was a dark moment in the history of the two countries and its legacy could be found by scraping just below the sometimes bumpy surface of contemporary relations. Some people had made comments associating the opening at the top of our building with the Japanese flag, and the mayor was feeling the heat.

During the course of the next few months, we proposed a variety of changes to our design. At first, Bill suggested a bridge near the bottom of the opening, but the Chinese said that wasn't enough. We needed to find a different geometry. So we developed a series of alternatives and eventually settled on a trapezoid that's wider at the top so it reaches out to the sky. It's not as elemental as a circle, but it has the advantage of being more surprising, less expected. Some people think it makes the building look like a giant

bottle opener. And, in fact, today, the gift shop at the top of the tower sells bottle openers in the shape of the building. I have one.

Mr. Mori's wife, Yoshiko, sat on the board of the Tate Modern museum in London, and both she and he enjoyed spending time in the UK. So Paul, Bill, and I often met them in London, either in our offices at Covent Garden or at a restaurant. I remember one meeting early on when we brought a bunch of models of the building to dinner with us and set them up on the table. We had a great time that evening, discussing the project and enjoying each other's company. That was when we picked the scheme with the circular opening at the top.

We continued to develop our scheme, responding to requests by the client and the Shanghai government. A lot of debate focused on the height of the tower. The original design called for a ninety-four-story building reaching 1,509 feet. The post–financial crisis plan was for a 101-story structure, but its exact height kept changing. The mayor wanted it to be the world's tallest, so we designed a version at 1,675 feet, which would make it a few feet higher than Taipei 101, nearing completion in Taiwan. Other people in the government, though, were pushing for a cap lower than that. In the end, we gave them a building that rises 1,614 feet. Although it didn't surpass the spire on top of Taipei 101, its roof and observation floors were the highest in the world at the time, beating out its rival in Taiwan. For a while, some people in the Shanghai government asked if we could add a spire to our building, a terrible idea that would have ruined the elegant form of Bill's design. Mr. Mori helped us resist that ill-conceived notion. To us, chasing the distinction of "world's tallest" was a fool's errand, since there would always be a future building that would take away the honor. Taipei 101 held the record for just five years before the Burj Khalifa in Dubai shattered it by more than one thousand feet. As amazing as that feat might be, it will soon be eclipsed by the Jeddah Tower in Saudi Arabia, which will rise one kilometer high (3,281 feet) when it is completed around 2020.

SWFC opened in August 2008 and immediately attracted big crowds to its observation and visitor center. Everybody wanted to cross the Skywalk on the hundredth story with its see-through glass floor providing vertiginous views of Pudong and the rest of Shanghai. So many people pay to visit this attraction that it generates eight times the revenue of a typical office floor! At the official opening of the building, Jose Carreras, one of the Three Tenors,

sang for a group of invited guests on the ninety-third floor. After he finished, it was my turn to make a few remarks. I turned to the famous singer and asked, "Is it easier to hit the high notes when you're on the ninety-third floor?" Everybody laughed, except Carreras, who gave me a look that seemed to say, "Are you crazy?"

The Park Hyatt in the SWFC has been a big hit, too, and the three-story collection of restaurants and bars at the top of the hotel, which was designed by Tony Chi, serves as a fabulous place to eat, relax, and enjoy the views.

The tower has earned a host of important design awards, including Best Tall Building Overall from the Council on Tall Buildings and Urban Habitat (CTBUH) in 2008, beating out Renzo Piano's *New York Times* Building, Norman Foster's 51 Lime Street in London, and Atkins's Bahrain World Trade Center. Tim Johnson, the CTBUH awards chairman that year and a partner at the firm NBBJ, which has designed skyscrapers around the world, said our "building's structure is nothing short of genius." *Architect* magazine honored SWFC in its Annual Design Review in 2009, quoting several jurors for the awards program, such as critic and educator Aaron Betsky, who called the building "one of the most elegant skyscrapers of recent years." Ralph Johnson, a partner at Perkins + Will, who also served on the jury, said, "It goes from very thin to very wide. Every angle of the tower is different as you go around the city." Getting such praise from our peers (and competitors) made me very proud.

A few months before SWFC opened, I invited Mr. Mori to lecture at a class I was teaching at Harvard's business school on strategic positioning in the real estate industry. (I've taught at both the business school and Harvard's Graduate School of Design.) He was thrilled by the opportunity and prepared a case study on Roppongi Hills as a "city within a city." The students read about the project ahead of time and wrote questions for Mr. Mori. To keep things moving in class, I had someone translate the questions into Japanese and send them to Mr. Mori, so he could prepare replies ahead of time. Harvard treated him as a star, arranging a lovely dinner at the dean's house the evening before and having someone drive him around Cambridge and Boston. In class, I introduced him as "the most unusual developer I have ever met." In his presentation, he told the students that to succeed in the real estate business, you need to have a clear vision. Then he explained exactly how he turned his vision into reality at Roppongi Hills. He talked

about vertical garden cities and how such places can be more compact and environmentally responsible than traditional ones. All of the Japanese students in the class were dressed in their best business attire and, at the end of the lecture, they lined up to give him their name cards. Mr. Mori loved the whole experience—visiting Harvard, spending time with the students, and expounding on his ideas about twenty-first-century urbanism. His wife later told me that his Harvard lecture was one of the highlights of his life.

In March 2012, Minoru Mori died at the age of seventy-seven. In its obituary of him, the *New York Times* quoted him as saying, "Asia is different from the United States and Europe. We dream of more vertical cities. In fact, the only choice here is to go up and use the sky."

In 2000, KPF was invited to compete in a design competition for a supertall building in Hong Kong's Kowloon district being developed by Sun Hung Kai Properties and the city's Mass Transit Railway (MTR). Sun Hung Kai, which was one of Hong Kong's biggest developers, had been founded in 1963 by Kwok Tak-seng, but by the turn of the millennium was being run by his three sons—Walter, Thomas, and Raymond—and his widow, Kwong Siu-hing. To be constructed on top of the new Kowloon Station, a fast-developing hub for trains to the recently completed airport and later to Shenzhen and other parts of China, the tower would provide 2.8 million square feet for a shopping mall, offices, a hotel, restaurants, and an observation deck. Our growing reputation with skyscrapers and our experience with projects such as the Japan Rail Towers in Nagoya, which integrate seamlessly with complex transit systems, helped get us on the list of invited architects. In the end, we beat out some very talented firms, including SOM, Pelli Clarke Pelli, and Kenzō Tange Associates for what would be called the International Commerce Centre (ICC).

Although not a household name in the US, the Kwok family often makes splashy news in Hong Kong. For example, the eldest son, Walter, was forced out of the business in 2008 by his mother, who controlled more than 40 percent of the company through a trust fund. According to local publications, Walter's mistress was wielding undue influence on him and his business decisions. In 2014, Thomas was found guilty of trying to bribe a government official and was given a five-year prison sentence, while his brother Raymond was acquitted of the same charge. Luckily, none of this affected our project or our relationship with Sun Hung Kai Properties.

An instant landmark for a part of Hong Kong that was still emerging, still filling in.

As we started work on the ICC, our client was busy building another super-tall directly across Victoria Harbor. Designed by Pelli Clarke Pelli, that project—named the International Finance Centre (IFC)—featured an eighty-eight-story building sitting on top of another transit hub and multi-level shopping mall. When completed, the two towers would act as a gateway straddling the narrowest part of the harbor, a pair of lighthouses visually connecting Kowloon with the Central district on Hong Kong Island. Underneath the harbor, a new express train would whisk people from one complex to the other in just a few minutes. In Hong Kong, the government has used major infrastructure projects—such as the construction of the airport on Chek Lap Kok Island, which opened in 1998, and the mass transit lines connecting the airport to the rest of the city—as magnets for private development. By selling the rights to build on top of mass transit stations to private companies, the government was able to pay for the public infrastructure, while focusing development in exactly the places it wanted. It was a brilliant strategy that worked exactly as planned.

Built as a catalyst for developing a new part of town on 825 acres of reclaimed land, Kowloon Station opened in 1998. Plans called for more than 7.25 million square feet of apartment towers, one million square feet of retail, 2.5 million square feet of office space, and two hotels—a Ritz-Carlton in our project and a W in a nearby tower. Another portion of the landfill would be turned into the West Kowloon Cultural District, an ambitious project master planned by Foster + Partners that would include a waterfront park, performing arts venues, and museums. Towering over all of this would be the ICC—118 stories and 1,588 feet tall.

Bill Pedersen and his team designed the ICC as a sleek shaft that tapers at the top and greets the ground plane on the north side with a curving glass shed that projects out to form an elongated entry canopy. To reduce wind loads, we cut away notched or "reentrant" corners and inclined the upper third of the tower one degree as it rises. The four main facades of the building are treated as individual planes separated by the chiseled corners, so they seem to not quite touch. By assembling the curtain wall out of overlapping panels one story high, we gave it a shingled profile that creates a dappled play of light and shadow. Bill sometimes referred to this shingled skin as scales on a dragon and the curving entry canopy as the tail, alluding to the Cantonese meaning of Kowloon: "nine dragons."

Making the building environmentally responsible was an important aspect of the project. Today green design is an essential part of almost any building, but back then it was less common. So in addition to the way it animates the building's envelope, we liked the shingled curtain wall because each panel shades the one below it and reduces the amount of energy needed to cool the interiors. We also specified a silver-coated, insulating glass that reflects the heat-generating spectrum of sunlight, while allowing the desirable visible spectrum to come inside. This glass provides three times the protection of uncoated glass, creating an important reduction in energy use. In addition, we worked with the Hong Kong Polytechnic University to develop a network of integrated sensors and energy-consumption monitors that help the building's HVAC system run more efficiently. As a result, the ICC uses 15 percent less energy than a typical office building.

Another unusual aspect of the project was the way it was built in phases—with each of four vertical blocks being constructed and fitted out, while the one above it was still under construction. This meant that tenants could move into one block before the rest of the building was finished. Although this made the entire project a bit more expensive and take longer, it provided the developer with revenue much sooner and limited the amount of office space hitting the market at any one time. It also provided an initial pool of customers for the shops and restaurants in the retail podium, so the public spaces in the project came alive sooner.

The logistics of such phasing, however, can be quite tricky, since you need to figure out how to keep building without disturbing the people already occupying lower parts of the tower. So, after the first tenants moved in, we used the south and west quadrants of the tower base as staging areas for constructing the upper portions. Concrete trucks docked at a pumping station in what would later become the hotel lobby. And cranes placed steel beams in an area that eventually would serve as the tenant drop-off. The ICC turned out to be the largest project up to that time to use vertical phasing.

When it opened in 2011, the ICC was an instant landmark for a part of town that was still emerging, still filling in. Today, with the first buildings in the West Kowloon Cultural District nearing completion, including the Xiqu theater complex designed by Canadian architect Bing Thom and the M+ museum designed by Herzog & de Meuron, the area around the ICC no longer feels like an urban edge. It's a vibrant part of Hong Kong that connects

Top: Aerial view of New Songdo City in Korea. KPF designed the enormous development as a smart city based on a strong environmental ethos.
Bottom: The Songdo Canal Walk area of the city is a pedestrian-oriented district where water, landscape, and architecture work together.

seamlessly with the bustling streets of old Kowloon and brings people right to the waterfront. Planning and building such a huge piece of urban real estate took decades and required incredible perseverance and faith. This kind of complex and expensive development is rare in the United States, but a number of forward-looking cities in Asia are undertaking it. KPF is fortunate to be working on projects in some of these places, reshaping skylines and streetscapes in the process.

Perhaps the most ambitious urban development we have tackled is Songdo, an entirely new city in South Korea. Just a fifteen-minute drive from Incheon International Airport, the country's busiest, Songdo was envisioned as a "smart" city that would showcase the latest digital technologies, as well as strategies for handling environmental issues such as waste, emissions, energy, traffic, and water. Much closer to the airport than Seoul, which is at least an hour and a half away by car, it could position itself to foreign businesses as a gateway to northeast Asia. About a third of the world's population is within a three-and-a-half-hour flight.

The Korean government jump-started the project by reclaiming fifteen hundred acres from the Yellow Sea on the west coast of the country. Then it looked for a private developer to build the city in collaboration with the government. The scale of the undertaking, though, was so enormous that it was difficult to generate much interest in the business community. It was a gigantic gamble, and none of the old-line development companies wanted to make the bet. After being rejected by the big guys in the field, the government started approaching less obvious candidates. At one point the Korean ambassador to the US contacted Tom O'Neill, a son of Tip O'Neill, the former speaker of the US House of Representatives, who suggested he speak with John B. Hynes III, whose grandfather had been mayor of Boston from 1950 to 1960. Such high-level activity on the part of the Korean government showed the importance it placed on building Songdo as a magnet for international businesses.

The scion of a powerful Boston family, John Hynes went to Harvard College, where he was captain of the hockey team in 1980, and then worked in real estate. He was still making a name for himself and working for other people in 2000 when the Koreans met with him. He had no track record in Asia and, reportedly, didn't even have a passport. He had recently become a partner at Gale & Wentworth, where he was overseeing the construction of

One Lincoln Street (now called State Street Financial Center), a thirty-seven-story office building in Boston. About fifteen years before, Stan Gale, the head of the New York–based company that his grandfather had started in 1922, established Gale International to work on foreign projects. Gale had done work in the US—mostly low-rise, residential buildings—but hadn't yet made much of an impact abroad. Other developers saw all of the risks in Songdo, but Stan and John saw it as their big chance.

Stan knows my son Steve, who was at the time president of Sonnenblick-Goldman, a real estate investment company that is now part of Cushman & Wakefield, and asked him to help out. When Stan agreed to build Songdo, Steve suggested that he give me a call. I remember talking to him about the project and trying to wrap my head around the numbers: a brand-new city for three hundred thousand people with eighty thousand apartments, fifty million square feet of office space, ten million square feet of retail, five million square feet of hotel facilities, a convention center, schools, campuses for foreign universities, parks, civic facilities, a world-class hospital, and the latest infrastructure. KPF had done a lot of master plans and urban design projects, but we had never done an entire city.

We wanted to make Songdo a great place to live and work, a smart city with a strong ethos of environmental responsibility. We would design it as a network of pedestrian-friendly districts and set aside 40 percent of it for green space, including neighborhood squares and a hundred-acre Central Park. All of the parking would be underground to free up space above for people to walk. A system of pneumatic tubes would suck trash from special receptacles and move it underground to a facility where it would be separated into recyclables and waste, some of which would be burned to create energy. All of the buildings would be connected by a digital network that allows residents and workers to conduct video chats with each other and control thermostats and lights remotely. If it's a cold day in January, you would be able to turn up the heat in your apartment when you're finishing up work at the office. Sensors in the buildings and streets would monitor energy use, lighting, and traffic flow to improve efficiency and sustainability.

This was all incredibly ambitious. And in 2001, it started to become a reality. Our team—led by Jamie von Klemperer and Richard Nemeth—did the master plan for the town (known officially as the Songdo International Business District) and designed the architecture for about 40 percent of the

buildings. Today, it is almost completed. It has twenty-two million square feet of LEED-certified space, which represents 40 percent of all the LEED-certified square footage in South Korea. Our 580,000-square-foot ConvensiA Convention Center, which opened in 2008, was the first convention center in Asia to earn LEED certification. A kilometer-long Canal Walk with shops, cafés, apartments, and offices connects business and residential neighborhoods and has become a popular place for people to gather.

Is Songdo perfect? No. Zoning regulations made it difficult to create truly great residential high-rises, and the transportation authorities required many roads to be wider than you would want in a town designed for pedestrians. Some of the tax breaks aimed at attracting foreign businesses haven't materialized, so the commercial parts of Songdo have lagged behind the residential projects and reduced its allure as an international hub. Some people have complained that the city feels empty and that the last buildings won't be done until 2020, several years later than originally projected. It's not unusual for some residents to run off to Seoul on weekends to partake in the urban bustle there.

But cities take a long time to grow, fill out, and become vibrant. A hundred years after Pierre L'Enfant developed his plan for Washington, DC, people were complaining that it was an urban wasteland that emptied out whenever Congress wasn't in session. Today, it has wonderful neighborhoods and an exciting civic life, no matter what the politicians' schedule might be. Songdo is still maturing and no doubt will get better with age. What has happened there in just twenty years, though, is nothing short of remarkable.

Songdo's legacy for KPF has been enormous. For one, it gave Jamie the chance to really prove himself as both a designer and a leader. It also led to another huge planning project for us—this one in China. Halfway through construction of Songdo, Gale International got a call from officials in Changsha, China, who basically said, "We saw Songdo and want one for us." Working with Gale, we developed a master plan for a 1,887-acre project called Meixi Lake that integrates architecture with parks, gardens, water, and mountains. The radial plan places a large lake at the center and fans out in a series of canals that connect eight neighborhood clusters housing ten thousand people. It also weaves in office buildings, cultural facilities, entertainment complexes, research-and-development blocks, and convention centers to create a community that will emphasize sustainability and healthy living.

Hudson Yards in New York.

Greater than Ever

I met Michael Bloomberg a few years before he became mayor of New York. His longtime companion, Diana Taylor, has been a good friend of my wife Barbara since Diana was at Smith Barney and Barbara was at Goldman Sachs and they worked together on funding a project in West Virginia. So I got to know Mike socially before he was elected in 2001. He was articulate and smart and didn't suffer fools gladly. I liked him immediately. When Barbara and I got married in 2002, he and Diana attended the wedding. The doorman of the building where we lived was impressed that we would occasionally get a visit from him.

In terms of work, I spent a fair amount of time with Mike in the course of KPF's involvement with plans to build a stadium on the west side of Manhattan that was a key element in New York's bid for the 2012 Olympics. I knew Jay Kriegel, who had served as Mayor John V. Lindsay's chief of staff and later became executive director of NYC2012, the organization behind the push to bring the Olympics to New York. Kriegel may not be a household name, but he's one of those dedicated people who make New York work. He and Dan Doctoroff, another savvy New Yorker, were the brains and muscle behind the Olympics bid.

The site for the stadium was the enormous rail yards west of Penn Station, twenty-eight acres of prime real estate dedicated to trains, not people. Although adjacent to the Javits Convention Center and just a few blocks from Penn Station, the main post office, and Madison Square Garden, the site was an urban black hole. The plan was to erect a giant platform above the tracks and build the stadium on top of the platform. Such a platform, though, is extremely expensive, in part because it has to be constructed while trains continue to run through the site and because it would have to support a very large building.

Thanks to the Japan Rail project in Nagoya, KPF had experience building on top of active train tracks. It also helped that I knew Jay Cross, who was the

president of the New York Jets, the NFL team that would be the main tenant of the stadium after the Olympics. Paul Katz and I first met Jay when he was running the real estate investment operations of Marlborough Properties, which hired us to design an office project called Thames Court in London back in the early 1990s. I kept in touch with him when he helped build the Air Canada Centre in Toronto for the Raptors and Maple Leafs and then oversaw construction of the American Airlines Arena in Miami for the Heat.

The Jets shared a stadium in New Jersey with the New York Giants, the area's other NFL team, and wanted to have a home of their own. KPF had done some studies of possible sites for them, but none had moved forward. The process, though, helped us develop strong relationships with the Jets' management and got us on the short list of firms to be considered for the Manhattan stadium. We ended up beating out SOM and Pei Cobb Freed.

The first time I met Woody Johnson, the owner of the Jets—who is now the US ambassador to the United Kingdom—was at a presentation we had organized at our offices. My daughter, Laurie Parkinson, who is a big Jets fan, had asked if she could come over and perhaps catch a glimpse of Johnson. I hesitated, but then hit on an idea. "Sure, drop by, and bring the twins." Her two youngest boys, Charlie and Matt, were about a year and a half old and adorable. On the day of the presentation, Laurie dressed the boys in bright-green Jets T-shirts and brought them up to the office. I gave each one a small banner reading, "Go, Jets!" and had Laurie wheel their double stroller into the conference room right before the meeting was about to begin. Johnson is known as a tough businessman, not a warm and fuzzy kind of guy. But when he saw Charlie and Matt waving their banners, he melted. The twins were a big hit with him, as was Laurie, who is one of the most sociable people in the world and can make friends with anyone. Whether the twins helped KPF land a huge project is an open question. I never ask clients why they select us, always figuring it's the strength of our ideas, our good looks, and our charm. Only if we don't get the job do I ask why.

It was a fun project to work on. Bill Pedersen and I met with the Jets' players and coaches to get their input on what they would like to see in a new stadium and how it should perform. Hanging out with them at their practice facility at Hofstra University on Long Island was a blast for two wannabe jocks like us. And since my family is filled with Jets fans, all of a sudden my esteem in their eyes soared, especially when Laurie and her two older boys,

Will and Alex, got the chance to travel with the team on a private train to a game in Baltimore. Will and Alex are both excellent athletes and played on their college football teams, Alex as a wide receiver on Princeton's undefeated 2018 Ivy League championship team.

Designing a football stadium for Manhattan was a huge challenge. Most teams put their stadiums in suburban locations, where they can surround the building with an ocean of parking. Driving to games and having tailgating parties before kickoff are revered NFL traditions. Taking the subway or arriving by taxi are not. Also, the Jets wanted the stadium to be a good urban citizen and help build a neighborhood, even though there wasn't really any sense of community around the rail yards where we would be building. So we wrapped the base of our stadium with restaurants, cafés, and bars that would stay open even when no games or events were taking place and designed a public park along the Hudson River. Running around the top of the building on the north and south sides would be rows of forty-foot-tall wind turbines and an array of solar panels that would generate energy and make the stadium a better environmental citizen.

To fit within Manhattan's street grid, the building was a rectangular box rather than the usual rounded form found at other stadiums. Bill used this constraint to develop a handsome design of crisply delineated planes and facades. A set of large, programmable LED screens would animate three sides of the building with moving images. A retractable roof would allow the playing field to serve as an extension to the nearby Javits Center, which would be connected underground. For the Olympics, the stadium would seat eighty-five thousand fans; afterward it would be trimmed down to accommodate seventy-five thousand for football games, concerts, and other special events. Our master plan for the project included a promenade and park on the north that would help connect the site to the river on the west and to the Penn Station area to the east. We were really proud of the design and felt it would make an important contribution to the transformation of a neglected part of town.

For a while, the client tried to lure James Dolan, the head of Cablevision and Madison Square Garden, to move his storied arena and teams—the Knicks and the Rangers—to our facility. In its current location, on top of Penn Station, Madison Square Garden prevented a true transformation of the sunken and charmless transit hub into something grander and more

beneficial to the urban fabric. Dolan toyed with the idea for a short while, then rejected it. After that, he became a vocal and free-spending critic of the plan to build a west side stadium, fearing our project would compete with Madison Square Garden for events and attention.

The architecture critic of the *New York Times*, Nicolai Ouroussoff, hated the whole project, including our design. In a review that ran in November 2004, he complained about the commercialized aspects of the project, including the shops, restaurants, and advertising on the LED screens. He even knocked the waterfront park, saying, "The park spaces, supposedly conceived as an act of civic generosity, are nothing more than banal front lawns for retail outlets." Such comments betrayed a lack of understanding of how cities work. People won't go to a park if there's nothing nearby to support it, especially one surrounded by rail yards, grimy industrial buildings, and car-body repair shops. Stores, restaurants, and a sports venue were absolutely essential to lure people to a mostly abandoned part of the far west side. Ouroussoff worried about the impact such establishments might have on the surrounding neighborhoods. What neighborhoods? No one lived anywhere close to our site. No one ever wandered nearby, unless they got lost leaving a convention at the Javits Center. Ouroussoff even waxed poetic about the "neighborhood's gritty but powerful mix of railyards and industrial buildings." I guess some aesthetes might find a certain charm to urban decay, but I would rather create a vibrant place where people can find other people and things to do.

Since its days as a Dutch trading outpost, New York has been a city that supports commerce and development. There are costs to growth, and change can be difficult for some people to accept. But New York has benefited greatly by regulations and a political climate that encourage building. Most construction projects move forward "as of right," which means they require no special approvals, as long as they meet zoning and building codes. Mayor Bloomberg's can-do attitude and smart management of the city's finances in the years after September 11 gave the business community confidence in New York's future. As a result, the economy took off and businesses started investing in some very big projects that would reshape the city's skyline and its neighborhoods.

After Bloomberg was elected mayor, he brought Doctoroff into his administration as deputy mayor for economic development and rebuilding and let him continue to shepherd the city's bid for the 2012 Olympics. In

addition to the main stadium above the rail yards, plans for the Olympics called for a series of other athletic facilities, parks, and major infrastructure projects around the city, including an extension of the Number 7 Line west of Times Square. The subway extension was critical to the bid, because it would link the main stadium to the rest of Manhattan and all the way to Flushing, Queens, where Shea Stadium and the US Open Tennis Center would also serve as Olympic venues.

It was a bold vision that looked beyond the Olympics to prepare the city to meet growing demand for better mass transit and improved environmental safeguards. Not everyone supported it, though. Some New Yorkers said the Olympics would ensnarl the city in traffic for two weeks and disrupt the routines of everyday residents. They didn't understand that the infrastructure projects embedded in the plan would make the city a better place for many years after the Olympics and would serve as catalysts for smart growth at key transit hubs, exactly where you want such development to happen.

While the mayor and many civic leaders pushed hard for the Olympics, some politicians opposed it, including many of the candidates running against Bloomberg in the 2005 elections. Another powerful foe was Sheldon Silver, who was speaker of the New York State Assembly. Most of the cost of the west side stadium would be paid by the Jets ($800 million), but the deal would require the city to pay $300 million to build the platform above the rail yards and the state to allocate $300 million for the stadium's retractable roof. Everything had to be approved before the International Olympic Committee (IOC) selected a host city on July 6, 2005.

I'm not a political analyst, but Silver's objection to the stadium seemed to be based on his fear that the redevelopment of the west side rail yards, which would also include major office and residential buildings, would compete with work being done at Ground Zero, which happened to be in the district he represented in lower Manhattan. I don't think Silver cared one way or the other about the stadium, but he wanted Bloomberg to delay commercial development around it until all the buildings at Ground Zero were leased. Bloomberg wouldn't agree to this because he understood that New York needed activity in both places. He wouldn't trade attention to one neighborhood for that in another. Great cities don't develop in a simple, linear fashion. As complex, networked organisms, they grow in multiple places and ways, all at the same time. During the twelve years of Bloomberg's

administration, the public and private sectors worked on significant projects in all five boroughs, transforming west midtown, lower Manhattan, downtown Brooklyn, Flushing, the west side of Queens, and great swaths of the waterfront along the Hudson and East Rivers. Each piece of development spurred work on other pieces, writing one of the most vibrant chapters in the city's history.

Joining Silver in opposition to the stadium was Dolan, the Madison Square Garden owner who spent $30 million in advertisements and lobbying to block the project. A month before the IOC would meet to announce the location of the 2012 Games, the Public Authorities Control Board rejected New York State's $300 million contribution to the stadium, effectively killing the project.

Bloomberg and Doctoroff scrambled to put together a plan B, which featured a new facility in Flushing to replace Shea Stadium and serve as the main Olympic venue. But KPF wasn't involved in that project, and the IOC ended up selecting London to host the 2012 Olympics. The Flushing stadium was approved by the city, even after the lost Olympic bid, and opened in 2009 as Citi Field, the new home of the New York Mets.

After all the hard work we had put into the west side stadium, its defeat was a bitter pill to swallow. Bill and his team had designed an amazing piece of urban architecture, one that would have helped revitalize a long-neglected part of the city and been a fantastic place to see a football game or attend a convention. I, for one, was looking forward to going there to attend the opening ceremonies of the Olympics, eating at the restaurants at its base, and taking my grandchildren to the parks around it. What a lost opportunity!

Failure, though, isn't always a dead end. With the Jets stadium, it actually laid the foundation for one of the biggest and most important projects in KPF's history.

Back in the late 1970s and early '80s, I got to know Ken Himmel, who had helped put together the mixed-use package for Water Tower Place in Chicago and then started working for my friend (and early client) Tom Klutznick. Ken had graduated from Cornell's famed hotel management school and would become an expert in fusing hotels, restaurants, and shops into vertical urban developments. After his success at Water Tower, he turned his attention to Copley Place in Boston and made it a vibrant addition to the Back Bay district. He opened a collection of acclaimed restaurants in Boston that includes

Top: As part of New York City's bid for the 2012 Olympics, KPF designed a stadium that could later be used by the New York Jets.
Bottom: With the support of Mayor Michael Bloomberg, KPF worked with the Related Companies to develop Hudson Yards on the same site as where the Olympics would have been.

Grill 23 & Bar, Harvest, Post 390, and Bistro du Midi. I'm a minor investor in Grill 23; if I were smarter and had more money at the time, I would have taken a bigger stake in it! In the mid-1990s, Ken started collaborating with Stephen Ross, the head of the Related Companies, helping the developer put together the hotel, restaurant, and retail components of the Time Warner Center, the gigantic project at Columbus Circle that would replace the much loathed and urbanistically disastrous Coliseum convention center.

KPF had competed for the Time Warner project back in the late 1980s as part of a team put together by the developer Olympia & York. The city, though, picked the proposal from Boston Properties, which had a design by Moshe Safdie. But community opposition to the height of the project and then the collapse of the commercial real estate market in 1989 killed the project. Before hiring Safdie, Boston Properties had asked us to design its project, but we had already committed to O&Y and had to say no. In 1996, the city once again requested proposals from developers and ended up picking Related, which had hired David Childs, the head of SOM's New York office, to design the 2.8-million-square-foot complex, and the Boston firm Elkus Manfredi to design the retail component of it.

I had been hearing a lot about Ross and his daring business strategies, so I asked Ken to introduce us. He arranged a meeting. When I arrived at the Related offices, I saw Childs and Ross reviewing plans for Time Warner. Ross invited me to take a look and give him my thoughts. SOM is one of our top competitors, and I would have loved the chance to design Time Warner. But David is an excellent architect, and I wasn't about to critique his work in front of his client. I certainly wouldn't want him to do that to me if the shoe were on the other foot.

Not long after that meeting, Steve became a trustee of the Urban Land Institute, where I already served in that role. At a ULI trustee meeting in Los Angeles, I saw him standing with a drink by himself and went over to reintroduce myself. During dinner that evening, we had a lively conversation, and near the end of it, he asked me, "Does KPF design university buildings?"

"Why, yes, we do," I replied. I mentioned some of the academic work we had done—such as the Wharton School of Business at the University of Pennsylvania—and talked about Jill Lerner, who oversees our education and institutional research projects. "Great. I'm planning on giving money to my alma mater, the University of Michigan, to build a new business school. I'll

have them put you on the list of architects to be considered for the job." We interviewed for the project and got it. Jill and Bill Pedersen designed a beautiful terra cotta, glass, and granite complex that includes both new and renovated structures. They worked closely with the dean of the business school, Robert J. Dolan, to make the buildings respond to the needs of the faculty, students, and staff. Phase one of the school opened in 2008 and prompted Jeff Blau, one of Steve's partners at the Related Companies, to give a large donation to help fund phase two, which we designed as well. Today, the Stephen M. Ross School of Business is one of the best in the nation, and our buildings there help give it a strong identity on the university's Ann Arbor campus, while providing really popular spaces for gathering, dining, and studying.

While the business school was under construction, Steve called me and asked KPF to help him put together a proposal for the west side rail yards. In the wake of New York's failed Olympics bid, the city issued a request for proposals for developing the twenty-eight-acre site where the Games and our stadium would have been. No one knew that piece of New York better than we did. We knew where every train trestle stood and where every track ran. We understood the history and geology of the place, the infrastructure running through it, and how you could build above an active rail yard. And we had explored countless strategies for creating a new neighborhood there.

Steve asked us to work on the master plan with Robert A. M. Stern Architects and the Miami-based firm Arquitectonica. I'm not a big fan of such design teams, because they tend to create plans that lack a coherent vision and character. But we were excited about the chance to tackle this challenging site once again and transform it into a new city within the city. For reasons I don't quite understand, representatives from Stern and Arquitectonica didn't show up for any of the meetings. Maybe they were busy with other projects. Maybe they didn't think Related's proposal would beat out the competition from other major developers: Extell, Tishman Speyer, Brookfield, and Vornado. We ended up doing all of the work on the plan, a fact that I communicated to Steve.

We worked really hard on the project, putting together a team of about fifteen KPF associates, who served in shifts twenty-four hours a day for two weeks straight. To accommodate this intense charette, we took over a space on the third floor of our office building, a grand room that the Steinway piano company had used in the past for musical recitals and rehearsals. It

Ross School of Business at the University of Michigan.

had great acoustics but no windows. Paul Katz and Brian Girard headed our team, working closely with me on the big ideas and overseeing the work of everyone else.

Our lead tenant at Hudson Yards was Rupert Murdoch's News Corporation, so we designed a great outdoor space that the media company could use for performances, live broadcasts, and special events. It was a wonderful integration of indoors and out, architecture and landscape, design and program. And it showcased one of our strengths: working closely with clients and users to develop plans that turned their needs into design opportunities.

About a week before the deadline for submitting the proposal, Murdoch backed out. That left Steve without an anchor tenant and almost no chance of winning the project.

In March 2008, the city and the Metropolitan Transportation Authority selected Tishman Speyer to develop the site now called Hudson Yards. Morgan Stanley would be a major investor and the lead tenant in the project. Once again, we confronted disappointment.

Just six weeks later, though, the deal fell apart. Rethinking its business position, Tishman demanded that the Hudson Yards deal not close until the area was rezoned for commercial use. The MTA refused and called Steve to see if he would take over the project. He was in China at the time and was given twenty-four hours to make a decision. It was May 2008, the subprime mortgage market was imploding, and many indicators were pointing the economy in a dangerous direction. Most developers were preparing for a downturn by reducing their exposure to risk, especially large, long-term commitments. But Steve is a gutsy businessman and knew that the biggest rewards go to those who march forward when everyone else is scurrying back. The next day he called back and said, "I'll do it."

The collapse of Lehman Brothers in September 2008 set off a full-fledged economic crisis. The world financial system teetered on the edge of a complete meltdown, and many people feared a second Great Depression. In the midst of all this craziness, Steve didn't waver in his decision to spend billions of dollars on a development that would take many years to show any returns.

Hudson Yards would encompass sixteen buildings with 13.4 million square feet of space, a four-acre public park, and connections to the hugely popular High Line and the nearby Hudson River Park. The tallest building,

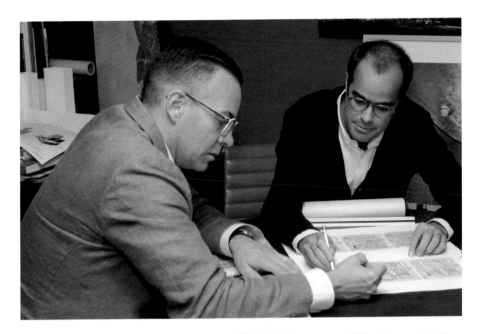

Top: Trent Tesch and Forth Bagley are two key principals who have worked on the Hudson Yards complex and many other projects.

Bottom: Marianne Kwok (seated, center) surrounded by part of the KPF team that designed Hudson Yards. The grouping imitates a famous photograph taken in 1933 of the all-male team of architects that designed Rockefeller Center.

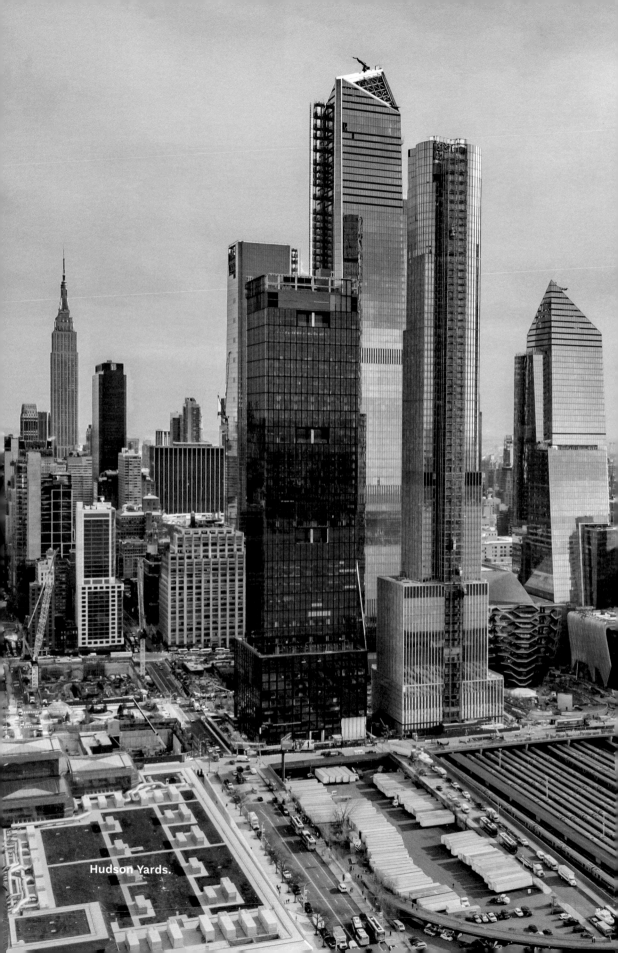

Hudson Yards.

A hugely ambitious project that remakes New York, pushing growth to the Hudson and transforming neighborhoods.

30 Hudson Yards, would rise 1,296 feet, putting it just below One World Trade Center and the Empire State Building, and would have a dramatic observation deck extending out sixty-five feet from the hundredth floor. The complex—running from Thirtieth Street on the south to Forty-First Street on the north and Eighth Avenue on the east to Eleventh Avenue on the west—would be the largest private development in US history. By any measure, this would be a hugely ambitious project and would remake the city of New York, pushing growth to the Hudson River and reinforcing the transformations of the Chelsea and Meatpacking districts.

None of this would have been possible without the work done by the city to lure the Olympics to New York. The legacy of that failed bid includes the construction of the Number 7 Line subway extension, which features a station at Hudson Yards, and the rezoning of the area around the rail yards to allow large amounts of commercial and residential construction. The chance to get the Olympics forced New York to rethink West Midtown and how it connects to the rest of the city. It allowed us to envision a great new neighborhood, a truly mixed-use place where people could work, live, shop, dine, hang out, see art, go to a musical performance, sunbathe, have a picnic, and enjoy fantastic views of the river.

Having Hudson Yards on our boards, along with our work in Asia, gave KPF a solid business foundation at a time when many American architecture firms were struggling.

As we moved from the master plan to the architecture of Hudson Yards, Bill Pedersen became involved once again. Bill's first encounter with Steve Ross came a few years before, when Steve had asked us to work on plans for redeveloping the area around Pennsylvania Station, a project he was doing with Vornado Realty. It hadn't gone well. At the request of Steve's vice president of design and planning, Bill had made some changes to the design and presented them at a meeting. Steve wasn't expecting any changes at this point and didn't like what he saw, so he took it out on Bill. Over the years, Bill has developed a pretty thick skin and took the criticism in stride. But I felt that Steve had gone too far and had treated Bill in a disrespectful way. That afternoon, I called Steve and let him know what I thought. To Steve's great credit, he admitted that the tone of his remarks had been wrong. He called Bill and apologized. I think it says a lot about Steve's character that he was willing to do this. Not many billionaires would have. Today, Steve and

Bill are good friends who love working together and have created some truly remarkable buildings as a team.

Bill's design for the first three buildings at Hudson Yards—a pair of office towers and an eight-story retail center in between—demonstrates his talent for sculpting architecture at different scales. The office buildings, called 10 and 30 Hudson Yards, play off each other with the form of one responding to that of the other. At Steve's suggestion, Bill tilted the fifty-four-story, 878-foot-tall structure at 10 Hudson Yards to face the Hudson River, while angling the 1,296-foot-high 30 Hudson Yards to address the city. The result is an architectural dance that animates the entire project on the skyline, while at the same time anchoring the complex at the plaza level two stories above grade—where our work meets the High Line.

Although 10 and 30 Hudson Yards are speculative office towers, they act almost as customized headquarters for their lead tenants. At 10 Hudson Yards, we created one lobby for Coach, which occupies 740,000 square feet of space, and another one on a different level for L'Oréal and SAP, the other big tenants. Each of these companies gets its own bank of elevators and private terraces overlooking the site. In addition, Coach enjoys its own fifteen-story atrium, a feature we added after the initial design phase to give the company an impressive gathering space for all of its employees. Most developers will adjust interior finishes and materials to meet the preferences of key tenants. But Steve goes many steps beyond this, working with big clients sometimes to reshape a building's architecture in response to their corporate culture and needs. This makes our job more difficult and requires us to make changes—sometimes very late in the process. But I think it creates better buildings, because they're more like tailored suits rather than off-the-rack outfits.

Marianne Kwok, who joined KPF in 1994 after studying at Cornell and Harvard, served as design director for 10 and 30 Hudson Yards, working closely with Bill and Related. Marianne is a really valuable player in the firm, contributing her design talent to projects in Asia and California, as well as many parts of Hudson Yards.

Like KPF, Related has a lot of extremely talented people. Our key collaborators there include Jeff Blau, the CEO; Bruce Beal, the president; Ken Wong, the COO and director of international development; Jay Cross, the president of Related Hudson Yards; and Ken Himmel, president and CEO of Related Urban, which focuses on large mixed-use projects.

Knowing how Steve and his partners work, we design buildings with flexibility in mind. For example, Trent Tesch, one of our principals, designed a fourth building—55 Hudson Yards—so some office tenants could have double-height loggia and extra-large openings on the facade, if they wanted. By using modular fenestration, Trent created a system that accommodates variation and allows a tenant to have either a large recessed opening with a balcony or one that is flush with the rest of the curtain wall. At these locations, a large module replaces four smaller ones—enlivening the building's facades with visual accents and giving them a sense of depth.

We worked with Kevin Roche John Dinkeloo and Associates on the conceptual phase of 55 Hudson Yards. Kevin, who won the Pritzker Prize in 1982, passed away as I finished the manuscript for this book. He was a bold form maker, having designed such extraordinary buildings as the Ford Foundation in New York and the Union Carbide Headquarters in Danbury, Connecticut, but was soft spoken in person. Born in Dublin, he came to the US to study with Mies van der Rohe at the Illinois Institute of Technology. Later he joined Eero Saarinen's firm, became a top designer there, and took over when Saarinen died at age fifty-one in 1961. Over the years, KPF competed against Kevin's firm for a number of projects and we always seemed to lose. So, I knew him as a formidable opponent. Later, I got to know him as a person and we became friends. He was a true gentleman who was considerate of others. A few years ago, I gave a talk at Yale and he was gracious enough to attend.

In addition to the master plan for Hudson Yards and the architecture of some of its key buildings, KPF designed the gigantic platform on which most of the project is built. A remarkably sophisticated piece of engineering and construction, this deck spans thirty active train tracks, three rail tunnels and a "tunnel box" for a proposed rail link from New Jersey to New York's Penn Station. Because trains generate a lot of heat, the platform must cool and clean the air underneath it, so rail workers can breathe and plants above it can survive. We also needed to identify where columns for all of the new buildings could be inserted through the platform to make sure they rested on proper foundations and avoided the train tracks.

Hudson Yards includes the work of many architects. Steve told me and Bill that he didn't want to do another Rockefeller Center with a uniform design aesthetic determined by one set of architects. Instead, he wanted to create

a collection of buildings by different architects with their own sensibilities. So he engaged some of the best firms in the world: Diller Scofidio + Renfro, Rockwell Group, SOM, and Foster + Partners. To create a real community, he has invested a lot of effort (and money) into the public aspects of the development—parks, gardens, and other outdoor spaces, as well as the Shed (a visual and performing arts building designed by Diller Scofidio + Renfro that can slide on rails to open to the outdoors) and the Vessel (a sixteen-story sculpture designed by Thomas Heatherwick that features 154 flights of stairs visitors can climb to enjoy views of the complex). Since Heatherwick is based in London and is an industrial designer by training, KPF did the working drawings for the Vessel at the client's request. In doing this, we developed a great relationship with him and he is now collaborating with us on the design of an amazing new terminal at Changi Airport in Singapore.

As I write this book, the first phase of Hudson Yards—on the eastern portion of the site—has just opened. A seven-story shopping center anchored by New York's first Neiman Marcus is buzzing with customers, a Spanish food hall run by chef José Andrés is luring hungry eaters, the Shed is offering all kinds of great art, pedestrians from the High Line are hanging out in the park at the center of Hudson Yards, and the Vessel is swarming with people snapping photos of it all. Judging by the crowds coming every day, this incredibly complex and challenging project is already a huge success— as a destination, a workplace, and a cultural hub.

With its mix of big buildings and small details, its integration of mass transit and foot traffic, its connections to surrounding neighborhoods and the river's edge, Hudson Yards embodies the spirit and character of New York City. But it also incorporates many of the lessons we have learned in Asia, where vertical urbanism is even more intense, more extreme. If you look at its architectural DNA, you'll find strands of Roppongi Hills in the way outdoor spaces knit the buildings together, you'll see the beginnings of its sky-high observation deck in the one at the World Financial Center in Shanghai, and its dialogue between building height and waterfront in Hong Kong's International Commerce Centre. Hudson Yards is the result of KPF's many years of experience working in global cities around the world. It is where so many of our ideas about architecture and urbanism come together.

Bill Pedersen and Bill Louie.

The Two Bills

I love talking with Bill Pedersen. He can seem shy and reserved, which comes from his Minnesota background, but he's actually a great talker. He uses words to create pictures in people's minds and engage them in a back-and-forth process that's always stimulating. When he speaks of the start of KPF, he likens it to a boat—with Shelley as the keel, Bill as the hull, and me as the sail. It's a great image that captures the simple, efficient structure of the firm—one that still works today, even with a new keel in place.

The funny thing about Bill and me is that for all our apparent differences—his midwestern reticence and my outgoing nature—we actually share so much in the way we approach things. A long time ago, we had all of the top people in the firm take a personality test, and it turned out that he and I scored exactly the same in the way we work with people. We're both inclusive personalities who don't feel the need to impose our will on others. We'd rather hear from them and get them involved in the decision-making process.

Bill often tells the story about the first project he did after I lured him to Jack Warnecke's firm in the early 1970s, when I was president there. It was for the North Academic Center at City College, New York, which wouldn't get built until many years later. He had just finished working at I. M. Pei's office, where he was trained to develop one scheme and make it as good as possible. So he used that process and went to his first client presentation with a design that he felt was damn good. Neither Jack nor I was at the meeting. Bill was on his own. He showed the project to about ten people, including the dean of the school of architecture, and carefully explained all the great things in his design. I'm not sure why, but everyone hated it, and no amount of discussion was going to change their minds. Dead end. He remembers leaving that meeting and telling himself, "I've got to find another way of doing this!" So he developed what he calls a comparative process, in which he shows the client a series of schemes and engages them in a conversation about the strengths and weaknesses of each one. By comparing the ideas and strategies

behind each scheme, he and the client can develop a project together. No dead ends. Instead, the client contributes and establishes an emotional investment in the evolving design. Meanwhile Bill is able to explore the project in great depth. We have used this approach ever since, and it works.

At KPF, we see architecture as a collaborative effort. Bill says it's like theater, since it requires the input of many different people, the architectural equivalents of actors, directors, producers, playwrights, set designers, and all sorts of consultants. If you don't enjoy the complex process of truly engaging with other people who have different perspectives, you shouldn't be an architect, or, at least, not one at our firm. Bill also talks about the importance of buildings playing roles—within their physical, social, and economic contexts. Each of his projects responds to the buildings around it, the neighborhood, and the city, just as a good actor responds to the other characters in the play and the vision of the director. A few years ago, he was watching the Golden Globes on TV and saw a tribute to Meryl Streep. What impressed him most was her ability to adapt her performance to the demands of each particular project. Meryl Streep, the person, disappears in each role, her artistry revealed in her talent to serve the particular film or play she is in. Very few people are as gifted as she, but every actor and every architect can learn from her collaborative method.

If we didn't operate in such a way, we wouldn't be able to work for clients like Stephen Ross of the Related Companies. Knowledgeable and hands-on, Steve requires his architects to respond to input from his team and outside consultants. He loves a spirited back-and-forth with everyone getting into the action. He holds himself to the same rules, always open to the needs of his clients and often willing to change a project to lure a tenant.

While some architects feel the need to stamp each of their projects with clearly identifiable marks of their genius, Bill couldn't care less about developing a brand. He's happy to lose himself in a project and share authorship with the client, the engineers, other designers, and members of the project team. What's most interesting to him is looking beyond himself and incorporating other people's perspectives and intelligence. This makes each project different, fresh, better. It also means he won't run out of ideas, because he is always tapping in to other people's minds.

Bill says the fundamental responsibility of buildings is to talk to each other and their contexts. At Hudson Yards, for example, the two main towers

lean in different directions, one to the river and the other to the city. They also respond to critical junctures with other elements on-site, such as the High Line and the entrance to the Number 7 subway line. While doing all this, the buildings engage in a dance with each other and their surroundings. Bill has been designing this way since the beginning. After all, what is 333 Wacker Drive other than an acknowledgment of the city and the bend in the Chicago River? Once you determine that buildings need to talk to each other, you realize the project team must do the same. So that becomes your process, too. It's all about dialogue.

It's also important not to make assumptions before you do your homework. It's dangerous to think you know something based on partial information. Bill tells the story about a project he and I worked on when we were at Warnecke's office. It was a headquarters for the Aid Association for Lutherans, an insurance company based in Appleton, Wisconsin. Bill is a Lutheran and had even taken out a policy with AAL when he and his wife, Elizabeth, got married. So all of us figured he would know how to deal with the clients on their initial business trip to New York. The first thing he told us was, "Don't order any alcohol at lunch, because Lutherans don't drink." In the morning, we met at our office and talked about our ideas for the project. Then we took everyone downtown to see a building Warnecke had done for New York Telephone. In the car back to our office, Jack tried to connect on a more personal level with the out-of-towners by talking a bit about his family. "My father-in-law comes from Wisconsin," he said, referring to George F. Kennan, the famous American diplomat. "Oh, where?" asked one of the Lutherans. "The capital, Milwaukee." That produced an awkward silence, since Madison happens to be the capital. For lunch, we took them to the Sherry-Netherland hotel, a gorgeous building on Fifth Avenue across the street from Central Park. When the waiter came over to take our order, Jack asked for an orange juice, I requested an iced tea, and Bill got a ginger ale. Our guests gave us a strange look and hesitated. Finally, one of them told the waiter, "I'll have a double martini." Turns out these guys hailed from the German, not the Norwegian, branch of Lutherans.

The AAL building proved to be a great project with a beautiful design by Bill. It also introduced us to Ware Travelstead, who served as the owner's representative and would later help KPF get work in London. As I mentioned in an earlier chapter, Ware is quite a character—a wheeler-dealer who always

thinks big and moves fast. He was an odd match with the Lutherans, who couldn't be more different in personality and business practices. But he encouraged the AAL executives to go with a very progressive design and supported our approach. He also convinced them to hire the great industrial designer George Nelson to create all of the furniture. Nelson brought in a talented Swedish weaver named Helena Hernmarck to design and produce a lovely tapestry for the project. Fifty years later, we worked with Helena again on a tapestry for one of our buildings at Hudson Yards, since Stephen Ross is a big fan of hers. Bill and Helena have become good friends, too, bonding over their love of design and craft.

I first heard about Bill from a guy named Jim Nash, who had worked at Pei's office and then moved to Warnecke's firm. When I mentioned that we needed another top designer, Jim told me about Bill, who was still at Pei, working directly with I. M. on the East Building of the National Gallery in Washington. Jim said, "You gotta get this guy. He's incredibly talented." So I met with Bill and was impressed immediately. But he wouldn't leave Pei, because they were still busy with the National Gallery. I respected that and told him, "When you're done with the project, give me a call." Bill loved working with Pei and took great pride in his contributions to the National Gallery. But he knew there was little chance he would ever move up in that office. Harry Cobb and Jim Freed were already in place there as partners, and the hierarchy was pretty much frozen. He wanted to run his own projects, which I promised he could do at Warnecke. About a year later, his work on the National Gallery was done and he was ready to move on. I hired him immediately and gave him the City College project and then the AAL headquarters and a building for the Brooklyn Criminal Courts. Both of the New York projects were eventually put on long-term hold, due to the city's fiscal crisis in the early 1970s. But Bill's designs were fantastic and proved to me that he was a special talent.

Bill likes to say that hockey saved his life. He had gone to a military academy in high school and was planning to go to West Point. But he loved playing hockey and decided at the last moment to attend the University of Minnesota, which had a great hockey program. If he had stuck with his original plan, he would have become a second lieutenant and gone to Vietnam. Who knows if he would have come back.

At the University of Minnesota, he enrolled in the Institute of Technology with the goal of studying architecture. His father had studied architectural

engineering and, along with his grandfather, started the first plan service in the US, providing floor plans to people who wanted to build houses. In high school and college, Bill worked as a draftsman for his father's company and picked up some important skills. But his real focus was hockey. At the start of his sophomore year, the *Minneapolis Star Tribune* quoted his coach, John Mariucci, as saying that Bill Pedersen will probably be one of the great defensemen to play for the University of Minnesota.

But studying architecture is an intense process and makes doing anything else extremely difficult. Not long after his coach had praised him in the newspaper, Bill had to pull a couple of all-nighters to finish a design project. When he showed up for a game that evening, he had no energy. After a couple of lackluster shifts on the ice, the coach benched him. For the rest of that season, he got very little playing time and eventually realized he couldn't do both hockey and architecture. One friend tried to convince him to switch to American studies, which supposedly required less time away from the hockey arena. It was a tough decision, and Bill says he came close to dropping architecture.

One of his design professors, James Stageberg, though, took an interest in him and encouraged him to continue. Stageberg was a talented architect himself and would later be named one of Minnesota's most important architects of all time by the Minnesota chapter of the American Institute of Architects. He was also a beloved teacher, who was one of the first people hired by the illustrious Ralph Rapson when he became dean at Minnesota in 1954.

So Bill stuck with architecture and left hockey behind. During his third year in school, he got a job with Leonard Parker, another local Modernist, who founded one of the state's preeminent firms. Parker was a tough guy who was born into a Jewish family in Milwaukee that tried to coddle him. He had a lovely voice, so he often assisted the cantor at his local synagogue. His protective mother wouldn't let him play basketball, fearing he might hurt his voice yelling to his teammates. So without her knowledge, he picked up boxing and ended up on the state's Golden Gloves team. In World War II, he fought his way up Italy, earned two Bronze Stars, and was with one of the first groups of soldiers to reach the Buchenwald concentration camp. Since he spoke Yiddish, he could talk with the prisoners and ended up writing a series of powerful letters to his mother back in the States. Years later, Minnesota Public Radio aired a reading of the letters.

Bill Louie in front of a model of his Mellon Bank Center.

Bill Pedersen in one of his chairs with a model of his Shanghai World Financial Center.

Parker studied architecture at Minnesota and MIT, then worked for five years for Eero Saarinen, who designed the Gateway Arch in St. Louis, the TWA terminal at JFK Airport in New York, and the General Motors Technical Center in Warren, Michigan. When he left to set up Leonard Parker Associates, Saarinen did a wonderful Chagall-like drawing showing Parker flying in the clouds with a T-square and looking down at all the buildings he had worked on. Everybody in the office signed the drawing, including Saarinen, who did his signature as a mirror image, just as da Vinci would do. Parker cherished that drawing and showed it to Bill as a way of linking their work to the masters who came before them. Eero himself could trace an illustrious architectural lineage, starting with his father, Eliel, who came from Finland and headed the Cranbrook Academy of Art outside Detroit. Working in Eero's office, Parker rubbed elbows with a generation of extremely talented architects, such as CésarPelli, Kevin Roche, and Robert Venturi. Charles and Ray Eames, who had studied at Cranbrook and were close friends of Eero's, came to the office frequently to collaborate on projects.

Bill says the most important thing he learned from Parker was his passion for architecture. It was a calling, not a career. He also learned how to draw and to put things together. The dedication and work ethic of the Saarinen office was passed by Parker on to Bill. It shaped who he is.

Bill remembers being hired by Parker at $1.25 per hour, far less than what his classmates were making at other firms. But Parker had a sly way of making Bill feel better. He would give him a nickel raise on a regular basis, so Bill could go home and tell Elizabeth, "Hey, I got a raise today!" He got about a dozen such raises. By the end of the year, Bill and Elizabeth had gotten married and Parker said, "Bill, you have more responsibilities now, so I'm going to give you another raise. How does two dollars an hour sound?" Bill laughs to this day and says he told Parker, "That sounds great!"

At KPF, we've been fortunate to hire some fantastic people. One of the first was Bill Louie, who was with us at Warnecke. Bill Pedersen calls him a great American success story, and he's right. Bill Louie grew up in the back of a Chinese laundry in the Bronx, working after school and on weekends with his immigrant parents and siblings in the laundry. It was a tough neighborhood, and there weren't many Asians. But a burly black kid who lived nearby took a liking to Bill and made sure no one messed with him. From an early age, Bill learned to make friends with people who were different from him.

After high school, he went to a one-year technical school in Brooklyn to learn drafting. Then he got a job in the South Bronx, working for a small practice. When he outgrew that firm, he came to Warnecke and took night classes at CCNY's architecture program. His goal was to become a job captain. He's a naturally smart guy and works hard, so he did well at Warnecke. His wife, Mae, was working at Pei's office as an administrative assistant, and she pushed him to think about the larger issues of architecture, not just the technical. She encouraged him to dream bigger. He and Bill Pedersen worked together on the North Academic Center and became good friends. Several days a week, they would grab sandwiches and eat together at the fountain outside the Plaza Hotel near our office. Pedersen would give him things to design on the projects they were working on, even though he wasn't a designer yet. Pedersen didn't care about titles or degrees, only ability. Louie was a talented designer, and Pedersen knew it.

When we started KPF, we agreed not to poach employees from Warnecke. So Bill Louie stayed there for about a year, until things got so slow that Jack let him come join us. Pedersen kept mentoring him for the first few years, and he kept proving himself. He's a man with a lot of integrity and commands respect. Eventually, we made him a partner and later put him on our board of directors. He's still with us and represents almost the entire history of KPF.

Louie and his wife, Mae, have been married for fifty years and have had the same car—a reliable red Saab—for about thirty of them. Mae worked as the administrative assistant to Araldo Cossutta at Pei's office, then went with him when he set up his own firm. She worked for Araldo until he died in 2017. She and Bill are rock-solid people.

Diversity has been an essential asset for KPF since the very beginning. As we grew and did more and more projects abroad, having a diverse staff became increasingly important. These days, we have associates from dozens of countries. We're a veritable United Nations, with dozens of different languages spoken here. Recent graduates from around the world come to KPF to learn how we do architecture. And they end up teaching us, too—about their countries and cultures. In today's interconnected world, a big architecture firm needs to have multiple perspectives embedded in its people and its DNA. It's the only way to survive as a global firm.

I remember when we first started doing work in Asia in the late 1980s, we were visited by executives from a Korean company looking for an architect

to do a big project. Their English was limited, so I asked my assistant if we had anyone on staff who spoke Korean. She finally found a young guy working in a windowless drafting room who came from Korea and brought him into the meeting. As soon as he handed his business card to the foreign delegates, they jumped to attention. I turned to Bill Pedersen, who noticed it, too. These senior executives from a powerful *chaebol* had all of a sudden become remarkably deferential to a kid we had working in one of our lower-floor spaces.

Well, it turns out that kid's family name is Min, which meant he's a descendant of Queen Min, the wife of the Korean emperor in the late nineteenth century. Our employee, Min Chul Hong, provided translation for the meeting, and later helped us get work in Korea. He could contact the chairman of any *chaebol* in Korea and get a reply. Since then KPF has done a remarkable amount of work there, including major projects such as the Lotte World Tower, the ConvensiA Convention Center in Incheon, the master plan for New Songdo City, the Dongdaegu Transportation Hub, the Ilsan Cultural Center, the Samsung headquarters, and the Rodin Museum in Seoul. Min wasn't involved in all of these jobs, but he helped us get going in his native country.

When we started to do work in China, we discovered that we had a bunch of people working for us who came from the families of high Communist Party officials. During the past three decades, KPF has become a magnet for smart, young Asian architects. We have benefitted greatly from their talent, their insights, and, yes, their connections. Most importantly, though, clients can see that our designs acknowledge key cultural elements that only a local person would understand. Our Chinese employees, for example, have brought their intelligence and sensitivity to national and local issues to our designs in Beijing, Shanghai, Shenzhen, and elsewhere.

The amazing thing about Bill Pedersen is his ability to work at different scales. As he was working on Hudson Yards, his wife, Elizabeth, developed pancreatic cancer, so he has been devoting much of his time to caring for her. Out at his house on Shelter Island with Elizabeth, he has been designing furniture—mostly pieces made of tubular metal and fabric. I don't know anyone else who could shift so gracefully from designing skyscrapers on the Hudson to crafting chairs and couches that delight the eye and support the human body. Recently, he designed a chaise longue made of one piece of tubular metal that loops around in such a way that when you slide the fabric

over it, the whole thing holds together and creates a really beautiful sculptural form. It has a remarkable sense of Platonic purity and is a manifestation of Bill's talent for merging design, engineering, craft, detail, and a focus on the human being.

Looking back at KPF from the perspective of where we are today, I marvel at our fortuitous timing. In 1976, cities were falling apart. A lot of people and a lot of businesses were running off to the suburbs, looking for safer, more stable places to live and work. The Bronx was burning, beautiful buildings were being abandoned, dirt and graffiti were everywhere, and parks were hubs for drugs and crime. And no one seemed to care or think anything could be done to make things better. There was the infamous headline from the *New York Daily News* in October 1975, after President Gerald Ford denied federal funding to New York to spare it from bankruptcy, that read, "Ford to City: Drop Dead." Fast-forward four decades and everyone wants to be in the city—not just New York, but almost every major city. We still have big problems—such as deteriorating subways and infrastructure, income inequality, and climate change—but cities have never been more attractive. The most talented young people and the most innovative companies all flock to cities now.

This urban resurgence has been a boon for KPF. It has given us the chance to shape skylines and neighborhoods in Shanghai, Tokyo, Singapore, Hong Kong, London, Frankfurt, Chicago, San Francisco, and New York. This incredible dynamic has transformed huge parts of metropolitan areas around the world and provided a primary focus for KPF's work during the past four decades. It has been a remarkable opportunity for us, since we specialize in designing the main components of these rising cities—tall buildings and large, mixed-use complexes. Each one of our projects establishes relationships to the city around it and sponsors an ongoing evolution in the urban fabric. This is a tremendously interesting architectural problem, one that we've made the central issue of our firm. No other problem is more important to us.

Me and Jamie von Klemperer.

Re-Generation

In recent years, I've had a running conversation with Jamie von Klemperer, KPF's current president, about the nature and spirit of firm transition. We worked out the legal and practical issues a while ago, so we talk instead about the larger, less tangible aspects of the process. What kind of place will KPF be in five or ten years? How do we keep changing without losing the essential elements that define us an architectural practice? Jamie is a philosophical person by nature, so he loves these discussions and often refers to ideas and approaches from other fields. As an undergraduate at Harvard, he majored in history and literature and then spent a year in England as a fellow at Trinity College Cambridge. Both of his parents were professors at Smith College, earning international reputations in their fields. His father, Klemens, who fled Nazi Germany, was a revered historian of twentieth-century Germany and Central Europe, while his mother, Elizabeth, taught English language and literature for more than forty years. The great German composer and conductor Otto Klemperer and the actor Werner Klemperer were also relatives. So he grew up surrounded by very smart people talking about the arts, culture, and society. Asking deep questions and searching broadly for answers are in his blood.

In our discussions, Jamie often uses a number of analogies to describe the ongoing, incremental transition at KPF. Sometimes, he talks about the firm as a classic car—a 1938 Bugatti or a 1961 Jaguar, let's say—equipped with new parts as old ones wear out or become obsolete. More often, he compares the firm to an academic department at a great university. "The physics professors at MIT and the focus of their research change all the time, but the reputation and significance of the department remain the same," he told me recently. The talent of the individual faculty members is critical to the success of the school, but somehow the department keeps moving forward even as people retire or die. Our role is to create an intellectual community that attracts the best thinkers and doers and lets them tackle the latest challenges.

Like a university, we need to train each class of associates here and provide them with a mission that addresses the most important issues of our time—designing buildings that people cherish, cities that inspire, and places that are sustainable in the face of climate change.

Jamie told me about the work of Geoffrey West, a theoretical physicist who ran the Santa Fe Institute for a while and has worked on a scientific model of cities. West has discussed the maturing and aging of institutions and the natural lifespan of things. He notes that while companies usually die, countries don't. Somehow, countries are able to change and carry on without losing their identities. Is there a way for an architecture firm to behave like a country? Can we develop a particular culture and character that evolve over time without expiring?

The topic of transition has had particular resonance since November 2014, when Paul Katz, who was KPF's president at the time, suddenly died. Just fifty-seven years old, Paul was the lanky, hard-charging, always-in-motion guy who took over the firm after Lee Polisano's London mutiny in 2009. He learned he had colon cancer just six weeks before he died, so his passing was a huge shock. He didn't tell many people about his illness—because he didn't want to burden others and didn't believe he would die. Nothing had ever stopped him before, so he figured neither would cancer.

Paul was a road warrior—flying all over the world to get jobs, meet clients, and oversee projects. He loved it, but such travel takes a toll even on a very fit, middle-aged man's body. I wonder sometimes if he had spent more time in New York, would he have gone for a colonoscopy early enough to catch his tumors when they could have been treated more easily? Architects, especially successful ones, often pride themselves on how many miles they log each year and how much they can push themselves. From all-nighters at school to long hours at the office, the architectural profession too often glorifies a culture of overwork. We need to change that and create a healthier lifestyle for architects.

From the start of his career at KPF, Paul was a rising star. He was active in our early work in Asia, starting with the Japan Rail complex in Nagoya, and turning that part of the world into a second home for the firm. After five of our principals in London tried to break up KPF and take many of our big clients, Paul worked tirelessly with me to rebuild the London office and make it stronger than ever. He relished a good fight and would do

everything possible to make sure his colleagues at the firm had the resources and support they needed to do their best work. Such tenacity earned him the devotion of many of the people who worked with him. But sometimes he could push too hard. Near the end of his life, he spent most weekends in our London office, and some of our team there resented having to work whenever he was there.

His drive, his way with clients, and his humanistic approach to buildings and cities, though, live on and serve as his greatest legacy. His knowledge and wisdom have been passed on, becoming part of the firm's genetic material. Paul was a contrarian, a maverick kind of thinker, who always wanted to zig when everyone else was zagging. As a result, he saw opportunities where no one else did. Like me, he understood the great potential of China as a place for innovative architecture. Back in the early 1990s, some people figured China would do a lot of building to catch up after a long period of almost no construction during Mao Zedong's rule. But very few experts thought it would be capable of creating important architecture.

Paul had a wonderful sense of humor that helped with all kinds of situations. I remember flying with him from London to Tokyo on one of our first trips to Asia in the early 1990s. When we landed at Narita airport, we discovered that his luggage had been lost en route. The only clothes he had were the ones he was wearing on the plane: jeans, sneakers, polo shirt, sweater, and jacket. So we immediately went shopping. Paul, though, was about six foot five and had enormous feet—quite different from standard sizes in Japan! After failing miserably to find anything that would fit him at a few stores near our hotel, I suggested going to a place that specializes in clothes for sumo wrestlers. Although not nearly as wide as a sumo champion, Paul found a pair of slacks, some shirts, and a sports jacket that sort of fit. They were anything but business attire, but they were the best he could do. For the next few days, we cracked jokes about his sumo outfit and American sneakers at each of our appointments. It turned out to be a fantastic way to break the ice that usually prevails at the start of such meetings. Everyone loved the good laugh and empathized with his plight. Within a few moments, Paul had shattered standard Japanese formality and made friends with everyone in the room.

In Paul's obituary in the *New York Times*, the writer Joseph Giovannini said, "In an age of specialists in architecture, Mr. Katz was an architect of wide scope who focused as much on fine detail as on the big urban picture." Paul

was amazing at keeping all aspects of a project in balance—from the needs of the client to the history of the place and the impact the building would have on its surroundings. He was an avid chess player, who once faced off against Magnus Carlsen, the Norwegian grandmaster, at a multigame demonstration during a conference in France. Paul was always thinking three or four moves ahead, combining strategic vision with tactical precision. As Jamie was quoted in the obituary, "For Paul, cities were an urban chessboard."

Even before Shelley Fox died in 2006, Bill and I and the rest of the KPF board had identified the next generation of leaders for the firm. We made Lee president and gave important roles to Paul, Jamie, and Greg Clement, while I served as chairman. We had a remarkably strong group of young talent at the top. In 2007, Greg, who was extremely well liked by both our staff and clients, died of melanoma at the age of fifty-six. Two years later, Lee tried to orchestrate his coup. Now Paul was gone.

We turned to Jamie. Although he was already on our board and part of our top leadership, Jamie understood that assuming the title of president would require him to exercise different skills. Was he ready for this? I never doubted it. But he needed to prove it—both to himself and to the rest of the firm. He needed to rethink his role at KPF. He was more involved in design than Paul had been, so his challenge was to somehow balance his new leadership responsibilities with his great talent for shaping architecture. Jamie's goal was to be a player-coach, something that neither Paul nor I had tried to be, even though both of us had been designers before leading the firm.

Jamie and Paul had met in architecture school at Princeton and developed a complex relationship as friends, colleagues, and rivals. While Paul was loud and at times brash, Jamie was calm and measured. Both, though, were savvy players who could take over a room with their intellects. At Princeton in the early 1980s, they studied with some heady professors—people like Anthony Vidler, Alan Colquhoun, and Kurt Forster, who discussed interpreting history in contemporary architecture and placing it in relation to the canon of Le Corbusier and Mies van der Rohe. The school was a real cauldron of design theory, and Jamie and Paul sharpened their thinking there. Although different in temperament and appearance, the two of them shared a love of history, not just architectural, but social and political. And they held the same fundamental views of architecture as a force for making better places, better cities. They brought those beliefs to KPF and applied them to the real world of practice.

An element of competition certainly ran through their relationship, but they were both smart enough to use that as an asset, not a liability. They were like Mickey Mantle and Roger Maris in 1961, playing on the same team and pushing each other to hit more home runs. And just as some sportswriters interpreted the two baseball players' healthy competition as a rift, there were some people who saw Jamie and Paul as oppositional forces in the firm. I never did, and neither did they. I think each of them valued the other and understood they could do more by working together.

Both of them were fearless explorers, always eager to conquer new territories and markets. Flying off to some new city or country never failed to excite them. I think they inspired each other, giving them both confidence that they could win that job in China or wow those clients in Hong Kong. They weren't the founders of the firm, but they were able to spearhead something new within the firm: a cadre of globe-trotting professionals doing remarkable work in far-flung places and building at a scale that was rarely possible in the US anymore. Although almost all of KPF's design activities happen in either New York or London, we have been so active in places like Shanghai, Hong Kong, Tokyo, and Seoul that they feel like home to us now. Because of principals like Jamie and Paul, we know the government officials there, the planners, the local architects, the developers, the players. When we work in these cities, they're so familiar that we can approach them almost as locals.

In London, Paul helped us develop deep roots after Lee left and set up his own firm. He served at my side during the three years I lived there— working with me to rebuild morale among our staff, attract creative people, engage with the building community, and make sure the quality of our work was the best. When I returned to New York full-time, he kept going to London almost every week to oversee the changes there.

Now the roots he helped plant have grown new shoots—like a banyan tree spreading out along the ground. Today, Jamie says the London office feels like a British firm with American connections, not a foreign practice doing work in the UK. If you look at the projects we've done there—such as our renovation and repositioning of Covent Garden—you'll see a sophisticated balance between historic preservation and contemporary Modernism that reflects a British sensibility. You'll see careful attention to particular types of brick, specific window mullions, and building proportions that define London. We've become comfortable responding to the role of history,

At the Jing An Kerry Centre in Shanghai, Jamie von Klemperer and his team created a series of courtyards and outdoor spaces that tie the multi-building project to its surroundings.

the values of human scale, and the particularities of circulation in the dense urban fabric of London. This has helped us work with city planners there and get necessary approvals from Westminster.

A spectacular example of our ability to integrate old and new is the Unilever headquarters in London, a colonnaded 1930s building that we totally transformed into a twenty-first-century workplace. Our team, led by John Bushell, preserved the historic exterior while carving out a new atrium that brings daylight and air into the center of the building and is crisscrossed by a series of suspended bridges and platforms. The project earned a BREEAM Excellent score for its energy efficiency and its conservation and reuse of materials.

While we have internalized the critical values that define a place like London, we have also been able to synthesize ideas and approaches from other parts of the world and employ them in the UK. Transferring knowledge from one place to another is one of the really valuable skills we bring to projects today. We can apply something we learned in Hong Kong to London or something from Shanghai to New York. Often, it's not a matter of just exporting or transplanting, but of transforming.

I think of the great buildings along the Bund in Shanghai designed by European architects in the late nineteenth and early twentieth centuries. These structures represent a hybrid architecture incorporating stylistic and technological elements taken from Europe, but adapted to the local culture and climate. Today, we look at them and immediately say, "That's Shanghai." I take great pride in my belief that most people look at KPF's World Financial Center on the other side of the river from the Bund and say, "That's Shanghai." Bill Pedersen's design captures a particular balance between expression and reserve, boldness in form and elegance in detail that represents Shanghai in the twenty-first century. It stands out among a riot of invention and ornamentation by remaining calm. I think it makes a profound statement on the city's skyline.

What's unusual about Shanghai is that it offers two very different settings for architecture: the brand-new environs of Pudong, which was mostly farmland thirty years ago, and the old, winding streets of Puxi, where you need to deal with the context of the French Concession and other colonial districts. KPF has designed tall buildings for both parts of town, always respecting the peculiarities of place. As a result, our Plaza 66 on Nanjing Road and our Kerry Center in the Jing An neighborhood—both in Puxi—create

pedestrian experiences that would be impossible in Pudong, while our WFC plays to the city's skyline in a way that would be inappropriate across the river in Puxi. At the Kerry Center, in particular, we orchestrated the pieces of a multibuilding, multiblock complex so they shift scales in a way that meshes beautifully with the multilayered history of the area. Two towers, a retail podium, a 508-key hotel, an event space, a range of office amenities, and even a preserved house where Mao had lived in the 1920s all fit together gracefully. Although it's a very modern project, the use of small components at the ground level and the flow of public space through courtyards really feel like Shanghai.

KPF has been extremely fortunate to have worked with some great clients in China, such as Ronnie Chan and his Hang Lung Group, which developed Plaza 66, and Robert Kuok, who founded Shangri-La Hotels and was involved with the Kerry Group for a number of years. Both Ronnie and Robert are visionaries who have helped shape a modern, sophisticated China that was hard to imagine at the start of the post-Mao era.

Paul loved Shanghai—as do I—with all of its odd, endearing juxtapositions, and his affinity for the city helped inform our work there. At the same time, he was able to communicate a set of core beliefs to everyone at the firm, no matter which office you happen to work in. He made sure we felt we were working collectively on something bigger than any one of us.

After Paul's death, some of the people who had worked most closely with him and saw him as their mentor thought about leaving the firm. Jamie understood this and talked to them about their fears and their goals. He convinced most of them that they were valued members of our team and should stay at KPF. It wasn't always easy, and in some cases it took him a while. But Jamie listened and explained that his vision for the firm included them.

A powerful part of his argument was the large number of important projects KPF was working on, projects that require the active involvement of many people in the firm. There's nothing more enticing to an architect than the chance to contribute to a challenging building that will have a big impact on its users and neighbors and serve as a model for the architectural profession as a whole.

One talented principal who left at this time was Anthony Mosellie, who had worked closely with Paul and joined Related as a senior vice president. In his new job, Anthony collaborates with us on Hudson Yards, though he's

Doug Hocking totally transformed an outdated office building at 390 Madison Avenue in New York, removing some floors to create double- and triple-height spaces attractive to today's commercial tenants.

now on the client side of the equation. I'm still close to him and consider him part of the extended KPF family.

While KPF is probably best known for designing new buildings, we apply the same kind of creativity to reimagining existing structures to make them work better. For example, L&L Holding, a New York–based real estate company founded by David Levinson and Robert Lapidus, asked us to tackle 390 Madison Avenue, a brown-brick office building from the 1950s that had been reskinned in the 1980s with blue-glass curtain wall. Its low floor-to-ceiling heights, difficult column grid, and squat massing made it unattractive to today's corporate tenants. But zoning changes in the area meant that a new building on the site would have to be considerably smaller—in terms of total floor area—than the existing one. So tearing down the old structure made no economic sense.

Doug Hocking, one of our design principals who had worked with Bill Pedersen on Roppongi Hills in Tokyo and the IBM headquarters in Armonk, New York, devised an amazing scheme for 390 Madison—removing all or part of some lower floors to create double-height spaces and then redistributing the excised floor area to eight new stories added to the top of the building. Totally transformed, the building now has the same amount of square footage as before, but offers new double-height spaces in its base, a triple-height amenity space with a wraparound outdoor terrace on the ninth floor, a number of smaller terraces on other floors, and eight new stories with great views and daylight. Doug and Lloyd Sigal, the managing principal for the project, acted as architectural surgeons, cutting away problem areas—such as old floors and columns—inserting new features, and reinforcing everything with an innovative structural system. Working closely with structural engineers at Severud Associates, they created a building cyborg, with the latest innovations implanted in an existing body. Old building materials with toxins have been removed, new mechanical systems installed, and a new energy-efficient curtain wall erected to bring more daylight into office interiors. The project, which was fully leased before its reopening in 2019, shows that inventive design can turn outdated building stock into valuable grade-A property.

Jamie knows that in addition to retaining the most talented people already on our staff, he needs to attract the best young architects coming out of school. One way he has done this is by teaching at various universities, something I have always done as well. It's a great way of staying current with

the latest intellectual discourse and learning what ideas are driving the work of both students and faculty. In architecture, many of the people who teach also run their own practices, often small, experimental ones. So teaching as an adjunct professor is an excellent way of staying on top of trends percolating just below the surface of the profession.

About seven years ago, Jamie was teaching a studio course at Yale with Paul Katz and Forth Bagley, one of our young principals who has demonstrated great skills with people and a knack for architecture. The students were asked to design a large, mixed-use rail complex in Chongqing, China, and they did such a good job that we ended up hiring eight of the ten members of the class! One of the great things Jamie has done is to bring a bit of an academic feeling to the firm, to create internal conversations about critical issues that we face as architects. We also invite outside experts to come and talk to us about the latest software, new building technologies, and important trends in the profession. We hold panel discussions on key issues such as urbanization and what's happening in Latin America. On almost any day of the week there is some kind of learning session going on in our offices. We even have a knowledge manager who orchestrates all this activity. It's a fantastic way of distinguishing KPF from other big firms that perhaps focus too much on individual buildings and lose sight of the bigger intellectual picture. It's also a way of connecting today's firm with KPF's founding belief in merging art and commerce.

Our associates don't come just from Yale and other big-name universities. Over the years, we have found great people at all kinds of schools: state universities, alternative institutions, and programs in places far from the coasts. We spend a lot of time at Penn, Harvard, Yale, Cornell, and Columbia, but we know there are talented students in less prestigious places as well. What makes someone good at architecture is often different from what appeals to college-entrance officials. Some of the best designers are late bloomers or were students who didn't fit into standard categories of accomplishment. And many of them now come from countries we don't normally think of when we cast our recruiting nets—places in Africa, Latin America, the Middle East, and Asia.

Our London office continues to do amazing work. Nearing completion now is a forty-two-story office tower designed by Bill Pedersen and managed by Charles Ippolito at 52 Lime Street in the heart of the financial district.

The project's dramatic, sharply faceted form has earned it the nickname the Scalpel. The Brits love giving monikers to buildings (and people), the better to remember them and, sometimes, poke fun at them. Within a few blocks of the Scalpel, you'll find the Gherkin (by Norman Foster), the Cheesegrater (Richard Rogers), and the Walkie-Talkie (Rafael Viñoly).

Our building's angular profile, though, does more than just grab your attention. By leaning away from the Cheesegrater (officially known as 122 Leadenhall Street), our tower disappears behind the dome of St. Paul's Cathedral when approached from the west on Fleet Street. Respecting such historic views is important in London, where the best new buildings add to an urban tapestry without messing up beloved aspects of it. We sliced the Scalpel's roof at an angle to acknowledge the composition of the growing cluster of tall buildings surrounding it and created a new public plaza that recalls Lime Street Square, which had been eliminated in the 1940s. Bill loves this complex give-and-take kind of design, welcoming the challenge of responding to a multilayered environment that has developed and changed over time. He is able to marry reductive sculptural form with the complexities of urban design and internal function. He's also proud that 52 Lime will be the first building to be certified Excellent under the 2014 BREEAM environmental standards.

The Scalpel joins a remarkable group of high-rise projects that the new generation of KPF designers are completing around the world. In 2017, the 1,819-foot-tall Lotte World Tower—designed by a team led by Jamie and Trent Tesch—opened in Seoul, becoming the fifth-tallest building in the world. Its sleek, tapered form and convex floor plates allude to ancient Korean ceramics, while its stacked program of uses—retail, offices, hotel, residential, hospitality, and observation floors on top—creates the kind of vertical urbanism that we have been exploring in Asian cities for a number of years now. Wrapping around the base of the tower, an eleven-story structure contains a shopping and entertainment center with a pedestrian plaza at grade and a two-thousand-seat concert hall on top. The entire complex has made a major contribution to Seoul's vibrant civic and commercial life.

Around the same time as the Lotte World Tower opened, our Ping An International Finance Centre debuted in Shenzhen, China. One hundred and fifty feet taller than Lotte, the Ping An tower adds to KPF's roster of super-tall buildings, standing fourth in the world in height and first in terms

Paul Katz helped spearhead our entry into Asia and always enjoyed participating in signing ceremonies, panel discussions, and other events in the region. He and I were the first people at KPF to understand the importance of Asia to a modern architectural firm.

Left: 52 Lime Street (colloquially known as the Scalpel) emerges from the historic fabric of the City of London.

Right: Lotte World Tower in Seoul combines office space, residences, a hotel, shops, convention facilities, and an observatory in one elegant form.

Left: The CTF Finance Centre in Guangzhou stands 1,730 feet tall and provides a mix of uses that includes retail, offices, apartments, and a hotel.
Right: The CITIC Tower anchors an emerging business district in Beijing, rising 1,732 feet. Nicknamed China Zun, it takes its shape from that of a *zun*, an ancient Chinese wine vessel.

of office buildings. Right now, we have designed four of the ten tallest buildings and six out of the top thirteen.

Forty years ago, Shenzhen was a small fishing village with about thirty thousand residents. In 1980, Deng Xiaoping designated it China's first special economic zone, sensing that its strategic location in the Pearl River Delta close to Hong Kong would allow it to serve as a threshold to the rest of the world. Deng was a smart guy, but I don't think even he understood how dynamic Shenzhen's growth would be during subsequent decades. Today the city has a population of more than thirteen million, significantly more than New York City.

Just imagine building all of New York (and more) in less than forty years! For much of this time, Shenzhen was a sprawling urban mess of factory districts, repetitive housing blocks, and supersized roads engulfing a number of densely patterned villages that happened to be in the way of new development. Because things change so quickly in China, many of the factories built in the mid-1980s got repurposed just thirty years later to become mixed-use, creative hubs where well-educated young professionals work for tech companies and can grab a good cappuccino, find a hip Thai restaurant, and hang out at a cool bar. Major companies like the developer Vanke and Ping An Insurance made Shenzhen their home, as millions of enterprising Chinese moved to the city in search of economic opportunity. Today, Shenzhen is developing a reputation as an urban laboratory where innovative architecture and planning are creating a richly textured metropolitan experience. At the physical center of this city, KPF's Ping An tower now stands as a visual and economic landmark, a 115-story exclamation point made of glass and stone.

A key player in our China work today is Inkai Mu, who studied at Tongji University's prestigious school of architecture and urban design in Shanghai and then got his master's degree at the University of Oregon. He joined us in 1999 and has worked on super-tall buildings such as Ping An, the CITIC Tower in Beijing, and the China Resources headquarters in Shenzhen. We have leveraged his experience with sophisticated, mixed-use towers in other parts of the world, too, such as One Raffles Quay in Singapore and the building in New York's Times Square that originally served as Morgan Stanley's headquarters and now houses Barclays Investment Bank. Inkai has proved to be extremely valuable in coordinating our New York practice with our offices in Shanghai and Hong Kong.

Rob Whitlock is another powerful voice in our Asia work, having contributed to many of our high-rise and mixed-use projects there. His concern for sustainability and public outdoor space has helped shape our approach to urbanism and the global city and informed the design of the multi-building Marina Bay Financial Centre on Singapore's waterfront. His skill at converting density into vibrant, high-rise urbanism can be seen in his design for Hysan Place, a forty-story tower in Hong Kong that stacks office floors above seventeen stories of retail and connects directly to parking and mass transit. The building's shifting forms create vertical gardens, rooftop oases, and large openings that allow wind to pass through and cool interior spaces. When it opened in 2012, it was the first LEED Platinum–certified commercial project in Hong Kong. Rob has also been busy with domestic projects, designing two elegant residential towers in New York—the Madison Square Park Tower, which was completed at the end of 2018, and 111 Murray Street, which should be done by the end of 2019.

If you look at some of our most important projects in Asia, you will see the fingerprints of Ko Makabe, who joined us in 1997 after earning his architecture degree at Oklahoma State. Ko helped with the Roppongi Hills complex in Tokyo and served as senior designer for the Nihonbashi 1-Chome mixed-use building in Tokyo and the INCS "Zero" Factory, which fuses architecture and landscape in Nagano, Japan. He also worked on the 101-story Shanghai World Financial Center and hospitality projects for us in Macau and Las Vegas. In 2014, Ko received the Outstanding 50 Asian Americans in Business Award, an honor given to people from many different fields.

One of our most versatile principals is Brian Girard, who has worked on major projects in the US, Europe, the UK, and Asia. He was senior designer for the expansion and renovation of the Museum of Modern Art in New York and contributed to the master plan of Hudson Yards. He led the master-planning efforts for Covent Garden and Floral Court, both projects in London that required us to weave old and new elements into a historic urban fabric. He was the design principal for the JR Central Towers, a 2.5-million-square-foot addition to our original JR Rail complex in Nagoya, Japan, and has been the lead designer for projects in South Korea and China.

Shawn Duffy is another one of our globe-trotting principals. Although currently based in London, he is managing the development of MGM Cotai, a mixed-use complex in Macau that features eight jewel-like boxes stacked into

The first LEED Platinum commercial project in Hong Kong, Hysan Place combines retail and office spaces in an expressive structure. Its shifting forms create vertical gardens and rooftop places where people can relax and enjoy the views. Bill Louie designed the concept for the project, then Rob Whitlock took over.

an abstract form. He was the project manager for our iconic International Commerce Center overlooking Victoria Harbor in Hong Kong and served in the same role for several office projects at Canary Wharf in London.

KPF has developed a reputation for designing innovative mixed-use complexes around the world. Jeff Kenoff, one of our most recent New York–based principals, has worked on a number of these projects, serving as senior designer for Riverside 66 Hang Lung Plaza, a fantastic retail center that revitalizes a waterfront property in Tianjin, China, as well as buildings in Hangzhou and Jakarta.

Other principals who have contributed to our work in Asia include Peter Gross, who has served as managing principal for many of our China projects; Bernard Chang, who manages our Hong Kong office; and Rebecca Cheng, who runs our Shanghai operation.

Keeping all of the firm's many parts moving in sync is Dominic Dunn, who oversees operations while also managing specific building projects. With his wry sense of humor and quick smile, Nick is great with people as well as numbers. He studied music before switching to architecture, which may explain why he's so good at orchestrating a lot of talented people. We sent him to London for a few years to oversee that office, but he's back in New York now, charming clients and building trust among team members. In some ways, he is filling the shoes of Shelley Fox. His involvement in particular projects, though, gives him a broader role.

Another behind-the-scenes force is James Brogan, who manages KPF's digital technologies, coordinating and connecting all of our international offices. Integrating the latest technologies with our design capabilities is essential to maintaining our status as a cutting-edge architecture firm.

Keeping an eye on our money and making sure it flows in the right direction is Peter Catalano, our chief financial officer. Peter has been with KPF for thirty years and represents the kind of dedication that makes our firm special.

In Abu Dhabi, we have been working on an enormous project for more than a decade. Our new airport terminal there will be one of the largest in the world, encompassing 7.9 million square feet with sixty-five gates, and will be able to handle eighty million passengers a year. Designed by our London office, the $2.8 billion project will hover above the flat desert horizon with an amazing roof structure that rolls like an artificial landscape and an illuminated interior that will be visible from a mile away. When it opens near the

end of 2019, it will serve as an iconic gateway to the United Arab Emirates, with its departure hall rising as high as 165 feet and eighteen long-span leaning arches that eliminate the need for most columns. At 590 feet, the largest of the arches is almost the same width as the Gateway Arch in St. Louis.

Mustafa Chehabeddine, the principal in our London office who spearheaded the design of the airport, represents the future of KPF. Educated in Beirut and London, Mustafa has worked on projects for us in China, Turkey, Kuwait, Dubai, and Britain since joining the firm in 1999. A talented designer, he's also great at working with clients and coordinating incredibly complex projects with consultants, contractors, and collaborators from around the world. It's hard to find people with such a broad set of skills.

Our managing director for the Abu Dhabi airport project is Jochen Tombers, who studied in Germany and the US and worked for firms such as Foster + Partners in Berlin and Richard Rogers Partnership in London. He has deep experience with airports, as well as tall buildings and master planning.

Building the incredibly sophisticated structure for Abu Dhabi's international airport has been a challenge and has taken longer than originally expected. Great buildings often take more time than lesser ones, but their long-term impact on the users' experience and the local economy more than make up for any delay. For example, Jean Nouvel's Louvre in Abu Dhabi was completed five years late, but it has been a huge hit with tourists, locals, and the international press. Along with the Louvre, our airport terminal is part of an ambitious plan by Abu Dhabi to position itself as a major destination for luxury, business, and cultural travelers. Planning for a time when oil is eclipsed by other sources of energy, the leaders of Abu Dhabi and the UAE are wisely diversifying their economy and creating new reasons for people to come and visit.

As I mentioned in an earlier chapter, I've long been fascinated by airports—in part because I have spent so much time in them, but also because they are often such dreary places. Rather than conceiving of them as large buildings, I think it makes more sense to approach them as small cities. So we try to create neighborhoods with different characteristics in our airport designs and develop the same kind of excitement you would get exploring London or New York or Shanghai.

In April 2018, we won the job of designing a new terminal at Singapore's Changi International Airport, already one of the best (and busiest) in the

One Vanderbilt in New York.

One Vanderbilt.

world. The new wing will allow the airport to service an additional fifty million passengers each year. Teaming with Heatherwick Studio from London, Architects 61 from Singapore, landscape architects James Corner Field Operations, graphic designer Bruce Mau, and engineers at Arup, we aim to make the terminal both spectacular and comfortable. It will have a series of skylights of different sizes and forms that will create a truly remarkable interior experience.

The scale and complexity of projects like airports demand that people from different fields work together. This is rarely easy. But we love the challenge of gathering research from different disciplines, listening to numerous perspectives, reconciling competing approaches, and developing a comprehensive design that exceeds the expectations of the client, users, and critics. Forth Bagley, one of our rising stars, played a critical role in establishing our relationship with Heatherwick and convincing the client to give us the commission. A graduate of Yale's school of architecture, where he has also taught, Forth has led the design or management of many of our most important projects in recent years, such as the 1,739-foot-tall CTF Finance Centre in Guangzhou, and hotel and retail projects in Beijing, Chengdu, Macau, Hong Kong, Bangkok, and New York.

We're still in the early stages of the Changi airport project, but I'm excited by what our design team, led by Trent Tesch, is already producing. A graduate of the University of Cincinnati, Trent joined KPF in 1996 and became a principal in 2009. He has worked on a broad range of projects for us, including the sinuous apartment block at One Jackson Square in Manhattan (with Bill Pedersen), the supertall One Vanderbilt next door to Grand Central Terminal (with Jamie), the Petersen Automotive Museum in Los Angeles (with me), and the ICC in Hong Kong (with Bill), in addition to the Lotte Tower mentioned earlier in this chapter. He's one of our stars.

Speaking of the Petersen Museum, I love telling the story of how we got that job. It started in France, where my second wife, Diane Barnes Kohn, and I were on vacation, staying at a fabulous house in Provence that Gerald Bratti and his wife, Nancy, had rented. Gerry owns Stone Logistics, which helps architects and contractors select stone in Europe for building projects, mostly in the US. Gerry was born into the stone business, having worked for his father, Peter, an immaculate dresser who knew all of the best suppliers in Europe and always kept a photograph of the pope on him. As any architect

It's all about speed and beauty and the art of the car.

Peterson Automotive Museum in Los Angeles

will tell you, visiting quarries—especially those in Italy—to select marble or granite is one of those tasks everyone in your firm volunteers for. You stay in elegant hotels and get wined and dined in style.

One day while driving to the Bratti house in Provence, Diane and I stopped at a nearby gas station to fill up our rental car. As the attendant serviced the car, I noticed Gerry walking toward us, accompanied by a man and a woman. Gerry introduced us to the couple, Doug and Linda Wood, who lived in a beautiful Philip Johnson–designed house in New Canaan, Connecticut, and would be joining us for a few days. We bonded quickly with Doug and Linda, and they remain two of my closest friends to this day.

For about a week in Provence, we had wonderful conversations about the French countryside, wine, automotive design, driving habits in various nations, and the state of the world. Everyone got along winningly, and the three couples became close friends. I did watercolors of the surrounding landscape and gave them to our hosts and each of the other guests. The paintings were long horizontals, about three feet wide—to capture the sweep of the views—and were quite beautiful. I only wish I had kept one for myself!

Years later, my third wife, Barbara Shattuck Kohn, and I, along with Doug and Linda, bought a share in a house in Tuscany, not far from Siena. On one of our visits to the house about six years ago, Doug and Linda invited David Sydorick, a retired investment banker who has an incredible collection of classic cars and has served on the board of the Petersen Automotive Museum since it began in 1994. Founded by magazine publisher Robert Petersen and his wife, Margie, the museum occupies an old department store on the corner of Fairfax Avenue and Wilshire Boulevard, an anchor of Los Angeles's "Miracle Mile" shopping corridor created by real estate developer A. W. Ross in the 1930s. Designed by Welton Becket in 1962, the original building offered glazing on just one facade, because it had window-less showrooms inside and a large parking structure on the back. Outdated for shopping and ill suited for much else, the building lay empty for several years after the Ohrbach's store there closed in 1986. Petersen, though, realized it would be perfect for showcasing museum-quality automobiles that need to be protected from too much sunlight.

One afternoon in Tuscany, David pulled me aside. I poured some white wine for the two of us and listened. Sitting on the terrace, we could see the rolling hills dotted with farmhouses and the stone towers of San Gimignano

While on vacation in Tuscany, I drew the initial sketch for the Petersen Museum. Joining us there were (from left to right): David Sydorick, a board member of the museum, along with Nancy Bratti, Doug Wood, Gerry Bratti, Ginny Sydorick, Linda Wood, and my wife Barbara.

in the distance. He told me that after nearly two decades in the old department store, the Petersen wanted to upgrade its identity and street presence. "We need a transformation" to attract more people, he said. Zoning regulations, though, prevented it from expanding either up or out. "We can't add or subtract anything. We're stuck in our existing box." The museum's board didn't know how to proceed. David had talked to Frank Gehry and now wanted to hear my thoughts.

"Why don't you just wrap the box in ribbons?" I suggested as we sat on a terrace enjoying the wine. "What do you mean?" asked David.

I grabbed a paper napkin, found a pen, and quickly sketched a flowing line spiraling up and around a simple rectangle. "It's a three-dimensional racing stripe made from the same kind of metal you'd find on a Ferrari. Since it's just a ribbon, it won't change your square footage or break any zoning regulations." David's eyes lit up and he said, "Yes, that's it!"

I must admit I loved the chance to reconceive a building by my old employer, Welton Becket. I had led the design team at the New York office of his Los Angeles–based firm back in the early 1960s and always respected his work, which expressed in architectural terms the optimistic, forward-thinking attitude that has long made Southern California so attractive. Cars are deeply entrenched in California's culture and economy, so designing an automotive museum was a dream assignment for me.

My sketch was a good start to the project, but it was just the first step in a much longer process of design development that required the skills of many other people. When I got back to New York, I showed Trent my drawing and explained the ideas behind it. "It's all about speed and beauty and the art of the car," I told him. Trent is a brilliant designer and a whiz with the computer. He and his team got to work taking my line drawing and turning it into a three-dimensional piece of architecture. We decided to clad the existing building in Ferrari-red, corrugated aluminum panels to provide a contrasting backdrop to the silver ribbons wrapping the structure. The exact pattern of the ribbons changed over and over, as Trent and I figured out the best way to express the aerodynamics of wind whipping around a speeding car. We created a 3-D model of the project and a seventy-eight-page book with drawings and a hand-engraved cover. It was pretty impressive, if I may say so myself.

David showed the book and model to Terry Karges, the museum's executive director, and the rest of the Petersen leadership. He also spoke with Peter

Mullin, who has his own collection of several hundred classic cars (including a $50 million Bugatti that he shares with another car aficionado), and was being wooed to join the board. Peter loved it immediately and accepted the role of board chairman and head fund-raiser for the expansion project. The simplicity of KPF's scheme combined with its powerful visual impact made it effortlessly persuasive. When David called me up with the good news and asked about our fee, I quoted him a pay structure that was more than fair. Considering how excited the museum was about the scheme, I could have asked for a lot more. Not taking advantage of that initial leverage probably cost us a few dollars but has resulted in a strong relationship with the Petersen board that may pay dividends as it plans to expand the museum in the future.

The $90 million renovation, which includes completely new interiors and exhibitions by the firm Scenic Route, opened in December 2015 and has been stopping traffic ever since. That month, *Fortune* magazine wrote, "The dramatic exterior is the first, vivid clue to the changes: Wrapped with 308 undulating steel ribbons, the hot-rod-red building looks like it's wearing racing stripes and traveling at 100 mph, leaving streaks of glowing taillights."

While this portion of the Miracle Mile was originally envisioned as a shopping mecca, it has now become a magnet for big-name architects—including buildings by Renzo Piano for the Los Angeles County Museum of Art (LACMA) and the Academy Museum of Motion Pictures (which, like our project, includes the renovation of an old department store), plans by Swiss architect Peter Zumthor for LACMA, and talk of a tower by Frank Gehry for the Los Angeles Metro transit agency.

Although I was born in Philadelphia and have lived most of my life in New York, I have become quite fond of California. In high school I spent a wonderful summer as a lifeguard for a family renting a house in California, and I was stationed there while serving in the Navy before shipping out to the Atlantic. When I worked for Welton Becket, I often went to his office in Los Angeles. Then, as president of Jack Warnecke's firm, I would bring my family to vacation each summer at his property on the Russian River. I love the weather in California and the way the mountains meet the ocean just north of Los Angeles. The people, the food, and a culture of let's-just-try-it experimentation are all attractive to me. KPF did a number of projects in Northern and Southern California in the 1980s and '90s, but we took our foot off the pedal there when we got busy in other parts of the world. We

didn't develop strong relations with the tech industry, despite our extensive credentials with corporate headquarters and office buildings.

We're changing that now with a new San Francisco office led by Angela Wu, who is expanding our reach in both Northern and Southern California. Josh Chaiken, one of our New York–based principals, is designing several projects in Los Angeles, including a large residential tower in the MacArthur Park area and a five-million-square-foot tech campus in Playa Vista. On much of our California work, we have collaborated with House & Robertson Architects, a great firm with offices in Los Angeles and San Francisco.

Hugh Trumbull, another New York principal, is designing an office project in San Jose for Boston Properties, which has been a fantastic client for us for many years on both the East and West Coasts. Owen Thomas, the CEO of Boston Properties, happens to be one of the most thoughtful and gracious people I know.

We're also doing a couple of projects in San Jose for TMG Partners, which Trent is designing. Lloyd Sigal is serving as project manager for much of the California work and is helping us develop new business there. Lloyd's father, Myron, was a project manager and principal at KPF at the start of the firm, so we've benefitted from two generations of Sigal talent.

Occasionally, though, I feel out of step with Californian culture. Back in the 1980s, KPF worked on plans for a Four Seasons hotel in Beverly Hills, and our client got tickets for Bill Pedersen and me to go to a gala at the Beverly Hills Hilton in honor of the comedian George Burns's ninetieth birthday. Bill and I got all dressed up in black tie and went to the event—in a blue-and-yellow Beverly Hills taxi. Everyone else arrived in their Rolls-Royces, Bentleys, or Maseratis and looked at us, wondering, "Who are those hicks?"

Back in Manhattan, one of our talented young principals, Hana Kassem, worked with Bill Pedersen on the design of the City University of New York's Advanced Science Research Centers, a gorgeous set of buildings that create a new campus for the school in Harlem. Michael Greene served as managing principal, as he has done on a number of projects both in the US and Asia.

Richard Nemeth, who has helped me teach courses at Harvard's business school on the Value of Design, has served as managing principal for a number of important international projects, such as the Azrieli Tower in Tel Aviv and the Royal Atlantis resort in Dubai. He is also managing an office tower in Vancouver and some mixed-use developments in Boston.

One of our most exciting projects nearing completion now is One Vanderbilt, a 1,401-foot-tall tower across Vanderbilt Avenue from Grand Central Terminal in New York. Although fifty feet lower than the tip of the Empire State Building's antenna, it will boast an observation deck and office floors significantly higher than those at the great Art Deco skyscraper eight blocks south. Jamie led our design team, sculpting the building as a set of four interlocking, tapering volumes that respond to the proportions of the nearby Chrysler Building.

Perhaps more important than its position on New York's skyline will be One Vanderbilt's role at ground level and below. At its base, we designed a series of angled cuts that create a visual procession to Grand Central and allow people walking east on Forty-Second Street to see the station's impressive cornice, which had been blocked by the previous building on our site. A new pedestrian plaza on Vanderbilt Avenue will link our building and the station, creating a wonderful place to slow down a bit and admire the architecture in one of the busiest spots in Manhattan.

We also connected the buildings underground, turning our project into a critical new element in Grand Central's complex web of transit infrastructure. When our building opens, commuters will be able to go directly from train platforms to a new transit hall under One Vanderbilt and enjoy daylight streaming in from above. Passengers on the city's 4, 5, and 6 subway lines will find improved entrances, corridors, and stairwells that our client SL Green has paid for. And when the East Side Access project is completed in 2022, patrons of the Long Island Railroad will finally be able to get off at Grand Central, using escalators, corridors, and spaces incorporated in our project. In all, SL Green will spend $220 million on below-grade transit improvements there.

One Vanderbilt adds an important new chapter to the history of this site. When Grand Central Terminal opened in 1913, it was seen as the start of a "Terminal City" that would include the construction of Park Avenue above train tracks running to the north and office buildings all around. Indeed, the station sparked an amazing period of development that lasted for decades. Like Grand Central, One Vanderbilt digs below grade to improve the city's circulatory system, reaches out to create a more exciting street experience, and rises above to entice our eyes.

Marc Holliday, the chief executive officer of SL Green, has built the company into the largest owner of commercial office properties and the dominant

landlord in midtown Manhattan. He has pursued a vision of returning east midtown to its role as a dynamic location for mixed-use development—a role it had relinquished in recent decades as lower Manhattan and the far west side offered greater opportunities for big projects. By 2017, the average age of buildings in the area was seventy-five years, and many were relics of the *Mad Men* era when advertising executives wore fedoras and took three-martini lunches. Working with Amanda Burden, who served as the city's planning commissioner under Mayor Michael Bloomberg, Marc helped make the argument for up-zoning the area to keep it competitive with other parts of town. The zoning changes were defeated by the City Council in 2013, but Burden granted One Vanderbilt variances that allowed it to essentially act as a test of the proposed rules. In 2017, the city finally passed the up-zoning for east midtown, allowing other projects to use the same rules as we did. City Councilman Dan Garodnick was a powerful voice supporting the changes. One of the key arguments he made was requiring new development to help fund transit-related improvements in the area. I like to think that One Vanderbilt helped the City Council see the huge benefits the city would experience under the new zoning.

Marc is a fascinating person who became CEO of SL Green in 2004 and has steadily expanded its mission. Once known mainly as an owner of commercial properties, the company has diversified under the direction of Marc and president Andrew Mathias to become an important developer. One Vanderbilt is the company's first ground-up development project, a giant statement of its ambition. While first-time developers can be difficult to work with, as they ascend a steep learning curve, Marc and Andrew have been great from the start. Their intelligence and leadership skills have made One Vanderbilt a really exciting project.

One Vanderbilt represents many of the key ideas driving KPF's vision for cities. It's a remarkably sophisticated piece of architecture that adds a lovely new note to the rhapsody of Manhattan's skyline. It demonstrates our attention to materials and details—balancing opaque surfaces with transparent and reflective ones. It responds sensitively to its physical, economic, and cultural context and engages the history of its place in an intelligent dialogue. Ultimately, it makes significant contributions to the way New Yorkers will move through, work in, and enjoy this very special part of their city. And as I write this, its construction is six months ahead of schedule!

The same developers—SL Green and Hines—have hired us to renovate

and expand One Madison Avenue, a late Art Moderne building from the early 1950s. We will create new roof terraces on the tenth and eleventh floors of the existing structure and then add an eighteen-story glass-and-steel office tower above that. Our design complements and respects the iconic Met Life Tower next door. Tommy Craig, senior managing director of Hines's New York office, has worked with us to shape both One Vanderbilt and One Madison. Tommy is a great guy and has a sharp mind for real estate. He and his wife Kim have become good friends of ours over the years. He was really impressed with KPF's One Vanderbilt team and said it was the best he has ever worked with. When we started on One Madison, he shook his head and said that team was as good as the first one! Comments like these demonstrate how deep our talent is right now.

Tommy's counterpart running Hines's Paris office is Patrick Albrand, who is keeping KPF busy in France. Patrick and his wife Alix are wonderful people who have become close friends of mine and Barbara's.

Today, KPF employs more than 650 people led by thirty-one principals and has offices in New York, San Francisco, London, Berlin, Shanghai, Hong Kong, Seoul, Abu Dhabi, and now Singapore. We're busier than ever, with active projects in twenty-two countries accounting for 418 million square feet of space. We're designing skyscrapers, corporate headquarters, residential buildings, mixed-use complexes, retail centers, hospitals, education buildings, civic and cultural institutions, master plans, renovations, and transportation facilities. Thanks to the diverse backgrounds and talents of our staff, we are well positioned to respond to changes in the market for architectural services and lead the profession for decades to come.

I'm eighty-eight years old and plan to stick around a while longer to see all these exciting projects move forward. I have enormous confidence in Jamie and the other KPF partners to take the firm where it needs to go without compromising our longtime values of collaboration, integrity, and design excellence.

Azrieli Tower in Tel Aviv.

Future Perfect

Although my mother lived to 106 and kept painting well into her hundreds, she closed her fashion design business years before. It was difficult for her to let go of her professional activities, and many of her clients cried at her farewell party, but she knew it was time. I still come to the office every day and travel for new business. My plan is to start cutting back on my work schedule in about a year. In the meantime, I concentrate on business development and client relations. Jamie von Klemperer is president of the firm and runs the show now. I'm chairman and serve him as a sounding board for new ideas and as a trusted adviser on strategy.

Having led KPF for four decades and run John Carl Warnecke Associates for years before that, I admit it's hard to let go of the day-to-day decision making. Sometimes I find myself thinking, "That's not the way I would do it," but I realize that my way might not be any better than the other way. I trust Jamie and don't second-guess him. The last thing I want to do is undermine him in any way. If he were to make a decision I thought was clearly wrong, I would tell him in private, and we would discuss it. But he's the president and calls the shots.

I feel as if I'm on a train and can see—after a long journey—the stop where I get off. The train, of course, will keep going without me. I've always loved fast trains, but this is one I'd like to slow down.

Sometimes I pause for a moment and ask myself, "How the hell did I get here?" My success still surprises me. Although I was always ambitious, I never would have predicted I would get this far. I was an only child growing up during the Depression in a tight-knit family in Philadelphia. When I was a kid, my mother ran her dress business out of our row house, and my bedroom doubled as the changing room. So I learned to do my homework in a noisy, bustling environment—often playing the radio to block out all the commotion. Women would come into my room, try on a new dress, and discuss its length and cut with my mother. I would sometimes help a customer with a zipper, a task that became increasingly enticing and distracting as I

got older. Knowing how to focus in the middle of lots of activity has served me well at architecture school, in the Navy, and then in practice. To this day, I have trouble working if it's too quiet.

Growing up, I didn't get to travel much. The longest trip I remember taking was to Pottsville, Pennsylvania, where we would go each Christmas to spend time with my father's sister and her family. My uncle owned a small department store there—Weiss's—so I would get new clothes and, more importantly, new toys. About one hundred miles northwest of Philadelphia, Pottsville was known for coal mining, textiles, and Yuengling beer. Taking the train there was an adventure. I loved watching the enormous steam-powered engines pull into North Broad Street Station in Philadelphia and then riding in the cars as we headed into coal country. In Pottsville, I watched the sons of coal miners play high school football on Friday nights and demonstrate an impressive kind of American grit. A remarkable number of great players came from the Pottsville area, including Johnny Lujack and Chuck Bednarik.

For her business, my mother would go to New York periodically to select fabrics or attend fashion shows. She didn't have money for a babysitter, so she would bring me along. When I was in high school, she sometimes told me to skip school and take the train to New York to pick up a dress or do some other errand for her. Despite my occasional absence from classes, she expected me to get straight A's in school.

New York was a fascinating place that seemed to be the center of everything, the sun around which all other towns and cities orbited. It was crazy and exciting—exactly what a teenage boy would love. My father's sister, Mary Zinn, lived in a beautiful apartment on West End Avenue, where she would play the piano whenever we came to visit. Her husband, Joseph, manufactured dresses, which was a big help to my mother in her business. Later, I would visit a girlfriend, whom I had met at summer camp, in Brooklyn where she lived. After that romance fizzled, I dated another girl from Brooklyn and became an expert at navigating public transit in at least two boroughs.

The late 1930s and first half of the '40s were a time of tension and fear. The Depression wiped out my father's medical research business, as most of his customers couldn't pay their bills. In 1939, we watched newsreels of the Nazi invasions of Poland, Holland, Belgium, and France and the bombardment of England. It made us wonder what might happen to the US. The Japanese attack on Pearl Harbor in 1941 brought us into the war, sending

waves of American soldiers off to distant battlefronts. My older cousins and some of my uncles served in the military, shipping out at different times. On the block where I lived, and almost every other block in America, all the young men were gone. Air-raid drills were a constant reminder that German planes might slip through our defenses and attack us at any moment. At night we pulled down the window shades so enemy pilots couldn't target us.

My mother's brother, Raymond Steinberg, was a Marine who had fought as a young man in World War I and then served again in World War II. He was the toughest guy I ever met and worked out every day, so his abdominal muscles were as hard as stone. He would tell me to punch him in the stomach and wouldn't flinch as I hurt my hands hitting him as hard as I could. He outlived two wives and died at one hundred with a toupee he had bought at ninety to help attract the ladies.

When the war ended, I was fifteen years old and familiar with the names of faraway places like Dunkirk, Normandy, Tobruk, Dieppe, Guadalcanal, Guam, Iwo Jima, and Hiroshima. I knew the names of all of the generals and admirals and was fascinated by the military.

As an adult, I have traveled extensively and gotten the chance to see—and work in—many parts of the world. Dining at fancy restaurants in Tokyo, Paris, and Rome and getting to know the neighborhoods of Shanghai, Madrid, and London are things I couldn't imagine as a kid in Pennsylvania. Architecture has opened all kinds of doors for me, providing access to people and experiences that have challenged me and made me smarter and, I hope, a bit wiser.

Some architects know what they want to be from as far back as they can remember. Not me. I thought about medicine and the law. I dreamed of doing something in sports broadcasting. But I didn't have a lot of confidence or a good understanding of my talents. Despite appearances, I'm actually a shy person by nature and have had to work hard on the way I present myself to others. I remember listening to the radio and hearing leaders like Churchill and Roosevelt inspire millions with their voices. How did they do that?

In high school, I took a course in public speaking. In the Navy, I learned about leadership and making timely decisions. As a practicing architect, I continued to work on critical skills and took a seventeen-week course called Communispond that really improved the way I make presentations and communicate with people. The course is open only to top-level executives and politicians and teaches you how to talk to small groups and large ones, how

to prepare speeches, how to speak extemporaneously, how to handle angry comments, how to write letters, and how to persuade. I've gotten pretty good at public speaking, but I always tell young architects that most of us have to work at developing such skills.

In the mid-1980s, the United States Information Agency invited me to participate in a traveling exhibition in the Soviet Union. The idea was to show off American design—from architecture to fashion to furniture. I had KPF provide drawings, photographs, and models of our Procter & Gamble project, which had recently been completed. As part of the program, participating designers gave a series of talks in various Russian cities, including Moscow, Leningrad, and Kishinev, a fascinating town about one hundred miles from Odessa. It was a remarkable trip to a country that was still saddled with the heavy weight of Communist rule and was just beginning to see the first sprouts of Mikhail Gorbachev's policy of *glasnost*, or openness. The hotels we stayed at were horrible, and the food was worse. But the exhibition drew huge crowds of people who were excited to see anything American.

The union of Soviet architects honored me with a medal, and a pair of architects in Moscow invited me to their new office to see their work. Only about 20 percent of architects in the country were allowed to set up their own practices, rather than work in large state-run operations, so these two men were understandably proud of what they were doing. Their office was on the ground floor of a small residential building. On a table in the center of the workspace, the architects had placed a clear glass holding a pair of small flags—one of the Soviet Union and the other the United States. It was a simple, but touching, gesture of welcome. My hosts toasted me with shots of vodka and then brought out their firm's "brochure" of projects, mimeographed on cheap paper as if it were a *samizdat* tract from a political dissident. It was a far cry from the glossy publications that KPF and American firms typically produced to show off our work, but the contrast made it all the more meaningful. Wherever I went on that trip, the warmth of the Russian people and the difficult circumstances they endured impressed me immensely.

I also visited a large, state-run architecture practice housed in a run-down government building where the floorboards poked up dangerously and the ceilings were falling down. I noticed a model of a building on a familiar site: the diplomatic sector of Nicosia, Cyprus, where we were designing the new US Embassy. The model I saw in Moscow that day was of the new Soviet

Embassy, which would be built directly across the street from our project and would be one story taller so it could look into our building.

My mother's mother hailed from Odessa, and somehow a group there heard about my talk in Kishinev. Nearly a hundred of them traveled all the way to the event, introducing themselves to me afterward. They gave me gifts and drew me close to them. I was incredibly touched by their kindness and shed a few tears with them. It was an amazing evening, one I will never forget. I only wished my grandmother were alive to share it with me.

Looking back on my career, I can now fully appreciate the importance of three critical decisions I made in 1976. The first was to leave my position as president of John Carl Warnecke & Associates and start my own firm. The second was to ask Bill Pedersen and Shelley Fox to be my partners. And the third was to designate Bill as our lead designer, even though I had been a designer in my previous positions. Everything that happened afterward flowed from those key moves.

Now I am focused on the future of KPF and am more excited about it than at any time in its past. We have remarkable talent in every role—leadership, design, detailing, production of drawings, and construction services—and great depth. We have an outstanding marketing and new-business team headed by David Niles. Above all, there's a spirit of teamwork and support for one another. It reminds me of the powerful football teams at the US Military Academy in the 1940s, coached by Earl "Red" Blaik. The 1944 and 1945 teams were national champions and had incredible players at every position. In fact, Army's second squad was so good that Coach Blaik sometimes started it in the first quarter and then brought out the best players only in the second quarter!

Having weathered the economic turmoil of 2008, the mutiny in our London office in 2009, and then the death of Paul Katz in 2014, the firm is currently riding a powerful wave of good fortune. We have thirty-one principals, the most ever, and they bring a depth of talent that is truly impressive. I'm really proud of them. It takes a great group of people to make great architecture.

Under Jamie's leadership, we have been growing in size and doing fantastic design. We've won major new projects in China, Southeast Asia, North America, Europe, and the Middle East. The more I see Jamie in action, the more I realize what an extraordinary leader he is—clear-eyed in his vision for the firm and empathetic to the people who work there. I take much pride in knowing that KPF is in such good hands.

In 2018, we opened a Singapore office to help oversee our work on a new terminal at Changi airport, a project that will accommodate up to fifty million passengers per year. We are teamed up with Heatherwick Studio from London and a group of talented collaborators, including Architects 61 from Singapore, James Corner Field Operations from New York, and Bruce Mau Design from Toronto.

In Tel Aviv, Jamie has designed the Azrieli Tower, a mixed-use building that will reach 1,115 feet and be the tallest in Israel. Its spiraling form narrows as it rises, gracefully enclosing shops, offices, apartments, a hotel, and public space for gathering and entertainment at its pinnacle. From its top, you'll be able to enjoy views of the Mediterranean to the west and, on clear days, Jerusalem to the east.

Our London office is busy with some remarkable work, including the Bermondsey Project, a twelve-acre redevelopment that will combine old and new buildings for mixed-income housing, a secondary school, offices, retail, and cultural activities. Outdoor spaces will provide areas for playing, relaxing, and gathering, and will connect the historic Peek Freans biscuit factory to the surrounding neighborhoods. We are also working with Ian Hawksworth, an old friend who had been with Hongkong Land and now runs Capital & Counties, a major developer in the Covent Garden and Earl's Court areas of London.

China remains a very important focus for KPF, as we develop our plan for Dongjiadu Financial City, an enormous mixed-use complex that will revitalize an area in the West Bund district of Shanghai facing the Huangpu River. We are also doing a big project for Ronnie Chan's company Hang Lung in Hangzhou and helping New York University with its program in Shanghai. In the newspaper, I read about the Chinese economy slowing down and some of the political and social challenges confronting the country. KPF, though, hasn't felt any effects of this so far.

In New York, our 1,401-foot-tall One Vanderbilt tower will top out this year, while we work on a number of interesting projects, including the transformation and expansion of two key buildings—the Port Authority bus terminal on Eighth Avenue and the granite-clad One Madison Avenue next door to the Metropolitan Life Tower.

As I finish writing this book, the first half of Hudson Yards has just opened, attracting huge crowds eager to check out the new city-within-a-city that is transforming the west side of Manhattan. The $25 billion complex is

Dongjiadu complex in Shanghai's West Bund district.

Top: In San Jose, California, Trent Tesch's design for Platform 16 takes advantage of the mild climate to offer a variety of outdoor spaces for the people working there.
Bottom: South Almaden, designed by Hugh Trumbull, is another project in San Jose that provides generous terraces and courtyards, along with 1.3 million square feet of office space.

the most expensive private development in US history and stitches together the city's urban fabric by replacing an open rail yard with a vibrant mix of offices, residences, shops, restaurants, cultural facilities, and public open space. KPF has worked on the project for eleven years, dedicating at one point as many as sixty-five members of its staff and involving seven partners over the course of its development. When Bill, Shelley, and I established KPF in 1976, we couldn't have imagined we would one day be responsible for such a grand endeavor. In terms of scale, ambition, and architectural sophistication, Hudson Yards is a long way from our first job, the interior renovation of an old armory—though the two projects are just two-and-a-half miles apart.

Since we opened our San Francisco office in 2018, I've been spending a lot of time in California devising our western strategy and working with Angela Wu to develop our business on the West Coast and into the mountain states. Angela is doing a fantastic job expanding our contacts and deepening our relationships in this part of the country. Having worked for SOM in San Francisco for nearly twenty years, she brings great experience to her new job. Sometimes old colleagues recommend us for jobs. For example, Don Treiman, who runs AHT Architects in Santa Monica, has mentioned us to potential clients when he thinks we might collaborate. Both he and his former partner, Emilio Arechaederra, who passed away in 2015, worked for me at Warnecke.

I have a house near Santa Barbara and love California, so my plan is to spend more time on the West Coast as I wind down my career. These days, I find myself doing exactly what I did after starting KPF—developing new business by calling on prospective clients and strengthening relationships. I still love winning new commissions, and recently got a project in Los Angeles from Rob Maguire, who was one of our first clients. Things come full circle.

I never accept "no, thanks" as the end of the line. If we don't get a job after competing for a big project, I stay in contact with the client. I'll take them to lunch, dinner, or some special event I have tickets for. I'll call them up and discuss things I know interest them—whether that's sports or the state of the economy. I make sure I'm not pushy or annoying, but I cultivate relationships like some people do orchids or bonsai—carefully and with the long term in mind. You can't do this with every possible client, but it's essential to do with the ones who hold the greatest potential. We've gotten many jobs from companies who gave previous projects to other firms or found that the first architect didn't work out. Persistence pays off.

I've also learned that the best way to get new jobs is to stay in touch with old and existing clients. The trust we've developed with them makes it easier for them to hire us for their next project and provides a solid foundation that allows work to move forward quickly and efficiently. As we fly around the globe, introducing ourselves to people looking for architectural services, we sometimes forget that the best future clients are often the ones we already know.

Over the years, I've received a number of good leads from my two sons, Steve and Brian. As I mentioned in a previous chapter, Steve works in finance and is the president of Cushman & Wakefield Equity, Debt & Structured Finance. His position in the financial world has put him in contact with a lot of companies looking for architects, and he has referred many of them to KPF. It was Steve who told Gale International to consider KPF for the master plan and design of New Songdo City in South Korea. Brian has worked in real estate for Ware Travelstead and Olympia & York and now puts together his own projects—usually with Steve—turning around underperforming properties. He and Steve recently revamped a mixed-use building from the 1980s in Hartford, Connecticut, upgrading its office floors and rethinking its hotel to create one of the most desirable properties in town. I feel extremely fortunate to have two sons and a daughter, Laurie, who are such talented, lovely people. And they've given me nine grandchildren, whom I love dearly.

Right now, KPF is running on all cylinders. Thanks to Jamie and our principals, the firm is bigger and better than ever. The amount of design talent on staff is truly remarkable. If I were coming out of architecture school today, I don't know if I could get a job at KPF. Luckily, I already have one! KPF is also expanding the types of services it provides, introducing a data-driven Urban Interface group led by Luc Wilson and hiring Carlos Cerezo Davila as our environmental performance director.

At many architecture firms, people come and go fairly quickly—either because they don't see paths for advancement within the firm or they don't feel rewarded in terms of monetary compensation or professional opportunity. Bill, Shelley, and I wanted KPF to be different, so we created a practice where talented architects could build their careers. Today, we have a large number of principals, directors, and staff who have been with us for two, three, even four decades. Even our chief financial officer, Peter Catalano, who is not an architect, has been with the firm for thirty-three years!

KPF and the rest of the architectural profession face a number of

challenges in the near future and beyond. We need to harness the latest technologies to make our buildings and our cities as efficient, safe, and healthy as possible. But technology must be treated as a tool used in the service of larger goals—such as creating diverse and vibrant places to live, work, play, and learn. While staying on top of the latest platforms and algorithms, we must never lose sight of our main goal, which is to design places where people are happy, productive, and healthy.

A role of the architect is to create value. That might mean making a project more successful financially, or creating a more productive and healthy work environment for people using it, or improving street activity in the area around it. Although it can be difficult to quantify, we need to do a better job of explaining and measuring how our work not only impacts a client's bottom line, but brings joy to the people who use our buildings.

Every one of our buildings is a one-off custom product. So we can't really test a building the way a car company can run a new model on a track at its development facility. Yes, we can mock up elements such as curtain wall components and see how they perform under certain conditions. But architectural projects require leaps of faith on the part of clients and designers. Building trust in our skills and our process starts at the beginning of a project and is essential to everything we do.

Architects also need to create a more inclusive profession that more accurately reflects our society. We need to attract more minorities to architecture schools, recruit them to work for firms like KPF, and then make sure they grow into leadership roles. When I was a child, the most dynamic leader I knew was my mother, who ran a business, as well as our extended family. So having women in charge seems perfectly natural to me. Right now, KPF has a group of really talented women who are reshaping the firm, people like Jill Lerner, Cristina Garcia, Marianne Kwok, Hana Kassem, Rebecca Cheng, Florence Chan, Terri Cho, Eunsook Choi, Claudia Cusumano, Rebecca Gromet, Laura King, Cindy Kubitz, Jenny Martin, Lauren Schmidt, and Jerri Smith. We need to do a better job, though, establishing the flexible work schedules and extended-leave policies that will allow women to have families and still rise through our ranks and make it to the top.

Some challenges go beyond the architectural profession. The impact of climate change, for example, requires action by almost everyone in society—from federal, state, and local government officials to business executives and

individuals considering ways to reduce their carbon footprints. Today, buildings generate nearly 40 percent of annual global greenhouse-gas emissions. That's more than what transportation or industry generate. Since buildings represent such a big part of the problem, architects must be a big part of the solution. We need to design projects with less embodied carbon and ones that require less carbon to operate. Very soon—in the next decade or two—we will need to create buildings that emit no greenhouse gases and use only alternative energy sources such as solar and wind. Our buildings and cities must be resilient in the face of rising sea levels and increasingly severe weather. We have no other legitimate option.

Society must also handle swings in our economy. For nearly ten years, US economic output has increased, a remarkably long period of growth after the fiscal meltdown of 2008. While the fruits of this recovery have not been enjoyed equally by all parts of our population, the economic expansion has had an enormous impact on construction and the architectural profession. You can see it in most big American cities, where construction cranes dot the landscape and skylines reach higher than ever. KPF has benefited greatly from this building boom, and today the firm employs more people than ever before.

Having been born during the Depression and seen quite a few ups and downs, I know that the economy moves in cycles. Bull markets turn into bears eventually, and booms collapse into busts. Buildings are usually the first projects to be cut or put on hold when the economy reverses course, so architects feel the pain almost immediately. Leaders should take care that their firm's workload is distributed over a diverse range of building types and markets. Otherwise, a drop in one could have a devastating impact on overall business. KPF has done extremely well with commercial office buildings in the past ten years, but these projects are most sensitive to swings in the economy. So we are expanding our efforts to win commissions from institutional clients—such as universities, governments, and transportation authorities—that are less dependent on market financing.

I've never met anyone who can accurately predict when the next downturn will hit. But I've learned to take note of certain warning signs. For example, when developers start buying extreme sites—ones that had long been passed over because they are too far out in terms of location, size, or building constraints—and architects start devising extreme designs in terms of their formal expression, use of materials, or structural hijinks, then you know a boom is near its end.

I sometimes worry that over-centralization might also pose risks to a large architecture firm such as ours. While KPF has offices in nine cities around the world, we do almost all of our design work out of New York and London. Might it make sense to move some design principals from New York to other offices for a few years at a time, so they can build relationships with local clients and not have to fly all over the place? Would a more decentralized organizational structure allow us to respond better to changing conditions and demands from our clients? These are things we are currently investigating.

Radical swings in our nation's foreign policy worry me as well. Since World War II, the United States has overseen a remarkable period of peace and prosperity based on respect for our allies and support for treaties that have tied much of the world to us. We now have a government that attacks our allies, questions the value of multilateral trade agreements, and looks favorably on dictatorships that wish us ill. KPF has benefited greatly from a world with fewer barriers and today does a lot of its business in countries that not long ago were mostly walled off from the world economy. A trade war with China might very well result in American architects losing access to the world's biggest market for construction and design services. We might also find that countries we have long called allies start turning away from all things American. Such developments could have a devastating impact on large firms and the architectural profession as a whole.

We need to plan for tomorrow right now. Who are our future clients? Who are the next Googles and Apples and Amazons? They may be in fields that barely exist right now or come from countries that we rarely visit. Thanks to all the talent at KPF, we're in position to meet the challenges of the future, beat out some great competition, and thrive.

When Bill Pedersen, Shelley Fox, and I founded KPF more than four decades ago, we wanted to create a dynamic firm that would carry on after we had retired or passed on. Shelley is gone, and Bill has reduced his involvement in recent years to help his wife battle cancer. I still work full-time but no longer run the day-to-day operations. The values we fought hard to establish—collaboration, teamwork, and nurturing new talent—are now hardwired into the firm. With Jamie and our new leadership in place, I am totally confident that KPF will remain one of the world's most important architecture firms for many years to come. Its future will surely be as bright or brighter than its past.

The experiment that Bill, Shelley, and I launched in 1976 has succeeded beyond our wildest dreams.

This new neighborhood on the Hudson River embodies the spirit and character of New York.

Hudson Yards.

Acknowledgments

There are so many people to thank for making this book possible. Writing it with Cliff Pearson has allowed me to relive many of the wonderful and exciting moments in my career, as well as some of the challenging and sadder ones. After so many busy years, I've probably forgotten some key people. I apologize to anyone who deserves to be in these pages but isn't. Write me a note and I'll try to get you in my next book!

I want to acknowledge a number of people in particular who played key roles in my life and are responsible for many of the successes and stories in this book.

I have been married three times and I want to thank my first wife, Barbara Kohn Welsh, who had to bear the brunt of those early days in my career when I worked long hours, didn't make very much money, and traveled much of the time to pursue work or attend project meetings with clients. A college graduate who gave up a career, she did an amazing job raising three wonderful children while I was working.

My second wife, Diane Barnes Kohn, was an interior designer and ran a German furniture showroom. Because of her work, we got the chance to travel together periodically and meet with each other's clients.

Most important is Barbara Shattuck Kohn, who has been my wife since 2002. Her background in investment banking has been a big help to me and her advice on many business matters have been invaluable. Barbara's charm, intelligence, energy and many other attributes contribute to her being the perfect hostess to our friends and our clients—both hers and mine. She has a knack of making everyone feel comfortable. She plays a major role in assisting me both personally and professionally—attending many social functions and joining me on key business trips. In the process, she sacrifices a lot of her personal time, even as she stays busy with her own career and volunteer activities. She serves on two major corporate boards, chairs the board of the Four Freedoms Park on Roosevelt Island, and had been chair of the board of her alma mater, Connecticut College. Her enduring love

and support have made the many hours and much effort of business socializing more enjoyable. Our family—which includes our two Bernese Mountain dogs, Quigley and Poggi—gives me great pleasure and happiness.

Above all, I want to thank my children Brian, Steve, and Laurie, who are special people and have always made me proud. They have also been helpful to my career, providing contacts with prospective clients and feedback on KPF's work. I'm sorry for the days when they were young and I was traveling, when I missed some key baseball and basketball games, school events, and dinners together. They have given me nine fantastic grandchildren who are joys to watch as they start doing great things of their own. This wonderful extended family includes my son Brian's children: Ethan and Hannah; my son Steve's wife, Yvette, and their children: Rachel, Christine and Harry; and my daughter Laurie's children: Will, Alex, and identical twins Charlie and Matt.

Barbara brings two stepchildren to our tightknit family, Charles and Alex Dubow. Charles and his wife Melinda have two children of their own, William and Lally. Expanding our family even further are Barbara's brother Bill Zaccheo and his sons, Tyler and Sean. So I am surrounded by several generations of remarkable people, whose love and talents inspire me every day.

I also want to thank the people with whom I work closely on a daily basis. Their support throughout the day, every day, gives me the opportunity to focus on the duties of being chairman of KPF and the time to devote to writing this book. In particular, my assistants, Sue Holbrook and Nicola Barry-Vertegt, are essential to me, impressing everyone with their professionalism and knowledge of KPF.

I want to recognize and extend my gratitude to the two people with whom I started our firm: Shelley Fox and Bill Pedersen and their families. I cannot think of two better people to work with to create something special. Each one of us was critical to the success of each other and the firm. Bill Louie wasn't a founding partner—having joined us right after our first year—but he has been an essential part of our success ever since.

Over the years, I have had many partners, most

of whom have been outstanding and have made enormous contributions to the success of KPF. I thank them all for their dedication, contributions, and friendship.

Knowing that KPF is in the very capable hands of its current president, Jamie von Klemperer, has allowed me to cut back on long trips to Asia and devote some time to work on this book, in addition to my duties as chairman. Jamie and I are fortunate to have a special group of partners whose work is outstanding and who are all vital members of a great team.

In fact, I want to thank the entire staff of KPF—including our talented lawyer Rob Boder—and acknowledge their families for all their sacrifices on behalf of the firm.

Architects do not create buildings alone. Our work requires us to collaborate with engineers, consultants, and all types of contractors—all of whom play important roles in the success of our work.

I want to thank our many clients around the globe who have shown faith in KPF and appreciated our work. I can't name them all here, but they have given us amazing opportunities to shape the places where we work, live, play, and learn. It has been an honor to work with them.

I need to mention, though, a few of our earliest clients, because they trusted us before we had proven ourselves. That takes courage! Bob Goldman and Al Schneider, senior vice presidents at ABC, were the very first, so they deserve a special thank you. The story of KPF would have been radically different without Bob and Al giving us a nice kickstart. Our work for ABC led us to Tom Klutznick and George Darrell of Urban Investment and Development, who gave us the chance to design 333 Wacker Drive, the project that established our reputation as major architects.

We also received early support from corporate and institutional clients such as Proctor & Gamble, AT&T, IBM, the Federal Reserve Bank, and the World Bank, and from developers like Henry Lambert and his brother Ben Lambert. Stanley Marcus of Neiman Marcus and Richard Ralston Hough of AT&T, who were clients of mine before KPF, helped me and my partners immensely by recommending us way back when we had very little work. Jerry Speyer was another early friend who helped us in many ways,

as was Jim Ratner, who has been saying nice things about me and KPF for more than thirty years now. Stuart Ketchum is another old and dear friend, a real estate expert who introduced me to many clients in Los Angeles and took me under his wing.

A few of KPF's recent clients also deserve special recognition, including Stephen Ross of the Related Companies, Marc Holliday of SL Green, Tommy Craig of Hines, and Owen Thomas and Robert Selsam of Boston Properties, who have given us the opportunity to create major works of architecture. We are also doing work now with two old friends, Ted Tanner of AEG and Wayne Ratkovich. Tom Farrell counts as both an old and a new client, since KPF worked with him for many years when he was at Tishman Speyer and is designing the first project being developed by his own company, Cove Property Group. Ken Himmel is another old-and-new client, having worked with us in Chicago back in the 1980s, then in Boston, and now on Hudson Yards.

Similarly, KPF is now working with Brookfield Properties and Silverstein Properties, two companies we have known for a long time. And I want to thank Gary Barnett and Tony Mannarino of Extell for bringing us to Brooklyn.

Our early success flowed from the help of some key consultants who took the risk of associating with us before we had built much of a track record. Talented engineers such as Norman Kurtz, who became a very close friend, as well as Joe Loring and his business partner, Bob Dorherty, Marvin Mass, Irwin Cantor, Les Robertson, Ed DePaola, and Augie DiGiacomo at JB&B stood by us from the start, contributing their creativity and knowledge to our projects.

Beverly Pepper, who is a great sculptor and a dear friend, was another person who believed in KPF from day one and gave us her spirited support.

Finally, I want to whole-heartedly thank Cliff Pearson for helping me with this book and applying the discipline needed for us to finish the job. We were a perfect team working together and supported by Arthur Klebanoff, our publisher; Brian Skulnik, our editor at RosettaBooks; Claudia Brandenburg, our book designer, John Chu, the image manager at KPF; and Artelia Ellis, who transcribed the many hours of interviews I did with Cliff.

KPF Principals 2019

James von Klemperer
A. Eugene Kohn
William Pedersen
William C. Louie

Ralph (Forth) Bagley
James Brogan
John Bushell
Joshua Chaiken
Bernard Yat Nga Chang
Mustafa Chehabeddine
Rong (Rebecca) Cheng
Shawn Duffy
Dominic Dunn
Cristina Garcia
Brian Girard
Michael Greene
Peter Gross
Douglas Hocking
Charles Ippolito
Philip Jacobs
Hana Kassem
Jeffrey A. Kenoff
Jill N. Lerner
Ko Makabe
Inkai Mu
Richard Nemeth
Lloyd Sigal
Trent Tesch
Jochen Tombers
Hugh Trumbull
Robert C. Whitlock

Past Principals

Past Principals
Sheldon Fox (deceased)
Robert L. Cioppa
Arthur May (deceased)
Robert Evans
David Leventhal
Lee A. Polisano
Gregory Clement (deceased)
Paul Katz (deceased)
Peter Schubert
P. Kevin Kennon
Anthony Mosellie
Karen Cook
Ronald Bakker
Fred Pilbrow
David Malott
Patricia Conway
Randolph Gerner
Miguel Valcarcel
Richard Kronick

KPF Employees

New York
Annette Addario
Christopher Allen
Cynthia Arnold
Debra Asztalos
Rebecca Gromet
Wai Hong (Adrian) Au
Melissa Au
Nicola J Barry-Vertregt
Rodney Bell
Anne Savage
Robert Boder Esq
Garnes C Byron
Nike (Nick) Cao
Theodore F Carpinelli
Peter Catalano CPA
Britton Chambers
Yu-chen Chang
Eun-Joo (Terri) Cho
Daniel Choi
Eunsook Choi
Sujung Choi
Chad Christie
Wai (John) Yip Chu
Bum (Brian) Chung
H Ryan Clark
Andrew J Cleary
Ramses M Conyers
Natale Cozzolongo
Francisco J Cruz
Claudia G Cusumano
Daniel Dadoyan
Jason Danforth
Angela E Duncan-Davis
Nathan Degraaf
Melanie Del Rosario
Colin M Deshong
Christopher Dial
Victoria Dushku
Bruce E Fisher
Robin Fitzgerald-Green

Kesler R Flores
Hidehisa (Hide) Furuta
Javier Galindo
Nicholas Gigliotti
Robert G Graustein
Susan Green
Jonah P Hansen
Molly Frances Hare
Regina M Henry
Sungwoo Heo
Keisuke Hiei
Courtney Higgins
Kingsley S Ho
Reilly Hogan
Suzanne Holbrook
Fredy Holzer Feliu
Joseph Hong
Manman Huang
Samyul Huh
Rutger Huiberts
Minho Jeon
Chen Jin
Keith Johns
Jaclyn Jung
Kazuki Katsuno
Christopher Keeny
Lisa Kenyon
Soroush Khajegi
Saif Khan
Hyun Soo (Richard) Kim
Min S Kim
Andrew J Klare
Caroline Jenna Omojola
Yu-cheng Koh
Paulina Kolodziejczyk
Marianne Kwok
Blake Kennedy Lam
Recardo Kydd
Derek Lange
Ephraim A Lasar
Hyunwoo Lee
Ki Yong Lee
Leif Lee
Terri Lee

Daniela Leon
Ana Leshchinsky
Lei Li
Grace Liao
Meghan Lilly
Brendan Lim
Bara Lincoln
Michael Linx
Xiang Liu
Devon Loweth
Lucia Marquez
Jennifer Martin
Kathleen (Kate) Mcgivern
Nicole Mcglinn-Morrison
Emily McNally
Gregory Mell
Jorge Mendoza
Jochen Menzer
Michael Minarczyk
Katherine Moya-Ramirez
Andrew Isaac Ng
Andrew Nicolaides
David Niles
Margaret Mayell
Elie Gamburg
Romina Olivera-zuniga
David S Ottavio
Jinsuk Park
Sonal Patel
Christopher Pettis
Anna Pietrzak
Cristian Piwonka Spichiger
John Christopher Popa
Amanda Prins
Franz Prinsloo
Lane Rapson
Ray (Devin) Ratliff
Mark A Rayson
Gilbiandres Reyes
Alexandra (Sasha) Rich
Sean Roche
Yoko Saigo
Scott Savage
Lauren Schmidt-Bninski
Robert Scymanski
Esteban Segovia Rocha
Hala P. Sheikh
John Simons
Amanda Slaughter
Jerri K Smith
Aleksandra Sojka
Sean Stadler
Matthew Styron
Blanche B Nunez

Charles Tsz Chiu Tsang
Octavio G Ulloa-Thomas
Rachel L Villalta
Daniel Weaver
Andrew T Werner
Michael Wetmore
Onaje Weza
Lucien Wilson
John Winkler
Chun Chung (Stephen)
 Norman Wong
Hung-kuo (Albert) Wu
Di Xia
Li Xia
Man Hei (Tulip) Yeung
Lester Yu
Loren Yu
Darina Zlateva
Dakota Swainson
Paul Michael Renner
Ina Ognianova Chorlev
Tsun Wai (Arnold) San
Steven Smolyn
Cass Turner
Yong Eun (Erica) Cho
Alexander Lightman
Shaoliang Hua
Stanislas Dorin
Hyung Joon (Joon) Kim
Diana Rosoff
Wei Meng
Thomas McCabe
Jacob Cohen
Philip Sanzari
Yutian Wang
Peng Wang
Lila Jiang Chen
Derek Chang
Luan Feng
Alexander James Mailloux
Michael Jacob Kirschner
Edward Parker Russo
Kadambari Srinivasan
Shaoxuan Dong
Mengshi Sun
Arianna Mirielle Galan
 Montas
Yaron Birnbaum
Dongbai Song
Mana Ikebe
Rana Haddad
Hyun Ju Kim
Alexander Arons Huseman
Jiarui Su
Kaixiang Huang

Jingxian Xu
Karen Ann Singh Reilly
Ruoyun (Ruo) Xu
Xi Chen
Sean Ostro
Laura Sandoval Illera
Dennis Mercado
Yeqing (Carter) Cao
Rebecca Lauren Brand
Liangzi Zhai
Lauren Lochry
Duk Won Kim
Andrea Beth Basney
Eric Engdahl
Evan Rawn
Rachel Ashley Muse
Michael Howard
Emily Canby Gruendel
Piotr Jan Jankowski
Sydney Valentine Moore
Tianci Han
Wenxin Chen
Nels Erickson
Mustafa Khan
Junghyun Lee
Ayman S Tawfeeq
Gabriel Andres Morales
 Villegas
Qingyi Chen
Dixin Bao
Kautilya Anil Chauhan
Leonardo Pablo Rodriguez
Barrie Levy
Alexa Roberts
Eugene Leung
Xiaohan (Anna) Wu
Michael Louis Jon Totka
Mingchao (Milo) Wan
Maria Jose Hurtado Ortiz
Kirk Newton
Jaeyoung Kim
Pedro Camara Campos
 Figueiredo
Yannan Chen

Rebecca Kent
Runyu (James) Ma
Weiqian (Wayne) Liu
Nicholas LiCalzi
Nishchal Agarwal
Chandler Archbell
Sean Francis Dempsey
Dennis (Dee) Camero
 Harvey
Huai-Kuan (Kuan) Chung
Yuejia Yang
Jingyuan (Vivian) Yang
John Hooper
Braydn Xavier Smith
Gregory Goldstone
Michael DeGirolamo
Erin Soygenis
Yunhee Jeong
Chao Qi
Yueh-Nan (Luke) Lu
Kathleen Rose Cool
Yafei (Yoyo) Zhang
Laura Schwanhausser
Stefan Al
Nicholas Desbiens
Karim Mosaad Mahmoud
Jianing Zhang
Robin R Umrao
Kamila Jujka
Yanling Deng
Sandra (Sandi) Miranda
Xueyan (Sabrina) Li
Chao Liu
Yuchi Wang
Maxime (Max) Leclerc
Fah Kanjanavanit
Matthew Kevin Acer
Xiyao Wang
Minquan Wang
Shikun Tang
Hyojin (Jinny) Lee
Grace Kikelomo Lawal
Fan Yang
Dhafar (Dani) Al-edani

Patrick Cheung
Yue Zhang
Chris Jordano
Yifei (Audrey) Li
Morta Bautrenaite
Zhen Tong
Myriam Hamdi
Xiaoyun Mao
Maciej Szczawinski
Tianmin Yang
Weiyu Liu
Asli Oney
Nazia Tarannum
Honor Bishop
Niharika Kannan
Jiaxing Yan
John Gibson
Brittany L Micheline
Kathryn (Kate) Leah Ringo
Ceren Arslan
Jun Deng
Diana Frances Tsung
Stefan Klecheski
Xuege Li
Peiyu Ding
Shiyu Wu
Phakhol (Bom) Chinburi
You Jin (Eugene) Hwang
Carlos Cerezo Davila
Michael Thomas Quixtner
Antoine (Bobbie) Robinson
Jingwen Li
Sheung Chui (Carol) Nung
Michael Koutsoubis
Tait Kaplan
Jacqueline Mai Arisumi
Yijie Hu
Qi Jia
Angela Wu
Isabel Rachel Kam
Lijing (Liz) Huang
Joel Peterson
Maxwell Harrison Strauss
Amira Riadi Letzkus
Tianyi (Momo) Wei
Johnny Lin
Shaina Sunjin Kim
Jamie Yun Canbolat
Wenqi Huang
Christian Cafiero
Monica Arbeit
Elyse Killkelly
Yi (Jeff) Zhu
Jesus Enrique
 Chuquipoma Quiliche

Claire Dub
Andrew Haas
Zoe Gatti
Ernest Rong-Wei Pang
Clifford Pearson
Eitan Meisels
Yusuke Nishimura
Danaichanok (Drew)
 Coumswang
Zehua Zhang
Veronica Quintero
Candy Chan
Sang Hun (Luke) Cho
Zhuoqing (Jokin) Cai
Wing (Michael) Xu
Ladane Amelie Rongere

San Francisco
Angela Wu

Turkey
Tugba Ilhan

Shanghai
Yi Xiong
Wenting (Wendy) Li
Nan (Samuel) Li
Yijia (Stella) Mu
Yong Ding
Minjie (Crystal) Peng
Feng (Louis) Li
Lingling He
Bei (Clare) Sun
Hu Wang
Chen Yang
Sulan Shen
Hang Zhang
Xiaopan (Angie) Dong
Jiankun (Joyce) Chen
Xiaohui Liu
Yuanzhen (Vicky) Pan
Guanghui (Rayka) Luo
Xiangzhou (Scarlett)
 Chang
Liaoliao (Xiliao) Xi
Maciej (Matt) Burdalski
Jing (Lynn) Lin
Zhencheng Cui
Fausto Nunes
Yang Zhang
Yi Yang
Yunying (Sherry) Liang
Yong (Thomas) Wang
Mengyun Mao
Haoxiang Liao

Jingyao Cheng
Haochen Dai
Mengwei Liu
Yiqiu (Rachel) Wu
Weizhe Wang
Chuan Qin
Yunxia Dai
Jie Sun
Long Fu
Zhiyu Zhang

London
Michiko Sumi
Donald Shek
Maciej Olczyk
Ralph Gebara
Alisdair Stratton
Charles Olsen
Maria Banasiak
Lydia Osa Firminger
Suzanna Wong
Ji Soo Han
Simon Gomm
Wen-yu Tu
Christopher Hill
Jessica Herring
Natalie Ward
Jorge Cortes Fibla
Martin Coyne
Enrique Ramos Melgar
Alison Flaherty
Alpa Sidpura
Tae-in (Timmy) Yoon
Vasilis Ilchuk Marcou
James Miles
Robert (Rob) Starsmore
Francesco Casella
Guillermo Bellon Grauvogel
Marta Gonzalez Anton
Ozlem Tugba Ergen
Marta Mur Aguilar
Asako Hayashi
Daniel Allan

Christopher Harvey
Samuel Edward
Simone Luccichenti
Armor Gutierrez Rivas
Louis Cobben
Anqi Yu
Rachael Samuel
Sian Confrey
Giuseppina Pagana
Simon Wimble
Louis Sullivan
Bonnie Ging Liu
Samson Lau
Charles Gibault
Frank Siyu Fan
Takeshi Obata
Chloe Victoria Brown
Maxwell Fenton
Anita Franchetti
Cobus Bothma
Samantha Berry Cooke
Pedro Font-Alba
Ross Page
Daniel Gazzelloni
Jens Hardvendel
Ana-Isabel (Anabel)
 Fernandez Rubio
Dennis Hill
Jiali (Sammy) Gao
Laura King
Kornelia Krueger
Cindy Liu
Leif Lomo
Alex Miller
Laura Piccardi
John Prendergast
Karen Pui
Rosa Rius Garcia
Amy Langford
Jorge Seabrook
Paul Simovic
Bo Youn Song
Ken Ing Chet Tan
Wesley Veira

Marthinus Louis Vorster
Pamela Zamora Wackett
Timothy Lupfunn Yu
Najwan Yassin
Vincent Chen
Alfie Hope
Celia Maria Fiallos
lend Gjinovci
Tereza Havel
Samiyah Bawamia
Brian Spring
Michael Christopher
 Smith
Nathan Ozga
Maria Muguerza Larumbe
Shaun Wakefield
Daniel Koo
Magdalena Skop
Jayson Thaker
Colin Bailey
Gemma Howe
Lijia (Freja) Bao
Yi Lu
Razvan-Gabriel Stanica
Agnieszka (Agnes)
 Jablonska-Pipe
Russell Newland
Javier Roig
Sarah Mokhtar
Jose Ignacio Cardenas
 Canales
Simon Bennett
Tadeu Batista
Deborah Churchill
Oriol Diaz Ibanez
Alessandro (Greg)
 Boccacci
Niraj Shah
Nicole Ducheylard
Alessio Rossi
Si Wai (Cecilia) Ho
Vjollca Pllana
Young Kang
Pegah Shirkavand
Mayank Thammalla
Anja Funston
Marco Caserta
Victor Llavata Bartual
Hennakshi (Henna)
 Jadeja
Gabriele Grassi
Kiesse Andre
Madeleine Rose Pelzel
Victor Tsz Hin Leung
Aaron Shun Wing Ho

Iain Anthony Tregoning
Patrick King Pong Lam
Catherine Frances Jenkins
Yee Lok Enoch Liang
Mir Jetha
Masahiro Nakamura
Boon Yik Chung
Krystal Tsai Ting
Francesco Stefanini
Chun Wong
Katsunori Shigemi
Iryna Goroshko
Elias Anka
Amber Christine
 Helena Russ

Korea
Heejin Kim
Jihwan Moon

Hong Kong
Lai Shan (Florence) Chan
Chak Leung (Alex) Kong
Yee Tak Lau
Kwok Chuen (Edwin) Lau
Joe Tshung Pang
Billy Bond Yin Chu
William Yu Mao
Satoshi Okawara
Hong Cheng (Ringo) Tse
Chi Chung (Ronald) Wong
Weijia (Dora) Dong
Olivia Yick Hung Choy
Xianyan Gong
Yeelok (Jackie) Luk
Cheuk Fan (Frankie) Au
Tianmeng (Timo) Wang
Dan Li
Sze Ling (Tracy) Yan
Jiexian (Shane) Dai
Wai Yin (Vivian) Wong
Hung Lai (Wesley) Ho
Weite Shi
Zhuopeng (Wallace)
 Zhao
Jianyu (Ken) Hu
Tin Yiu Fung
Sharel Shao-Jui Liu
On U (Derrick) Leong
Chun (Rose) Bao
Fuk Man Mui
Jiang Wu
Man Fai (Martin) Tang
Pui Yin (Jim) Lau
Diana Guedes Afonso

Germany
Cindy Kubitz

Abu Dhabi
Ayman Magdi
Pinar Hatipoglu
Edibe Sarac
Sibel Ceray Akcan
Nerisa Galvez Santiago
Mary Carolyn Ardaiz
Bashar Abdallah
Mine Halici
Joanna Cobilla
Maria Lourdes (Des)
 Evangelista

Singapore
Shiju Balakrishnan
Marylene (Len) Mendoza
 De Lara
Rinor Komoni
Ofelia Caras Pascual
David Cunningham
Stephane Depuits
Ser Lin Teh
Cheok Kuan (Michelle) Chan
Jocelyn Sook Wai Yip
Geok Ling (Diane) Lim
Charles Simon Dio
 Frivaldo
Vincent John (Vinz)
 Dabi Bernales
Sun Sun Teoh
Maria Louise Ramos
 Tolentino
Li Lian (Lilian) Ho
Cristito Justo (Chris)
 De leon De Perio
Charmaine Suba Calma
Win Htun Kyaw
Steffen Kleinert
Bety Karjadi
Priscilla Pei San Ho
Liana Hani Liong
Huiwen Wang

Kohn Pedersen Fox
Key Projects, 1977–2024

1. ABC World Headquarters, New York City, Capital Cities/ABC, 1977-1991
2. Motorola Campus, Austin, TX, Motorola, 1979
3. Kincaid Towers, Lexington, KY, Kentucky Central Life Insurance, 1979
4. AT&T Regional Headquarters, Oakton, VA, AT&T Long Lines, 1980
5. Amoco Tower (1670 Broadway), Denver, Reliance Development, 1980
6. Rocky Mountain Energy Company Headquarters, Broomfield, CO, Rocky Mountain Energy, 1980
7. 8 Penn Center, Philadelphia, Reliance Development, 1981
8. ABC News Washington Bureau, Washington, DC, Capital Cities/ABC, 1981
9. 333 Wacker Drive, Chicago, Urban Investment & Development, 1983
10. Hercules Incorporated Headquarters, Hercules Incorporated, Wilmington, DE, 1983
11. One Logan Square, Philadelphia, Urban Investment & Development, 1983
12. Goldome Bank for Savings Headquarters, Buffalo, NY, Goldome Bank for Savings, 1983
13. Procter & Gamble World Headquarters, Cincinnati, Procter & Gamble, 1985
14. Tabor Center, Denver, Henson-Williams Realty, 1985
15. General Re, Stamford, CT, General Re Insurance, 1985
16. Lincoln Center, Minneapolis, Lincoln Properties, 1987
17. CNG Tower, Pittsburgh, Lincoln Properties, 1987
18. 1000 Wilshire Boulevard, Los Angeles, Reliance Development, 1987
19. Stanford Graduate School of Business, Palo Alto, CA, Stanford University, 1988
20. Two Logan Square, Philadelphia, JMB Urban Investment & Development, 1988
21. 101 Federal Street, Boston, Franklin Federal Partners, 1988
22. 900 N. Michigan Ave., Chicago, Urban Investment & Development, 1988
23. 135 East 57th Street, New York City, Madison Equities, 1988
24. Washington Mutual Headquarters, Seattle, Wright Runstud & Co., 1988
25. 125 Summer Street, Boston, A.W. Perry, 1989
26. 388 Greenwich Street, New York, Shearson Lehman Brothers, 1989
27. 712 Fifth Avenue, New York City, The Taubman Companies, 1990
28. 225 West Wacker Drive, Chicago, Palmer Group, 1990
29. BNY Mellon Center, Philadelphia, Richard I. Rubin & Co., 1990
30. Interstate Tower, Charlotte, NC, Faison Enterprises, 1990
31. Federal Home Loan Bank Headquarters, San Francisco, Federal Home Loan Bank, 1990
32. 311 South Wacker Drive, Chicago, Lincoln Properties, 1991
33. Canary Wharf FC-4 and FC-6, London, Brookfield Property, 1991
34. AARP Headquarters, Washington, DC, Oliver T. Carr Company, 1991
35. 181 North Clark Street (Chicago Title & Trust), Linpro Company, 1992
36. Federal Reserve Bank of Dallas, Dallas, Federal Reserve Bank of Dallas, 1992
37. IBM Canada Headquarters, Montreal, Marathon Realty, 1992
38. NASA Headquarters, Washington, DC, Boston Properties, 1992
39. 550 South Hope Street, Los Angeles, Obayashi Global, 1992
40. Goldman Sachs headquarters, London, Goldman Sachs, 1992
41. 27 Old Bond Street, London, Matsushita Investment & Development, 1992
42. Chifley Tower, Sydney, Bond Corporation Holdings, 1992
43. DZ Bank Headquarters, Frankfurt, AGIMA, 1993
44. United States Embassy Cyprus, Nicosia, US Department of State, 1993
45. Bank Niaga Headquarters, Jakarta, CIMB Niaga, 1993
46. Daniel Patrick Moynihan US Courthouse, New York City, BPT Properties, 1994
47. Hanseatic Trade Center, Hamburg, Citigroup, 1994
48. Lincoln Square, New York City, Millennium Partners, 1995
49. First Hawaiian Center, Honolulu, First Hawaiian Bank, 1995
50. Grand Centre, Hong Kong, Hang Lung Properties, 1995
51. World Bank Headquarters, Washington, DC, the World Bank, 1996

52. Mohegan Sun Earth Tower Hotel, Uncasville, CT, Mohegan Tribal Gaming Authority, 1996
53. Atlanta Federal Center, Atlanta, Prentiss Properties, 1996
54. US Federal Courthouse, Minneapolis, BPT Properties, 1996
55. Orchard Building Redevelopment, Singapore, Allsland, 1996
56. Buffalo Niagara Airport, Buffalo, NY, Niagara Frontier Transportation Authority, 1997
57. IBM World Headquarters, Armonk, NY, IBM, 1997
58. Forum Frankfurt, Frankfurt, Oppenheim Immobilien, 1997
59. Mark O. Hatfield US Courthouse, Portland, OR, General Services Administration, 1997
60. IBM World Headquarters, Armonk, NY, IBM, 1997
61. Telecom Headquarters, Buenos Aires, Benito Roggio e Hijos, 1997
62. The Landmark, Hong Kong, Excelsior Hotel (BVI) Ltd., 1997
63. Rodin Museum, Seoul, Samsung, 1997
64. 63 Ly Thai To, Hanoi, Excelsior Hotel (BVI) Ltd., 1997
65. Provinciehuis, the Hague, the Province of South Holland, 1998
66. Warsaw Financial Center, Warsaw, Poland, Golub & Company, 1999
67. Plaza 66, Shanghai, Hang Lung Properties, 2000
68. JR Central Towers, Nagoya, JR Tokai, 2000
69. One Raffles Link, Singapore, Excelsior Hotel (BVI) Ltd., 2000
70. LKG Tower, Manila, International Copra Export, 2000
71. Baruch College Vertical Campus, New York City, City University of New York, 2001
72. Gannett/USA Today Headquarters, McLean, VA, Gannett and Hines, 2001
73. 30 Hill Street, Singapore, Sewbawang Properties, 2001
74. Thames Court, London, Union Investment Real Estate, 2001
75. New Songdo City, master plan, Incheon, NSIC (Gale International and POSCO E&C JV), 2001
76. Hongkong Electric Company Headquarters, Hong Kong, Hongkong Electric Company, 2001
77. Singapore Exchange Centre, Singapore, United Overseas Bank, 2001
78. The Wharton School, Huntsman Hall, Philadelphia, University of Pennsylvania, 2002
79. Five Times Square, New York City, Boston Properties, 2002
80. AIG Europe Headquarters, London, AIG Global Real Estate Investment, 2002
81. Clifford Chance Headquarters at Canary Wharf, London, Canary Wharf Contractors, 2002
82. Dongbu Financial Center, Seoul, Dongbu Corporation, 2002
83. Philadelphia International Airport, Terminal 1, Philadelphia, US Airways, 2003
84. Roppongi Hills, Tokyo, Mori Building Company, 2003
85. Grand Hyatt Tokyo, Tokyo, Mori Building Company, 2003
86. 191 North Wacker Drive, Chicago, Hines, 2003
87. Benrather Karrée, Dusseldorf, Hines, 2003
88. Endesa Headquarters, Madrid, Endesa, 2003
89. Danube House, Prague, Europolis Real Estate Asset Management, 2003
90. Nile House, Prague, AHI Development, 2003
91. Chater House, Hong Kong, Hongkong Land Group, 2003
92. River City Prague, Prague, Europolis Real Estate Asset Management, 2003
93. Brickel Arch, Conrad Hotel, Miami, Estoril, 2004
94. World Trade Center, Amsterdam, ING Vastgoed, 2004
95. Hoofddorp East and West, Hoofddorp, Netherland, NS Vastgoed, 2004
96. Nihonbashi 1-Chome, Tokyo, Mitsui Fudosan, 2004
97. 505 Fifth Avenue, New York City, 579 5th Ave. LLC, 2005
98. AZIA Center, Shanghai, GIC Private Limited, 2005
99. Tour CBX, Paris, Tishman Speyer, 2005
100. Bur Juman Centre, Dubai, Bur Juman Centre, 2005
101. CEC Headquarters, Taipei, Continental Engineering Corp., 2005
102. Shr-Hwa International Tower, Taichung, Tzung Tang Development Group, 2005
103. Pudong Shangri-La Hotel, Shanghai, Kerry Properties, 2005
104. Beijing Science Technology Park, Beijing, Beijing Science Development Company, 2005
105. INCS Zero Factory, Nagano, INCS, 2006
106. Unilever Headquarters, London, Unilever Plc, 2007

107. Abu Dhabi Investment Authority Headquarters, Abu Dhabi, ADIA, 2007
108. One Raffles Quay, Singapore, Cheung Kong Holdings, 2007
109. Shanghai World Financial Center, Shanghai, Mori Building Company, 2008
110. Niaga II Tower, Jakarta, Grahaniaga Tatautama, 2008
111. 20 Gresham Street, London, Hermes Real Estate, 2008
112. CSCEC Tower, Shanghai, China State Construction & Engineering Corp., 2008
113. Niaga II Tower, Jakarta, Grahaniaga Tatautama, 2008
114. 555 Mission St, San Francisco, Tishman Speyer, 2009
115. Michigan Ross School of Business, Phases 1 & 2, Ann Arbor, MI, University of Michigan, 2009 and 2017
116. RBC Centre, Toronto, Cadillac Fairview, 2009
117. One Central, Macau, Shun Tak Holdings, 2009
118. KPMG European Headquarters, London, Canary Wharf Contractors, 2009
119. Songdo First World Towers, Incheon, NSIC, 2009
120. Ilsan Cultural Center, Seoul, Government of the City of Ilsan, 2009
121. Songdo Canal Walk, Incheon, NSIC, 2009
122. One Jackson Square, New York City, Hines, 2010
123. Kerry Properties Head Office, Hong Kong, Kerry Properties, 2010
124. Robert H. Jackson US Courthouse, Buffalo, NY, General Services Administration, 2011
125. Heron Tower, London, Heron Property Corp., 2011
126. International Commerce Centre (ICC), Hong Kong, Sun Hung Kai Properties, 2011
127. International Bank of Qatar Headquarters, Doha, International Bank of Qatar, 2011
128. Marina Towers, Beirut, Marina Towers S.A.R.L., 2011
129. Ventura Towers, Rio de Janeiro, Tishman Speyer, 2011
130. Tour First, Paris, ALTAREA-COGEDIM, 2011
131. The Langham & Andaz, Xintiandi, Shanghai, Shui On Land, 2011
132. ConvensiA Convention Center, Incheon, South Korea, 2011
133. Standard Chartered Dubai, Dubai, Gulf Resources Development and Investment, 2012
134. Covent Garden master plan, London, Capital & Counties, 2012
135. Infinity Tower, Sao Paulo, GTIS Partners, 2012
136. Hysan Place, Hong Kong, Hysan Development Company, 2012
137. China Huaneng Group Headquarters, Beijing, China Huaneng Group, 2012
138. First International Finance Centre, Mumbai, Vornado Realty Trust, 2012
139. Sixty London, Amazon Headquarters, London, AXA Real Estate, 2013
140. Jing An Kerry Centre, Shanghai, Kerry Properties, 2013
141. KIPCO Tower, Kuwait City, United Real Estate Company, 2013
142. Marina Bay Suites, Singapore, Cheung Kong Holdings, 2013
143. Centra Metropark, Iselin, NJ, the Hampshire Companies, 2013
144. ASU Business School, Tempe, AZ, Arizona State University, 2013
145. Kerry Parkside, Shanghai, Kerry Properties, 2013
146. Hogeschool van Amsterdam, Amsterdam, Trimp & van Tartwijk, 2013
147. National Theater of Cyprus, Nicosia, Cyprus Theatre Organization, 2013
148. Otemachi Tower, Tokyo, Tokyo Tatemono, 2014
149. 23-39 Blue Pool Road, Hong Kong, Hang Lung Properties, 2014
150. Northeast Asia Trade Tower, Incheon, NSIC, 2014
151. Riverside 66, Tianjin, Hang Lung Properties, 2014
152. Canary Wharf BP4, London, Canary Wharf Contractors, 2014
153. Porta Nuova Varesine, Milan, Hines, 2014
154. NYU Shanghai, Shanghai, New York University, 2014
155. Harbin Bank Headquarters, Harbin, Harbin Bank, 2015
156. Concord Adex, Toronto, Concord CityPlace Developments, 2015
157. Deloitte Tower, Montreal, Cadillac Fairview, 2015
158. MNP Tower, Vancouver, Oxford Properties, 2015
159. NYU College of Nursing, College of Dentistry and School of Engineering, New York City, New York University, 2015
160. Prudential Newark, Newark, NJ, Prudential, 2015
161. Petersen Automotive Museum, Los Angeles, Petersen Automotive Museum, 2015

162. 500 West 21st Street, New York City, Sherwood Equities, 2015
163. CUNY Advanced Science Research Centers, New York City, City University of New York, 2015
164. Vista Guanabara, Rio de Janeiro, GTIS Partners, 2016
165. Vista Mauá, Rio de Janeiro, GTIS Partners, 2016
166. 27 Wooster Street, New York City, The Stawski Group, 2016
167. Parc du Millenaire 3 & 4, Paris, ICADE, 2016
168. South Bank Tower, London, CIT, 2016
169. Ping An Financial Centre, Shenzhen, Ping An Insurance Company, 2016
170. CTF Finance Center, Guangzhou, New World Development Company, 2016
171. Goldin Financial Global Centre, Hong Kong, Smart Edge Limited, 2016
172. Tokyo Garden Terrace, Tokyo, Seibu Properties, 2016
173. 75 Rockefeller Plaza, New York City, RXR Realty, 2017
174. Ernst & Young Tower, Toronto, Oxford Properties, 2017
175. JR Gate Tower, Nagoya, Central Japan Railway Company, 2017
176. SOHO Tianshan Plaza, Shanghai, SOHO China, 2017
177. Genesis Building, Bulgari Hotel, Beijing, Beijing Huadu, 2017
178. WF Central, Mandarin Oriental Wangfujing, Beijing, Excelsior Hotel (BVI) Ltd., 2017
179. Lotte World Tower and Concert Hall, Seoul, Lotte Group, 2017
180. Dongdaegu Transportation Hub, Daegu, South Korea, Shinsagae Co. Ltd, 2017
181. Floral Court, London, Capital & Counties, 2018
182. 52 Lime Street ("the Scalpel"), London, WRBC Development, 2018
183. Madison Square Park Tower, New York City, The Continuum Company, 2018
184. Collegiate School, New York City, Collegiate School, 2018
185. CITIC Tower, Beijing, CITIC, 2018
186. One Shenzhen Bay, Raffles Hotel, Shenzhen, ParkLand Real Estate Development, 2018
187. Robinson Tower, Singapore, Tuan Sing Holdings, 2018
188. MGM Cotai, Macau, MGM Resorts International, 2018
189. 28 Chidlom, Bangkok, SC Asset, 2018
190. Rosewood Bangkok, Bangkok, Rende Development, 2018
191. YTL Headquarters, Kuala Lumpur, YTL Corporation, 2018
192. Pacific Gate, San Diego, Bosa Development, 2018
193. Main Street Place master plan, Bellevue, WA, Benenson Capitol Partners, 2018
194. Hudson Yards Phase 1, New York City, Related Companies, 2019
195. 390 Madison Avenue, New York City, L&L Holding Co., 2019
196. Hudson Commons, New York City, Cove Property Group, 2019
197. 111 Murray Street, New York City, Fisher Brothers, 2019
198. 2 Waterline Square, New York City, GID Development, 2019
199. Victoria Dockside, Hong Kong, New World Centre, 2019
200. Sequis Tower, Jakarta, PT Prospero Realty, 2019
201. Singha Headquarters, Bangkok, Singha Corporation, 2019
202. Abu Dhabi International Airport, Midfield Terminal Complex, Abu Dhabi, Abu Dhabi Airport Company, 2019
203. Three Sixty West, the Ritz-Carlton, Mumbai, Oberoi Realty, 2020
204. Crystal Plaza, Shanghai, Tishman Speyer, 2020
205. TP Link Headquarters, Shenzhen, TP Link Technologies Company, 2020
206. MSB Tamachi, Tokyo, Mitsubishi Estate, 2020
207. One Vanderbilt, New York City, SL Green, 2021
208. Azrieli Tower, Tel Aviv, Azrieli Group Ltd, 2021
209. Platform 16, San Jose, CA, TMG with Boston Properties, 2021
210. One Madison, New York City, SL Green Realty Corp., 2022
211. South Almaden, San Jose, CA, Boston Properties 2023
212. Jakarta MPP, Jakarta, Mori Building Company, 2022
213. Place de L'Etoile, Luxembourg, Silver Etoile, 202?
214. Changi Airport Terminal 5, Singapore, Changi Airport Group, 202?
215. The Bermondsey Project, London, Grosvenor, 2024
216. 10 South Van Ness, San Francisco, Crescent Heights, 2024

Index

Page numbers in italics reference pictures

10 Hudson Yards (New York), 243

30 Hudson Yards (New York), 242–243

52 Lime Street (London), 269–270, *272*

55 Hudson Yards (New York), 244

135 East 57th Street (New York), *95*

181 North Clark Street (Chicago), *98*

225 Wacker (Chicago) 129

333 Wacker Drive (Chicago), *62*, 63, *64–65*, 66–67, 69, 77, 85, 129, 249

390 Madison Avenue (New York), *267*, 268

712 Fifth Avenue (New York), 96

900 North Michigan Avenue (Chicago, IL), 77, 97

1250 René-Lévesque (Montreal), 126, 171

AAL (Aid Association for Lutherans) (Appleton, WI) *39*, 69, 114, 249–250

Aarons, Philip, 170

ABC (American Broadcasting Company), 59, 129, 168, 170

Abu Dhabi airport, Midfield Terminal Complex, 198–199, 277–278

AIA (American Institute of Architects), 177
 September 11 attacks, 178–179

AIA Architecture Firm Award (1990), 11

Aid Association for Lutherans (AAL) (Appleton, WI), *39*, 69, 114, 249–250

airports, 165–168
 Abu Dhabi airport, Midfield Terminal Complex, 198–199, 277–278
 Buffalo Niagara Airport, *150*, 164–168, *166–167*
 Changi International Airport (Singapore), 245, 278, 281

Alger, David, 178

American Broadcasting Company (ABC), 59, 129, 168, 170

American Institute of Architects (AIA), 177
 Firm of the Year (1990), 11, 155–156
 September 11 attacks, 178–179

Amoco Tower (Denver), *50*, 77

Architects 61, 281, 298

ARK Hills complex (Tokyo), 204–205

Arledge, Roone, 60

armory project for ABC (New York), 59–63, *61*

Arnold, Michael, 141

Arquitectonica, 97, 235

The Art Commission (Philadelphia), 89–90

Art Deco, 97

art show for Hannah Kohn (Guggenheim Museum), 17, 21–23

Arup, 281

Asia, 137, 140
 China. *see* China
 Hong Kong. *see* Hong Kong
 Indonesia, 145, 147
 Japan. *see* Japan
 Korea. *see* Korea
 Philippines, 148
 relationships, 147–149
 Taiwan, Taipei 101, 215
 Vietnam, 147

AT&T Long Lines Eastern Regional Headquarters (Oakton, VA), *72*, 73–75

attempted takeover of KPF, 189–196

August 2003 power outage (US), 182

Azrieli Tower (Tel Aviv), *292*, 298

Bacon, Ed, 33–34

Bagley, Forth, *239*, 269, 281

Baker, Michael, 110–111

Baker Harris Saunders, 110–111

Bakker, Ron, 192

Ballard, Claude, 116–117

Bank Niaga (Jakarta), 126, *146*, 147

Baruch College (New York), 159–162, *160–161*

Becket, Welton, 40–41, 284

Benoit, Walt, 69

Bermondsey Project (London), 298

Best Tall Building Overall (Council on Tall Buildings and Urban Habitat, 2008), 216

Betsky, Aaron, 216

Beyer, Blinder, Belle, 96

bid for 2012 Olympics, New York, 227, 230–231, 242

Bintzer, William, *23*

Blaik, Earl "Red," 297

Blau, Jeff, 235, 243

Bloomberg, Michael, 182, 227, 230–232, *233*, 290

Bodouva, Bill, 165

Boland, Tom, 156

Bond, Alan, 99

BOORA Architects, 164

Boston Properties, 234, 288

Bratti, Gerald, 281, 284, *285*

Bratti, Nancy, *285*

Brogan, James, 277

Bruce Mau Design, 298

Brutalist movement, 26

Buffalo Niagara Airport, *150*, 165–168, *166–167*

Burden, Amanda, 289–290

Burj Khalifa (Dubai), 215

Burnell, Jack, 129

Bushell, John, 124, 176, 192, *195*, 198, 265

business cards, Japan, 207–208

Butler, Brad, 81, 86

California, 287–288
 "Miracle Mile" (Los Angeles), 284, 287
 Petersen Automotive Museum (Los Angeles), 281–287, *282–283*
 Salk Institute (La Jolla, CA), 151

Canary Wharf (London), 114, *115*, 116

Cannon Design, 165

Carlsen, Magnus, 262

Catalano, Peter, 277, 302

Cates, Phoebe, *13*

Chan, Florence, 303

Chan, Ronnie, 142, 212, 266, 298

Chang, Bernard, 277

Changi International Airport (Singapore), 245, 278, 281

Chehabeddine, Mustafa, 278

Cheng, Rebecca, 277, 303

Chi, Tony, 216

Chicago, 63
 181 North Clark Street, *98*
 225 Wacker 129
 333 Wacker Drive, *62*, 63, *64–65*, 66–67, 69, 77, 85, 129, 249
 900 North Michigan Avenue, 77, 97

Chicago Title & Trust tower, 97–99

Chifley Tower model (Sydney), *15*

Chifley Tower (Sydney, Australia), 99

Childs, David, 234

China, 140, 144–145, 256
 CITIC Tower (Beijing), *273*, 274
 Dongjiadu Financial City, 298
 Meixi Lake (Changsha), 225
 Pearl of the Orient, 144–145
 Ping An Tower (Shenzhen), 270, 274
 Shanghai. *see* Shanghai
 Shanghai World Financial Center, 211–216
 urbanism, 201–202

China Zun, *273*

Cho, Terri, 303

Choi, Eunsook, 303

CIMB Niaga (Jakarta), 145–147

Cioppa, Bob, *83*, *87*, 159, 176, 178

CITIC Tower (Beijing), *273*, 274

Clark, Joseph Jr., 34

Clement, Greg, 159, 176, 186, 197
 death of, 262

clients, finding, 152–155

climate change, impact on architecture, 303–304

Coach, 243

Cobb, Harry, 77, 250

commercial projects, 11–12

comparative process, 247–248

Conran, Terence, 211

Conway, Pat, *53*, 70, *87*, 158–159

Cook, Karen, 124, 192

Corner, James, 281

Council on Tall Buildings and Urban Habitat (CTBUH), 216

Covent Garden (London), *184*, 187, 275

Craig, Tommy, 174, 291

Crocker Bank project, 76

Cross, Jay, *23*, 227–228, 243

CTBUH (Council on Tall Buildings and Urban Habitat), 216

Cusumano, Claudia, 303

dancing, early years, 18

Darrell, George, 66

de Cozar, Michael, 124

Dennis, Michael, 116

density, 201

Denver, Amoco Tower, *50*, 77

Design Excellence program, GSA (General Services Administration), 164

Diller Scofidio + Renfro, 245

diversity, 202, 255–256

Doctoroff, Dan, 227, 230–232

Dolan, James, 229–230, 232

Dolan, Robert J., 235

Dongjiadu Financial City, 298, *299*

Drexel University, 99

Duffy, Shawn, 275–276
Dunn, Dominic, 277
Dutch pension fund (PGGM), 120–123
DZ Bank tower (Frankfurt), 120–123, *121*

early life of Gene Kohn, 17–26, 293–295
 camp, 24
 dancing, 18
 education, 18
 Navy, 27–30
Eastdil Realty, 89
economic cycles, 304
education of Gene Kohn
 early years, 18
 master's degree, 30–33
 University of Pennsylvania, 25–27, 30–33
Elkus Manfredi, 234
Endesa, 176
exhibition in London, 110, *112*
expanding range of building types, 156–158

Fay Jr., Paul B, 41
Federal Reserve Bank of Dallas, 100, *101*
Feiner, Ed, 164
Fife, Eugene, 119
Firm of the Year (1990), 155–156
Fisher, Arnold, 40
Fisher Brothers, 40
Fleet Street, 117, 270
Fletcher, David, 111
Forbes, Matthew, 52, 58
foreign policy, radical swings in, 305
Forgey, Benjamin, 105
Foster, Norman, 96, 111, 216, 270
Four Seasons, 90–91, 97
Fox, Judy, *23*, *112*, 159
Fox, Shelley, 7–11, *9*, *23*, 38, 47, 51, 52–54, *53*, 57–60, *87*, 109, *112*, 297, 305
 death of, 159, 197
 retirement, 14, 159
Frankfurt, Germany, DZ Bank tower, 120–123, *121*
Freed, Jim, 250
future of KPF, 270–275, 293, 297–305
 London offices, 269–270
 von Klemperer, Jamie, 259–263, 268–269

Gale, Stan, 223
Gale & Wentworth, 223
Gale International, 224–225
Gannett/USA Today headquarters (McLean, VA), 173–174, *175*
Gapp, Paul, 67, 97, 155–156
Garcia, Cristina, 176, 303
Garodnick, Dan, 290
Geddes, Robert, 27
Geddes Brecher Qualls Cunningham, 27
Gehry, Frank, 17, *23*, 97, 286, 287
General Reinsurance (Stamford, CT), 92–93
General Services Administration (GSA), 162–164
Gensler, 62, 67
 Goldman Sachs project, 120
Gerstner Jr., Louis V., 171, 173
gimmicks, 77–78, 228
Gio (celebrity barber), 154
Giovannini, Joseph, 261
Girard, Brian, 238, 275
globalization. *see* going global
Gluckman, Richard, 209
Goff, Bruce, 32
going global, 109–110
 Asia, 137, 140, 147–148
 Canary Wharf, 114–115, 116
 DZ Bank tower (Frankfurt), 120–123
 Hong Kong, 141
 Indonesia, 145–146
 Japan, 130–132
 London offices, 110
 meeting with Prince Charles, 111–114
 Peterborough Court project, 117–120
 Russia, 127
 Vietnam, 147
Goldberger, Paul, *23*, 67, 82, 86, 89, 91, 94–97
Goldenson, Leonard, 59
Goldman, Bob, 59–60
Goldman Sachs, Peterborough Court project, 117–120
green design, ICC (International Commerce Centre), 220–221
green space, 204–205
Greene, Michael, 124, *203*, 288
Greenspan, Alan, 101, 104
Grill 23 & Bar, 234
Gromet, Rebecca, 303
Gross, Peter, 277

Ground Zero (New York), 14, 180–182

GSA (General Services Administration), 162–164

Guggenheim Museum, art show for Hannah Kohn, 17, *21–23*

Hang Lung Properties, 142, 212, 266, 277, 298

Hanoi, Vietnam, 147

Harris, Simon, 110–111

Hartz, Bill, 93, 95

headquarters, 93

 Gannett/USA Today headquarters (McLean, VA), 173–174, *175*

 IBM Headquarters (Armonk, NY), 171–173, *172*

 Procter & Gamble headquarters (Cincinnati, OH), 78–81, *79*, *84*, 85–86

Heatherwick, Thomas, 245

Heatherwick Studio, 281, 298

Henri Bendel store, 96

Hercules Corporation (Wilmington, Delaware), 70, *71*, 73

Hermitage Museum, 96

Hernmarck, Helena, 250

Heron Tower (London), *188*

Herzog & de Meuron, 221

Himmel, Ken, 232, 234, 243

Hines, 174, 290

Hines, Gerald D., 174

Hines, Jeff, 174

history of Kohn Pedersen Fox (KPF), 7–14

Hocking, Doug, 172, 209, 267–268

Holliday, Marc, 289–290

Hong Kong, 141–142, 217

 Hysan Place, *276*

 ICC (International Commerce Centre), 217, *218–219*, 220–221

 Kowloon Station, 220

Hong Kong Polytechnic University, 221

Hongkong Land, 141, 147

Hotel Okura (Tokyo), 132–133

Hough, Richard, 73

Hudson Yards (New York), *226*, *233*, 234–235, 238, *239–241*, 242–245, 248–249, 298, 301, *306–307*

humor, 168

Hunter, Anna, 114

Hynes III, John B., 223

Hysan Place (Hong Kong), 275, *276*

I. M. Pei & Partners, 47, 54

IBM, 171–173

 1250 René-Lévesque (Montreal), 126

IBM Headquarters (Armonk, NY), 171–173, *172*

ICC (International Commerce Centre), 217, *218–219*, 220–221

Indonesia, 145–147

interiors, KPFC (Kohn Pedersen Fox Conway Associates), 158–159

International Commerce Center (ICC), 217, *218–219*, 220–221

Ippolito, Charles, 195, 269

Iran, 44, 46–47

 bank project, 57–59

Israel, Azrieli Tower (Tel Aviv), *292*, 298

Jacobs, Bob, 38, 40

Jacobs brothers, 77

James Corner Field Operations, 281, 298

Japan, 130–132

 ARK Hills complex (Tokyo), 204–205

 business cards, 207–208

 Hotel Okura (Tokyo), 132–133

 Japan Rail, 134–135

 JR Central Towers (Nagoya), *128*, 134–137, *138–139*, 275

 Nagoya complex project, 201, 202, 217, 260, 175

 recession, 205

 Roppongi Hills (Tokyo), 205–211, 216

 Taisei Corporation, 129–130, 133–134

 Tohoku earthquake and tsunami (March 11, 2011), 211

Japan Rail, 134–135, 134–137, 201–202

Jeddah Tower (Saudi Arabia), 215

Jennings, Peter, 6

Jerde, Jon, 211

Jing An Kerry Centre (Shanghai), *264*

jobs of Gene Kohn

 Becket, Welton, 40–41

 John Carl Warnecke & Associates, 39, 41, 43–49

 Kahn & Jacobs, 38

 Kling, Vincent, 35–38

 Nolen & Swinburne, 34–35

John Carl Warnecke & Associates, 39, 43–49

Johnson, Philip, *10*, 27, 90

Johnson, Ralph, 216

Johnson, Tim, 216

Johnson, Woody, 228
JR Central Towers (Nagoya), *128*, 134–137, *138–139*, 275

Kahn, Ely Jacques, 38
Kahn, Louis, 25, 32, 151
Kahn & Jacobs, 38
Kamin, Blair, 67, 69, 97–98
Kassem, Hana, 288, 303
Kato, Yoshito, 206, 207
Katz, Paul, *23*, 130–136, *131*, 140, 143, 159, 190–191, 202, *203*, 262–263, *271*
 death of, 260–262
 Hongkong Land, 141–142
 Roppongi Hills (Tokyo), 209
 saving London office, 198
Kennan, George F., 43
Kennan, Grace, 43
Kennedy, Jackie, 43
Kennedy, John F., 41, 43
Kenoff, Jeff, 277
Kerry Center (Shanghai), 265–266
Kevin Roche John Dinkeloo and Associates, 244
Kincaid Group (Lexington, KY), 75–76
King, Laura, 303
Kline, Kevin, *13*
Kling, Vincent, *31*, 33–34, 35–38
Klutznick, Philip M., 63
Klutznick, Tom, 63, 66, 129
Kohn, Barbara Shattuck, *112*, 153, 178, 192, 227, 284, *285*
Kohn, Brian, 44, 116, 302
Kohn, Diane Barnes, 26, 281, 284
Kohn, Hannah, 17–18, *19–23*
 Guggenheim art show, *21–23*
 paintings by, *22*
Kohn, Steve, *23*, 44, 223–224, 302
Kohn, William, 17, 18, *20*, 82, 87, *131*
Kohn & Associates, 49, 51
Kohn Pedersen Fox Conway Associates, (KPFC), 158–159
Kohn Welsh, Barbara, 25, 27, 30, 37, 38
Korea, 255–256
 Lotte World Tower (Seoul), 270, *272*
 New Songdo City (Korea), *222*
 Songdo 221–225
Kosaka, Hideo, 132
Kowloon Station (Hong Kong), 217, 220

Koyl, George S., 26
KPFC (Kohn Pedersen Fox Conway Associates), 158–159
Krens, Thomas, 17, *23*, 211
Kriegel, Jay, 227
Krimendahl, Fred, 118
Kubitz, Cindy, 303
Kuok, Robert, 266
Kwok, Marianne, *239*, 243, 303
Kwok, Raymond, 217
Kwok, Thomas, 217
Kwok, Walter, 217
Kwok Tag Seng, 217
Kwong Siu-hing, 217

L&L Holding, 268
Lambert, Ben, 89
Lambert, Henry, 77, 89
Landmark, Hongkong Land, 141–142
Lapidus, Robert, 268
Le Corbusier, 25, 204–205, 209, 262
LEED certification
 Hysan Place (Hong Kong), *276*
 Songdo (Korea), 225
Lehman Brothers, 194, 209, 238
L'Enfant, Pierre, 225
Lerner, Jill, 158, 160, 234, 303
 Baruch College, 162
Leventhal, David, 124, 125, 192
Leventhal, Robert, 125
Levin, Neil, 180
Levinson, David, 268
Liangyu, Chen, 214
Lime Street Square (London), 270
Lincoln Square (New York), *169*, 170
line duties, 54
Linneman, Peter, 96
Logan Square project (Philadelphia), 34, *88*, 89–92, 129
London
 52 Lime Street, 269–270, *272*
 Bermondsey Project, 298
 Covent Garden, *184*, 187, 275
 exhibition in London, 110, *112*
 Heron Tower, *188*
 Lime Street Square, 270
 Royal Fine Art Commission (RFAC), 118–119

London offices, *108*, 124–126, 176, 263, 265
 attempted takeover of KPF, 189–195
 future of KPF, 269–270
 saving, 196–199
L'Oréal, 243
Lorillard, 52
Lotte World Tower (Seoul, Korea), 270, *272*
Louie, Bill, 34, 55, 57, *87*, *131*, 178, *246*, *252*
 Bank Niaga (Jakarta), 147
 career summary, 254–255
 General Reinsurance (Stamford, CT), 95
 Plaza 66 project (Shanghai), 142, 143
Louie, Mae, 255
Louvre in Abu Dhabi, 278
Luckman, Charles, 40–41

Madison Equities, 95
Maguire, Rob, 76, 301
Makabe, Ko, 136, *203*, 275
Maki, Fumihiko, 130, 211
management structures, 8
Manhattan stadium (New York), 227–232, *233*
Marcus, Stanley, 45, 151–152
Marina Bay Financial Centre (Singapore), 275
Mark O. Hatfield US Courthouse (Portland), 164
Martin, Jenny, 303
Mass Transit Railway (MTR), 217
master's degree, University of Pennsylvania, 30–33
Mathias, Andrew, 290
Mau, Bruce, 281
May, Arthur, 70, *87*, 88, 89, 159
 One Logan Square (Philadelphia), *88*, 89–91
Mays, Willie, 154–155
McHarg, Ian, 25, 26, 32
Meixi Lake (China), 225
Mellon Bank Center (BYN Mellon Center), 34, *252*
Mendell, Mark, 165
Metropolitan Transportation Authority (MTA), 238
Middleport Pottery Studios, 113
Midfield Terminal Complex (Abu Dhabi airport), 198–199, 277–278
Mies van der Rohe, Ludwig, 33, 63, 244, 262
Millennium Partners, 168, 170–171
Miller, George, 177
Min Chul Hong, 256

MIPIM, 186
"Miracle Mile" (Los Angeles), 284, 287
Modernism
 updated Modernism, 100
 World Bank Headquarters (Washington, D.C.), 100, *102–103*, 104
Morgan, Lewis & Bockius, 89–90
Morgan Stanley, 214, 238, 274
Mori, Akira, 204–205
Mori, Minoru, 202, *203*, 204–209, *210*, 211, 216–217
 ARK Hills complex (Tokyo), 204–205
 Roppongi Hills (Tokyo), 205–211, 216
 Shanghai World Financial Center, 211–216
Mori, Taikichiro, 204, 207–209
Mori, Yoshiko, 209, 215
Mori Building, 202, 211
Mori Trust, 205
Morocco, Navy, 29–30
Morrison, Alasdair, 141
Mosellie, Anthony, 124, 266
Motorola project (Austin, TX), *68*, 69–70
MTA (Metropolitan Transportation Authority), 238
MTR (Mass Transit Railway), 217
Mu, Inkai, 274
Mullin, Peter, 286–287
Mumford, Lewis, 25, 26
Munakata, Shiko, 132
Murdoch, Rupert, 238
Murray, Peter, 110
Muschamp, Herbert, 97
Museum of Modern Art (MoMA), 174–176

Nagoya complex project (Japan), 201, 202, 217, 260, 175
NASA project, 41
Nash, Jim, 250
Navy, 8, 27–30, 54
Nealy, Craig, 118, 209
Neiman Marcus, 151–152
Nelson, George, 250
Nemeth, Richard, 224, 288
networking, 153–155
Neutra, Richard, 25
New Songdo City (Korea), 221–225, *222*
New York, 38, 95–97, 289–290
 10 Hudson Yards, 243

30 Hudson Yards, 243

55 Hudson Yards, 244

135 East 57th Street, *95*

390 Madison Avenue, *267*, 268

712 Fifth Avenue, 96

armory project for ABC, 59–63, *61*

bid for 2012 Olympics, 230–231

Hudson Yards, *226*, *233*, 234–235, 238, *239–241*, 242–245, 248–249, 298, 301, *306–307*

Lincoln Square, *169*, 170

North Academic Center at City College, 247

One Madison Avenue, 290–291, 298

One Vanderbilt, *279*, *280*, 290–291, 298

Pahlavi project, 57

Seagram Building, 85

Shed, Hudson Yards (New York), 245

subway system, 201

Time Warner Center, 234

Vessel, Hudson Yards, 245

New York Jets, Manhattan stadium, 227–232

New York Times, 12, 59, 67, 92, 97–98, 140, 151, 162, 211, 216, 230

 article by Paul Goldberger, 82

 obituary for Paul Katz, 261

News Corporation, 238

Niles, David, 297

Nolen & Swinburne, 34–35

North Academic Center at City College (New York), 247

Nouvel, Jean, 278

NYU in Shanghai, 298

Ogg, Charlie, 35

Oldenburg, Claes, 123

Olympia & York, 92, 116, 124, 234

Ondra, 194

One Logan Square (Philadelphia), 34, *88*, 89–91

One Madison Avenue (New York), 290–291, 298

One PNC Plaza (Pittsburgh), 41

One Vanderbilt (New York), *279*, *280*, 290–291, 298

O'Neill, Tom, 223

Ouroussoff, Nicolai, 230

over-centralization, 305

Pahlavi project (New York), 57

Palumbo, Peter, 96

Park Hyatt, Shanghai World Financial Center, 214–216

Parker, Leonard, 251, 254

Parkinson, Laurie, *112*, 228

Paul Taylor Dance Company, 13

Pearl of the Orient, 144–145

Pedersen, Bill, 7–11, *9*, 14, *23*, 47, 51, 52–55, *53*, *56*, *83*, *87*, *131*, 178, *183*, *246*, *253*, 297

 AT&T Long Lines Eastern Regional Headquarters (Oakton, VA), 74

 135 East 57th Street (New York), 94

 Baruch College (New York), 162

 Canary Wharf (London), 116

 career summary, 247–255

 Crocker Bank (Los Angeles), 76

 DZ Bank tower (Frankfurt), 123

 furniture designer, 256–257

 General Reinsurance (Stamford, CT), 95

 Hudson Yards (New York), 242–243

 ICC (International Commerce Centre) (Hong Kong), 220

 Madison Equities, 95

 Manhattan stadium (New York), 228–229

 Peterborough Court project (London), 117–120

 Procter & Gamble headquarters (Cincinnati, OH), 81

 Roppongi Hills (Tokyo), 209

 Shanghai World Financial Center, 212, 214, 265

 Wacker Drive project (Chicago), 62–66

Pedersen, Elizabeth, 249, 256–257

Pei, I. M., 47, 250

Pei Cobb Freed, 77, 78

Pelli Clarke Pelli, 217

Perkins, G. Holmes, 25

Perkins + Will, 66–67

Peterborough Court project (London), 117–120

Petersen, Margie, 284

Petersen, Robert, 284

Petersen Automotive Museum (Los Angeles), 281, *282–283*, 285, 286–287

PGEM, DZ Bank tower (Frankfurt), 120–123, *121*

phasing, ICC (International Commerce Centre), 221

Philadelphia, 33–34, 38

 airports, 168

 Logan Square project, *88*, 89–92

Philippines, 148

Pilbrow, Fred, 124, 192–193

Ping An Tower (Shenzhen), 270, 274

Plaza 66 project (Shanghai), 142, *143*

Polisano, Lee, 124–126, 159, 185, 198

 attempted takeover of KPF, 189–195

Portland, 164

Postmodernism, 85–86, 89, 93, 97, 99–100

preparing for the future 55–57

Prince Charles, 111, *112*, 113–114

Prince's Regeneration Trust, 113–114

Princess Diana, 113

Princess Grace, *45*

Procter & Gamble headquarters (Cincinnati, OH), 78–81, *79*, *80*, *84*, 85–86

Progressive Architecture, 105

public speaking, 295–296

Pudong, Shanghai World Financial Center, 212–214

Rees, Peter Wynne, 118

refuge floors, 180

Rehkopf, Fritz, 46

Related Companies, 233, 234–235, 248

relationships, 129, 301

 Asia, 147–149

 China, 144–145

 developing through organizations, 152–153

 Hong Kong, 141

 Hongkong Land, 147

 Indonesia, 145–146

 Japan Rail, 134–136

 Taisei Corporation, 129–130, 133–134, 137

Reliance Insurance, 77

research, importance of, 92–93

RFAC (Royal Fine Art Commission) (London), 118–119

Rich, Nigel, 141

Robert A. M. Stern Architects, 235

Roberts, Keith, 92–93

Robertson, Leslie, *23*, 179, 214

Roche, Kevin, 124, 244, 254

Rocky Mountain Energy (Broomfield, CO), 77, 92

Roppongi Hills (Tokyo), 203, 205–209, *206*, 211–212, 216–217

Rose family, 154

Ross, Stephen, *13*, 234, 235, 238, 242–243, 248, 250

Ross School of Business (University of

Michigan), 158, 235, *236–237*

Rossiter, Ehrich, 192

Rossiter, Thomas Prichard, 192

Roth, Steve, 154

Royal Fine Art Commission (RFAC) (London), 118–119

Royal Institute of British Architects (RIBA), 110, 111

Rudolph, Paul, 25–27

Russell, Carl, 41, 43

Russia, 127

 St. Petersburg 96–97

Saarinen, Eero, 168, 244, 254

Safdie, Moshe, 234

Salk, Jonas, 151

Salk Institute (La Jolla, CA), 151

Samuel Zell and Robert Lurie Real Estate Center, 96

San Francisco office, 301

SAP, 243

saving London offices, 196–199

The Scalpel, 269–270, *272*

Schmidt, Lauren, 303

Schneider, Al, 59–60

Schwartz, Martha, 163, 165

Scott Brown, Denise, 25, 111

Seagram Building (New York), 33, 85

September 11, 2001, 176–182

 urban resurgence, 14

Severud Associates, 268

Shah of Iran, 43, 46–47

Shanghai

 Jing An Kerry Centre, *264*

 Kerry Center, 265–266

 NYU in Shanghai, 298

 Plaza 66 project, 142, *143*

 subway system, 201

Shanghai World Financial Center, *200*, *210*, 211–212, *213*, 265

Sharp, Issy, 90–91

Shed, Hudson Yards (New York), 245

Shenzhen China, Ping An Tower, 270, 274

Sigal, Lloyd, 124, 268, 288

Sigal, Myron, 288

Silfen, David, 198

Silver, Sheldon, 231

Silverstein, Larry, 180

Singapore office, 298

Skidmore, Owings & Merrill, 40, 73, 76, 86, 104, 156, 212Skilling, John, 179

SL Green, 289, 290

Smale, John, 81, 86

smart cities, Songdo (Korea), 221–225

Smith, Jerri, 303

softball team, 8, 55, 56, 77, 155

Solomon, David, 96

Solomon, Jean, 96

Songdo (Korea), 221–225

Songdo Canal Walk (Korea), *222*

Sotheby's, 96–97, 174

Soviet Union, traveling exhibition, 296–297

Speyer, Jerry, 158, 174, 176

Springer, Brad, 70

St John-Stevas, Norman, 118–120

St. Petersburg, Russia, 96–97

staff assignments, 54

Stageberg, James, 251

start of Kohn Pedersen Fox (KPF), 52–59

Stein, Al, 70

Steinberg, Raymond, 295

Stephen M Ross School of Business, 158, 234–235, *236–237*

Stone Logistics, 281

Streep, Meryl, 248

subway systems, 201

Sudjic, Deyan, 110

Sullivan, Louis, 63, 66, 85

Sun Hung Kai Properties, 217

Supreme Court Building, 97

Suvretta House Hotel, 46

Sydney, Australia, Chifley Tower, 15, 99

Sydorick, David, 284, *285*, 286–287

Sydorick, Ginny, *285*

Tabor Center (Denver, CO), 77

Taipei 101 (Taiwan), 215

Taisei Corporation, 129–130, 132–134, 136–137

talent, finding, 155

Taniguchi, Yoshio, 133, 174, 176

Taniguchi, Yoshiro, 132

Taubman, Alfred, 94, 96–97

Taylor, Diana, 227

teamwork, 57, 69, 297, 305

Tel Aviv, Azrieli Tower, *292*, 298

Tesch, Trent, *23*, *239*, 244, 270, 281
 Petersen Automotive Museum (Los Angeles), 286

Thames Court, 228

Theophilus Parsons Chandler Architecture Fellowship, 30

Thom, Bing, 221

Thomas, Owen, 288

Time Warner Center (New York), 234

Tishman Speyer, 174, 235, 238

Tokyo, green space, 204–205

Tombers, Jochen, 278

Tomimoto, Kenkichi, 132

Trafalgar house, 141

traveling exhibition in the Soviet Union, 296–297

Travelstead, G. Ware, 94, 114, 116, 249–250

travertine, 152

treatment of employees, 170–171

Trumbull, Hugh, 288, 300

Unilever (London), 176, 265

union of Soviet architects, 296

University of Minnesota, Pedersen, William, 250–251

University of Pennsylvania, 25–27
 giving back as an alumnus, 152–153
 master's degree, 30–33
 Wharton School Huntsman Hall, *157*

updated Modernism, 100

Urban Land Institute (ULI), 153, 234

Urban Land Institute (ULI) conference (San Francisco, 1985), 109

U.S. Federal Courthouse in Minneapolis, *163*, 164–165

van Bruggen, Coosje, 123

Venturi, Robert, 25, 32, 111, 254

vertical urbanism, 201, 202–204

Vessel, Hudson Yards (New York), 245

Vietnam, 147

von Klemperer, Jamie, *9*, 14, 142, 143, 159, 190–191, *195*, *258*
 Bank Niaga (Jakarta), 147
 future of KPF, 176, 186, 197, 259–260, 262–263, 268–269, 293, 297
 Shanghai, 264–266
 Songdo, 224–225

Wacker Drive (Chicago)
 225 Wacker Drive, 129
 333 Wacker Drive, *62*, 63, *64–65*, 66–67, 69, 77, 85, 129, 249
Warnecke, John Carl, 41–44, *42*, 47–49
Washington, DC, 173, 225
Webb, Nigel, *112*
West, Geoffrey, 260
West Kowloon Cultural District, 220–223
Wharton, Geoffrey, 180
Wharton School Huntsman Hall, *157*, 158
Whitlock, Rob, 275
women, leadership at KPF, 303
Wong, Ken, 243–244
Wood, Doug, 284, *285*
Wood, Linda, 284, *285*
work experience of Gene Kohn
 Becket, Welton, 41,
 John Carl Warnecke & Associates, 39, 41, 43–49
 Kahn & Jacobs, 38
 Kling, Vincent, 35–38
 Nolen & Swinburne, 34–35
World Bank Headquarters (Washington, D.C.), 100, *102–103*, 104–105, *106–107*
Wright, Frank Lloyd, 25, 32
Wright, Jason, 171
Wu, Angela, 288, 301

Xiaoping, Deng, 274

Yamasaki, Minoru, 179, 180

Zinn, Mary, 294

Photo Credits

Page 6: Courtesy of KPF

Page 9: Britain Hill/*Outline* (top); John Chu/KPF (bottom)

Page 10: Courtesy of A. Eugene Kohn

Page 13: John Chu/KPF (top); courtesy of KPF (bottom)

Page 15: Courtesy of KPF

Page 16: Courtesy of A. Eugene Kohn

Page 19: Courtesy of A. Eugene Kohn

Page 20: Courtesy of A. Eugene Kohn

Page 21: Courtesy of A. Eugene Kohn

Page 22: Courtesy of A. Eugene Kohn (top); courtesy of A. Eugene Kohn (bottom)

Page 23: Courtesy of KPF

Page 24: Courtesy of A. Eugene Kohn

Page 28: Courtesy of A. Eugene Kohn

Page 31: The Philadelphia Inquirer/Special Collections Research Center, Temple University Libraries

Page 39: Elliot Fine

Page 42: Courtesy of A. Eugene Kohn

Page 45: Courtesy of A. Eugene Kohn

Page 50: Courtesy of KPF

Page 53: Courtesy of KPF (top); courtesy of KPF (bottom)

Page 56: Courtesy of KPF

Page 61: Peter Aaron/ESTO (left); Jock Pottle (right)

Page 64–5: Barbara Karant

Page 68: Courtesy of KPF

Page 71: Jock Pottle

Page 72: Ezra Stoller/ESTO

Page 79: Jock Pottle (top and bottom)

Page 80: Barbara Karant

Page 83: Courtesy of A. Eugene Kohn

Page 84: Barbara Karant

Page 87: Courtesy of KPF

Page 88: Norman McGrath

Page 95: Jock Pottle

Page 98: Barbara Karant

Page 101: Richard Payne

Pages 102–3: Timothy Hursley

Pages 106–7: Michael Dersin

Page 108: PHILIPVILE

Page 112: Courtesy of A. Eugene Kohn (top); Courtesy of A. Eugene Kohn (bottom)

Page 115: Timothy Soar

Page 122: Dennis Gilbert

Page 128: Courtesy of JR Central

Page 131: Jock Pottle

Pages 138–9: Nacasa & Partners

Page 143: H.G. Esch

Page 146: CI & A Photography

Page 150: Timothy Hursley

Page 157: Jeffrey Totaro

Page 160: Michael Moran

Page 161: Michael Moran

Page 163: Don Wong

Pages 166–7: Timothy Hursley

Page 169: Jock Pottle

Page 172: Peter Aaron/ESTO

Page 175: Timothy Hursley

Page 183: John Chu/KPF

Page 184: Courtesy of KPF

Page 187: Timothy Soar

Page 188: Hufton + Crow

Page 195: John Chu/KPF

Page 200: H.G. Esch

Page 203: John Chu/KPF (top); John Chu/KPF (bottom)

Page 206: Mori Building

Page 210: China Photos/Getty Images (left); Shinkenchiku (right)

Pages 218–9: Grischa Rueschendorf

Page 222: GUST (top); (bottom) Jae Seong Lee

Page 226: Connie Zhou

Page 233: KPF (top); John Chu/KPF (bottom)

Pages 236–7: Raimund Koch

Page 239: John Chu/KPF (top); John Chu/KPF (bottom)

Pages 240–1: Bernstein Associates Photographers

Page 246: John Chu/KPF

Page 252: Sheena Kim/Unique Lapin Photography

Page 253: Kristine Larsen

Page 258: John Chu/KPF

Page 264: Tim Franco

Page 267: Neoscape

Page 271: Courtesy of KPF

Page 272: Morley Von Sternberg (left); Lotte Corporation (right)

Page 273: Tim Griffith (left); H.G. Esch (right)

Page 276: Grischa Ruschendorf

Page 279: Martin Tang/KPF

Page 280: KPF

Pages 282–3: Raimund Koch

Page 285: A. Eugene Kohn [Tuscany shot]

Page 292: Courtesy of Jamie von Klemperer/KPF

Page 299: Rendering by Atchain

Page 300: Rendering by Plompmozes (top); Rendering by Byencore (bottom)

Pages 306–7: Connie Zhou [Hudson Yards from NJ]

Page 310: John Chu/KPF (left); Courtesy Weaselworks Films (right)

Page 311: Naki Studios/Erica Moffitt (top left); Naki Studios/Erica Moffitt (bottom right)

Page 312: Sheena Kim/Unique Lapin Photography (top left); Agnese Sanvito (bottom right)

Page 313: Xiao Long (top left), Francesca L Photography (bottom right)

Front and end papers: Drawing by Zoe Gatti/KPF